AFRICAN AIR
GEORGE STEINMETZ

AFRICAN AIR

GEORGE STEINMETZ

ABRAMS
NEW YORK

To Verna, who wouldn't let me go . . .
To Lisa, who always welcomes me back.

"The machine does not isolate man from the great problems of nature but plunges him more deeply into them."

Antoine de Saint-Exupéry, *Wind, Sand and Stars*

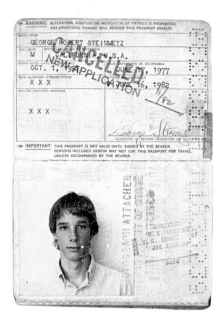

George Steinmetz's passport, 1977

"A journey doesn't need motivations. Before long, it proves to be sufficient unto itself. One thinks one is going to make a journey, yet soon it is the journey that makes or unmakes you."

Nicolas Bouvier, *The Way of the World*

A friend of mine from college used to say that every great idea occurs to you before the age of thirty, and after that it's just recycling. I'm beginning to think that Billy was right.

I got the idea for this book when I was a twenty-one-year-old hitchhiker, mooching rides across the Sahara Desert in an odd assortment of commercial trucks and overstuffed Land Rovers. It was in March of 1979, and as I bumped along the rutted tracks of southern Algeria into Agadez, Niger, I felt so small, like a tiny insect crawling across a gigantic eroded plain. I felt I needed more context and wondered what it would be like to see this same landscape from the air, to be able to see its patterns and what lay over the horizon.

It was on this trip that I fell in love with Africa and decided to spend my life taking pictures. I also came up with the hare-brained scheme of transporting a small aircraft on a voyage of discovery around the Sahara to see and photograph it from above. Back then, this seemed completely unrealistic, as so many impossible things would have had to fall into place to make it happen. First, I would have had to find a way to pay for this dream. I'd need to find the right pilot and aircraft that would let me take off and land in unforgiving terrain. On top of that, there was an intractable civil war going on in Chad, which has some of the most spectacular landforms in the Sahara. And last but not least, I'd need to acquire the photographic skills to pull the whole thing off. It wasn't until 1997, after eleven years of working for GEO and *National Geographic* magazines, that all the pieces would fall into place and I would realize that my youthful dream was within reach. But I'm getting ahead of myself...

I had come to Africa in 1979 as much to explore a place I knew nothing about as to escape the world I was from. Life had been pretty smooth for me, growing up on a palm-lined street in Beverly Hills, California, and attending Stanford University. After three years in college I was restless and still had no clue what I wanted to do when I graduated. I was desperate to explore the world beyond the privileged one I knew. The previous summer, I had been to Europe on a rail pass, and after taking the pass as far as it would go, I ended up running out of money in Morocco. There, I met a guy who had just ridden a motorcycle across the Sahara. That seemed like a grand adventure to me, and so I decided there and then that I was going to hitchhike across Africa.

When I informed my mother of my ambitious travel plans, she refused to let me go. I was

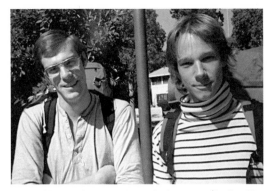

Curt Holzinger and George Steinmetz leaving Los Angeles for Africa, February 1979

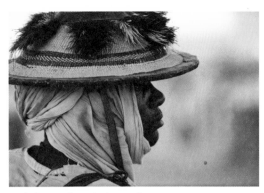

Wodaabe nomad, Ingal, Niger, April 1979

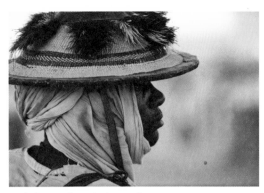

Postcard from Niamey, Niger, to father David Steinmetz, April 1979

about to turn twenty-one, and when I reminded her that I didn't need her permission, and would use my own hard-earned money, she retreated to her bedroom and slammed the door. The idea of her youngest son dropping out of Stanford, just shy of a geophysics degree, to go out into the unknown was more than she could bear. In January 1979, I bought a one-way ticket to London. With $4,000 in my money belt, I started making my way across Europe by train and thumb. My friend Curt Holzinger, who had been hitchhiking with me, kindly lent me his camera outfit when we parted ways in Algiers. I figured I would encounter bare-breasted women with plates in their lips, like I had seen in *National Geographic* as a kid, so I packed lots of film. I had a rucksack crammed with everything I could imagine I'd need, including a snakebite kit, a syringe for anaphylactic shock, and big hiking boots.

I had no training in photography, and Curt had given me just one 35 mm camera—an Olympus OM1 and two lenses—so, true to my strict budget, I was a film economist. I mailed letters and small packages of film back to my mother every month or two when I hit a capital with a functioning postal system. In spite of her months of protesting, my mother quickly became my most avid fan and told me that I had great talent. But you can't always believe your mother. She also sent me care packages with canvas shirts, shorts, and cartons of clove cigarettes. My boots felt hot and didn't last very long, and I soon learned that flip-flops require no sock washing.

In 1979, there were no mobile phones or even satellite phones, no Internet cafés, and no 911.

It was challenging and exciting living as a wandering vagabond with a camera. That first trip was a real dirtbag safari. I got around by whatever means I could hustle up while trying to learn French, Swahili, and Arabic from truck drivers and dictionaries. I had a rule that I would try anything before paying for a ride, which sometimes involved standing by the side of a road all day without any luck. I couldn't afford to be picky, so I rode in or on just about everything, but most commonly atop open cargo trucks, or, if I was lucky, up in the cab. I was a novelty out there in the middle of the continent, and most good-natured Africans would stop when flagged down by a tall blond kid with a backpack.

Outside of the big cities there were no hotels, but I quickly learned that if I wandered around villages looking polite and meek, accommodations

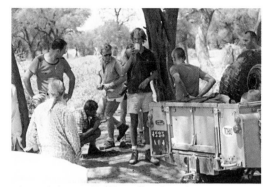

George Steinmetz with military officers in northern Cameroon, May 1979

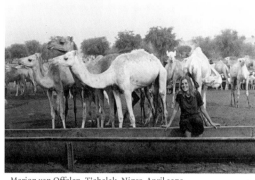

Marion van Offelen, T'abalak, Niger, April 1979

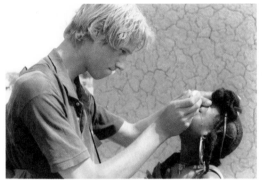

George Steinmetz giving antibiotic eyedrops to a Wodaabe girl, Ingal, Niger, April 1979

had a way of materializing. Most African villagers took sympathy on the curious outsider. Someone would inevitably offer me a place to stay in their home—often displacing the primary inhabitant—cook the best meal they could muster, and endure my linguistic and cultural gaffes. In rougher towns I often got invited to sleep on the floor or porch of the local police station, as much for my own protection as out of the policemen's sense of hospitality. I felt kind of guilty, a kid from Beverly Hills, bumming beds and rides from people much poorer than I was, but I was very much on my own and home was a long way away.

I didn't know what I was doing at first, so I followed my instincts, which needed a lot of honing. I got sick, fell into some tight spots, and learned how to get out of them. At one point, while rid-

ing in the cab of a fuel truck across a bleak section of the Algerian Sahara, the driver pulled over to change his oil. When I wandered around the corner and saw him urinating, he started toward me with his pants unzipped. After a brief moment of shock, I pulled out a hunting knife my grandmother had given me and started peeling an orange. That seemed to do the trick, and he kept his distance for the rest of our journey.

I was also learning how to take pictures. Within a few months and some encouraging letters from my mother and father, I started to direct my travels to areas where I thought I could get good shots. I had a few guidebooks and picked up whatever advice I could from the odd collection of overland travelers I met along the way. I had dreams of experiencing the least changed

cultures in Africa. But hitchhiking alone across the Sahara without speaking French or Arabic was not easy.

I finally made it across the desert in April in the back of a Land Rover owned by a pair of German dentists. When we got into Agadez, Niger, they were disappointed to discover that not only was the city dirty but the beer was warm. So they abruptly decided to return north to Algeria while I decided to go south. On my way out of town, I had an amazing spot of luck. The car I was traveling in stopped to pick up a passenger stranded by a breakdown, and in climbed a charming twenty-eight-year-old Belgian ethnologist, Marion van Offelen. Marion had spent months living alone with the local Wodaabe nomads, and we spent hours on that drive discussing everything from

Boy carrying a "welcome" mat, Mandara Mountains, northern Cameroon, May 1979

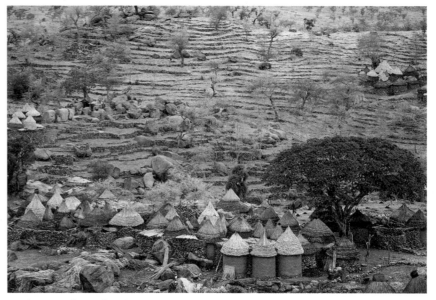

Mandara Mountains, northern Cameroon, May 1979

local living habits to the artwork of Jasper Johns. We decided to travel together for a while, as we had discovered that we were both interested in finding pockets of African culture that remained as untouched by the modern world as possible. On top of that, I desperately needed a friend who spoke French, and I suppose she needed someone who could keep undesirables at arm's length.

We headed east, going through Nigeria to Cameroon, where we hoped to spend time with the Kirdi people in the Mandara Mountains. Marion thought they might be one of the most traditional people in West Africa, wearing little more than leaves for clothing. We also decided that the only way to see Africa was to get out of the car and walk, and we wanted to try living with the local people to better understand them.

When we got to Cameroon, we ended up going on a game drive in Waza National Park with members of the French military. They were taking a break from their job of keeping the lid on N'Djamena, the capital of Chad, during the civil war of 1979, and they invited us to go back there with them. When we told them that we had no visas, they told us it was no problem, there was no government in Chad, and they ran the ferry into the country. We took them up on their offer, spending the second week of May in the Chadian capital.

N'Djamena was a crazy place in 1979. Guns were everywhere and gasoline was sold in green wine bottles on battle-scarred streets. Marion instantly became the object of desire for the Frenchmen who were barely hanging on in the

capital. We dined in restaurants filled with drunk mercenaries, where frozen pizzas had been flown in from Paris, and the customers would set a loaded pistol on one side of their plate and a hand grenade on the other. By day we went waterskiing on the river while watching out for hippos, and by night we danced to Boney M. and ABBA in rented houses while drinking Johnny Walker. It was quite a different sort of education compared to the one I had experienced growing up in California.

In Africa I had to learn to win over all kinds of people: nuns, witch doctors, tribal chiefs, mercenaries, Pygmies, petty African bureaucrats, ambassadors, and swarms of African children shouting "*Mzungu! Mzungu!*" ("White person! White person!" in Swahili). Years later, I heard

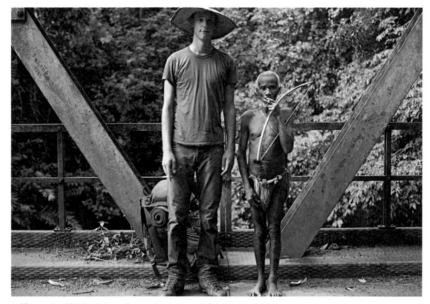

Self-portrait with Mbuti Pygmy hunter, Ituri Forest, Zaire, June 1979

a joke that could have been the final exam for a bachelor's degree in African hitchhiking: What do you call a drunk African soldier with a gun? The answer: "Sir."

Marion and I were hitchhiking along the Logone River, which forms the border between Chad and Cameroon, when our truck was stopped in the middle of nowhere in the midday heat by a young, drunk, and heavily armed soldier. He wanted Marion to come with him, but not to any police station. He tried to pull her out of the car. There's a Tom Waits song with the line "Don't you know there ain't no devil, there's just God when he's drunk." In that desolate patch of Africa, that young soldier was the equivalent of God. With the civil war rendering Chad completely lawless just twenty yards across the river, it was a

very bad situation. We barely talked our way out of that potential nightmare, and I learned that if you don't treat even the most unsavory individual with respect, a difficult situation can quickly turn into something really horrible.

In June, we continued east into what was then the Central African Empire. Jean-Bédel Bokassa had just crowned himself the country's emperor for life and spent $200 million on the ceremony, bankrupting the national treasury in the process. We went out in the forest to find elephants with a BaAka Pygmy tracker who made a shelter for us out of bent saplings and banana leaves while we counted the fireflies. Our tracker was a real contradiction. For modern appearances he called himself Jean-Pierre, but as a boy he had followed the BaAka Pygmy custom of chipping his front

teeth into sharp points, giving him the fearsome grin of a piranha. That night he showed me how to smoke local tobacco with a pipe made out of a leaf wrapped around a bundle of sticks. I felt that I was about as far away from Beverly Hills as I could ever get.

On our way out of the forest, we slept on the floor of a hut occupied by a homesick Peace Corps volunteer, who smoked local marijuana while listening to live broadcasts of American baseball games all night. A friend of his back in Chicago had taped American radio programs for him, complete with the traffic and weather reports, which seemed strangely surreal in a village with no cars, surrounded by a forest of uniform temperature. It was then that I realized that the purpose of my trip had changed: It was no longer

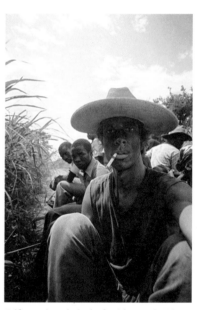

Self-portrait on the back of a pickup truck, Zaire, August 1981

Market day in Mora, northern Cameroon, May 1979

Postcard from Bangui, Central African Republic (CAR), to father
David Steinmetz, June 1979

Postcard from Bangui, CAR, to father David Steinmetz, June 1979

about escaping where I was from. What was far more important, and interesting, was to understand Africa.

At this point, Marion and I decided that we should go our separate ways. It had been a largely platonic relationship, and two months of travel in five countries had not been easy. Many years later she would turn portions of her West African experiences into the book *Nomads of Niger* about the Wodaabe.

I hitched a ride to the Central African Republic's capital city, Bangui, where the security situation was tense, bought a French dictionary, and crossed into what was then called Zaire. I then became the guest of a generous captain aboard a freight boat up the Congo River into what Joseph Conrad had called the "Heart of Darkness." The boat was a moving marketplace for every town and hamlet along the river, with at least a dozen dugouts tied alongside while their owners traded goods and got a lift upstream at the same time. In the place where Mr. Kurtz had his horrors, I found a river of extraordinary beauty. Even then, Zaire was teetering on the brink of disaster. The corrupt Mobutu government had abandoned the country's infrastructure, and the still incomplete Trans-African Highway was a rutted canal meandering through the Ituri Forest, with mud holes the size of swimming pools. I got off the truck and stayed in Mbuti Pygmy villages on the edge of the Ituri Forest. I ate, drank, danced, and smoked in their villages, as I had to walk forty-five miles of that highway before catching a ride out.

From there I moved on to East Africa, where I wanted to see wildlife. Idi Amin's government in Uganda had just fallen a few months earlier and the country was too dangerous to travel, so I had to go through Rwanda without a visa to reach the Serengeti Plains in Tanzania. But what I found in Kenya and Tanzania was not the Africa of Joy Adamson and *Born Free*. I soon realized that game viewing would be next to impossible without my own car, and most of the traffic there was mini-buses filled with wealthy tourists who didn't want a hitchhiker along for their safari. With my chutzpah and modest means, I could explore Africa's human terrain most effectively.

In October, I headed up north to Sudan, which many people told me still contained some of the wildest cultures in Africa. The First Sudanese Civil War had been settled some seven years

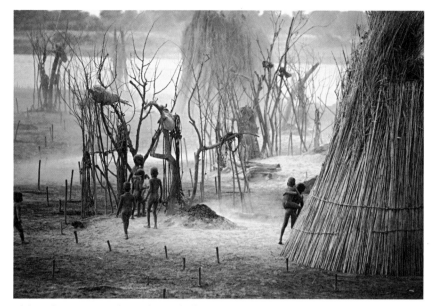

Dinka cattle camp, Bor, southern Sudan, April 1982

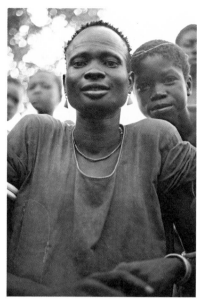

Dinka villagers, southern Sudan, August 1979

earlier, and there were still tribes of naked people herding their cows in the swamps of the Nile. When I got to Juba, the capital of southern Sudan, I found a place so raw and detached from the rest of the world that I could imagine someone walking into town in ancient robes and being taken as a messiah. The Dinka people, who predominate in the south, walked around with little more than pieces of cloth tied over their shoulders. On the road into town I saw men walking with ten-foot-long spears and wearing nothing more than sunglasses and ski hats.

The Dinka were as curious about me as I was of them, and when I look back at the pictures I took then, I can see that. I had wanted to go into the swamps of the Nile to spend time with the Dinka in their cattle camps. But I was low

on money, film, and patience, and the Nile was in flood, making travel to the wetlands impossible without a boat. There was a steamer that ran once a month from Juba to the north, but it was overdue, and every day the ticket man said to come back tomorrow. Other travelers had been waiting two to three weeks, many coming down with malaria in the process. I finally got a ride with a Dutch doctor in a Land Rover pickup heading west around the swamp, but only later did I find out that the so-called doctor had stolen the truck from missionaries in Kenya. When he ran a military checkpoint, the guards leveled their guns at us. I was riding in the back of the pickup, sitting on a two-hundred-liter drum of fuel, and when I saw the guns, I started pounding vigorously on the roof of the cab. Fortunate-

ly, the doctor stopped, but then we were both detained.

A few days later, after the Sudanese authorities realized I was simply a bystander along for a ride, I was released. From there, I headed west to Wau, where I was able to catch the only reliable transportation in the area, the weekly train to Khartoum. It was right in my budget (free) as long as I rode with the half of the passengers who preferred to sit and sleep on the arched roof of the train for the duration of the three-day trip. There were no windows on the train and all the bathrooms were filled with baggage. So the roof was roomier and certainly smelled better than the inside of the train, and it had a great view. The tricky part was sleeping perpendicular to the spine of the arched roof so I didn't roll off the train in the middle of the night.

Brook LeVan riding on top of a truck in northern Kenya, December 1981

Postcard from Khartoum, Sudan, to father David
Steinmetz, October 1979

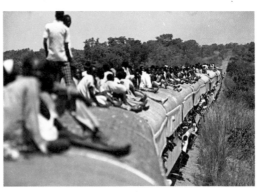

Weekly train from Wau to Khartoum, Sudan, October 1979

Truck stop, Epulu, Zaire, August 1981

When traveling in Africa, I had a rule that it was OK to drink anything that came out of a pipe, and to always eat at the busiest food stall on the street. But in southern Sudan there weren't many pipes or roadside restaurants, and I got a bad case of amoebic dysentery. The only way to go to the toilet was to hop off the train when it stopped and relieve oneself outdoors, in full view of passengers. With my illness, which required frequent jumps off the train, I spent much of the journey in the treeless barren plains, while a two-tiered audience of thousands cheered me on from the train.

When I emerged from Africa in December, after eleven months of travel, my pack was virtually empty. I came home in flip-flops, shorts, a Chinese T-shirt, and a very serious tan. It was on that trip that I decided I wanted to take pictures for a

living. My mother was not very enthusiastic about that idea. "All photographers have bad breath and BO," she told me. I replied that if that were the case, then maybe I would be successful!

I decided to complete my studies at Stanford as a sort of a career insurance policy, finally receiving my bachelor of science degree in geophysics in 1981. During my last month of classes, I had a meeting with my departmental adviser. Bob Geller was a great teacher and brilliant scientist who loved what he did, and that morning he gave me the pitch to become one of his graduate students. As I listened to his enthusiastic description of my academic possibilities, I realized that he was the kind of guy who probably thought about shock waves propagating through three-dimensional media while he was in the show-

er. If I was going to be happy, I had to do what I thought about in the shower, and it wasn't shock wave propagation. I was flattered by the offer but blurted out that all I really wanted to do was to go back to Africa and take pictures. But I'd need to make some money and learn more about photography beforehand.

My best bet for publishing photos of Africa in the United States was *National Geographic*, but that would prove to be a hard nut to crack. After I returned from a second trip to Africa in 1983, I went out to Washington and managed to get a meeting with Bob Gilka, the *Geographic*'s legendary director of photography. Gilka had quite a reputation: It was said that he fired a photographer once by calling him up and firing a starter-pistol into the telephone while the poor guy listened

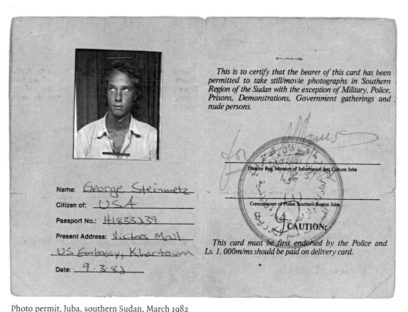

Photo permit, Juba, southern Sudan, March 1982

On assignment for *Mother Jones* magazine, Kumasi, Ghana, May 1985

on the other end. The prospect of meeting him was quite intimidating, but I showed up wearing a bow tie and my Sunday-best sport coat with a carousel of slides tucked under my arm. Next to his door was a framed work in needlepoint that read: "Wipe Your Knees Before Entering." When I got inside, he asked me a few questions and seemed gruffly surprised that I had hitchhiked, mostly alone, through Africa for a total of two and a half years. He told me he didn't know many photographers who would do that for pictures. Then he put my carousel in his projector and held down the advance button without release. I watched those two and a half years and eighty slides flash by in little more than a few minutes. He stopped once when he saw a photo he didn't like. "Doesn't work," he said curtly. I tried to

explain some of the difficulties of the situation, but he cut me off.

"Is that an excuse?" he asked.

"Uh, I guess so," I said.

"Well, we publish photographs here, not excuses."

He told me that while he appreciated my sweat and determination, he wanted me to come back when I had learned how to use strobes and artificial light, as he wanted a more balanced photographer who could handle a wider variety of situations.

This was a humbling blow, but I wasn't ready to give up on my dream. So I went back to my apartment in San Francisco and started looking for jobs as a photo assistant. My mother, of course, told me to get realistic and go get a job

in the oil business. But even that was no longer an option, as oil prices had collapsed and there were no jobs for people with my limited experience at finding oil fields. I finally found a job as a second assistant to a commercial still-life photographer. I started out by taking out the trash and running errands, slowly moving up to more responsible tasks. But after a few months, I was fired for insubordination.

Eventually, an acquaintance introduced me to Ed Kashi, a young photographer my own age who was just starting to get jobs with national magazines. Eddie and I became inseparable, traveling all over the state on day jobs. I was his assistant, hauling his big strobes out of the car, setting them up, breaking them down, and on the way back asking every question about the profession

Self-portrait, San Francisco, June 1983

George Steinmetz with Captain Thomas Sankara, Ouagadougou, Burkina Faso, May 1985

I could think of. It was 1983, and Silicon Valley was a hot story with the advent of the personal computer. We'd do two or three shoots a day, collecting a day's pay for each gig. We shot guys in ties and the occasional winery, computer factory, or local personality. It was a great education. But eventually Ed had to fire me, too, for arguing with him on location about how to do a shoot. It was the classic beginner's problem—full of ideas, but not much experience, and incapable of picking my battles. But we remained close friends, and he started giving me the little jobs that he was too busy to take on.

Within two years of my sobering interview at *National Geographic*, I was making a living with a camera and a case of newly purchased lights. But making portraits of businessmen was not why I

had gotten into photography. I wanted to explore the world and get back to Africa.

An editor at *Mother Jones* magazine told me of a story that the magazine was doing on Ghana's new revolutionary leader, Flight Lieutenant Jerry Rawlings. The picture budget for the story was a little more than the round-trip airfare to Ghana, but I jumped at the assignment. *Mother Jones* is politically left of center, as was the revolutionary Rawlings, and with magazine credentials, I figured I could get into all kinds of places off-limits to the public. I spent six weeks making a photographic portrait of Rawlings's Ghana, which was followed by a week under arrest in neighboring Burkina Faso. Burkina Faso's border forces stopped me when I was taking pictures of smuggling on the Burkina-Ghanaian border. They

transported me to the Gendarmerie National in the capital, Ouagadougou. My second night there, somebody blew up the National Armory and the police went nuts. They must have thought I was Rambo or something, as they had me strip off my clothes and they locked me up in a cell the size of a large phone booth with half a dozen other prisoners. There was no toilet and the stench was horrible, and we all thought we were going to die as bombs, shouts, and automatic gunfire continued all through the night. They let me out of the cell the next day, but started talking about a military tribunal for the "American spy." A few days later, Rawlings got word of my predicament and, miraculously, I was released. The next day I was invited to the presidential mansion in Ouagadougou. There, Burkina Faso's leader, Captain

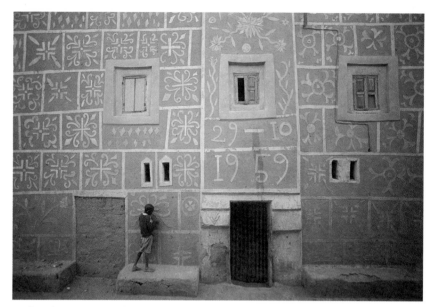

Agadez, Niger, 1997

Thomas Sankara, apologized for my arrest and detention, and I apologized for photographing his border without permission. Sensing an opportunity, he then asked me if I could help him get new tires for the wheels of his government's twin engine Beechcraft that had been a gift during the Kennedy administration. "I don't want AWACs," he joked. I smiled and asked if I could take his photo.

In 1985 Bob Gilka retired, and I set up a meeting with his replacement, the equally legendary Rich Clarkson. Rich was known as a talent finder who had given starts to some of the best people in newspaper and magazine photography. I showed him my new work from Ghana and I suggested doing a story on what I had studied in college: how to find oil. In the offices and field camps of the big oil companies where I did my summer internships, I had heard a lot of tall tales that now formed my shoot list, and Rich pushed the idea through *National Geographic*'s bureaucracy. At the age of twenty-nine, I had my first of what would turn into more than twenty major *National Geographic* assignments.

For the next decade, I worked as a magazine photographer for French and German *GEO* and for *National Geographic*, and returned to Africa every chance I could, often hanging around after the job was done. I kept returning to the idea of photographing the Sahara from the air, but flying in Africa is not easy or cheap, and it takes time to build up enough credibility to get other people to pay for it. In 1996, a marvelous opportunity presented itself: *National Geographic* agreed to finance my idea of shooting a loosely defined aerial portfolio for a series the magazine was doing on the upcoming millennium. Naturally, I put Africa on the top of my shoot list. But as I buzzed around the edges of the Sahara in small planes, I became frustrated. I wanted to get closer to the land, to fly at a more human speed and scale. While flying at a hundred miles per hour, I had a hard time trying to explain to a pilot where my eye told me to go in three-dimensional space.

This particular assignment took me through Niger, where I was offered a ride on a private plane all the way out to Agadez, which I hadn't seen since I hitchhiked across the Sahara eighteen years earlier. The town hadn't changed much, except that there was now cold beer and a paved road. I found out that the intermittent

George Steinmetz after being attacked by wasps, Limbe, Cameroon, June 1989

Self-portrait while waiting for a pilot to show up, Nouakchott, Mauritania, April 1997

rebel uprising in the Sahara was waning, and for the first time in decades even lawless Chad was opening up to travel. There were even small local tourism companies providing cars and guides out into the desert. In Niamey, where I had been in 1979, I met Marc Alberca, an expatriate bush pilot with access to an ultralight that would fit into the back of a pickup. All the pieces had finally fallen into place, and my twenty-year-old dream of photographing the Sahara from the air seemed about to become a reality.

When I returned home from that trip, I wrote up a proposal for *National Geographic* to do a story about flying over the Central Sahara, and called Marc excitedly when it was accepted. Marc turned out not to be available, so I found myself with no way to get off the ground. There were no civilian

helicopters in Niger or Chad, and very few places to land a plane out in the desert, let alone find fuel or safe haven from sandstorms.

I had heard about powered paragliding, a new kind of superlight experimental aircraft, but dismissed it at first as too dangerous. But there really were no local alternatives, and importing a more conventional aircraft would be a bureaucratic nightmare.

Without many options at my disposal, I decided to investigate powered paragliding. Everyone I asked thought it was far too risky, but then I located a few who had actually gone up in one. Those people told me it was a reasonable thing to do—as long as I limited my flying hours to when the air is calm in the early morning and late afternoon, the only time I want to take photos anyway.

So in July 1997, I went to the nearest paragliding school I could find, in Torrey Pines, California. The owner of the place, David Jebb, took me on my first paragliding flight as a passenger.

The moment we lifted off the cliff and flew out over the Pacific, I was hooked. Not only was the view stunning, it was like a dream, floating silently and slowly like a bird, with unlimited views in every direction. We cruised up and down a nudist beach and over the cliff-top mansions of billionaires. I signed up for lessons that afternoon. I was recently married, and my wife, Lisa Bannon, thought I was joking about the idea at first, or at least assumed it would pass—but it didn't. William Langewiesche, a jet pilot who had written a wonderful book on the Sahara, put me in touch with his friend, François Lagarde,

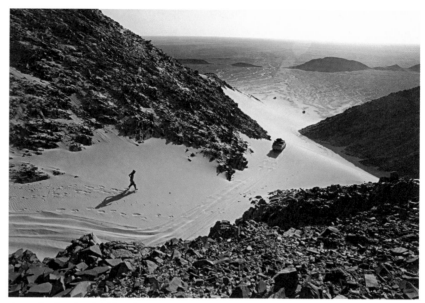

Descending into the Ténéré from the east, Niger, November 1997

a doctor in France, who was passionate about powered paragliding. On the phone I asked him a flood of questions about this fledgling sport. Was it possible to learn how to fly in six weeks? What kind of equipment would I need and where could I get it? Could I pack it into small enough pieces to check as baggage on an airplane and get past an African customs agent? And was it safe? I was especially concerned about flying with my hands on the camera instead of the brake lines of the paraglider and the engine's throttle. François was skeptical about my plans, but patiently answered all my questions. After many phone calls and lessons, he realized I was quite serious. Eventually he offered to come along on the trip to keep the flying safe and for the adventure of it all.

I flew to Europe where François and I went on a shopping spree to get the best flight equipment, and two weeks later, we met again in Arizona to train in more realistic field conditions. I took off OK, but true to my habit of pushing the limits, I spent too much time taking pictures. I ran out of gas on my first flight over Monument Valley, and had to make an emergency landing in the desert. François was frantic when he found me, walking out of a little dry wash with all my flight gear still attached, but I was ecstatic: The worst-case scenario was not so bad after all. I could fly at twenty-seven miles per hour, hands free, with unlimited views in every direction, and most important of all, the perspective in flight was absolutely unbelievable. I couldn't wait to get to the Sahara, but was nervous about safety. If anything went wrong

out there we would be very much on our own and we both had to be extremely careful.

In the fall of 1997, I was back in Agadez on assignment for *National Geographic* to photograph the Central Sahara. Francois had come to help me fly, along with Donovan Webster, who had been assigned by the magazine to write the story. In Agadez, we met up with Mohamed Ixa, a local Tuareg, who'd been recommended as one of the best guides in the Sahara. He greeted us dressed as he did every day: with ten yards of indigo cloth wrapped around his head with a matching robe and sandals. It felt strange handing over some $30,000 in cash for our five-week trip to Ixa, someone I'd never met before, in a dark hotel room. But the next morning at sunrise his five people and three four-by-fours roared up to our

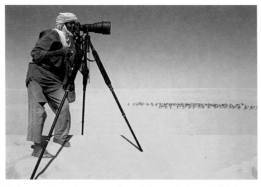

Driver watching salt caravans through George Steinmetz's big lens, Ténéré, Niger, November 1997

Digging out of the sand while crossing the Ténéré, Niger, December 1997

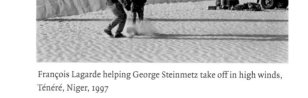

François Lagarde helping George Steinmetz take off in high winds, Ténéré, Niger, 1997

hotel and soon we were off. We had one car for people, one for the flight gear, and a pickup to carry food, fuel, and water.

It was the season for the salt caravans when Tuareg nomads led thousands of camels carrying funnel-shaped blocks of edible salt from the Saharan oases of Bilma and Fachi across the desert as far south as Nigeria. It takes them about a month to travel each way across hundreds of miles of trackless sand. I had hoped to photograph the caravans from the air in a way that no one had seen before, to capture the epic drama of the men who cross the world's largest desert every year.

Mohamed's abilities at route finding never ceased to amaze me. For fun I tested him out on the flat, featureless plain of the Ténéré, asking him the direction to a particular place two

hundred miles away on my map. With the sun overhead and a flat horizon without a single landmark or point of reference, he would point in the direction of a spot that never failed to be within a few degrees of accuracy. I called it TPS: Tuareg Positioning System.

On our second day out, Mohamed found the first caravan of hundreds of camels for me to photograph. Flying over them was a magical experience. From up high they looked like chains of army ants, but down low the camels and their Tuareg masters were undisturbed by my quiet, slow-flying aircraft. We traveled in rough synchronization with the largest caravan, camping wherever I landed at nightfall, and letting the caravan go ahead to rest at midnight. We'd then catch up with them the next morning as Mohamed would

follow their tracks by car headlights to find their camp before sunrise.

It was a magnificent sight to behold, ten men and more than a hundred camels, moving their ancient cargo on a trade route used for centuries by their ancestors. It was also an ideal training ground for a neophyte pilot, as I could take off and land almost anywhere in the flat sea of white sand. With this level of logistical support, I had almost total control of our movements, both on the ground and in the air. The days of hitchhiking and having to wait all day for a car with an empty seat to pass by were far behind me. They had been replaced with the complex calculations of fuel range, permits, and personnel issues raised by an expedition team drawn from three different cultures.

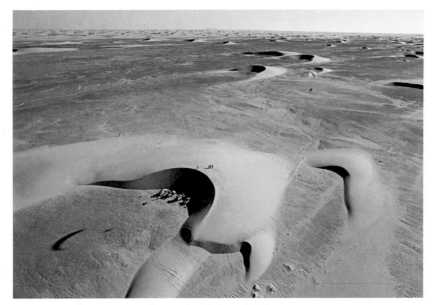

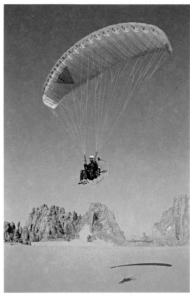

Alain Arnoux landing at camp, Mourdi Depression, Chad, March 1998

George Steinmetz flying in his motorized paraglider north of the Tibesti, Chad, March 1998

As we continued around the Ténéré, I became emboldened with flying and started to explore beyond what Mohamed could find for us on the ground. On a flight over the town of Fachi, I spotted an old fort hidden behind the town wall, and inside its battlements were enormous granaries used to store food during the lawless era of trans-Saharan banditry.

I began to realize that the paraglider enabled me to discover areas that were unreachable by other means, allowing me to get photographs of places never before seen. François and I discovered pre-Islamic cemeteries that were easy to spot from the air, as they are round, while Muslim graves are oblong and point the head of the deceased toward Mecca, like a compass needle. We reached the ghost town of Djado, once a major rest stop for caravans taking black slaves from sub-Saharan Africa to Libya and the Mediterranean shore. Outside Djado, we saw signs of ancient agriculture in an area that hasn't had sufficient rainfall for crops in thousands of years. We could land our motor rigs almost anywhere, and then take off again to get back to camp before the midday heat. From above, we were able to scout new routes for Ixa's cars that even he was unaware of. Around the campfire at night I began to wonder what it would be like to take my new flying machine to other parts of Africa.

In my youth I had scouted the land by foot. But now I wondered what I might find if I could access roadless areas of Africa from the air with my hundred-pound aircraft thrown on the back of a donkey or camel, or into a dugout canoe?

How safe would it be to fly over the terraced volcanoes of Rwanda, or herds of migrating zebra in Botswana, or the coral reefs off the Kenyan coast that I had traveled to decades ago? Despite the photographic potential of other areas, deserts seemed the safest environments for me to fly my motorized paraglider, since there are unlimited places for me to take off and land. And with their exposures of raw geology, deserts are the most visually appealing. So I decided to embark on a series of arid explorations.

I nibbled away at that idea for a few years until *National Geographic* offered me my dream gig: to shoot an aerial portfolio of Africa for a special issue on the entire continent. Dr. Mike Fay, a botanist I had worked with in Africa ten years before, was making an aerial survey of Africa with a small

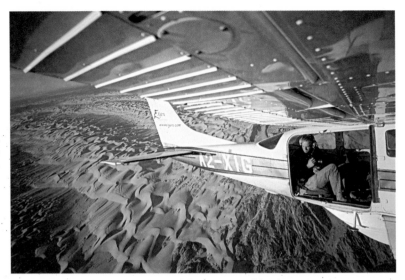

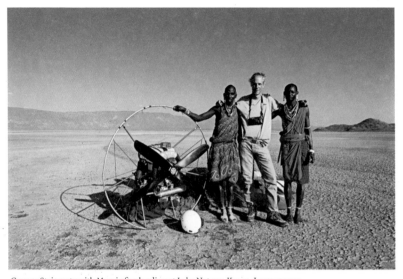

Working in Hennie Rawlinson's Cessna 206, Skeleton Coast, Namibia, July 2004

George Steinmetz with Masai after landing at Lake Natron, Kenya, January 2005

plane. They had big plans for the project, with no defined budget, and they wanted me to photograph his discoveries. So I proposed the ultimate setup, and hired small planes with expert bush pilots in southern and eastern Africa where there was a well-developed network of airfields with safari infrastructure. For the rest of the continent, I'd use cars, boats, and whatever else I could improvise on the spot, kind of like hitchhiking on a big budget. I called my French friend Alain Arnoux, a world champion of motorized paragliding, who had accompanied me on my many desert expeditions, and he agreed to join me for one last adventure. Together we flew over six more African countries to finish the body of work that you now hold in your hands.

This book is not a complete survey of Africa from the air. That would be an endless task. Taking aerial photos with a motorized paraglider is a slow process and the continent is far too vast to be explored in its entirety with such methods. So I made my wish list of all the places I had yet to see from above. I sought out the most unique examples of Africa's major types of terrain, cultural groups, and eco-regions to complete a visually representative mosaic. For architecture, I chose Mali, with its masterpieces of mud buildings. For animals, Botswana had the biggest variety of herds and the largest freshwater oasis. For coastal terrain, I went to the Skeleton Coast of Namibia and its surreal landscape of mysterious fairy circles. For rural population density, it was Rwanda, and for the geology of the Great Rift Valley, I went to Kenya. For urban and industrial Africa, I chose

South Africa. And for North Africa, I went to the Atlas Mountains of Morocco, which in wintertime are blanketed in snow.

There is a magic to Africa—its sounds and smells, the wonderfully positive spirit of its people and, of course, the unparalleled beauty and expanse of its landscape. And while I no longer go to Africa to escape the world I'm from, I find that there is always more to explore, to question, and, ultimately, to understand. ▨

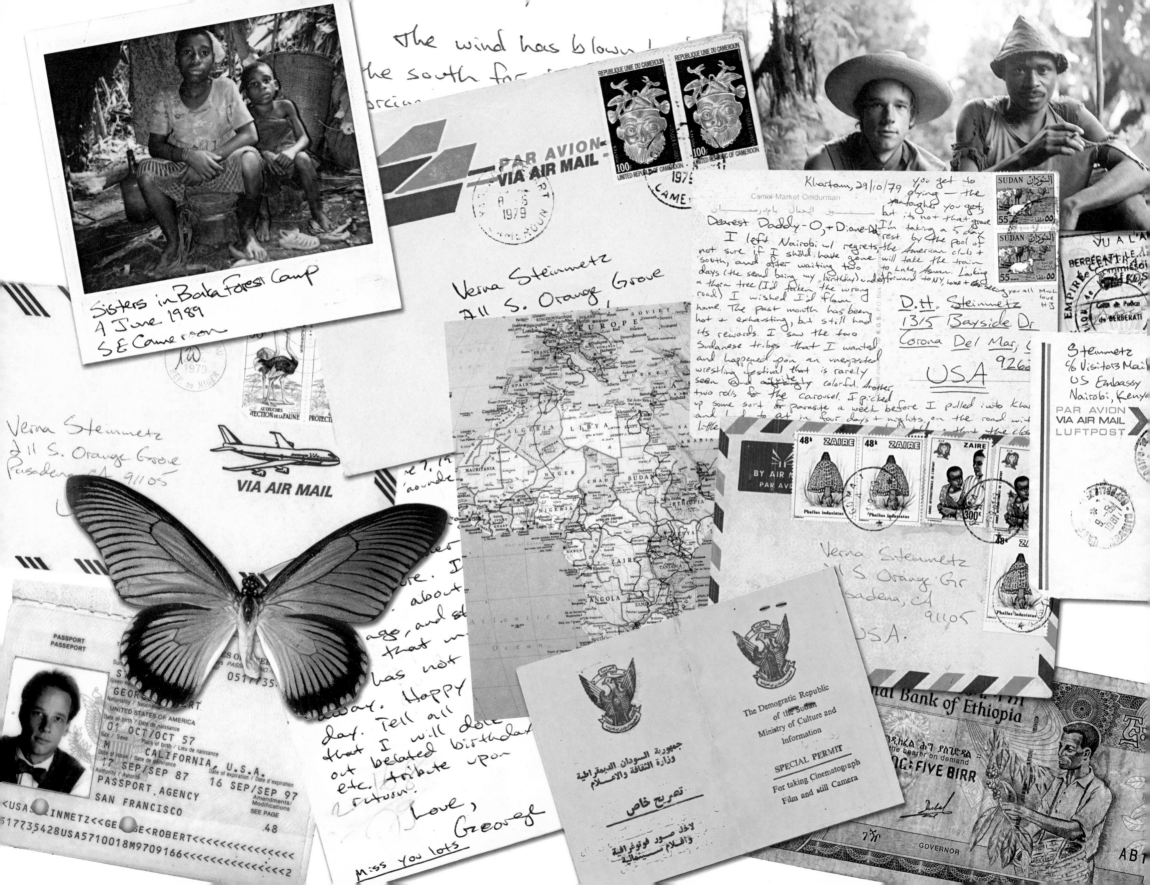

The wind has blown [...] the south for [...]

Sisters in Baka Forest Camp
4 June 1989
S.E. Cameroon

PAR AVION
VIA AIR MAIL

Verna Steinmetz
711 S. Orange Grove

Verna Steinmetz
711 S. Orange Grove
Pasadena CA 91105

VIA AIR MAIL

PASSPORT
Passeport

GEORGE [...] ROBERT
Nationality / Nationalité
UNITED STATES OF AMERICA
Date of birth / Date de naissance
01 OCT/OCT 57
Sex / Sexe Place of birth / Lieu de naissance
M CALIFORNIA, U.S.A.
Date of issue / Date de délivrance
17 SEP/SEP 87 16 SEP/SEP 97
Authority / Autorité Amendments/
PASSPORT AGENCY Modifications
SAN FRANCISCO SEE PAGE
.48

Khartoum, 29/10/79
Camel-Market Omdurman

Dearest Daddy-O, + Diane-

I left Nairobi w/ regrets
not sure if I should have gone
south, and after waiting two
days (the second being my birthday) under
a thorn tree (I'd taken the wrong
road) I wished I'd flown
home. The past month has been
hot + exhausting, but still had
its rewards. I saw the two
Sudanese tribes that I wanted
and happened upon an unexpected
wrestling festival that is rarely
seen and [...] colorful. Another
two rolls for the carousel. I picked
up some sort of parasite a week before I pulled into Kha[rtoum]
and had to put in four days + nights on the road with [...]
[...] that the clo[...]

you get to
drying — the
[...]ougher you gets
but its not that [...]
I'm taking a 5 day
rest by the pool of
the American club +
will take the train
to Lake Aswan. Looking
forward to NY, home + [...]
seeing you all Much
love HB

D.H. Steinmetz
1315 Bayside Dr
Corona Del Mar, [...]
926[...]
USA

Steinmetz
c/o Visitors Mail
US Embassy
Nairobi, Kenya

PAR AVION
VIA AIR MAIL
LUFTPOST

SUDAN
55
55

Verna Steinmetz
[...] S. Orange Gr
[...]sadena, CA
91105
USA

[...]e 7, 19
[...]ounde

[...]re. I
[...] about
[...]age, and [...]
[...] that [...]
[...] has not
[...]way. Happy
[...]day. Tell all
[...] I will done
out belated birthday
etc. tribute upon
return.

Love,
George

Miss you lots

The Democratic Republic
of the Sudan
Ministry of Culture and
Information

SPECIAL PERMIT

For taking Cinematograph
Film and still Camera

جمهورية السودان الديمقراطية
وزارة الثقافة والاعلام

تصريح خاص

لاخذ صور فوتوغرافية
والافلام سينمائية

[...]al Bank of Ethiopia

FIVE BIRR

GOVERNOR

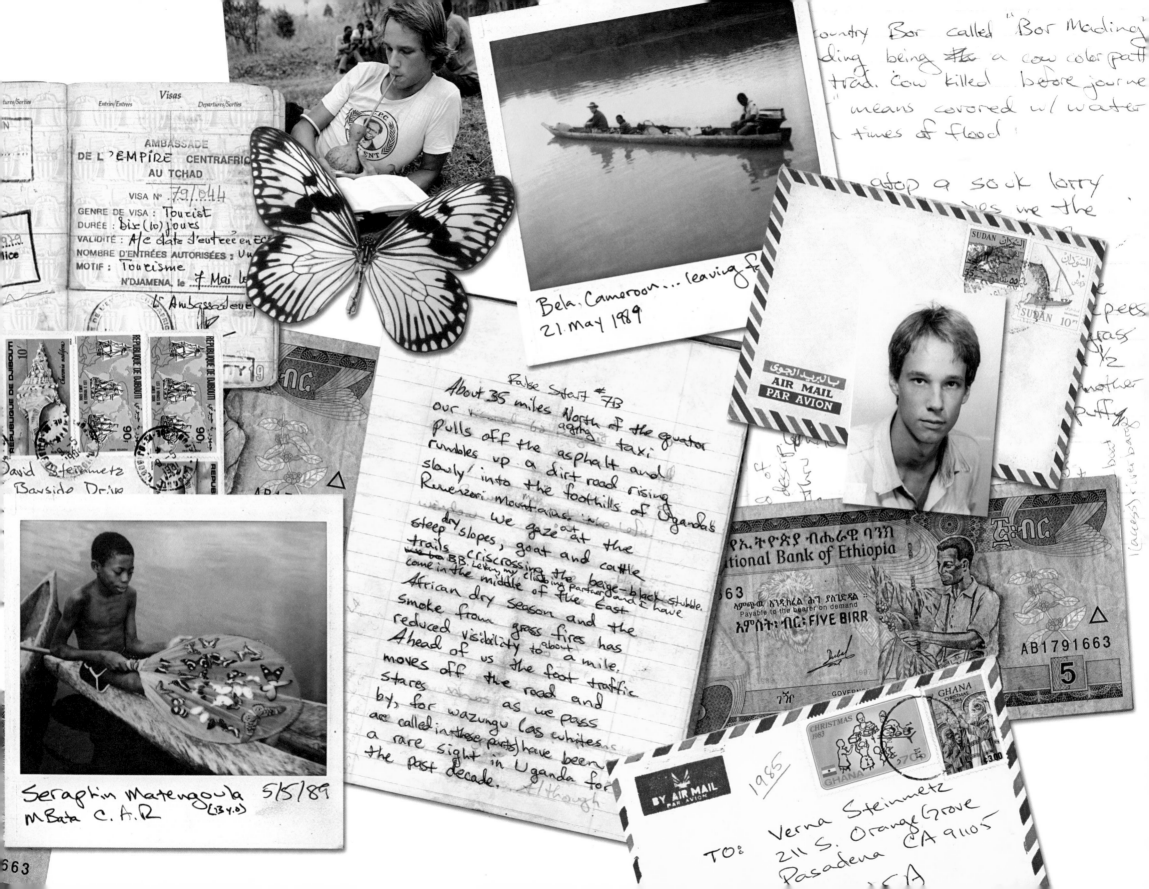

"I had come to Africa as much to explore
a place I knew nothing about as to
escape the world I was from."

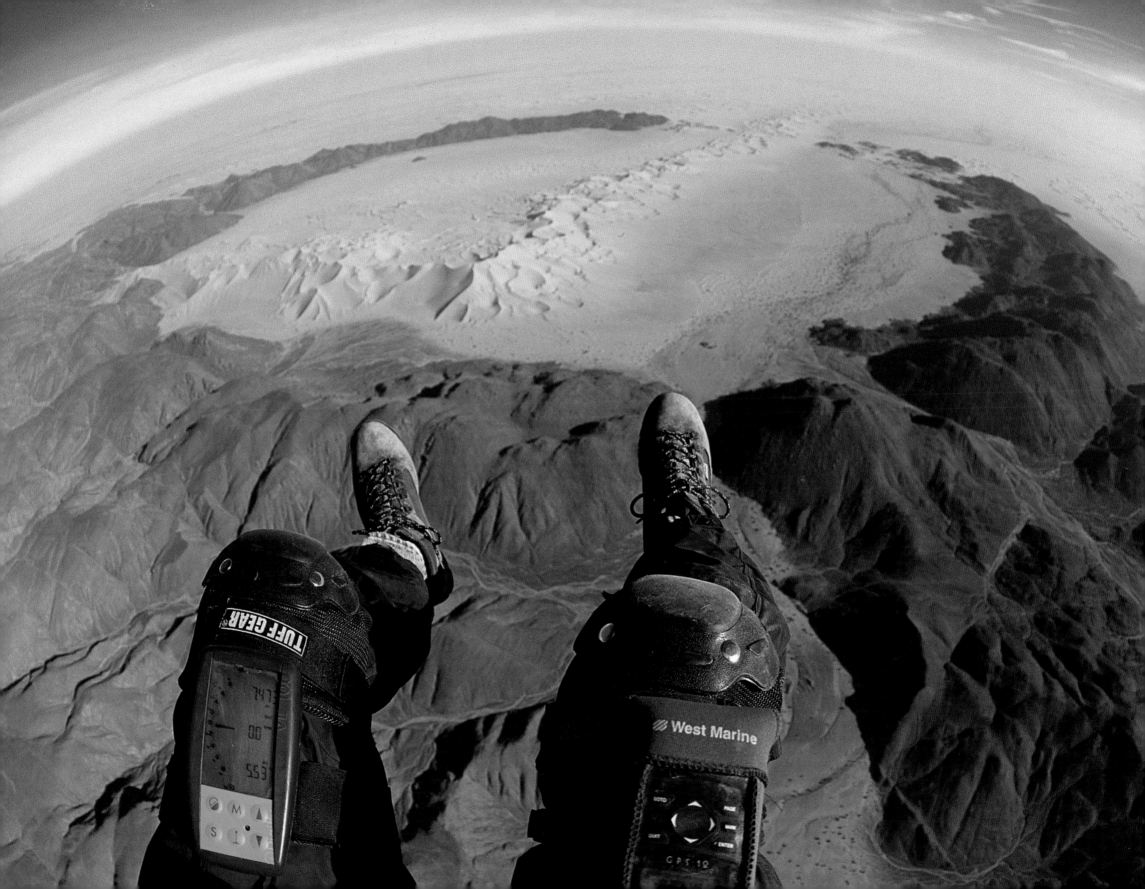

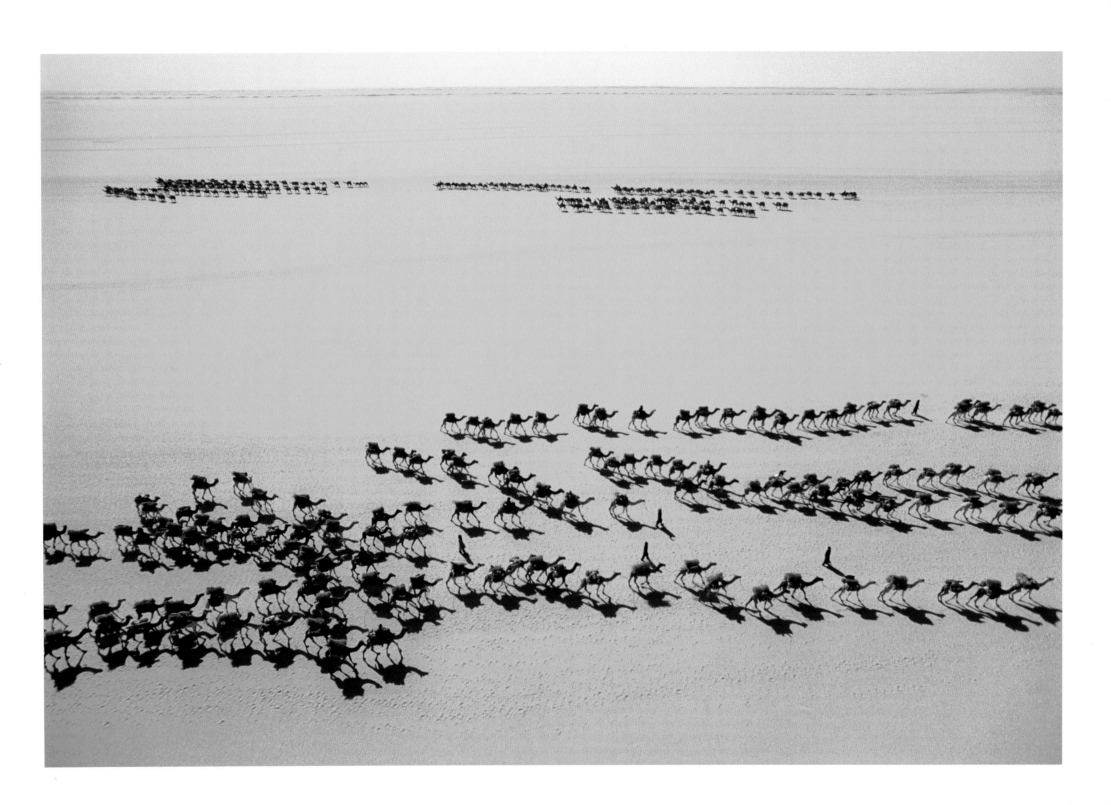

PREVIOUS PAGE: Paragliding over Arakaou, Niger

ABOVE: Salt caravans, Fachi, Niger

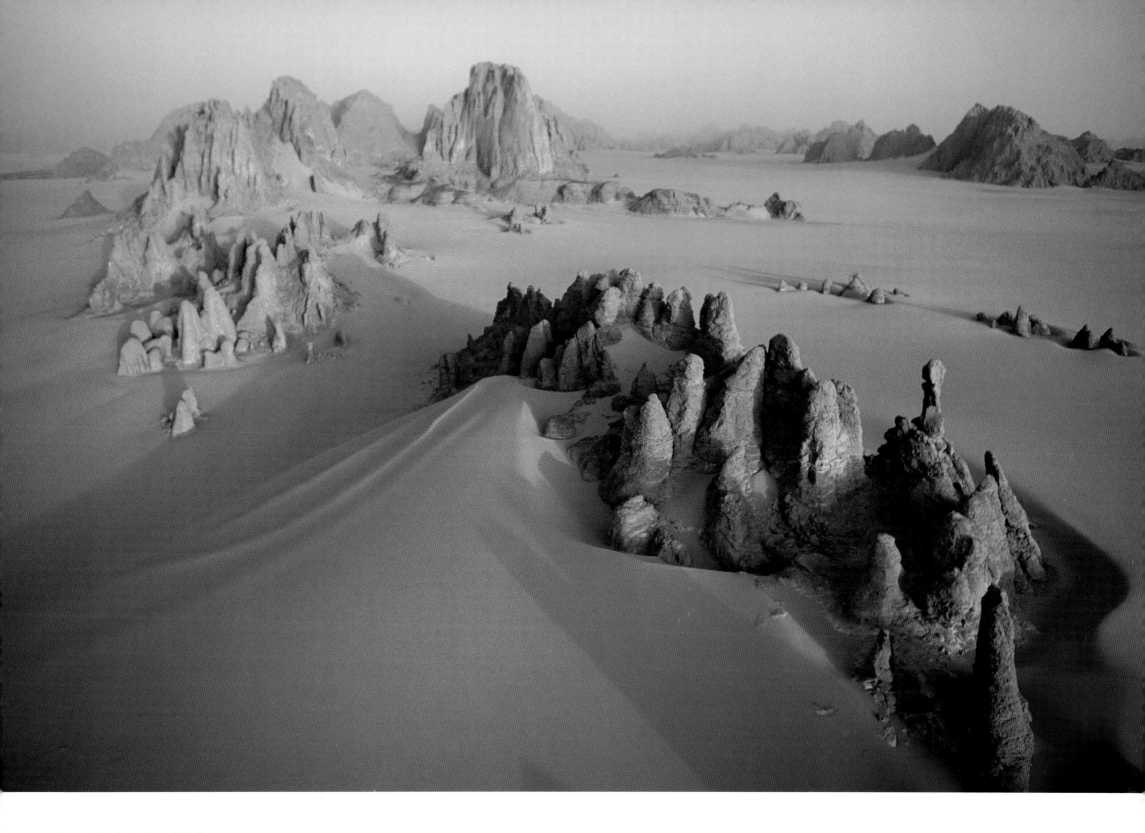

Pinnacles of sandstone, Karnasai, Chad

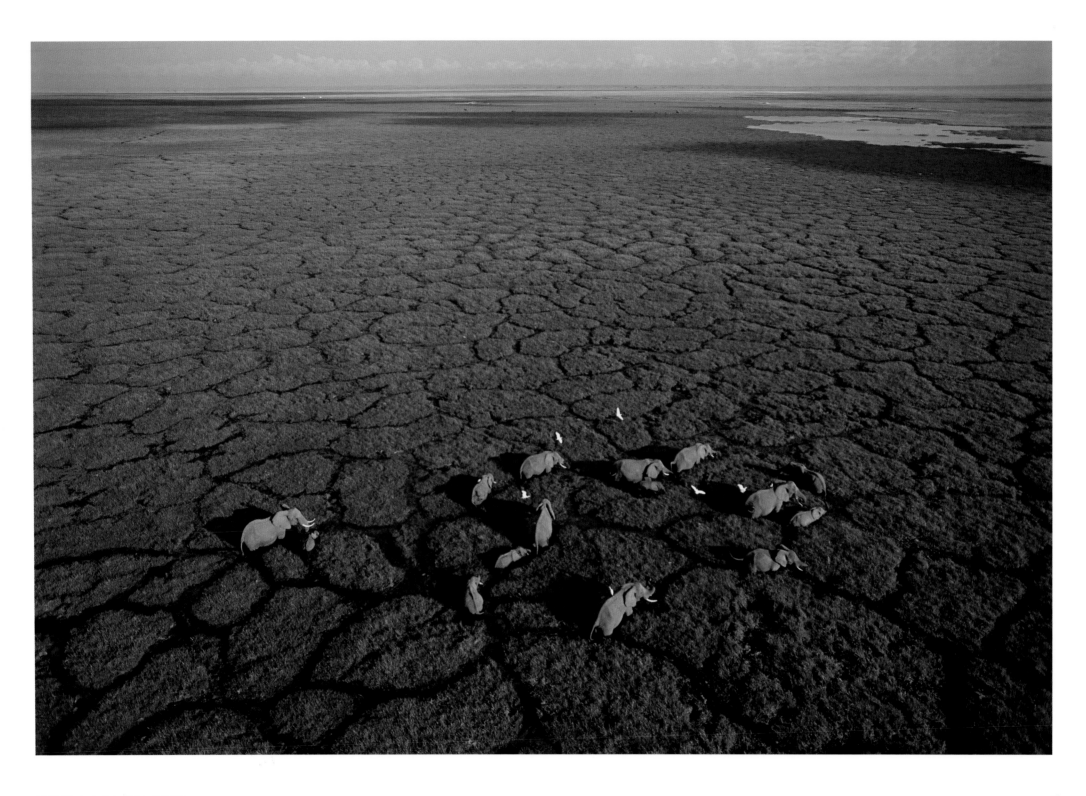

ABOVE: Elephants, Lake Amboseli, Kenya
OPPOSITE: Airplane shadow, Lake Natron, Tanzania

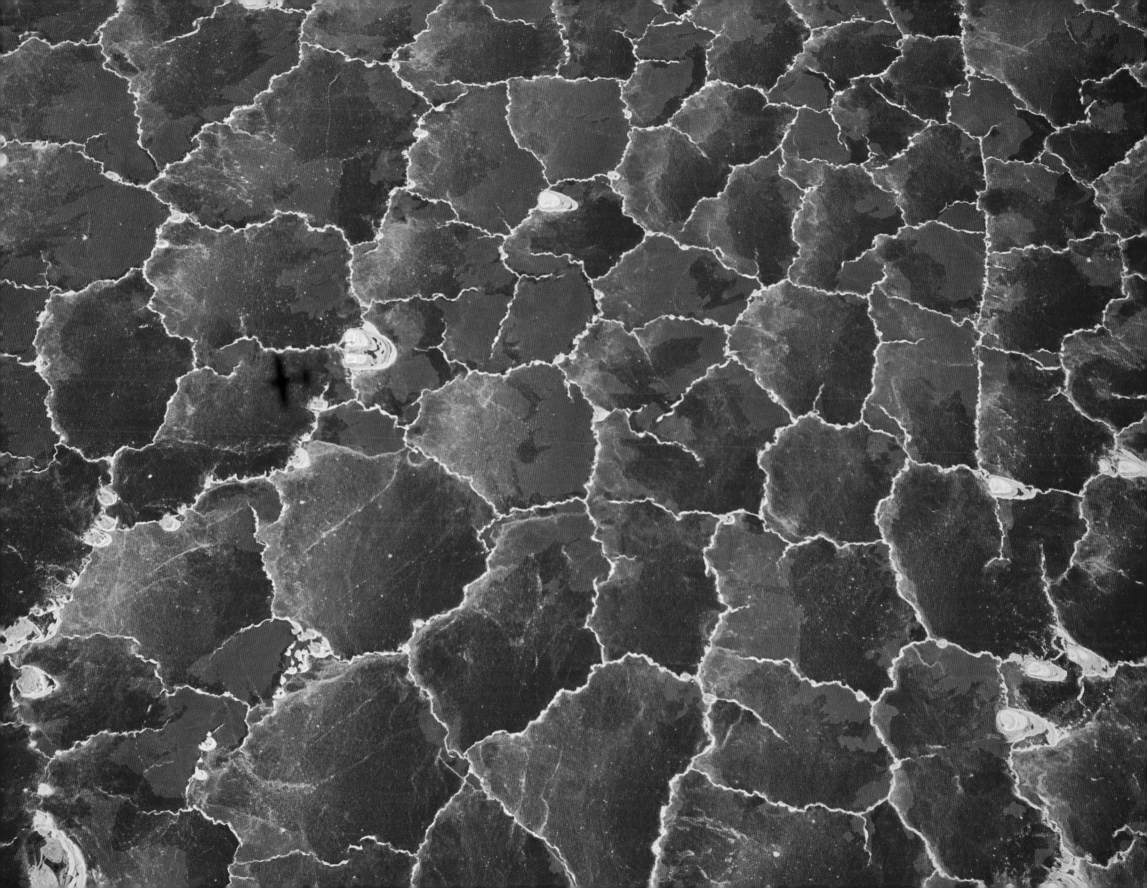

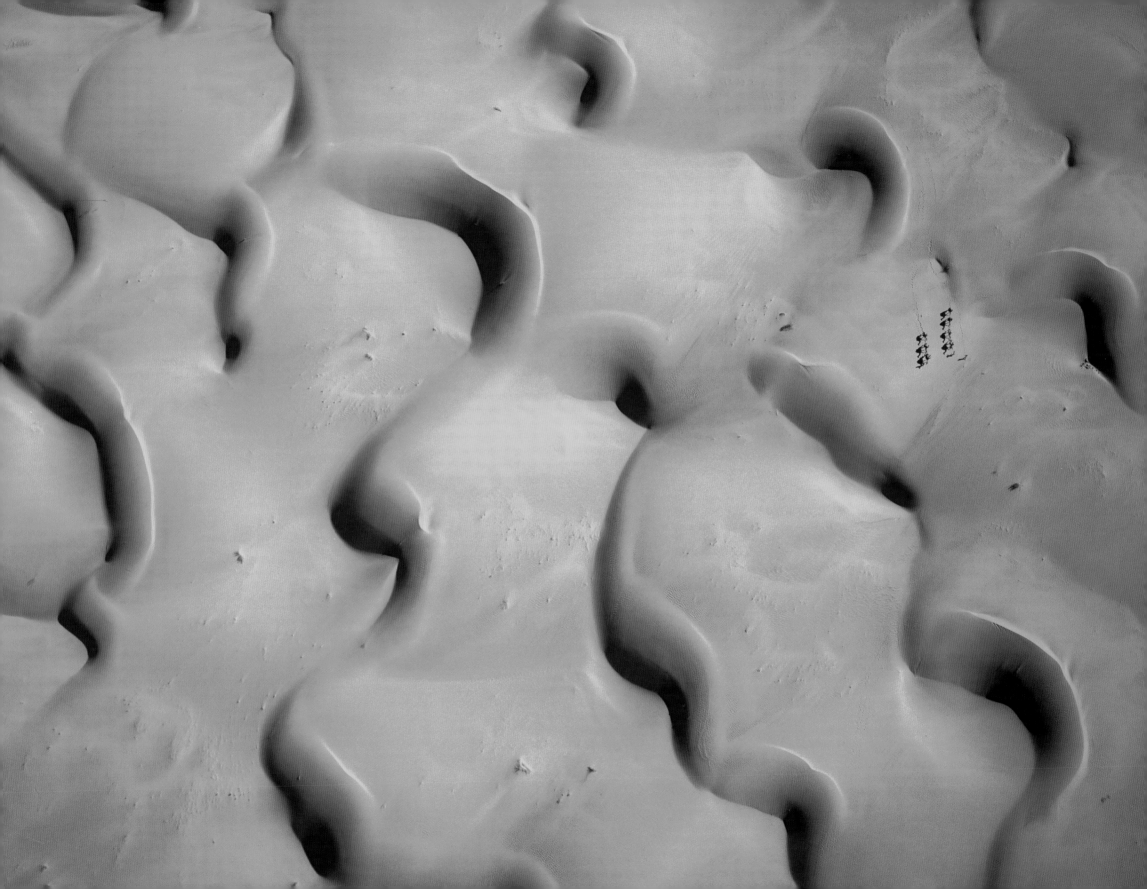

OPPOSITE: Camel caravan near Chinguetti, Mauritania

ABOVE: Three cars crossing the Ténéré, Niger

OVERLEAF: Sanga village, Bandiagara Escarpment, Mali

31

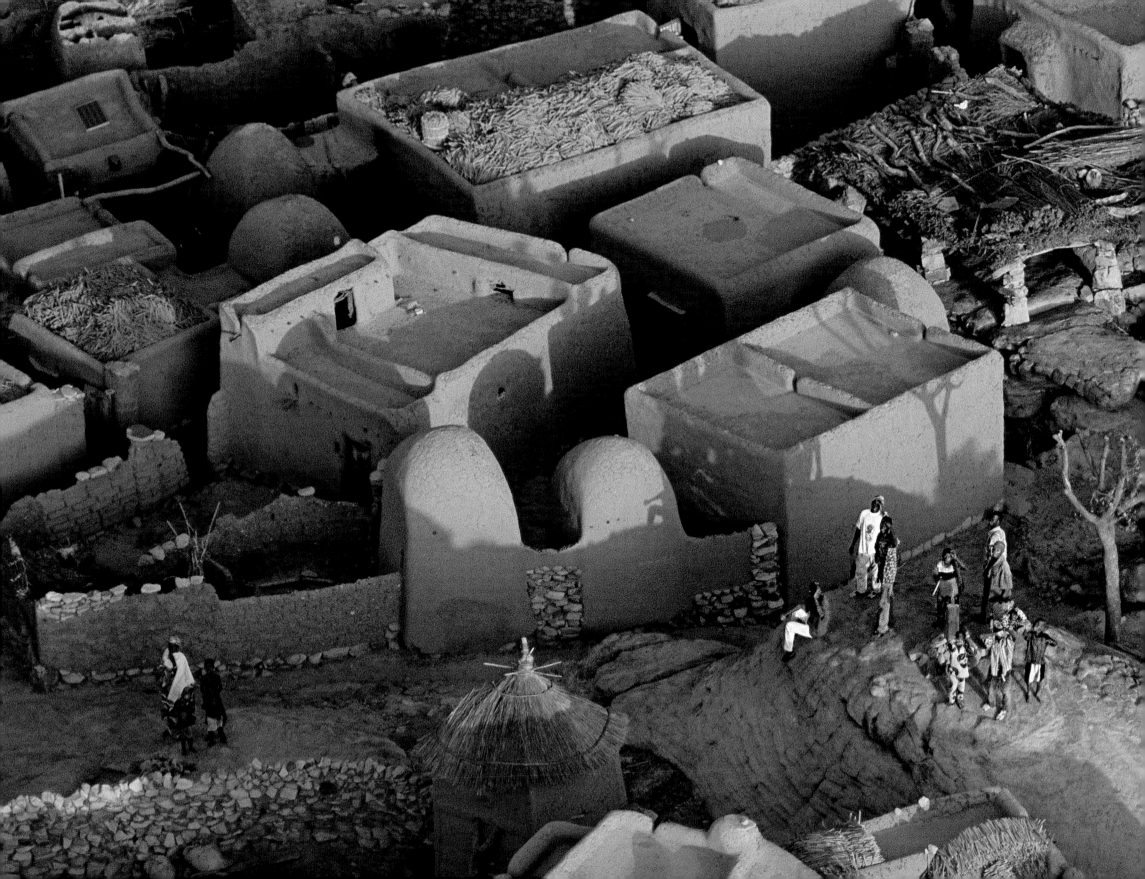

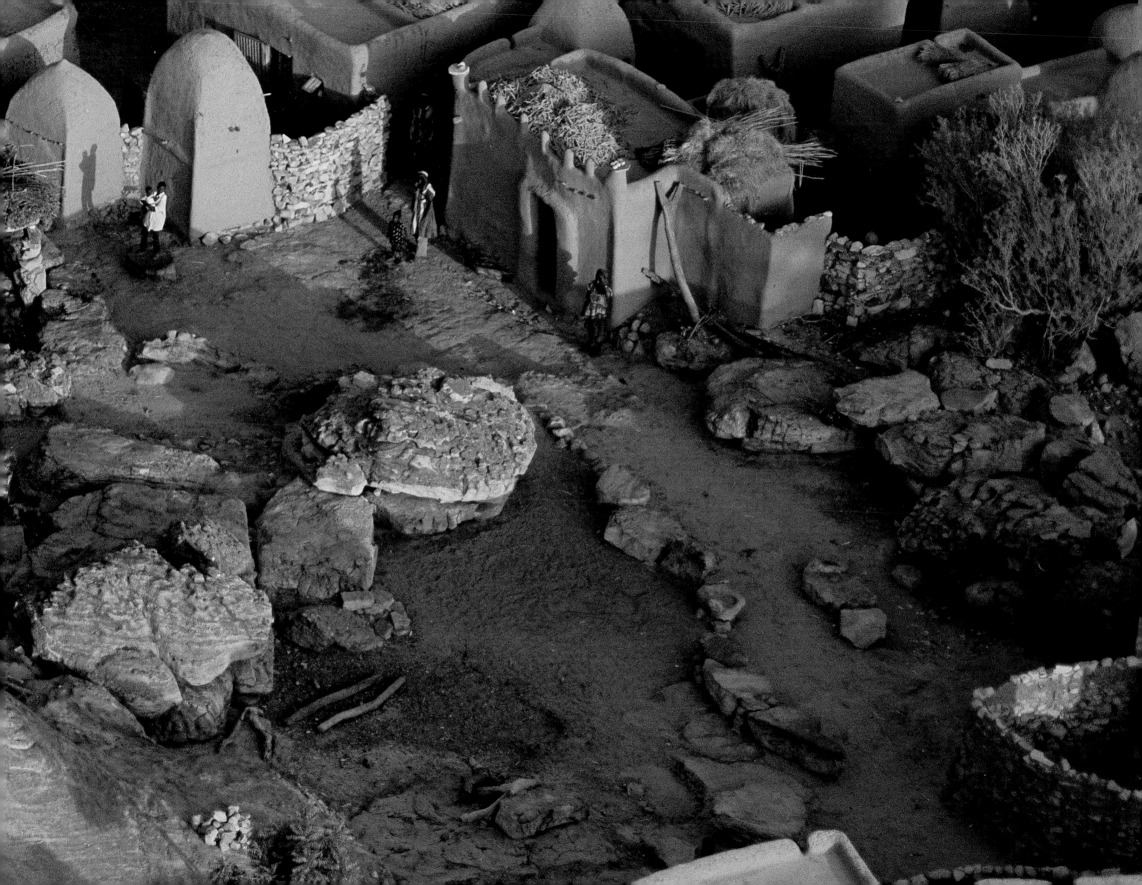

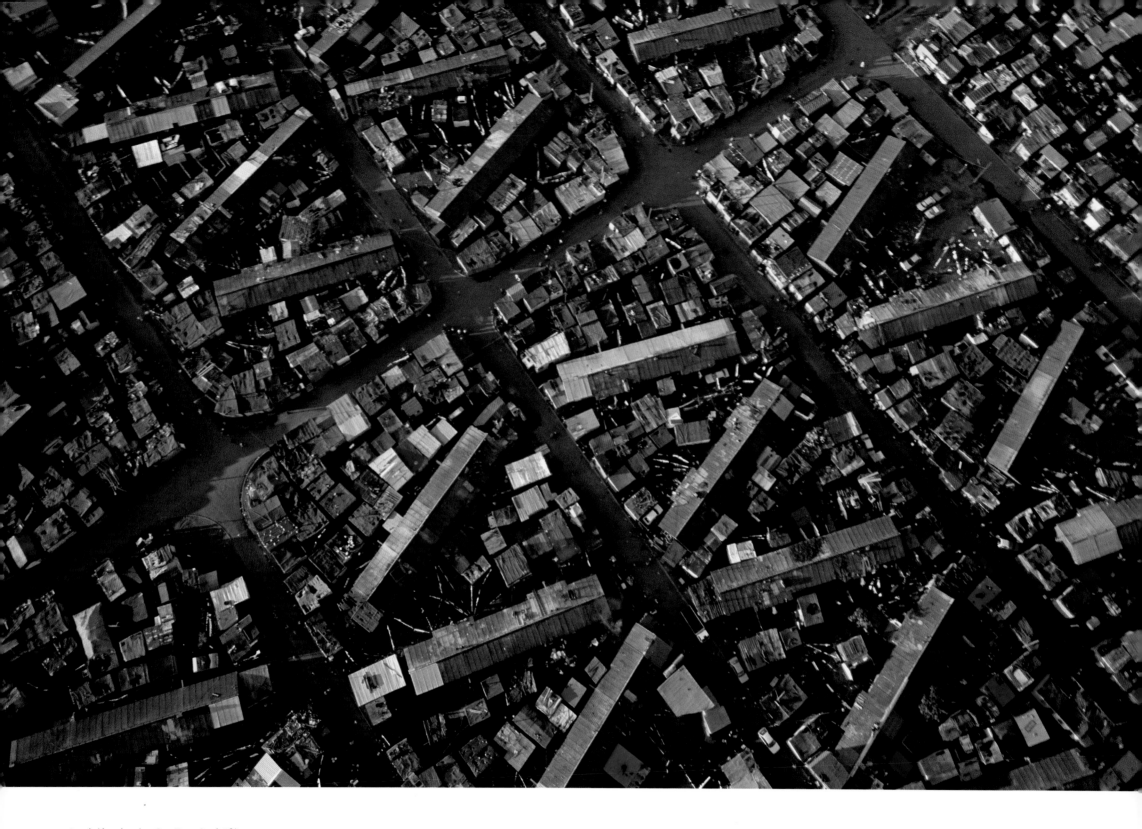

Apartheid-era housing, Cape Town, South Africa

34

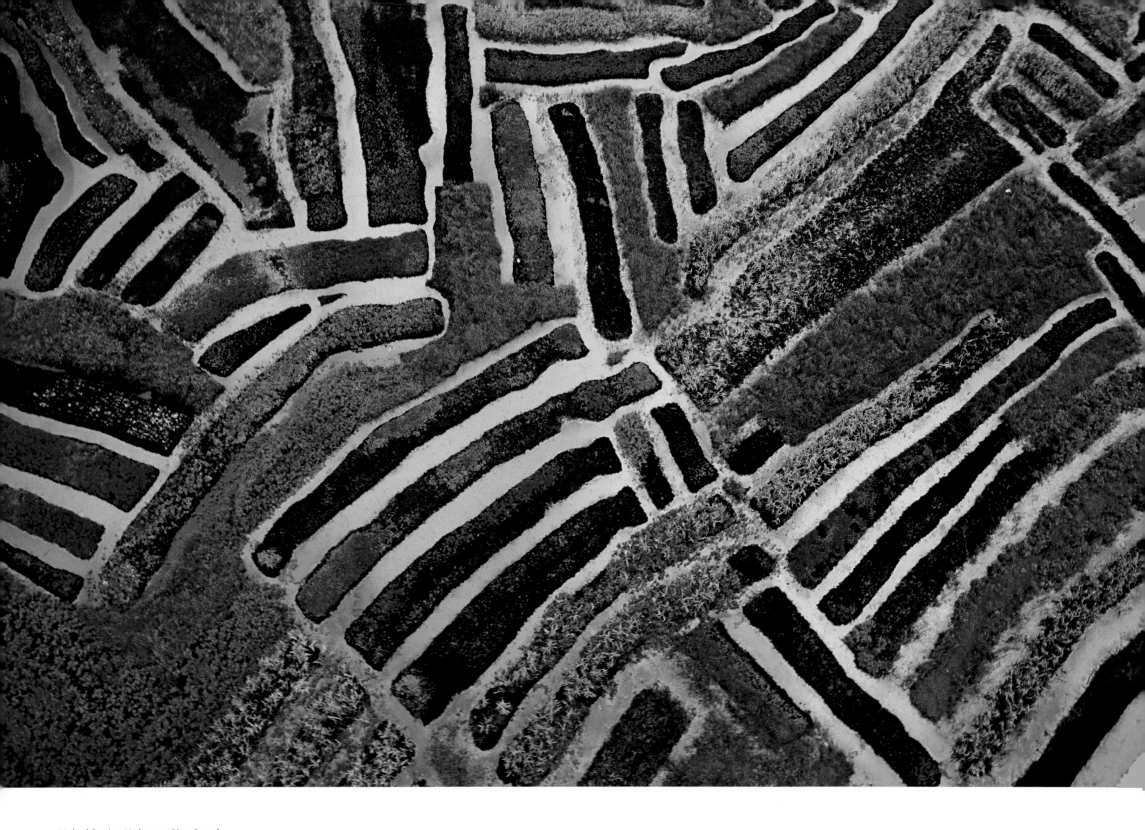

Wetland farming, Nyabarongo River, Rwanda

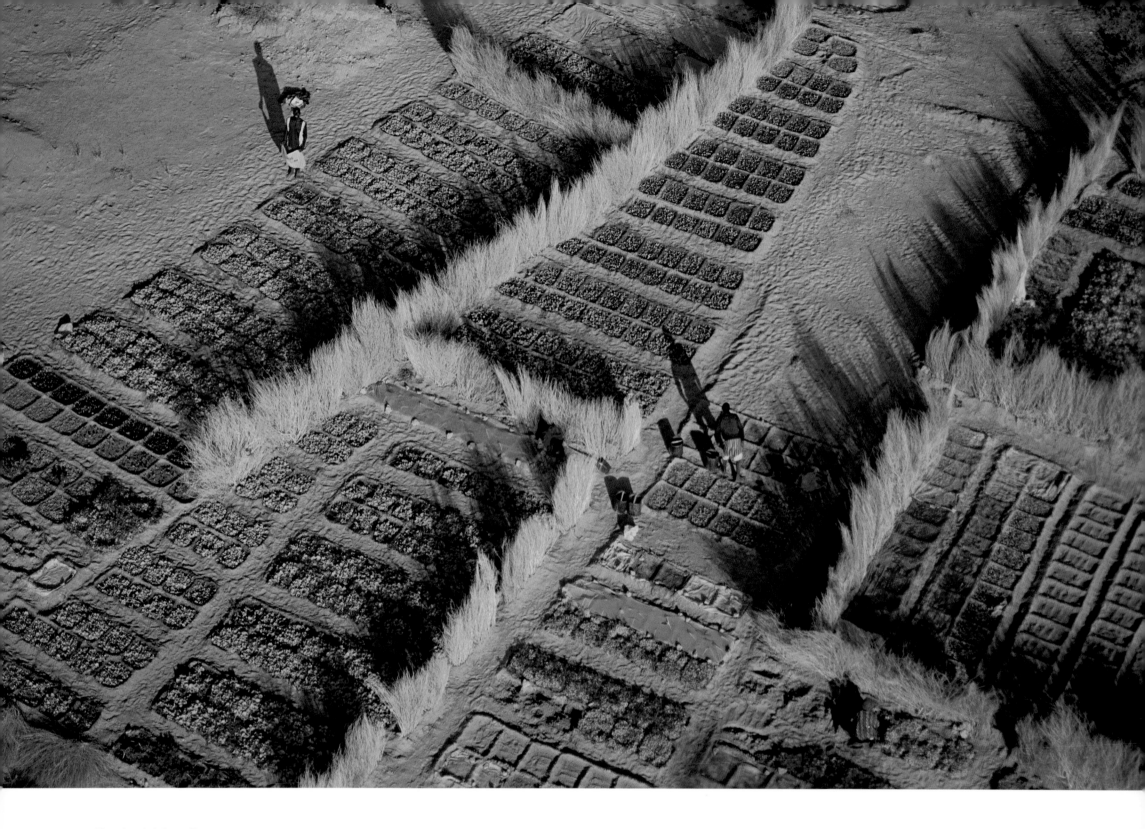

Vegetable garden, Timbuktu, Mali

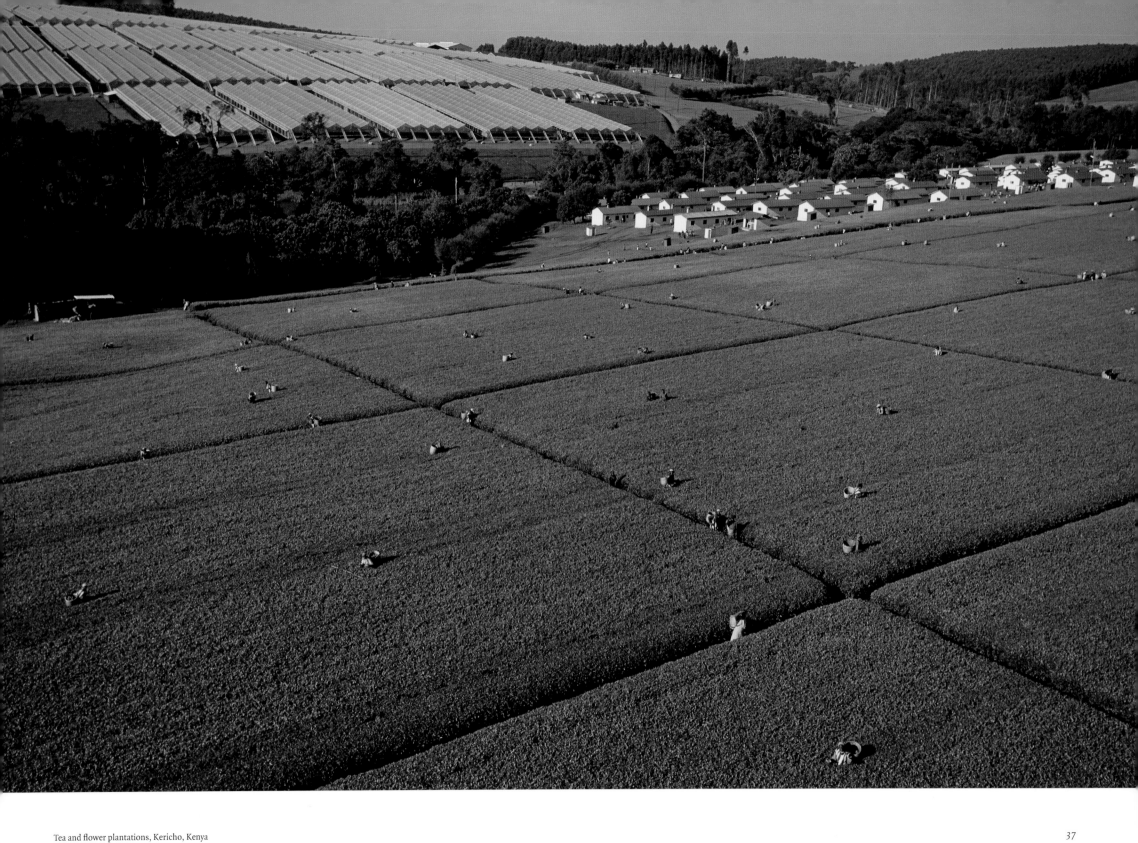

Tea and flower plantations, Kericho, Kenya

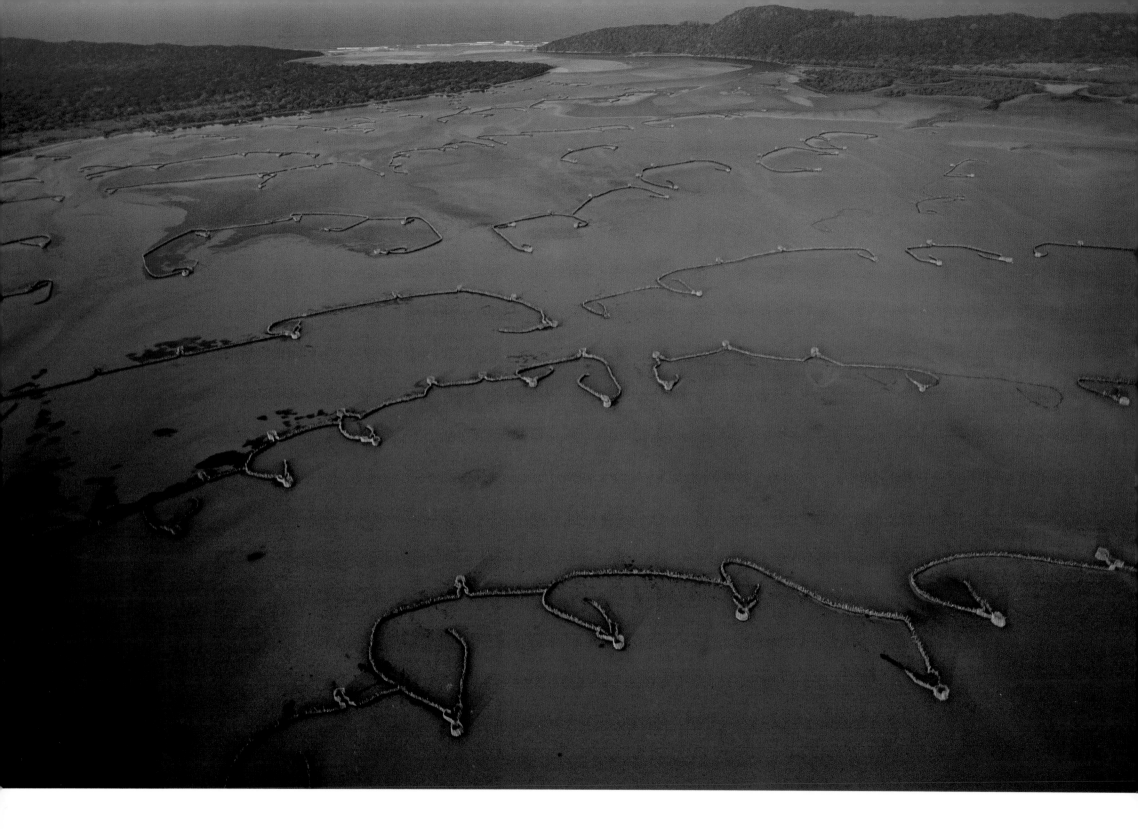

Fish traps, Kosi Bay, South Africa

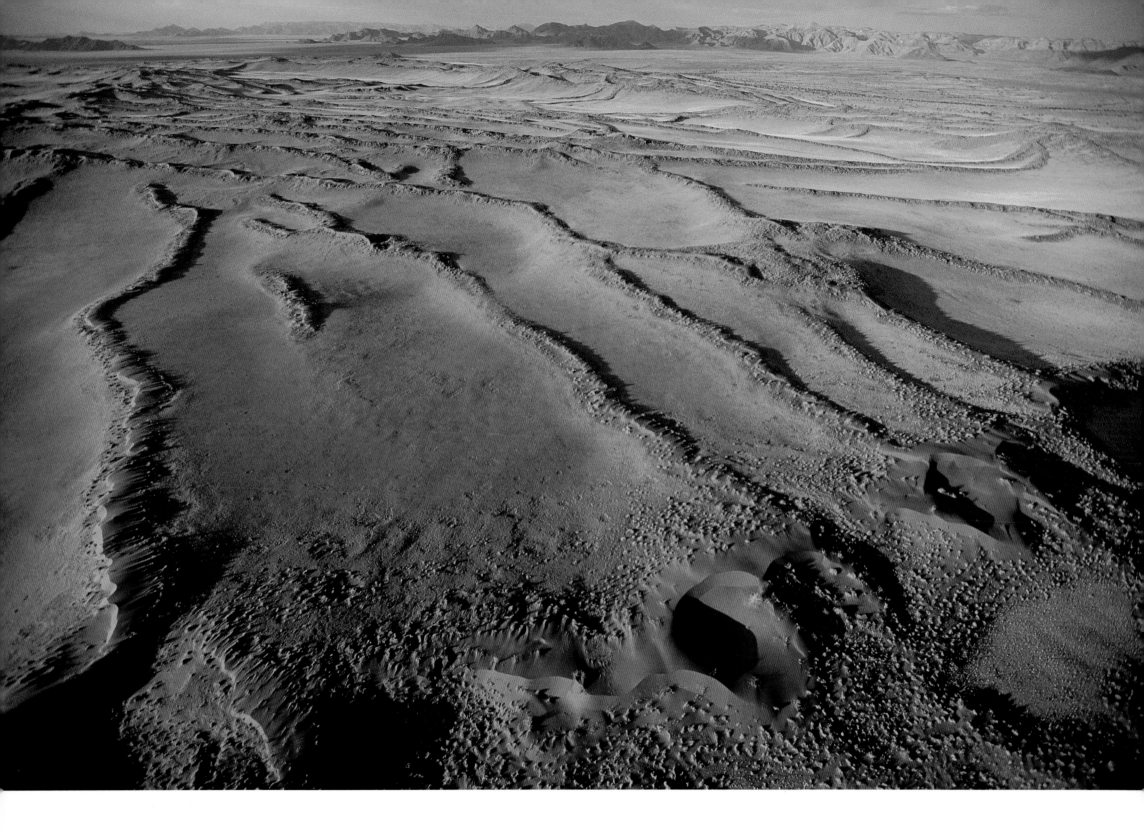

ABOVE: Vegetated dunes, Namib-Naukluft Park, Namibia

OVERLEAF: Subterranean aqueducts, Skoura, Morocco

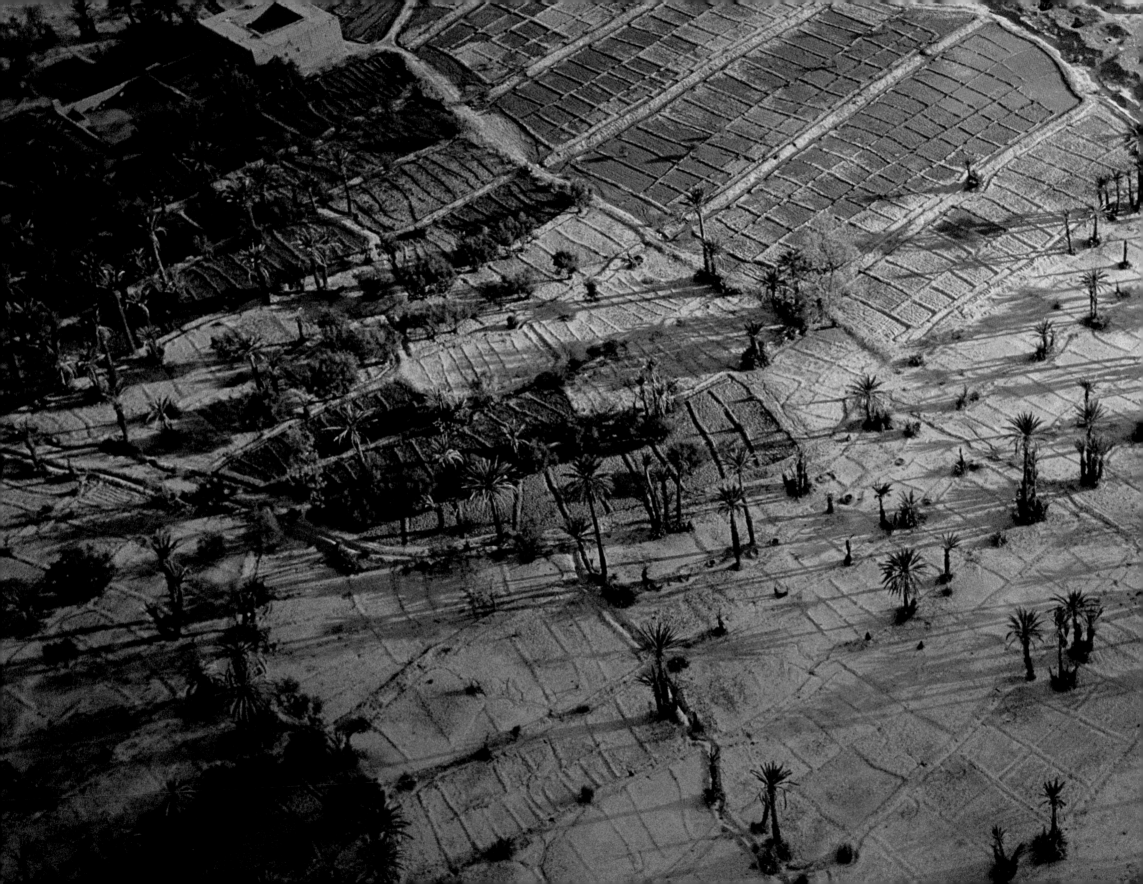

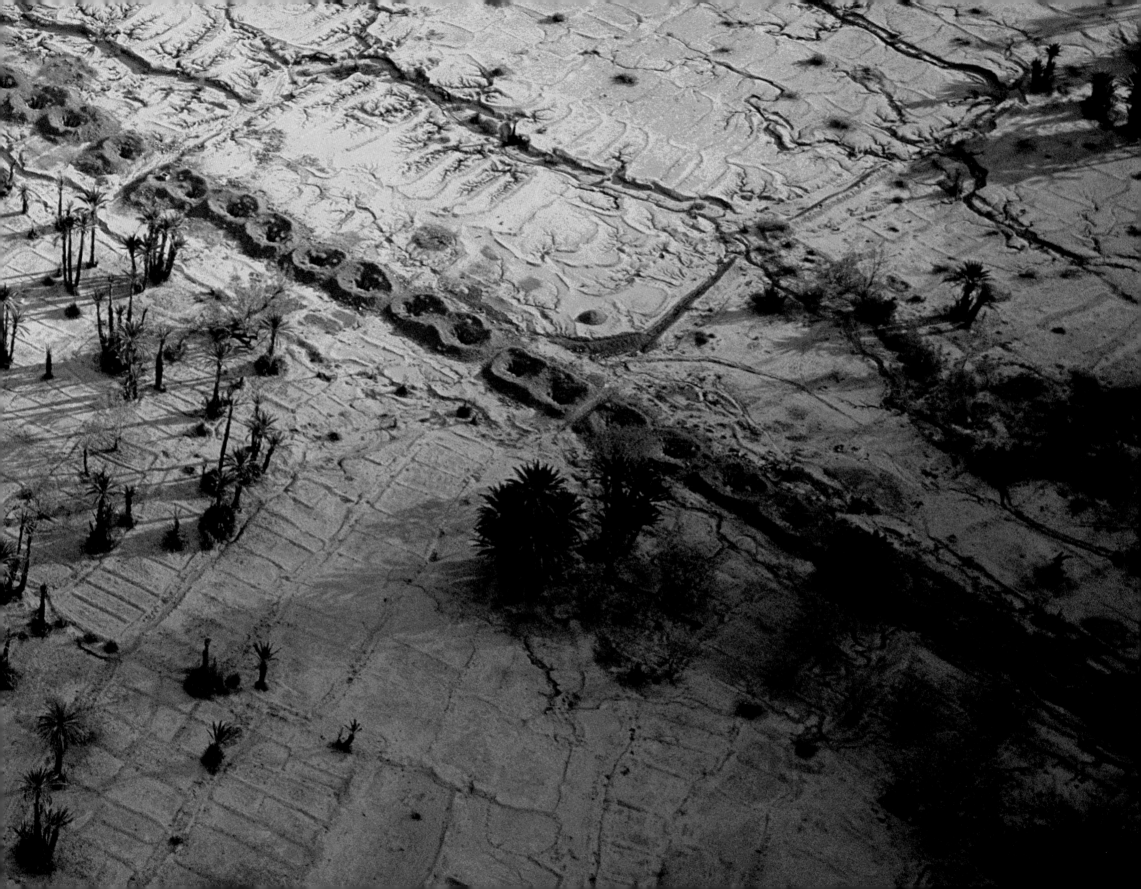

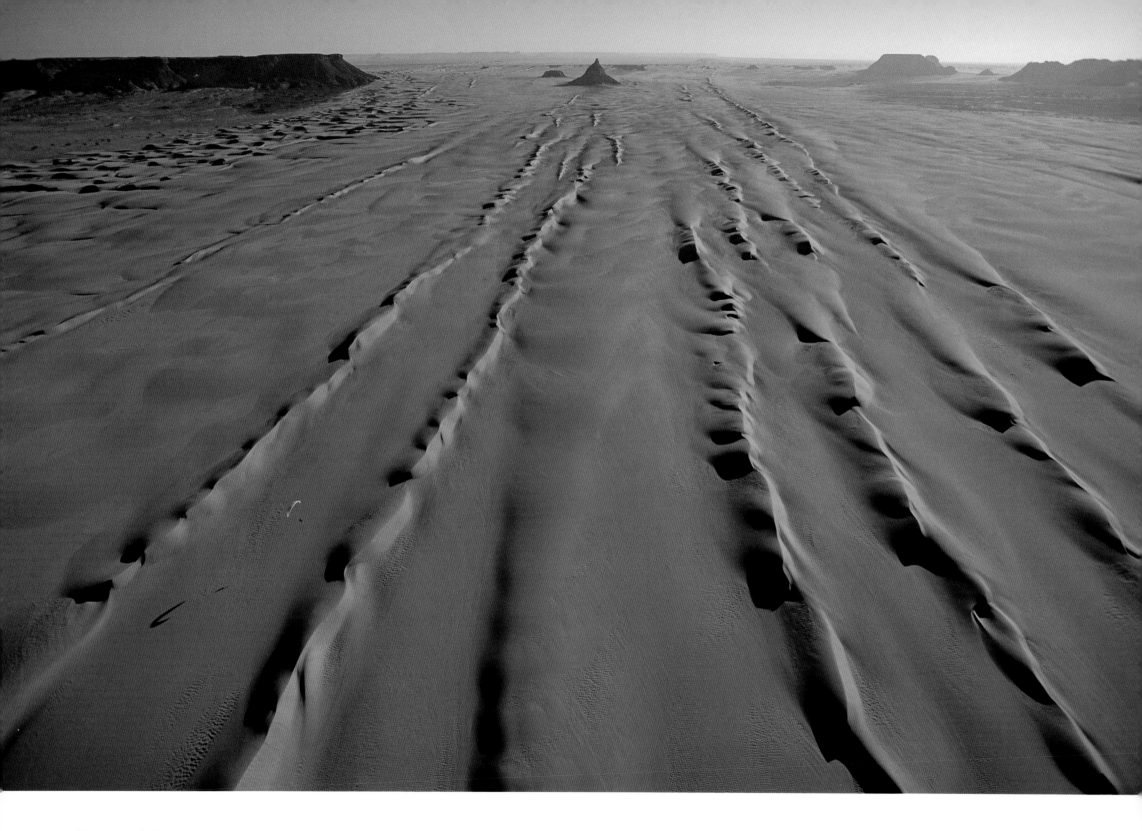

Seif dunes, Demi, Chad

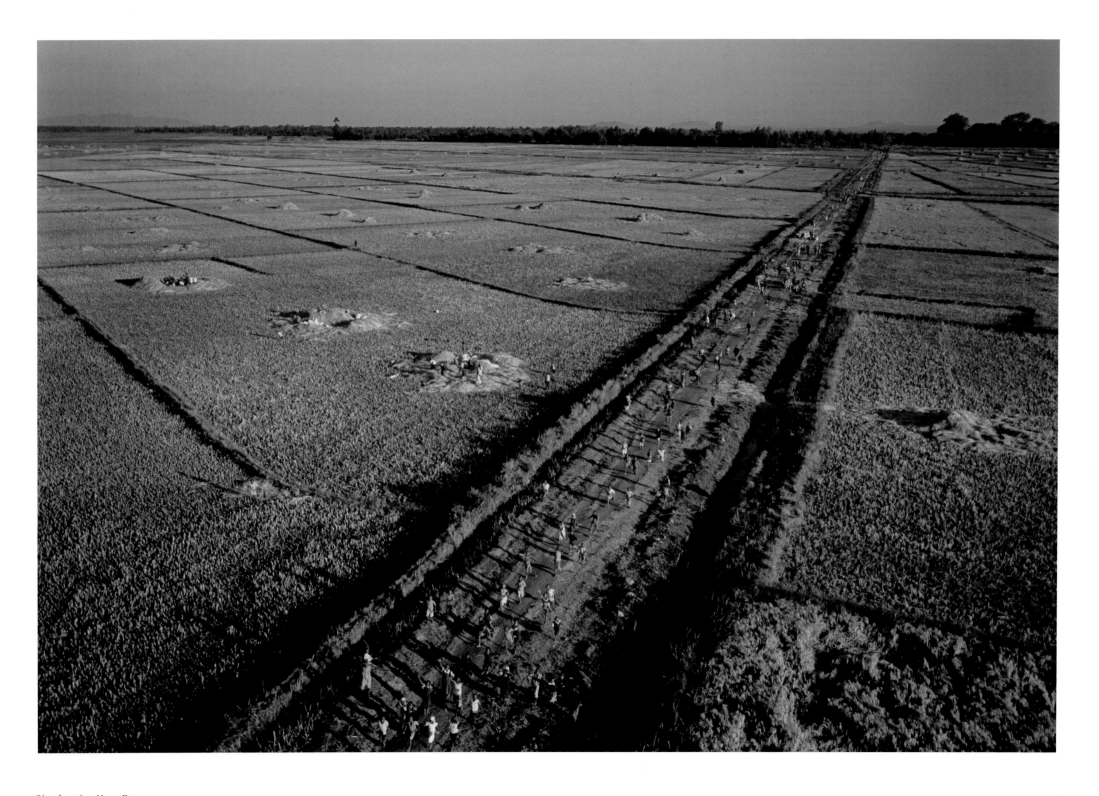

Rice plantation, Mwea, Kenya

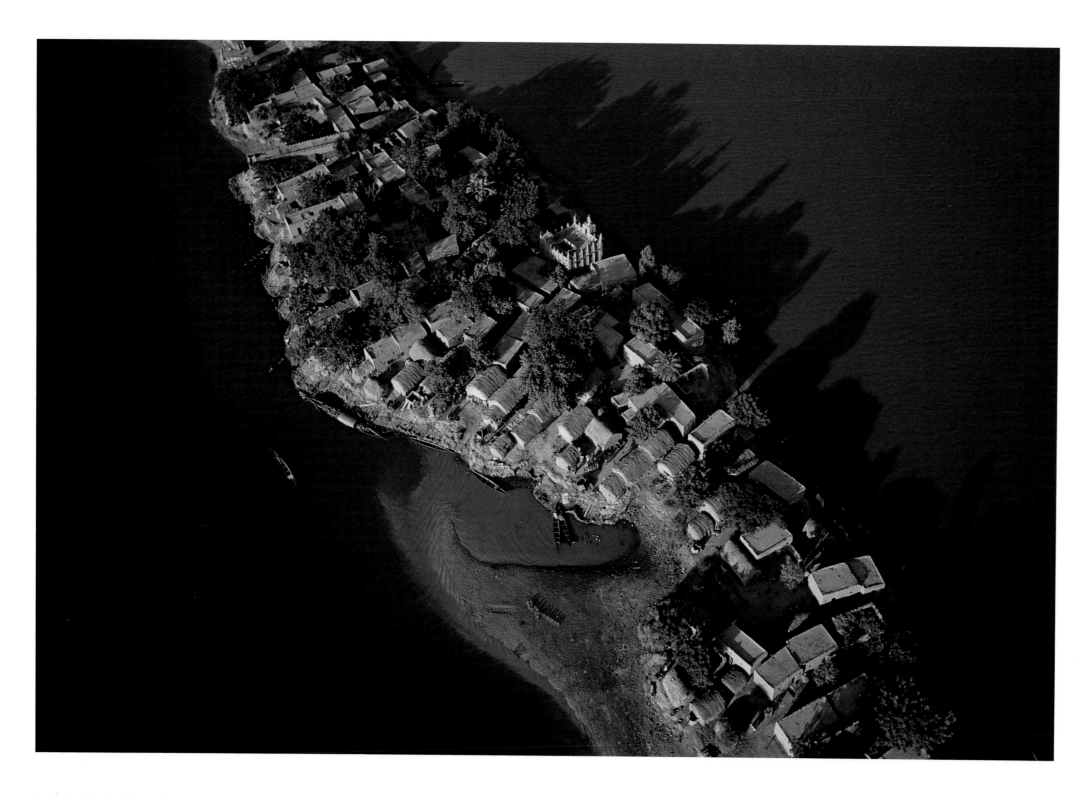

Bozo fishing village, Bani River, Mali

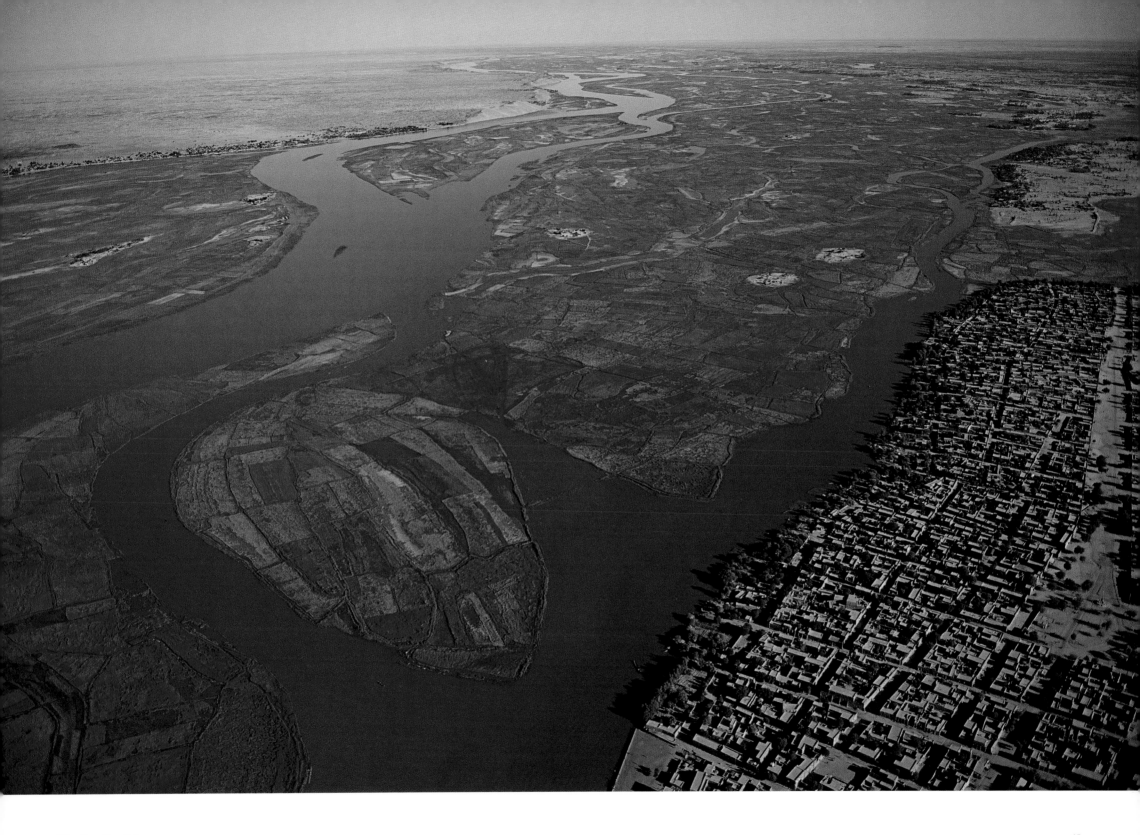

Niger River, Gao, Mali

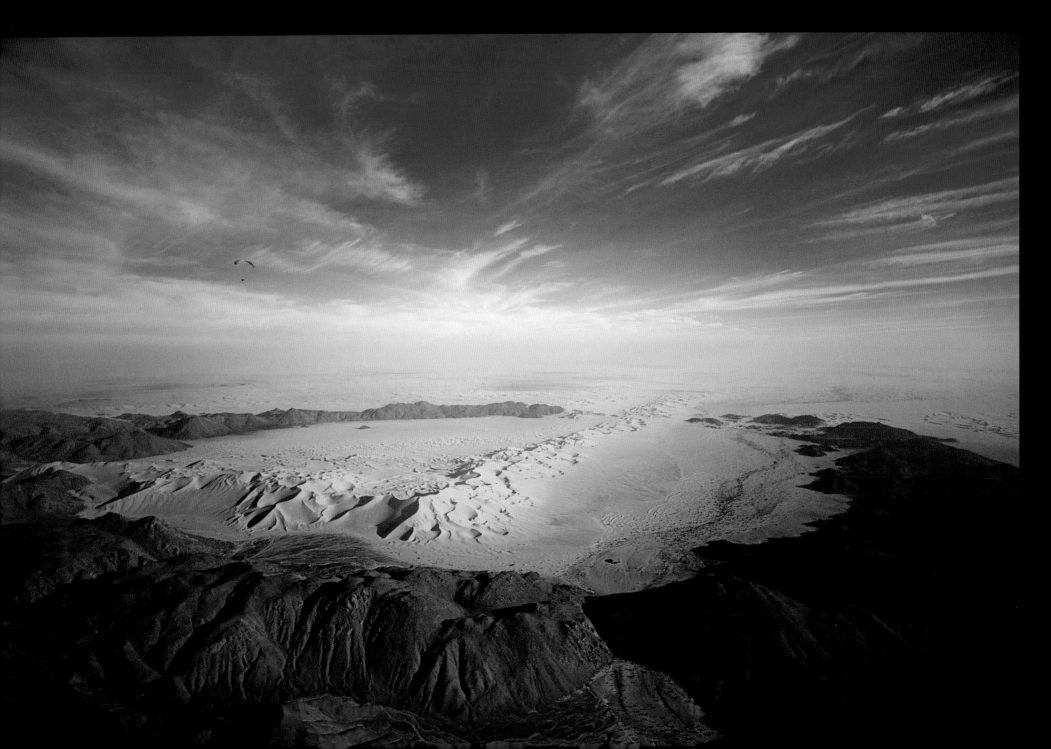

My life hangs by the threads of Kevlar parachute lines and I can see the fear in my trembling hands as I try to change lenses on the camera dangling from my neck. Suddenly I'm seized by the fear of dropping something that might get sucked into the whirling propeller on my back, shattering the force of the finely tuned motor.

At 7,500 feet, this is far higher than I ever wanted to go in my paraglider, but it's the only way to photograph the seven-mile-wide volcano that sprawls beneath me in Niger. With my widest-angle lens having a ninety-degree view, I realized I would have to get at least a mile above the volcano in order to capture the entire crater on film. Certainly an airplane would have been easier for the altitude gain, but wing and wheel struts would get in the way of such a wide view, and the nearest airport is an hour and a half away by plane. And there are no planes in nearby Agadez. While I'm told it's safer to fly at great heights, which gives you much more time and space to recover from a problem, I wonder if I would be capable of using this advantage while in the grips of terror during a free fall. My current fear, however, is

eased somewhat when I focus my mind on taking pictures of the spectacular geologic process laid bare below me.

I had first taken off in the murky predawn light, as I had wanted to be above the crater in time for sunrise, but François was not far behind me in an identical aircraft. It took us more than an hour to gain 5,500 feet, and I felt the panic slowly rising within me. But now I've reached the limits of my equipment and fuel supply, and from the harness of my one-seater, I have an unrestricted 180-degree view of the strange world that lies below. And now, despite my fear, the effort is rewarded. From this altitude the desert is stranger and more beautiful than I imagined. With a breached rim on its eastern side, the ancient volcano has become half filled with sand blowing in off the Sahara. It appears as if the earth has had its living skin peeled away. All is laid bare—the bones of bedrock, the flesh of soil, the veins of dried-up watercourses that once fed dinosaurs. I spy areas to explore later on foot: ceremonial sites of peoples who have vanished into prehistory and the traces of old caravan routes visible only from the air. François and I idle our motors and drift slowly down toward our camp, saving a little fuel so we can play around closer to the ground, over the beautiful dunescape below.

Ironically, flying has brought me closer to the desert, as I am completely exposed to the forces of sun and wind that shape it. We have quickly become students of the wind, reading its imprint

on the dunes, much like kayakers scouting rapid. Even my expert companion finds flight conditions here capricious and challenging. It's a dangerous place to put one's faith in the fragility of technology. And I ponder the wisdom of an old barefoot nomad who had watched us in flight. "They want to die," he said, "but God has not chosen their time." ▨

LEFT: Mohamed Ixa tracking George Steinmetz in flight over the Ténéré, Niger

ABOVE: Topographic map of

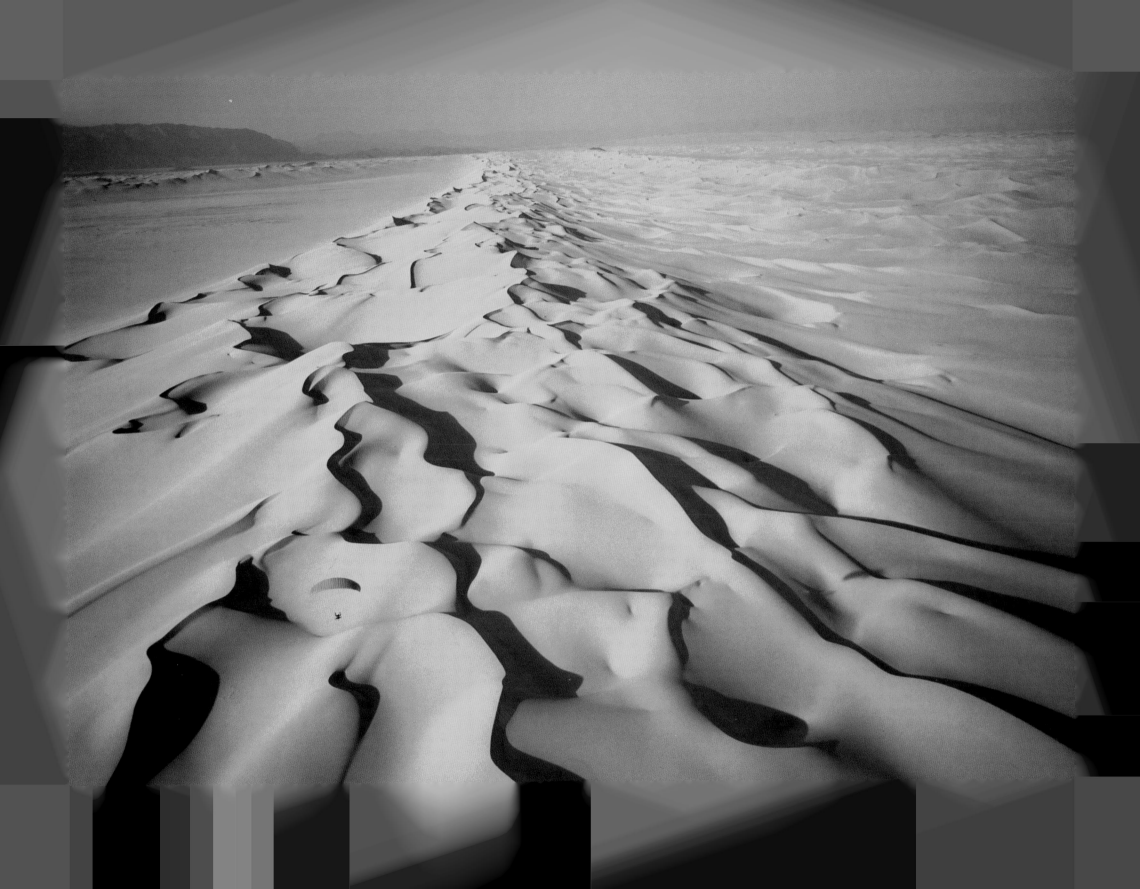

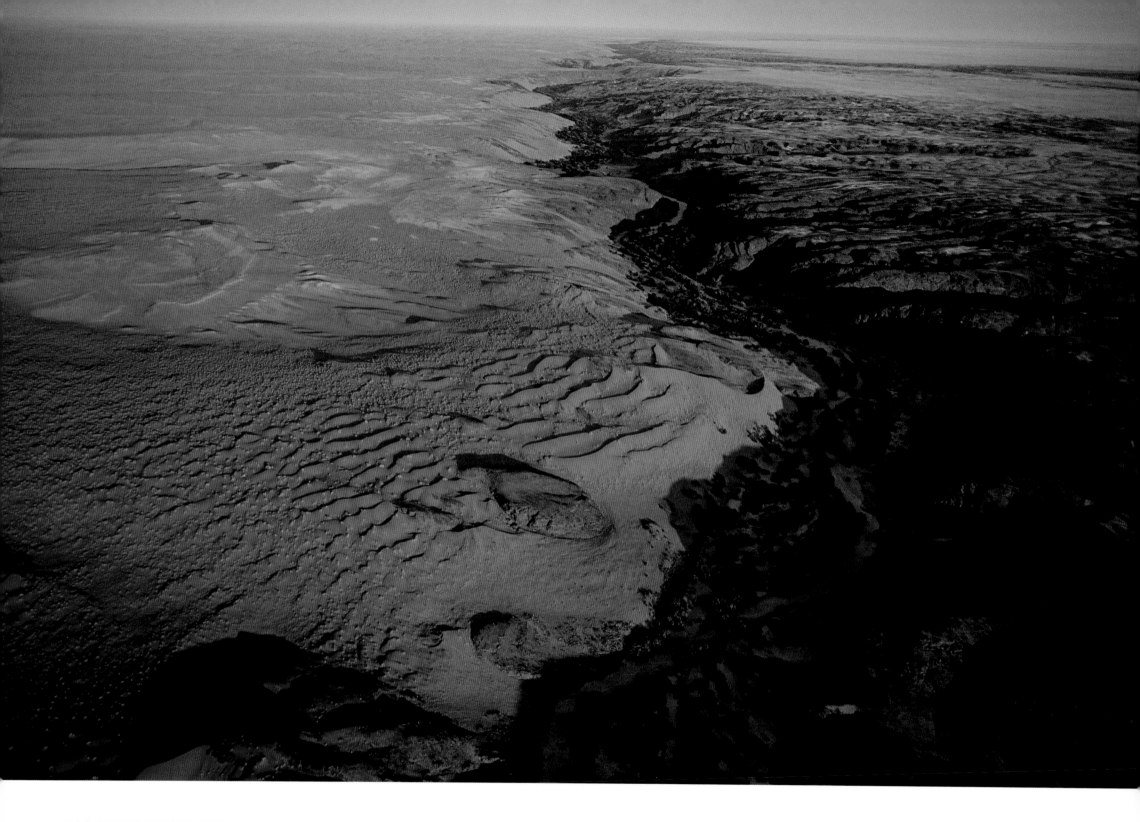

Kuiseb River, Namib-Naukluft Park, Namibia

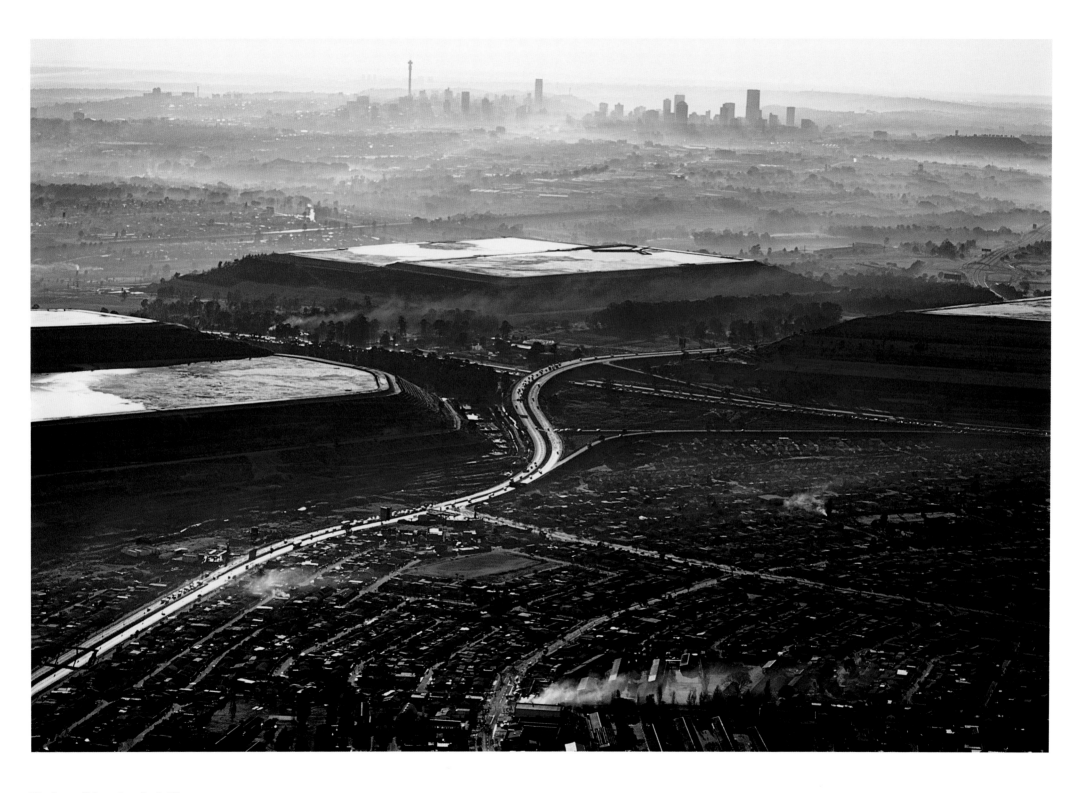

Mine dumps of Johannesburg, South Africa

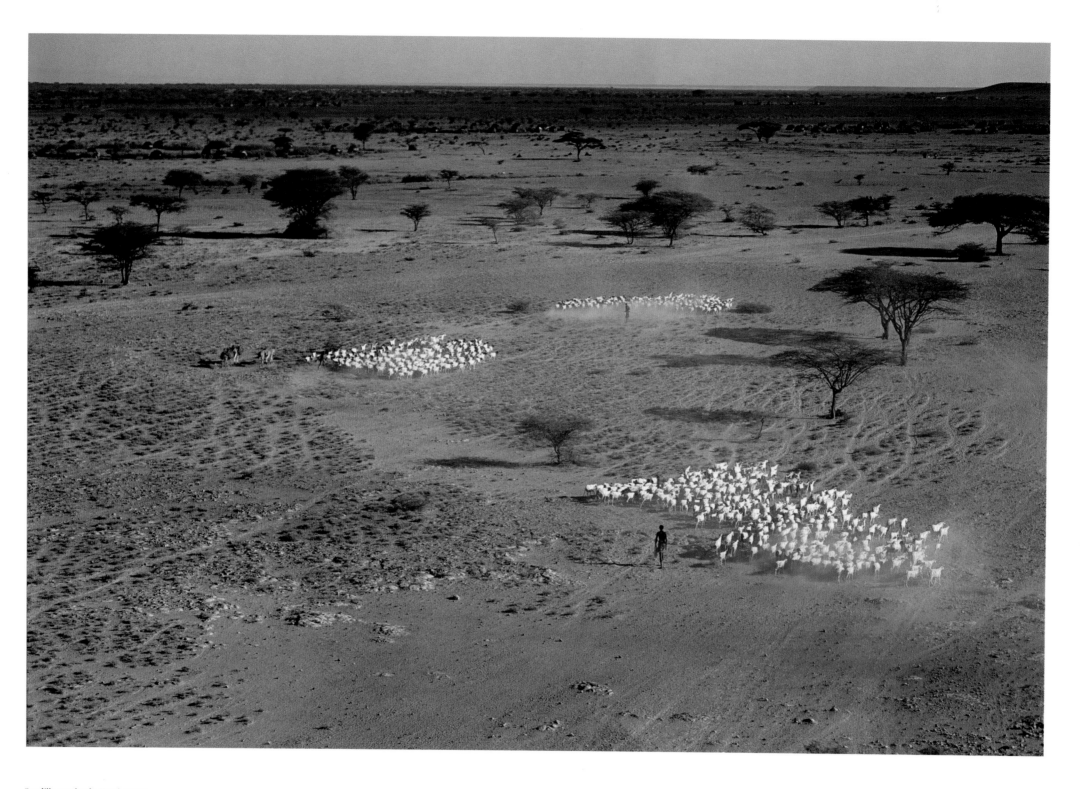

Rendille goat herds, Kargi, Kenya

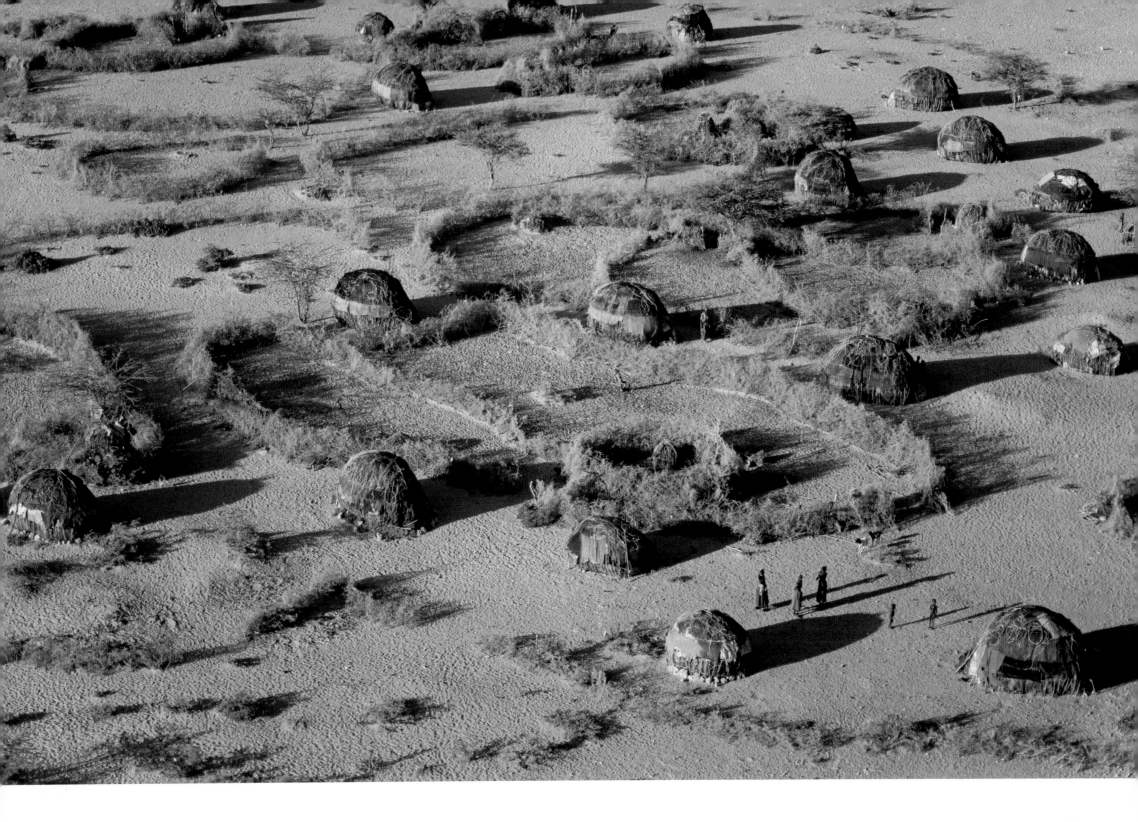

Rendille village, Kargi, Kenya

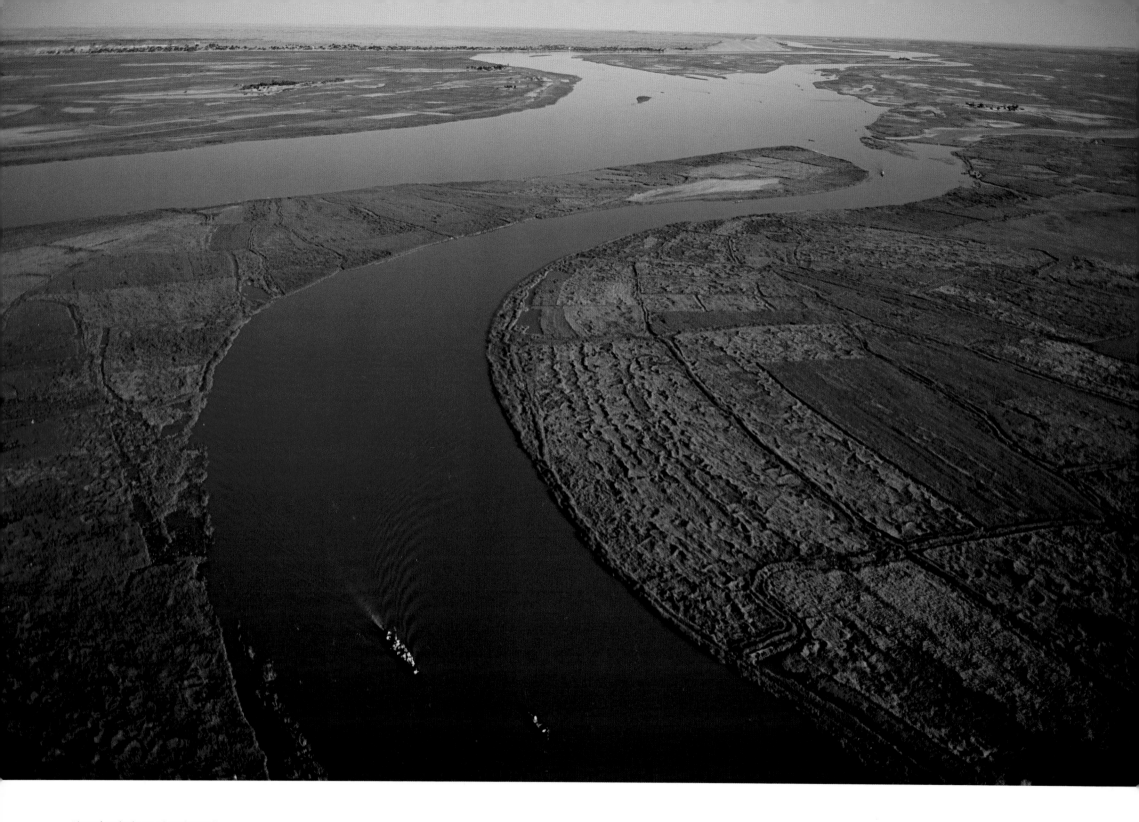

Rice and market boats, Niger River, Mali

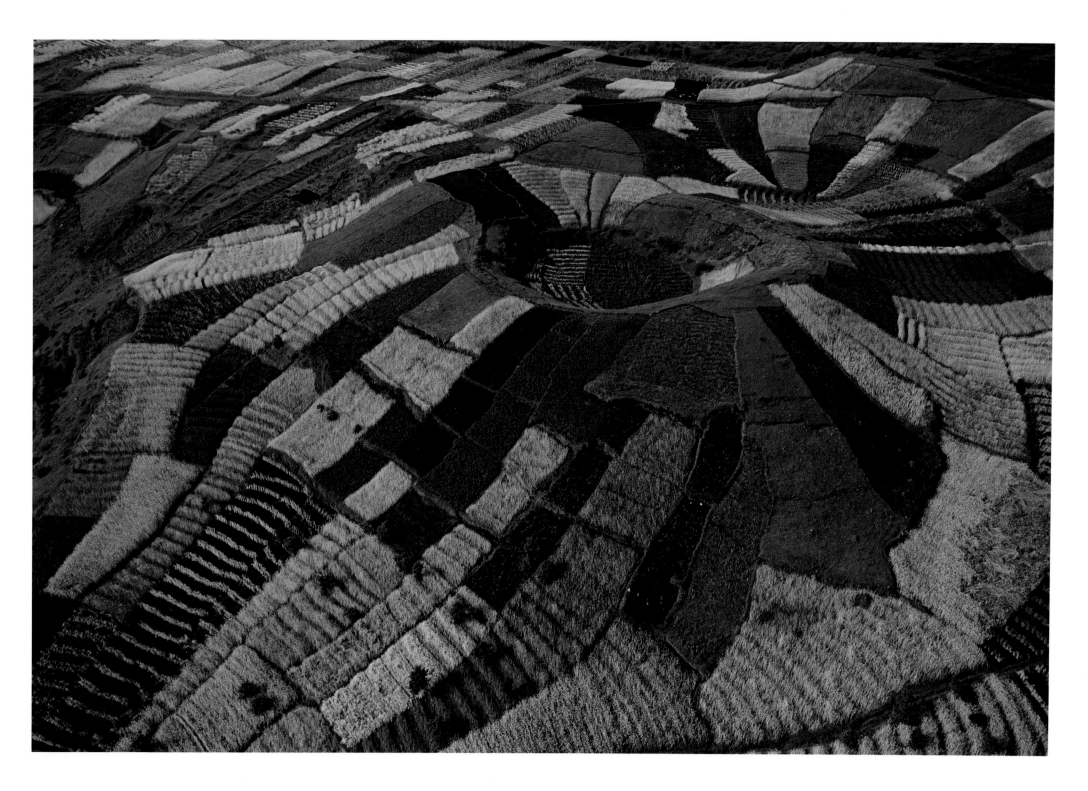

ABOVE: Terraced volcano, Virunga Mountains, Rwanda
OVERLEAF: Suburban sands of Nouakchott, Mauritania

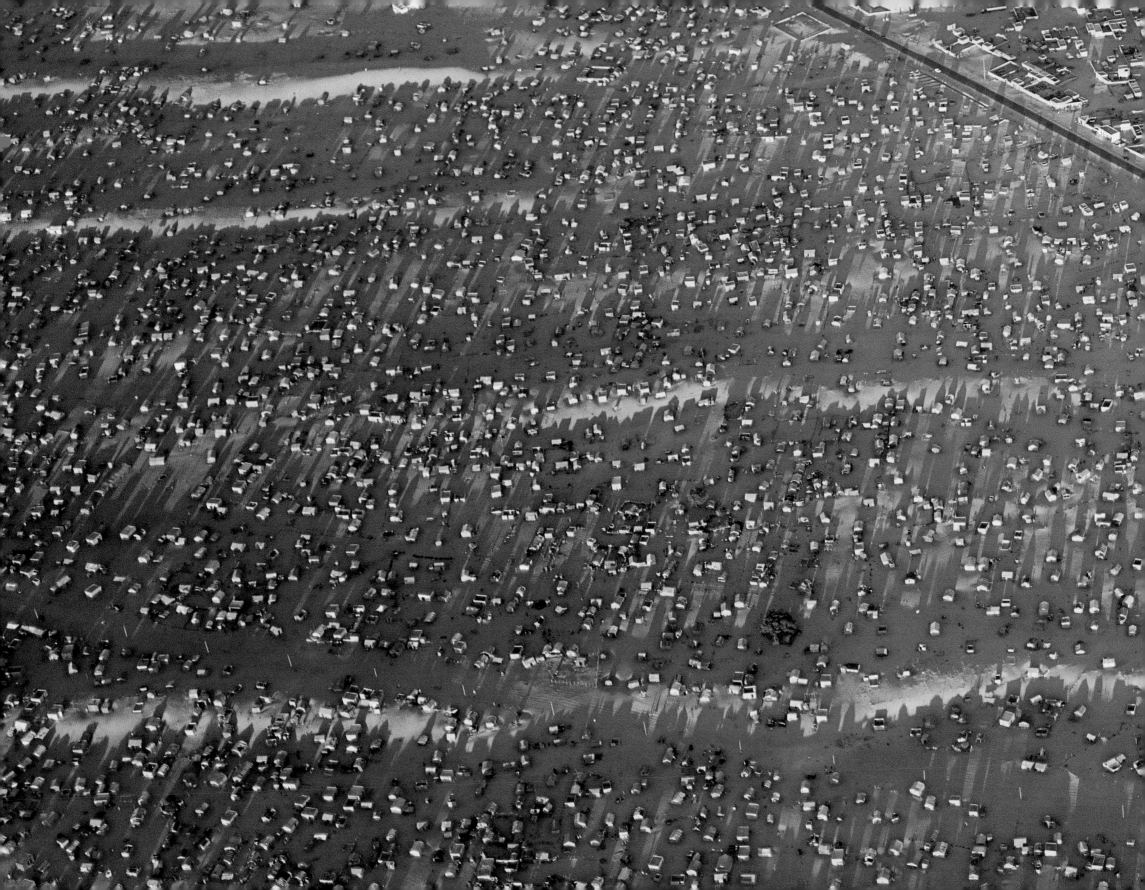

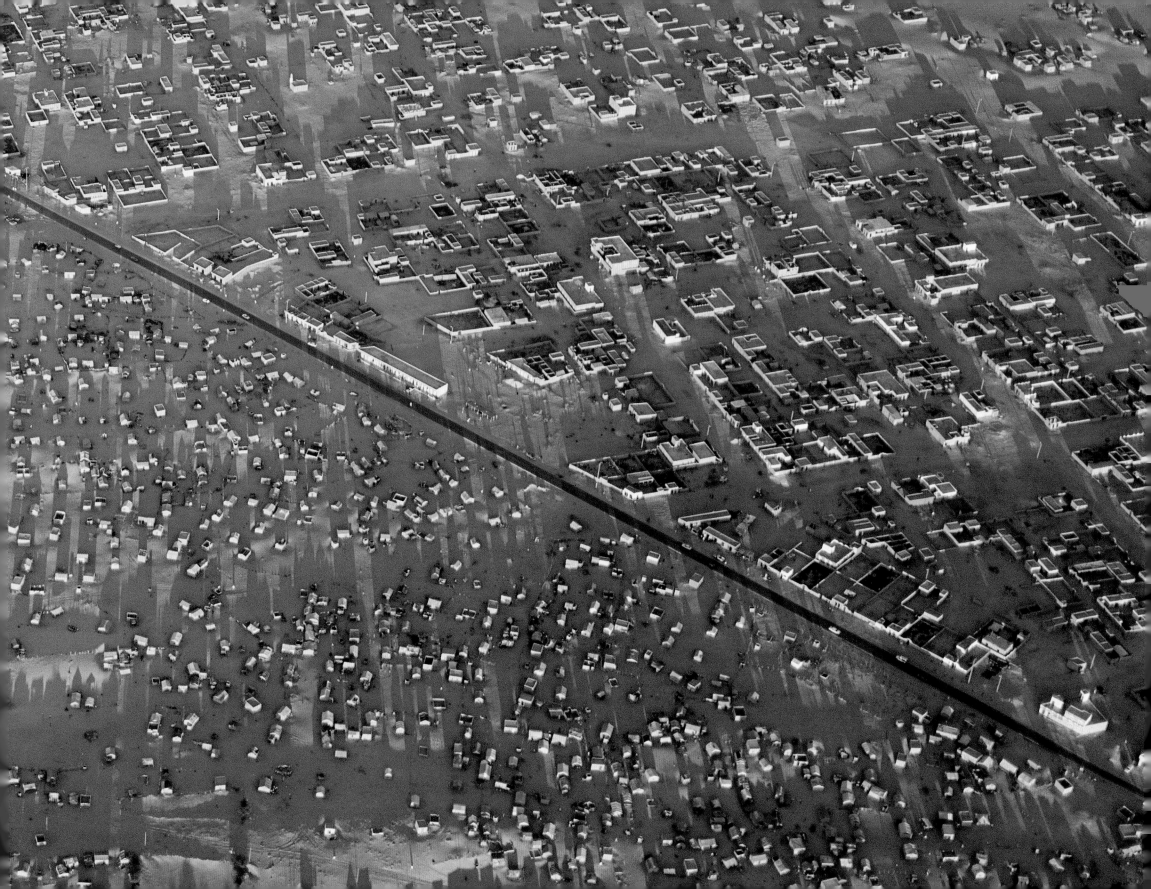

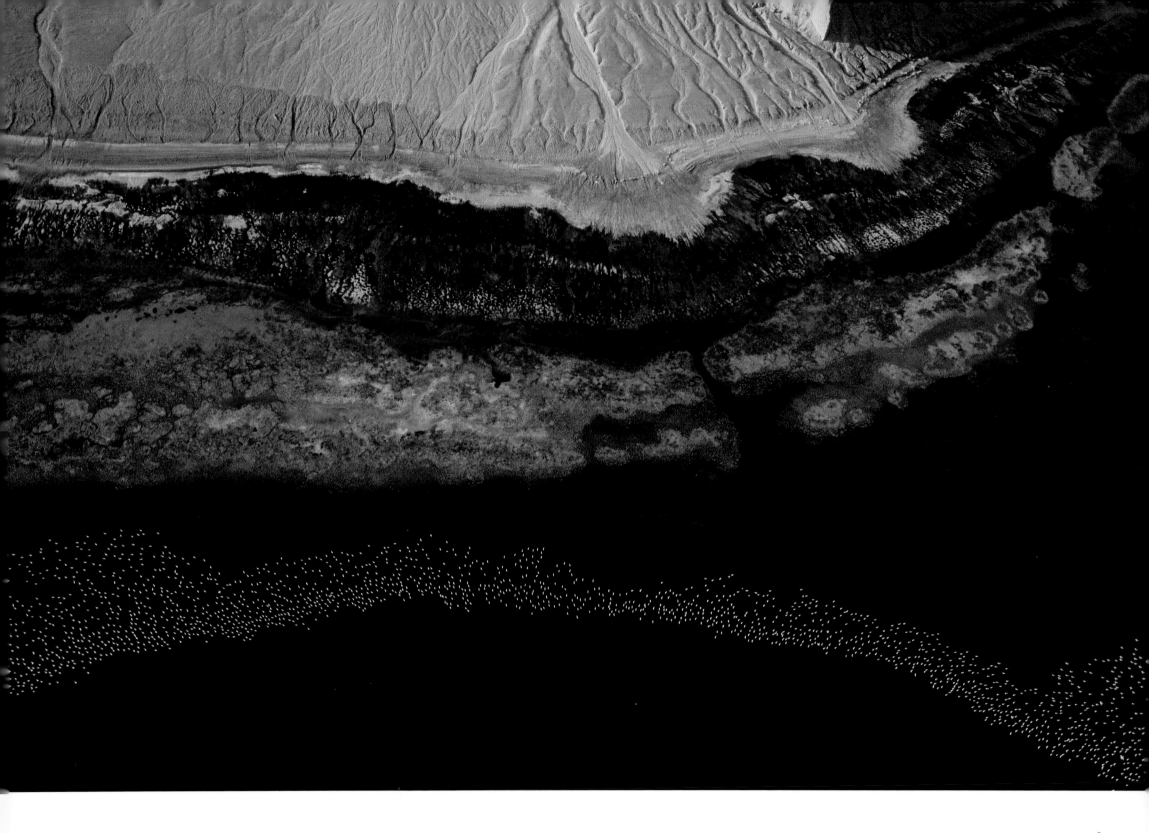

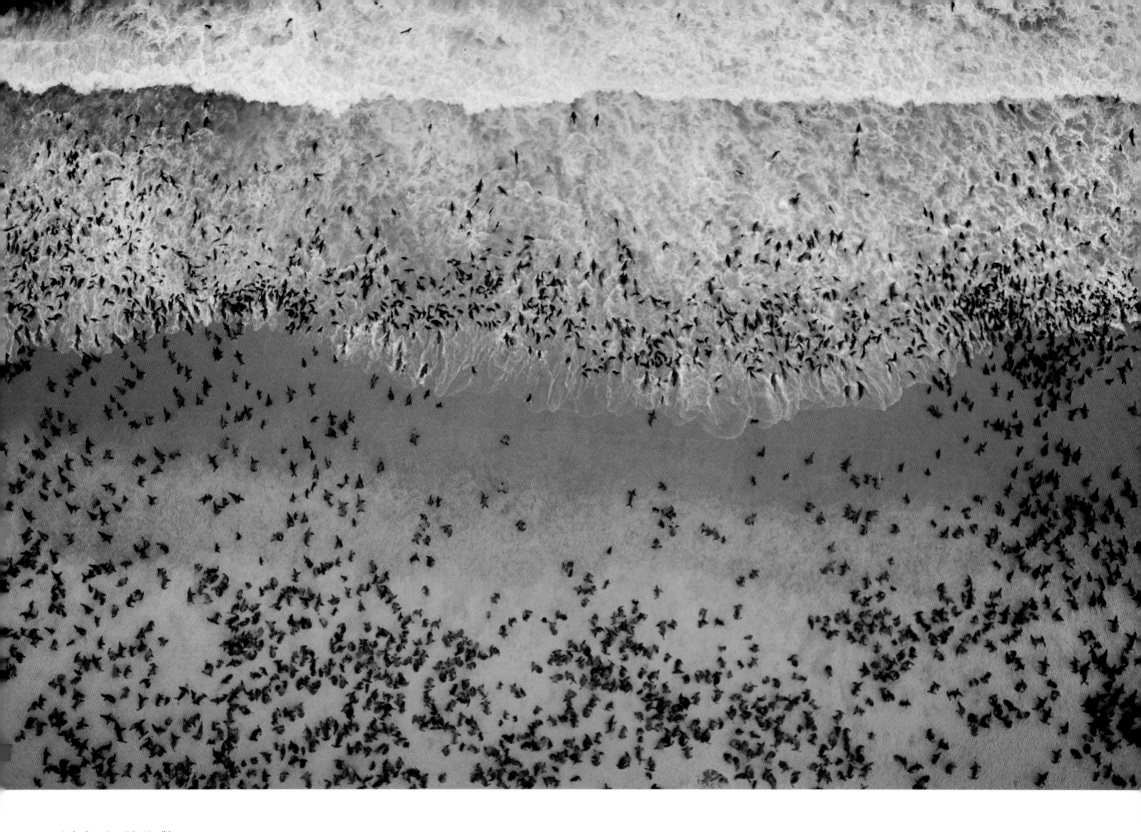

Seal colony, Cape Fria, Namibia

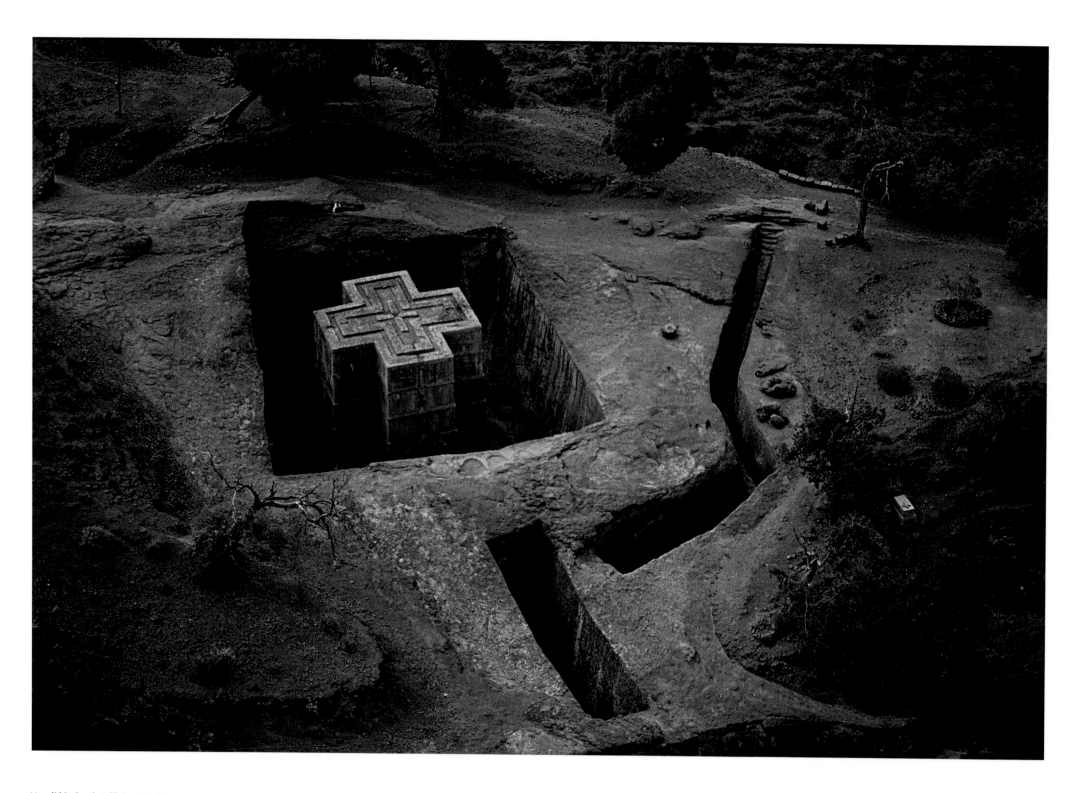

Monolithic church, Lalibela, Ethiopia

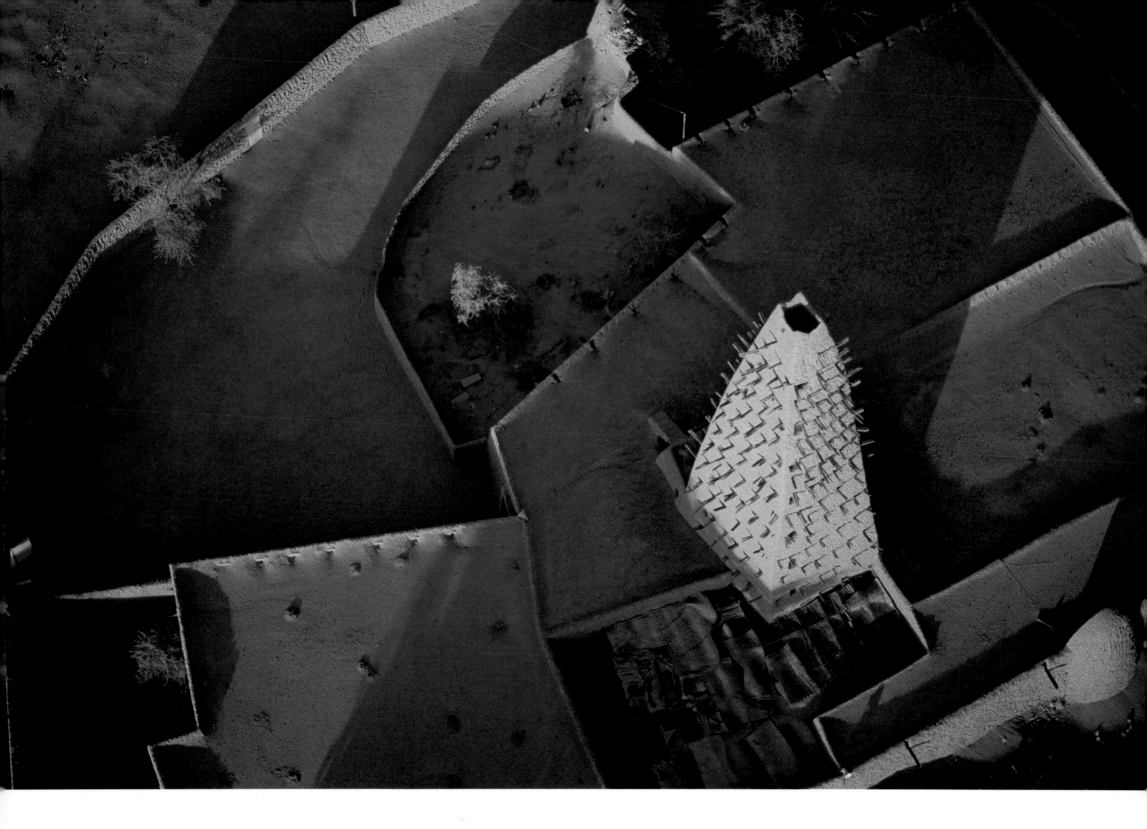

Grand Mosque, Agadez, Niger

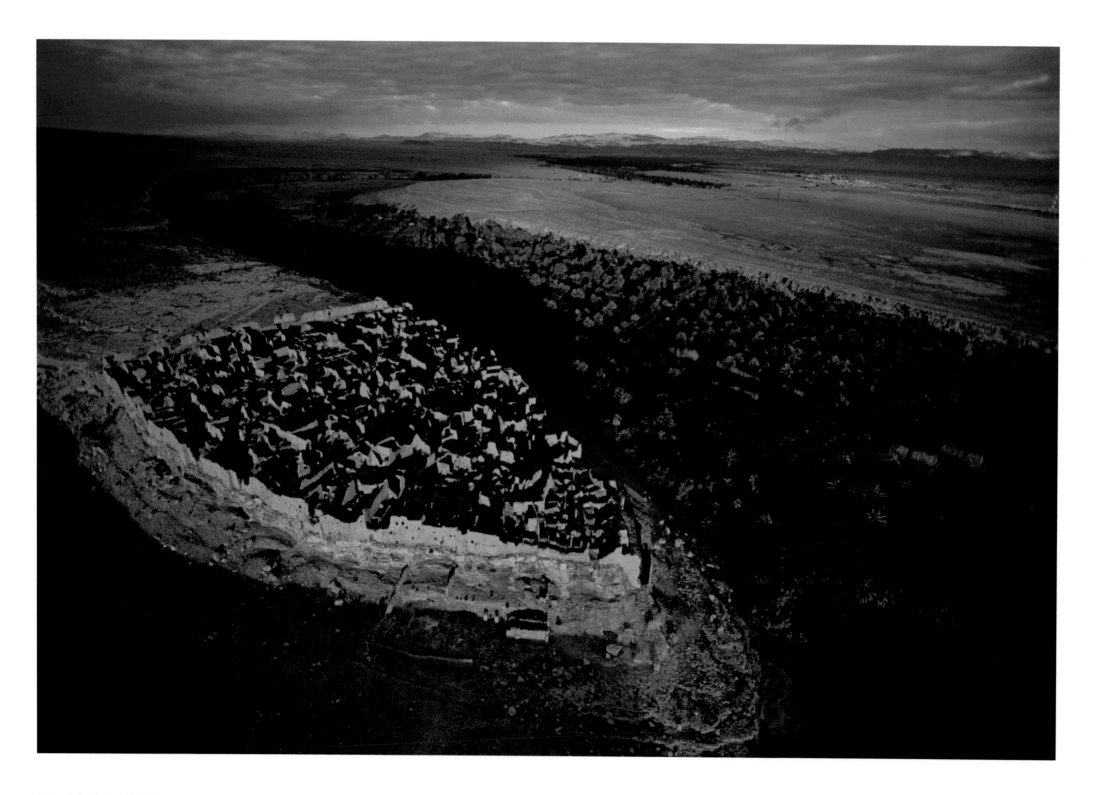

Ruins of a fortified city, Meski, Morocco

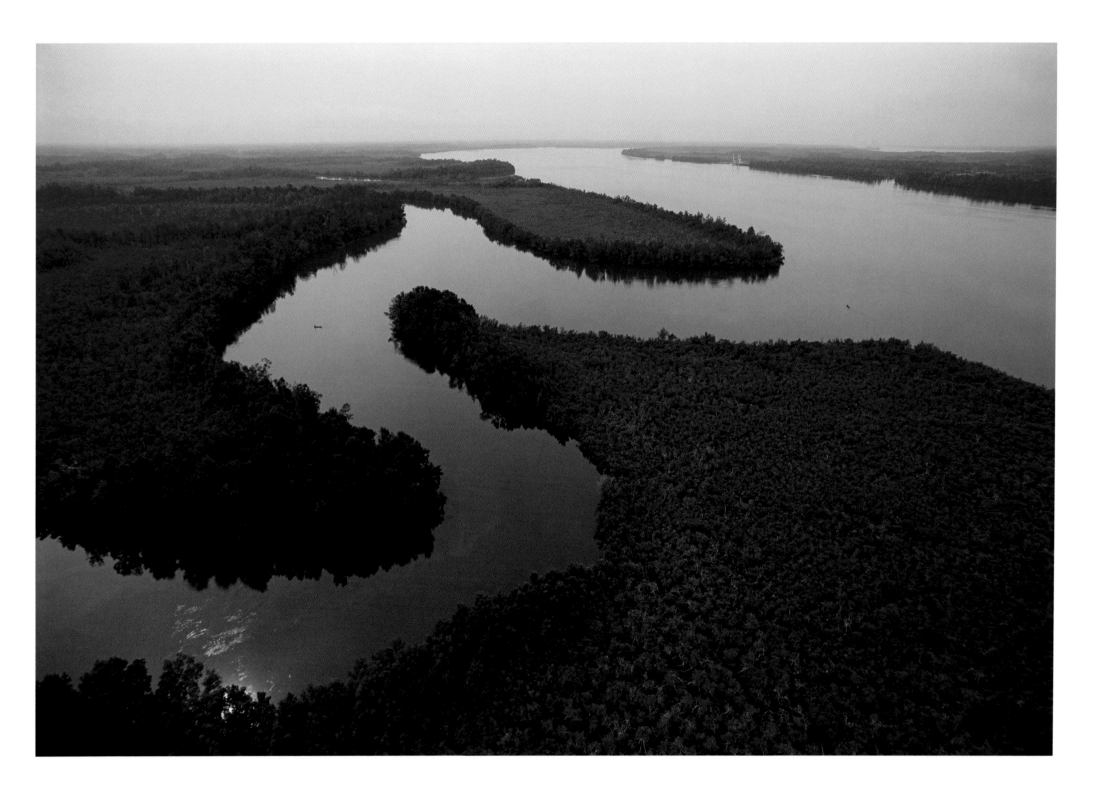

ABOVE: Swamp forest, Niger Delta, Nigeria

OVERLEAF: Two people on a dune, Chinguetti, Mauritania

63

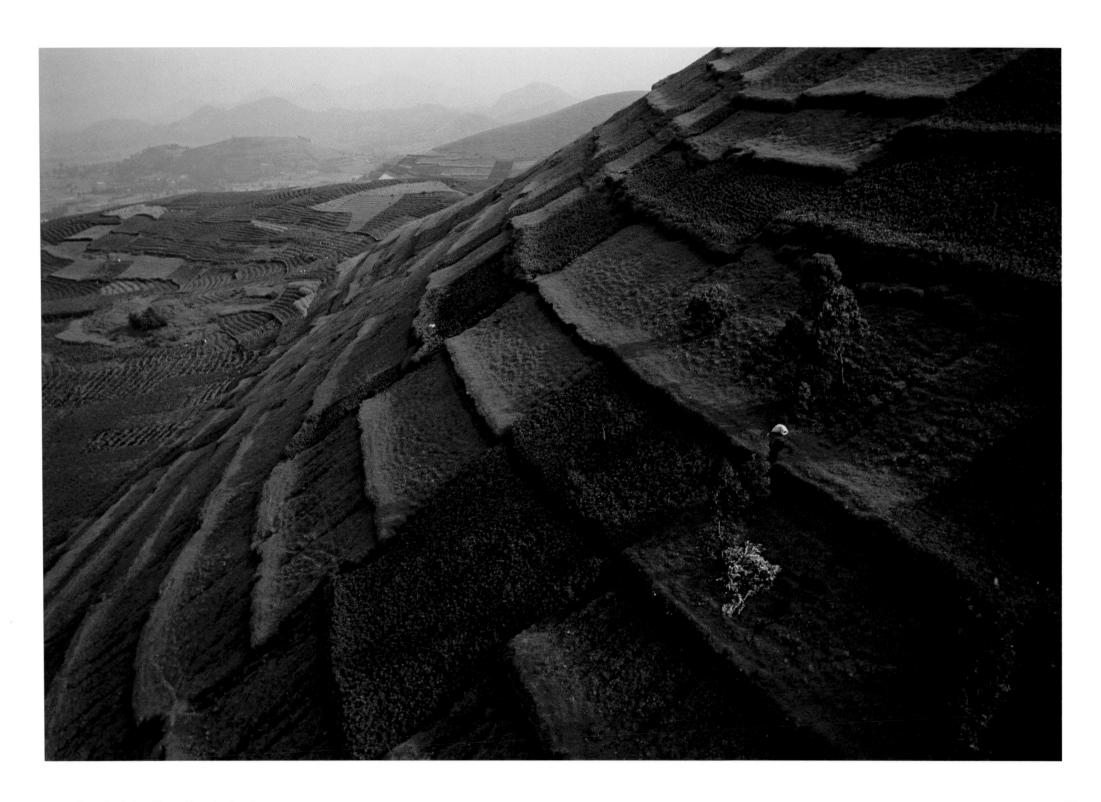

ABOVE: Terraced agriculture, Virunga Mountains, Rwanda

OPPOSITE: Vertically oriented bedrock, Ugab River, Namibia

66

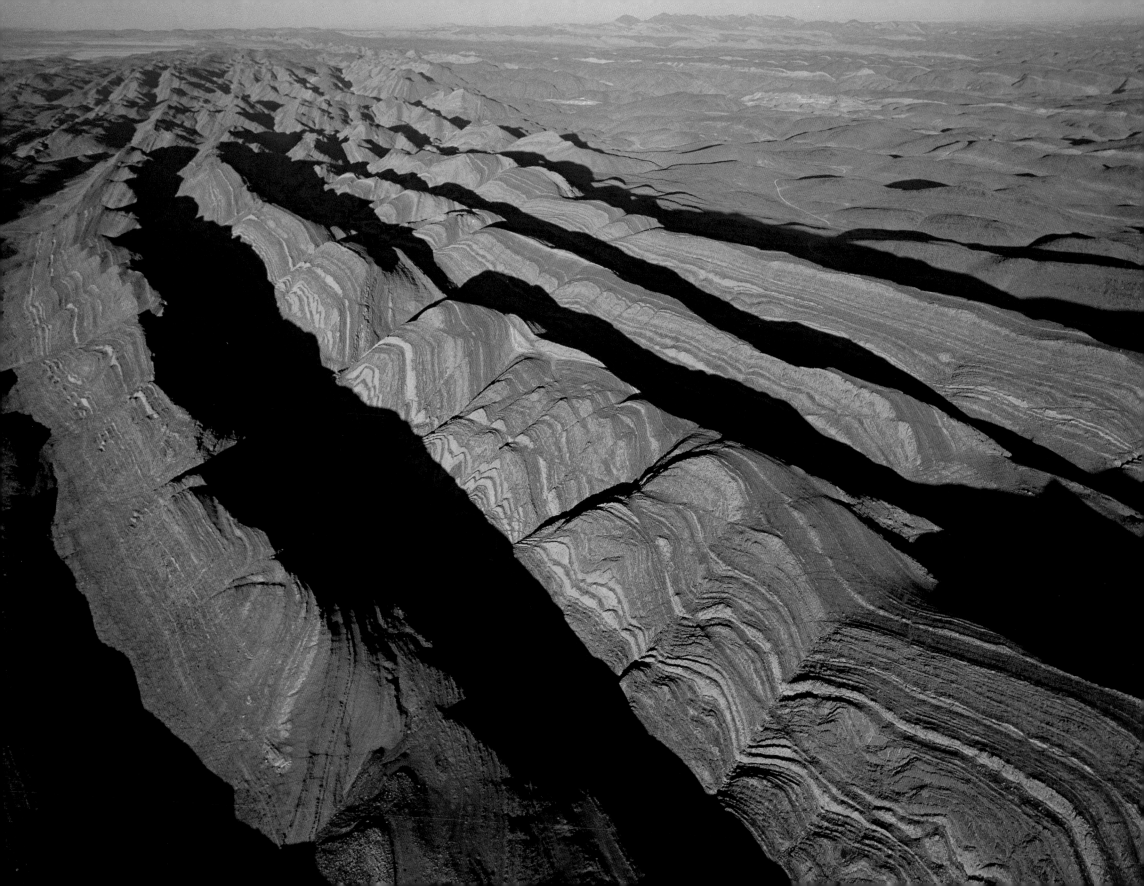

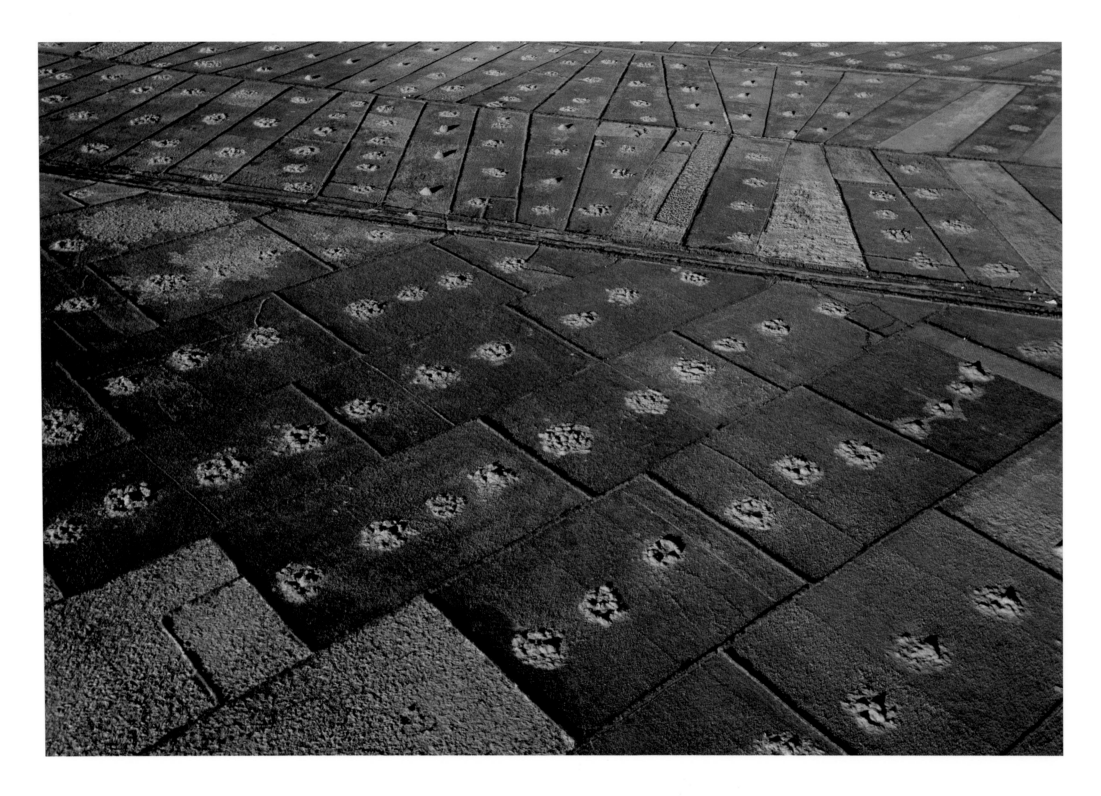

Rice plantation, Mwea, Kenya

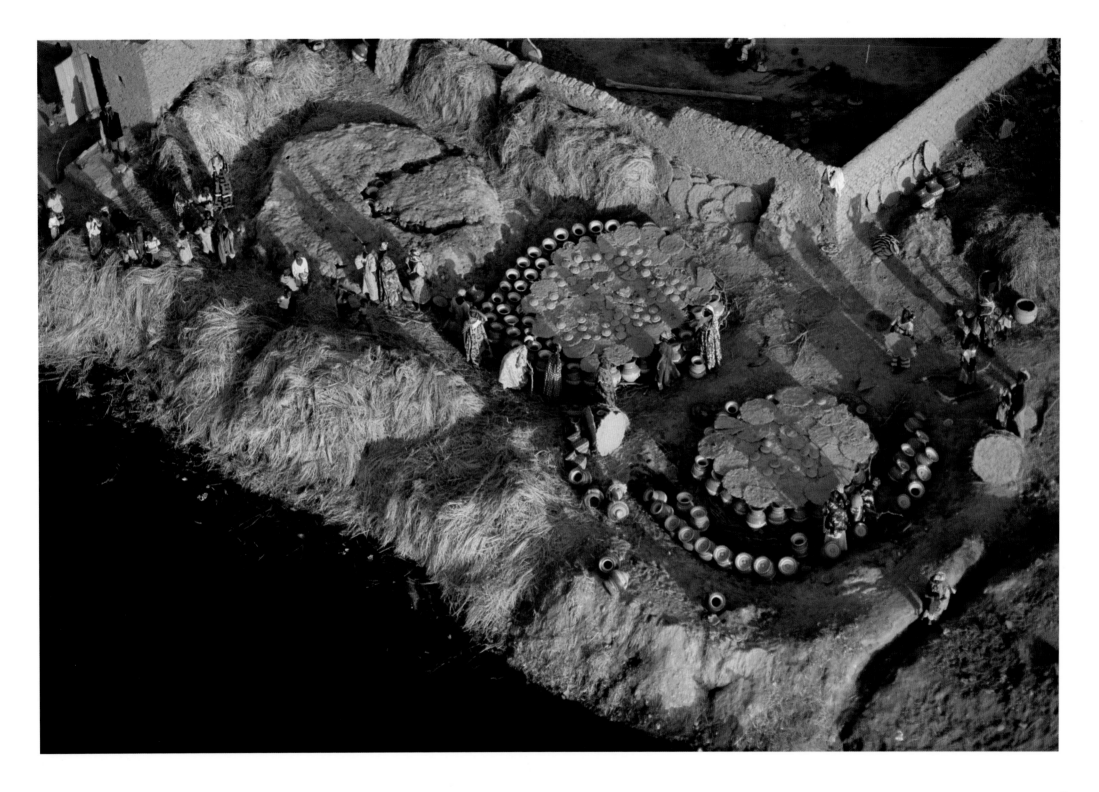

Firing water jars, near Mopti, Mali

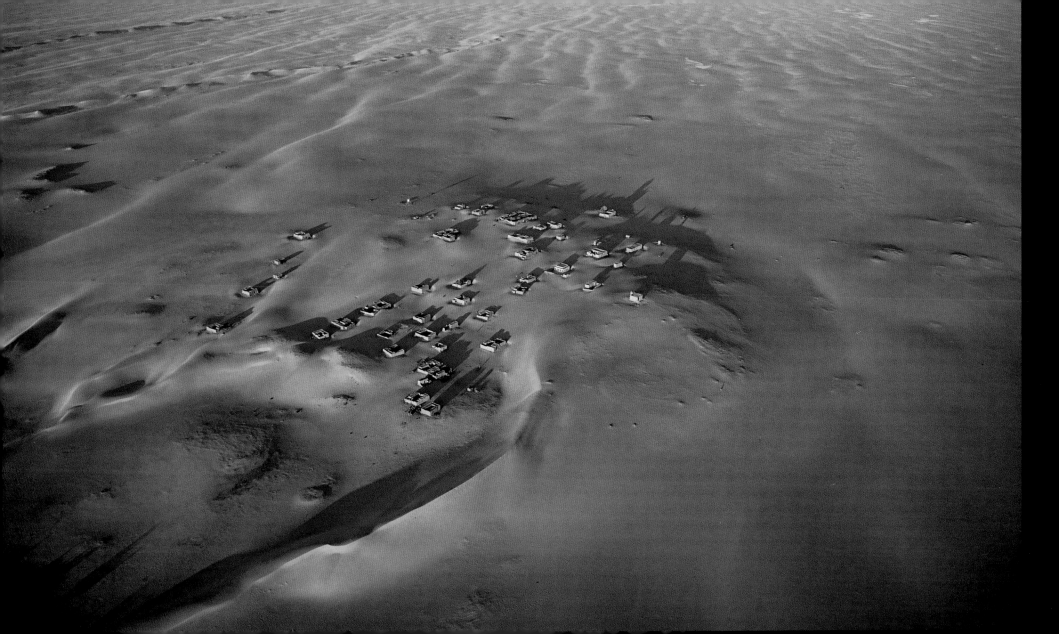

had just driven seven hours north from Timbuktu to reach this small desert hamlet in northern Mali. It was 2004, and I was here on assignment for *National Geographic* to photograph the salt caravans of Mali, which carry salt from the deposits of Taoudenni to Timbuktu via camel across the western Sahara in November. Araouane is the only regular stopping point for the caravans on their long journey and the perfect place to photograph a way of life on the edge of the desert.

For a number of years leading up to our arrival, northern Mali had been plagued by uprisings of the local Tuareg nomads against the central

ry and kidnappings of foreigners. For this reason, we decided to hire a desert guide who could help us with security in Araouane and eventually take us up north to Taoudenni. In Taoudenni, it was said, laborers work in slavelike conditions for the Tuareg and are paid in little more than food and water to dig salt out of an ancient lake bed in the middle of the Sahara. This is a lawless area where the government has no influence over radicalized Islamic bandits who move freely across the borders of Algeria and Mauritania. Our journey was risky, but if we could work out our security situation and conserve fuel, we just might be able

to ge... ... photos of this most remote corner of Africa.

I was traveling with Alain Arnoux, a world-champion pilot of motorized paragliding and a companion of mine on many expeditions. We had two cars that we'd hired in the capital, Bamako, but one of our drivers refused to go north, fearing for his safety, and the other driver was nervous about the prospect. Before leaving for Araouane, we checked about security with the gendarmes near Timbuktu, who recommended that we go with northern Tuaregs. So we hired a young Tuareg guide named Omar, who wasn't the first guide candidate we had met, but he spoke perfect French and English, and was very bright and flexible. He seemed more knowledgeable than the first candidate, old Ahmed, who was more interested in negotiating his fee and prices for the cars than in figuring out where we should go and what we might find.

By 8 AM the next morning, Omar had five cars parked in front of our hotel from which to choose. It then took six hours to negotiate prices, load the cars, install the radios, and buy spare parts and fuel. There were further delays after our remaining driver declared that the four-wheel drive on his car no longer worked and would need an expensive repair that would take many days. Alain, a master in the art of Afro-engineering, checked the car and discovered that it was perfectly fine, revealing the ruse of a driver who hadn't wanted to go north all along, and

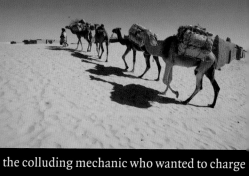

the colluding mechanic who wanted to charge large fee for a faked repair. We finally left aroun 2 PM with full tanks and 680 liters of extra fuel i back. It was tough driving on soft sand, and a many points the tracks disappeared altogethe but we made some progress after Alain relieve our incompetent driver before he could bur up the clutch in soft sand. Along the road from Timbuktu, the great caravan route was nothin more than a sandy track through grass and thi scrub. That is, until we reached Araouane. Her we found some thirty low mud homes half bu ied in a sea of bare sand. Omar checked in wit the headman of the village, who had heard w were coming via Ahmed who had called ahea on the town's shortwave radio.

The salt caravan season was just begin ning, and we were told one was expected from the south the following day. Alain prepared th engine of my motorized paraglider after w moved our vehicles to an abandoned tourist cam at the edge of town and had lunch under the mea ger shade of its thorn trees. Omar said he didn'

feel well, a problem with his liver, and wandered off to town while I prepared for a scout flight in my paraglider.

I went for an exploratory flight that afternoon. From the air, I discovered that just a few miles out of town in every direction there was abundant vegetation. It seemed that caravans of camels resting in Araouane had eaten every bush and blade of grass within a day's walk of the town's three wells, leaving the town surrounded by sand dunes. While I was exploring this surreal landscape and waiting for the perfect light for pictures, Alain came on my flight radio with an urgent request for me to land—there was a

problem with Omar. I ignored the request, as a flight over Araouane was too rare an opportunity to drop for a personnel problem, but when he repeated the urgency of the situation and told me that the whole town was upset, I realized I had to come down to help sort out the situation.

What I found was a group of elders from Araouane in our camp, demanding that we do something about Omar. They said he had lost his mind, taken off all his clothes, and was wandering around town and into houses totally naked. This was wildly unacceptable behavior in an isolated, pious Muslim town, and they asked us to either tie him up like a goat or lock him up in one

of our cars for the night. When I refused, they replied that somebody in town was likely to shoot him during the night, and it would be my responsibility since I had brought him here. So I set out in search of Omar and found him huddled in an abandoned home half filled with sand. He wore nothing but his underwear and had a distant look on his face and a nervous tic that kept his head twitching from side to side. He seemed to be in some kind of a trance and couldn't understand anything I said, although he did seem to hear me. I couldn't tell what the problem was, but he seemed afraid of something. Apparently, he had refused all offers of food and drink since lunchtime, and this had me worried, since the midday temperatures were higher than 104-degrees Fahrenheit. The village men were agitated and outraged by my refusal to comply with their wishes—they wanted this crazed, naked man out of their town, and I can't say I blamed them. I couldn't imagine what had caused Omar to react so strangely so suddenly, but I needed to continue my work. So we left Omar with a blanket for the night and hoped for the best.

The next morning, I took off at sunrise in my paraglider to find the promised camel caravan camped just outside of town. After an hour or so, I landed to find that Omar's condition remained the same. There was no way to evacuate him except to drive him all the way back to Timbuktu, which would use up so much time, fuel, and car money that we would never be able

to reach the saltworks of Taoudenni. We spent an hour or two on my satellite phone trying to reach someone from his family in Timbuktu and to find out the medical nature of his problem, but could reach no one who had an answer. But then someone suggested that old Ahmed, the guide we had rejected, had put a spell on Omar, and that he had told this to the people in Araouane by shortwave radio before our arrival. This seemed preposterous at the time, as I couldn't accept the idea of a voodoo curse while running a modern expedition in the middle of the Sahara. But whatever the nature of Omar's problem, it was clear that we had to return or he would die.

It was difficult to get him into the car and secure him with a seatbelt, and nobody wanted to sit next to him, especially the Malians who were repelled by his strange behavior. Finally, our interpreter, Petit Moussa, agreed to do it. He gave Omar sips of water from a damp cloth, and about halfway back, Omar fell asleep and his neck twitches stopped. We pulled into Timbuktu after dark, and dropped Omar at home, where he started drinking water. I never saw Omar again, but I heard from his friends at the hotel that he was continuing to regain his senses. It was never clear to us what befell Omar. But later I began to realize that he probably had, indeed, succumbed to Ahmed's subterfuge, and I had to try to accept that our expedition had been forced to a halt by a voodoo curse. Perhaps black magic works if you believe in it, and it seems Omar was a true believer. ◼

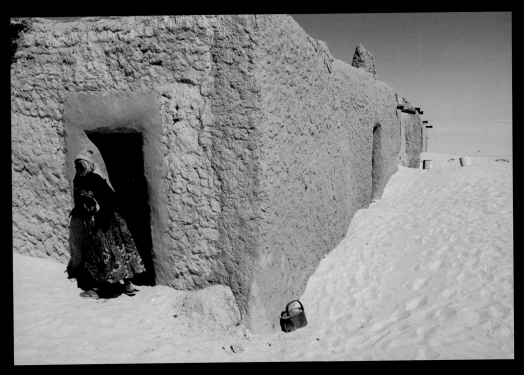

Village chief's house in Araouane, Mali

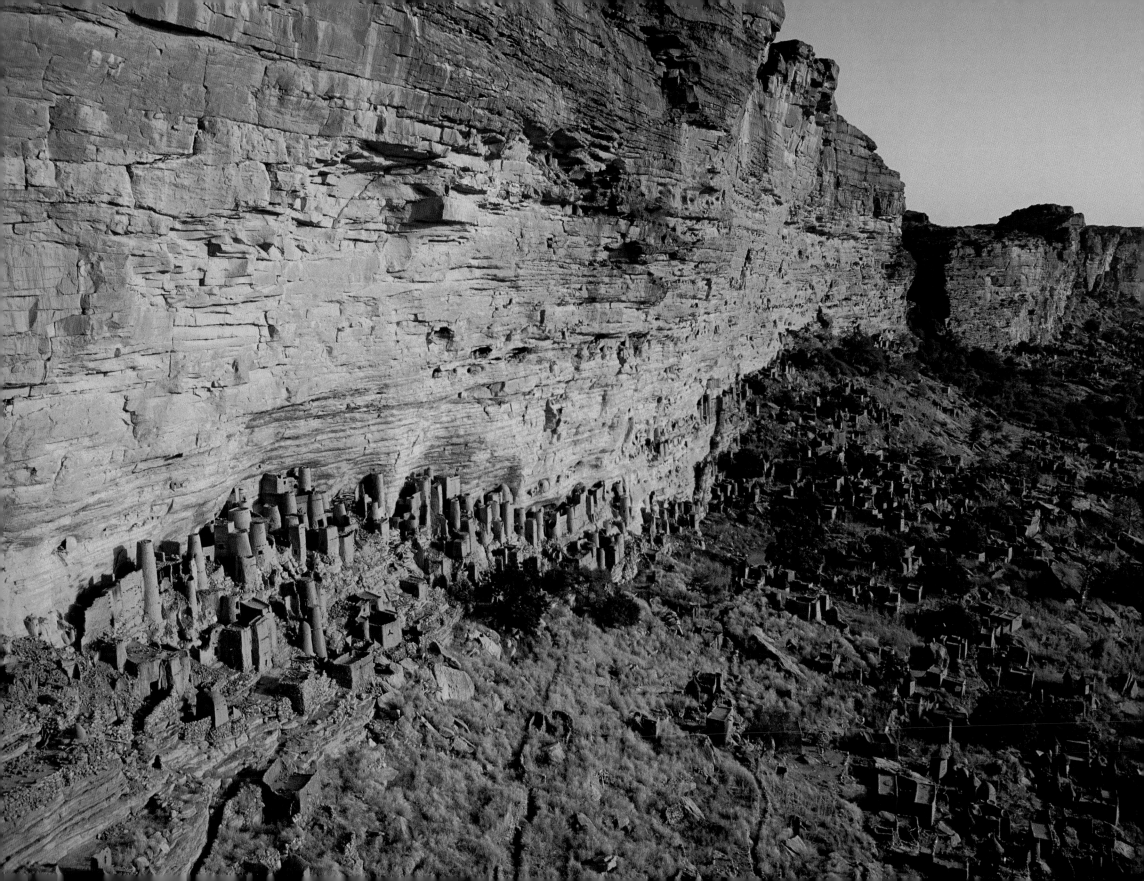

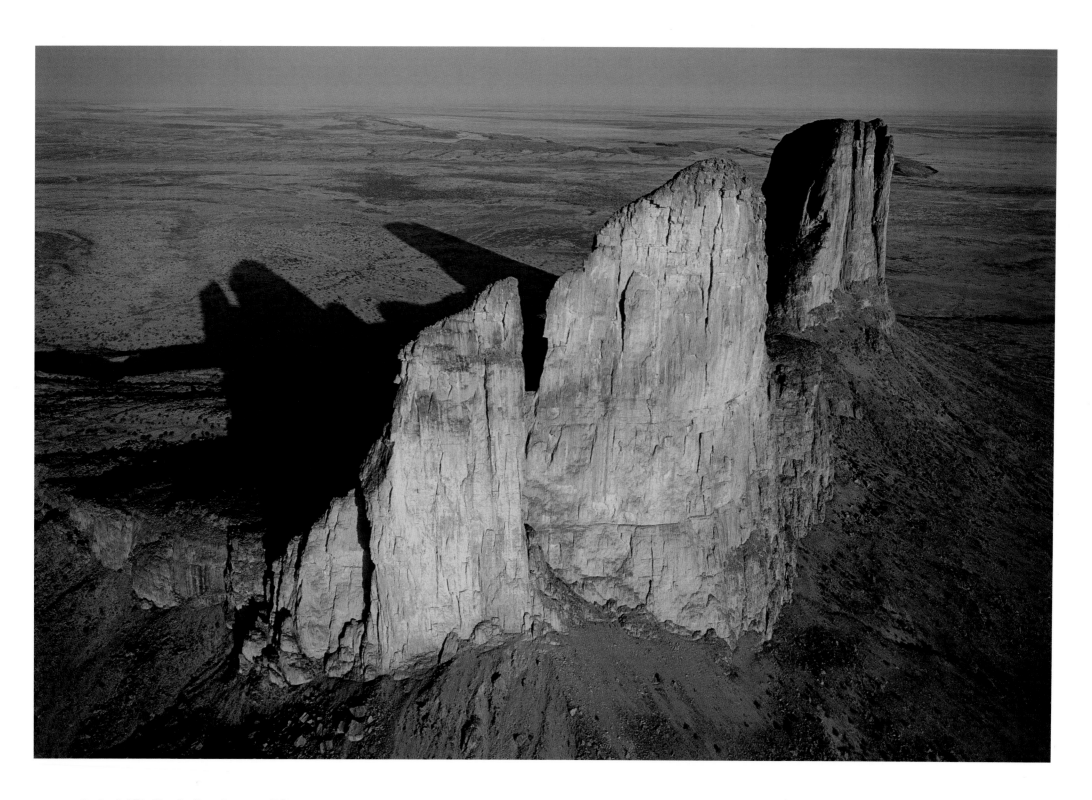

OPPOSITE: Abandoned cliff dwellings, Bandiagara Escarpment, Mali
ABOVE: Hand of Fatima, Hombori, Mali

75

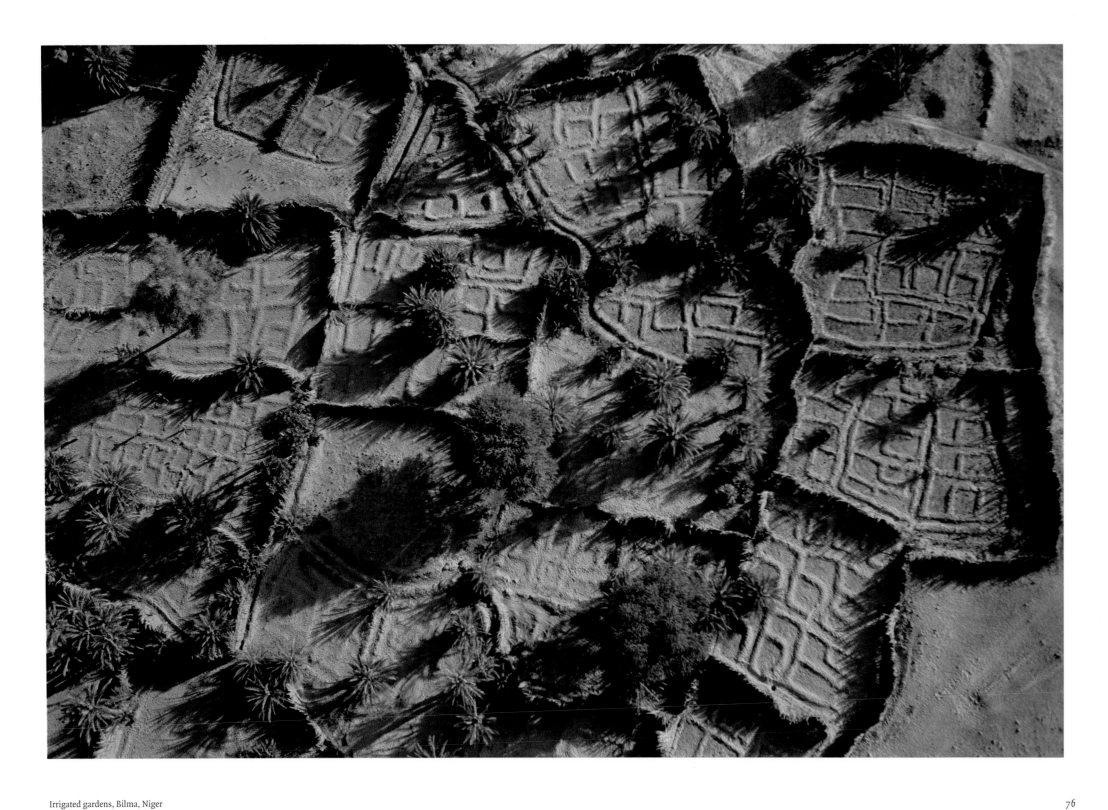

Irrigated gardens, Bilma, Niger

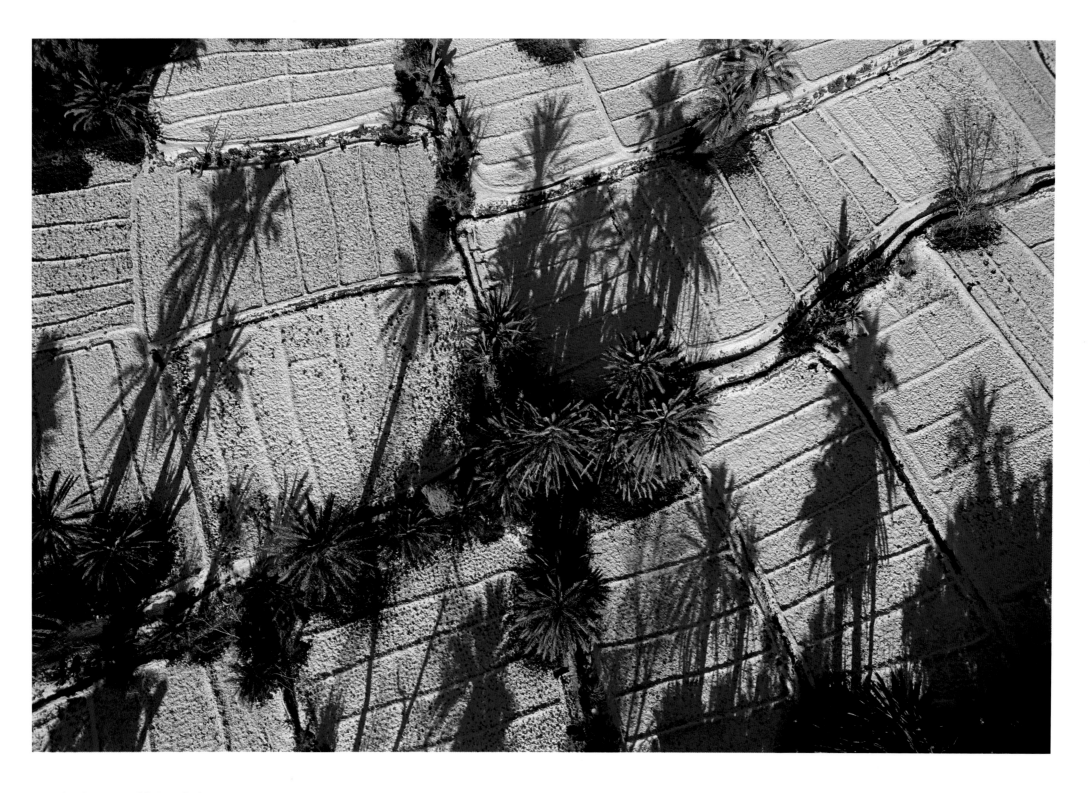

Date palms after a rare snowfall, Gorges du Ziz, Morocco

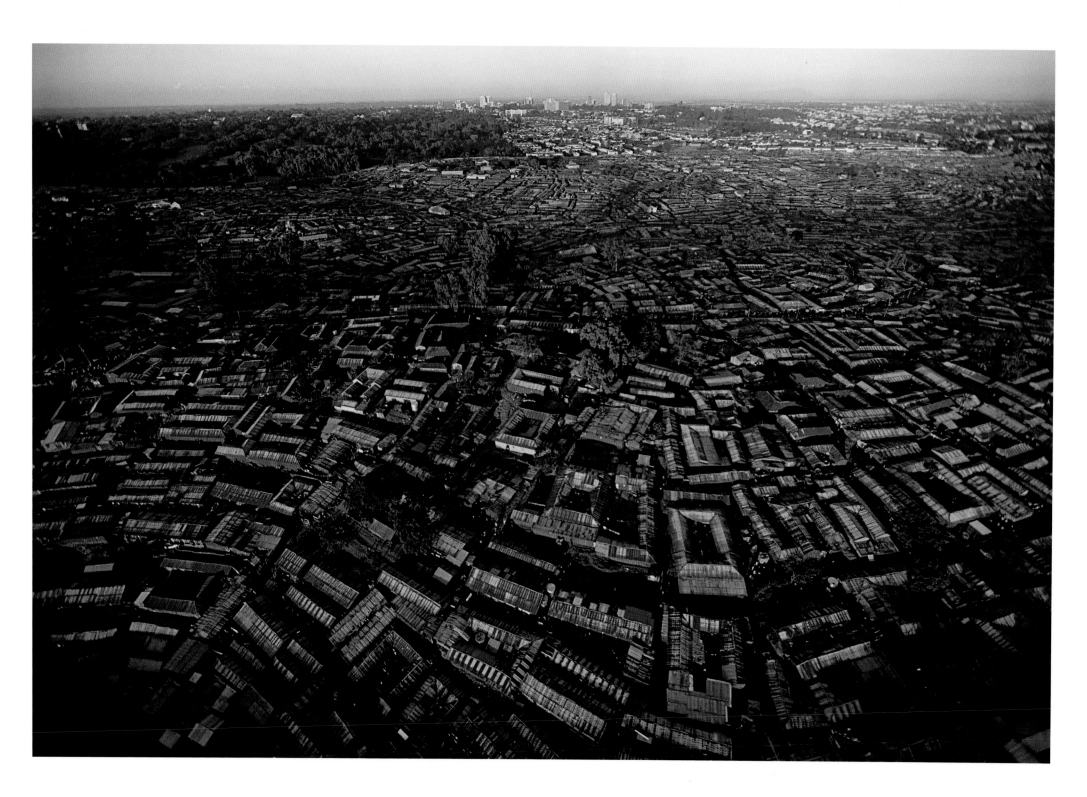

ABOVE: Kibera slum, Nairobi, Kenya
OPPOSITE: Wind streets on the Ennedi Plateau, Chad
OVERLEAF: Sandstorm, Karnasai Valley, Chad

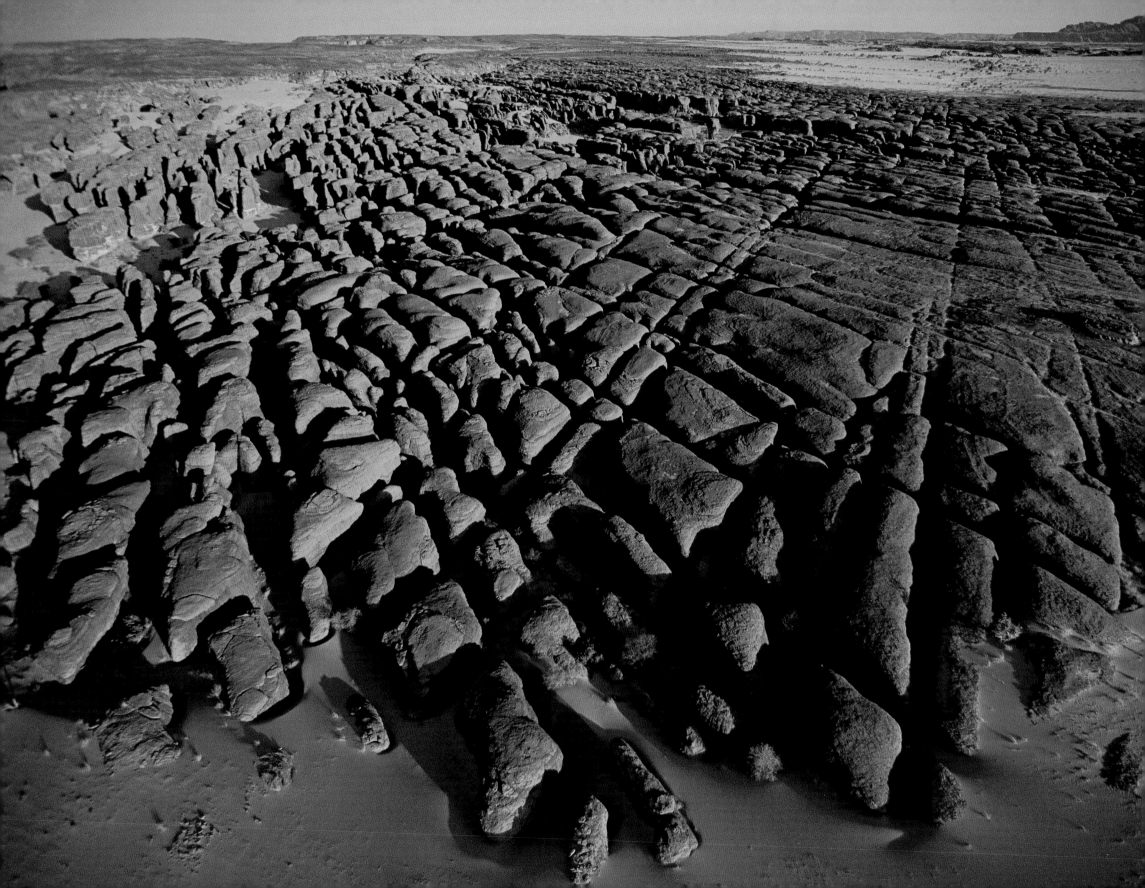

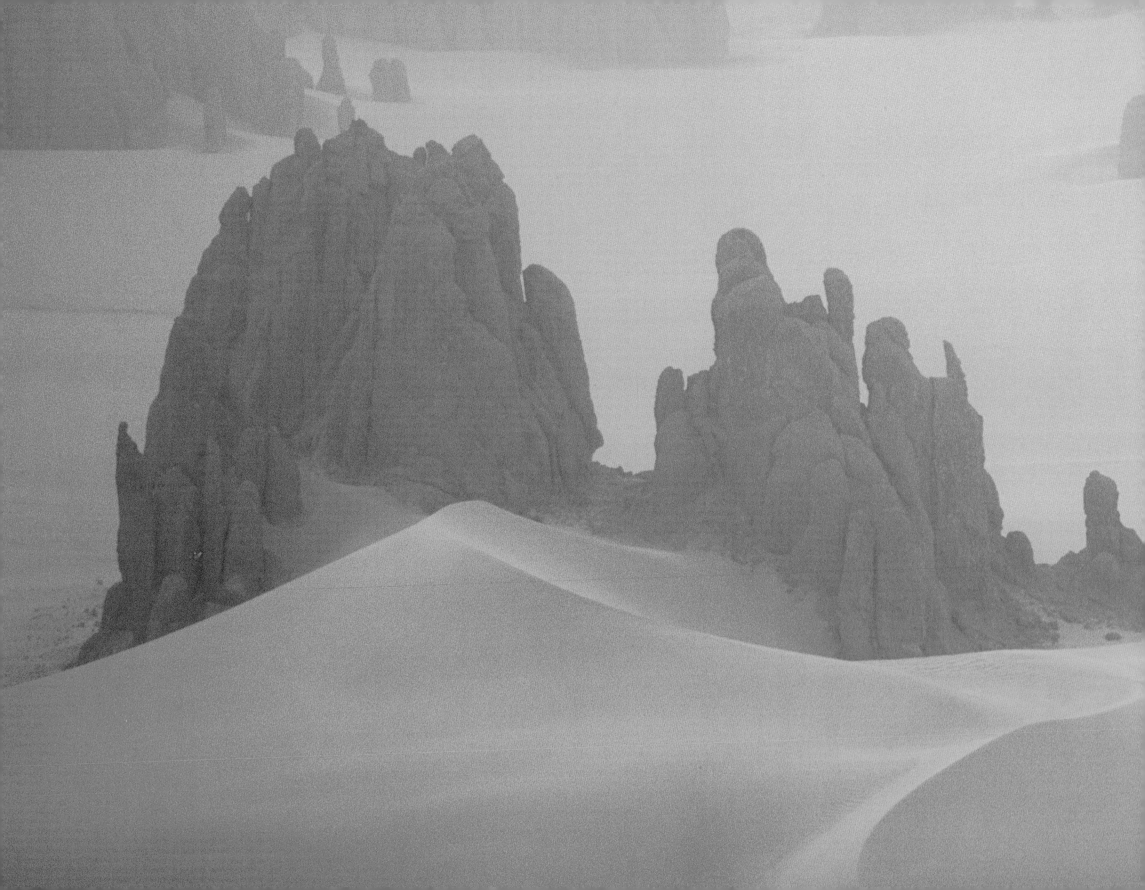

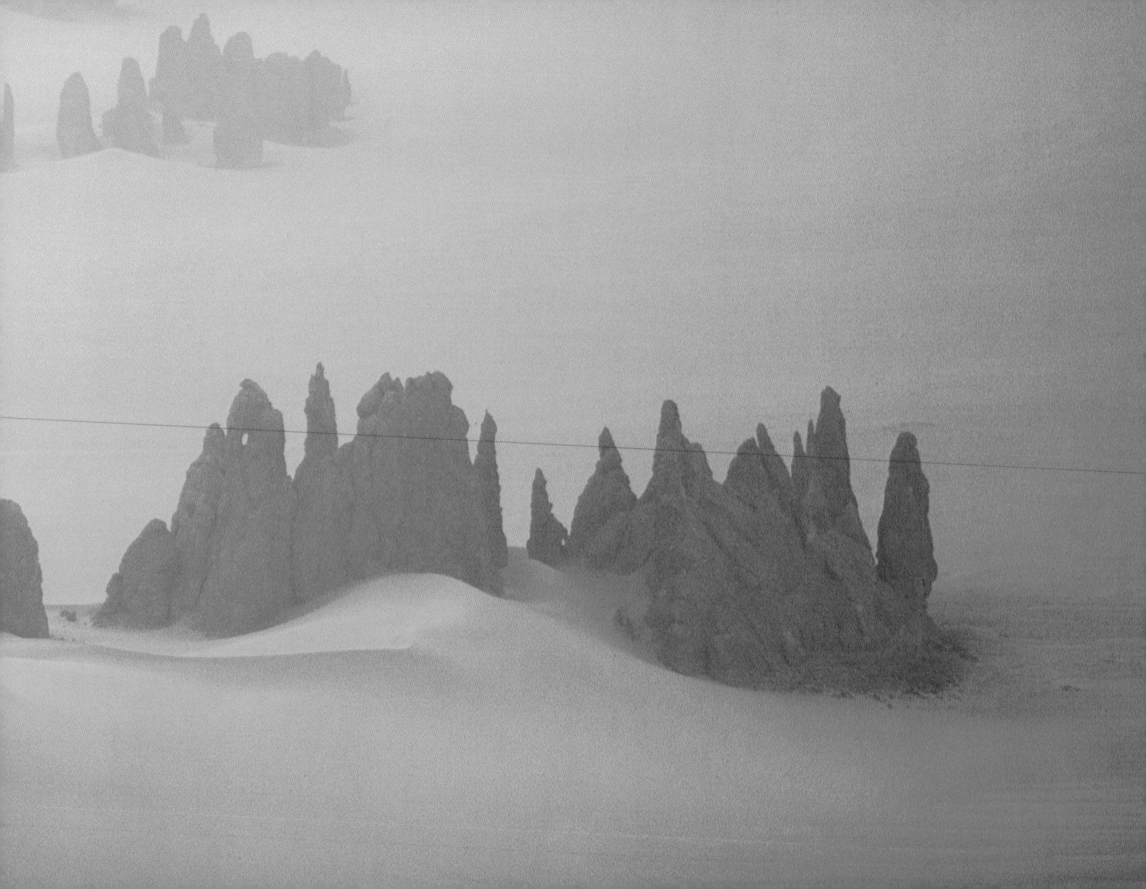

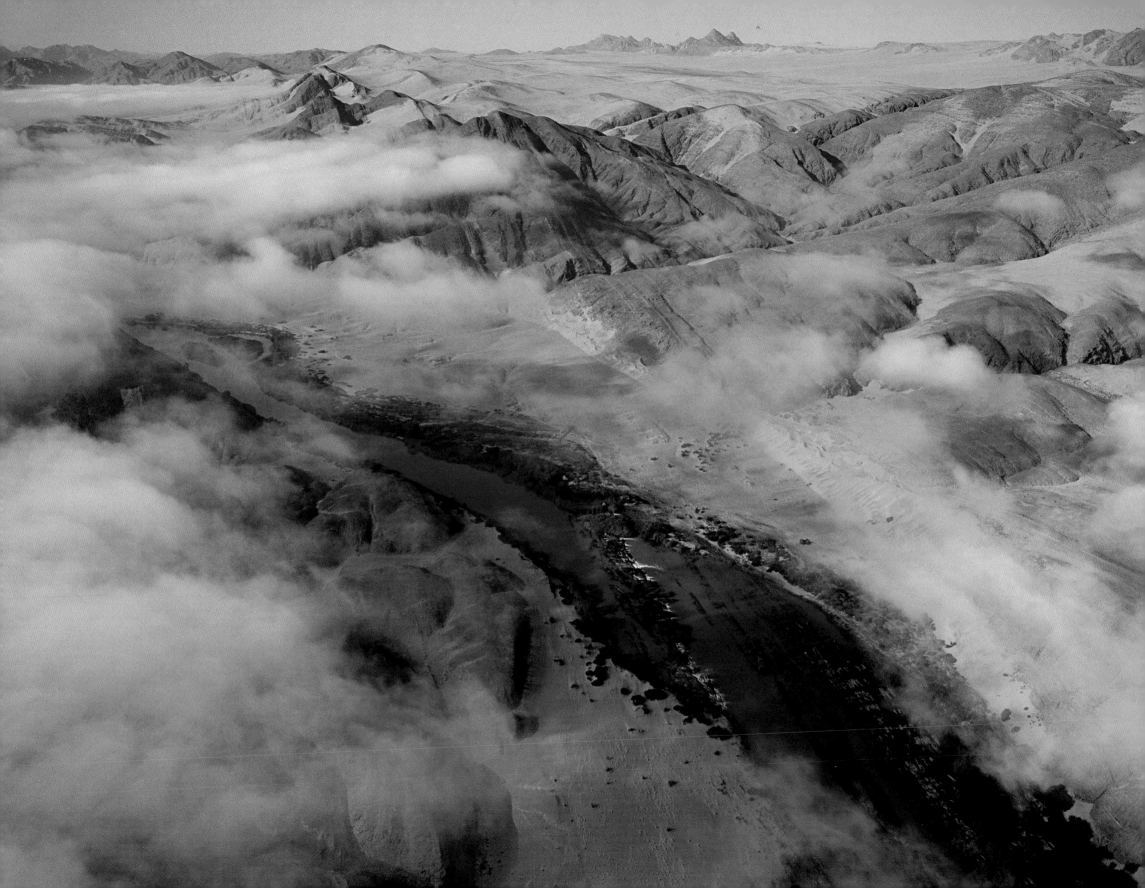

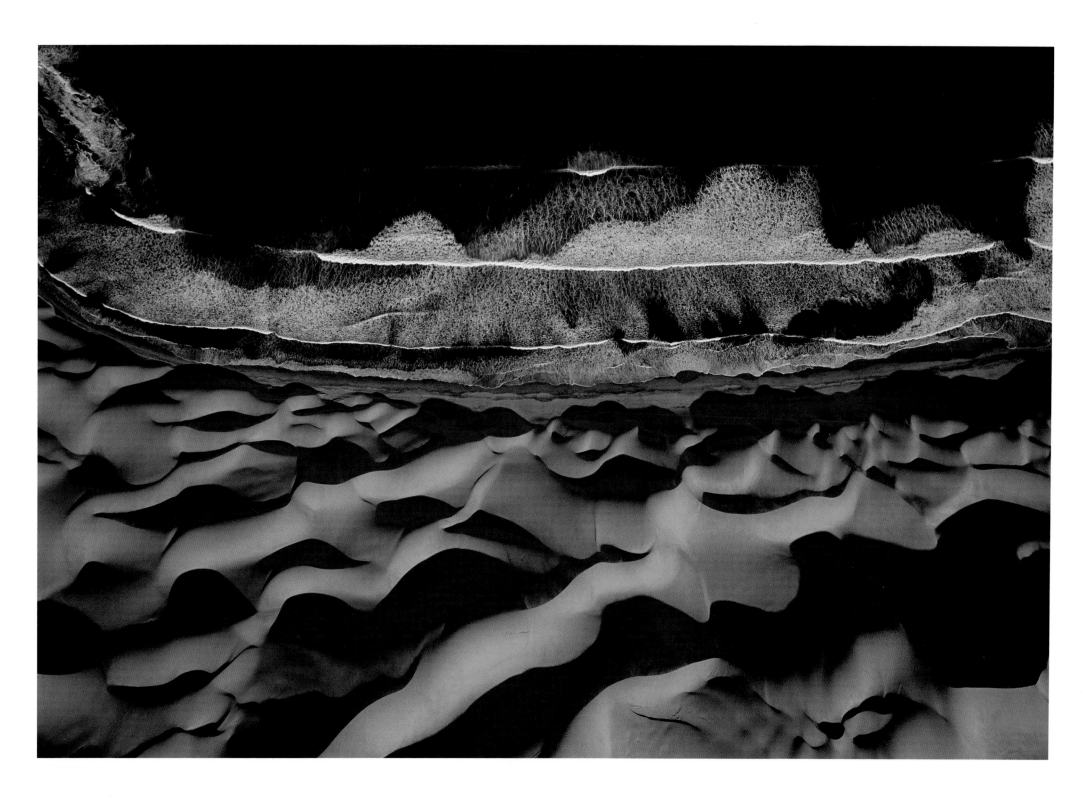

OPPOSITE: Coastal fog, Kunene River, Angola/Namibia
ABOVE: Skeleton Coast, Namibia

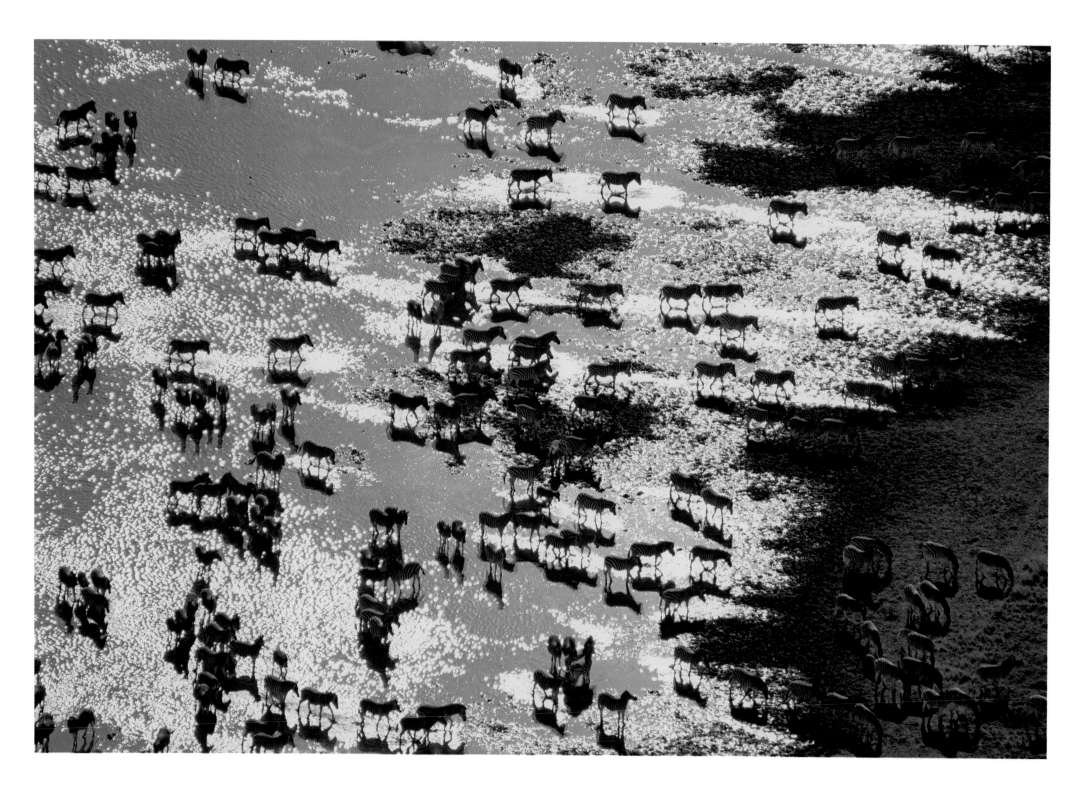

ABOVE: Zebras, Makgadikgadi Pans, Botswana
OPPOSITE: Freshwater flood, Okavango Delta, Botswana

84

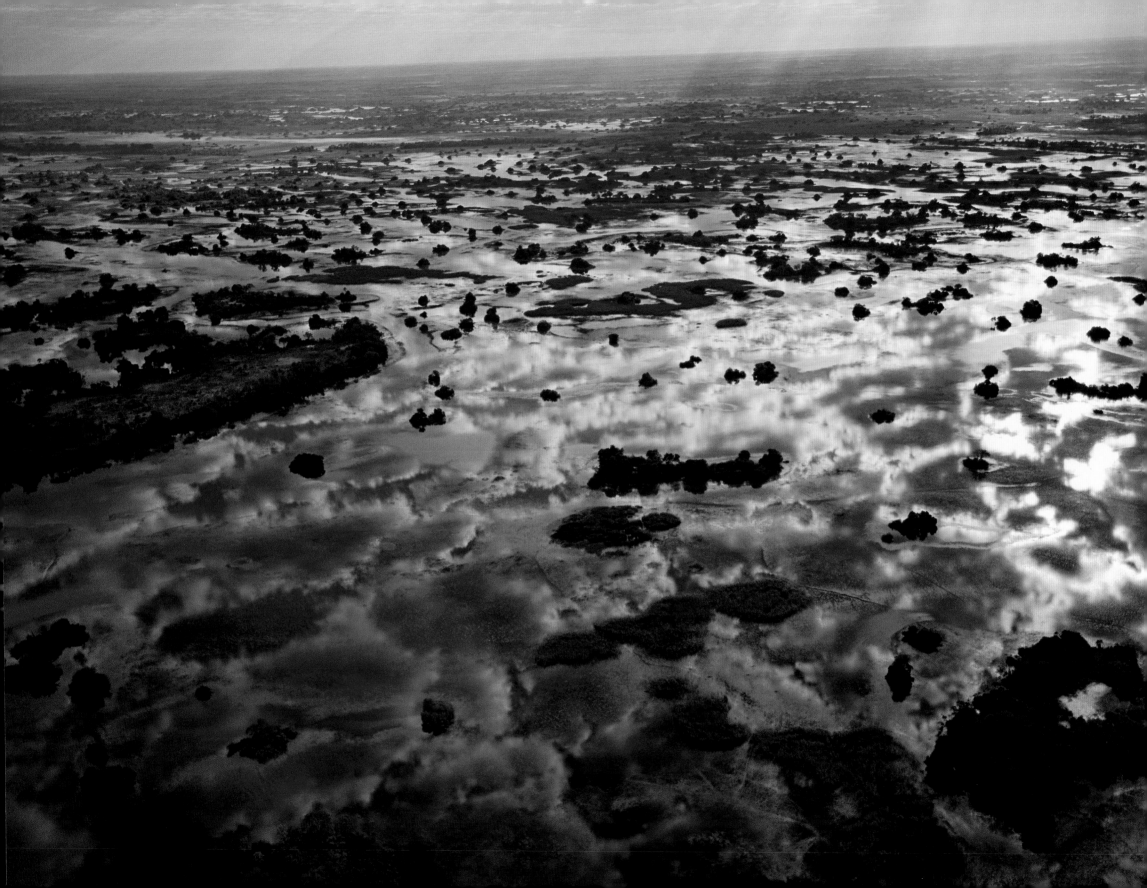

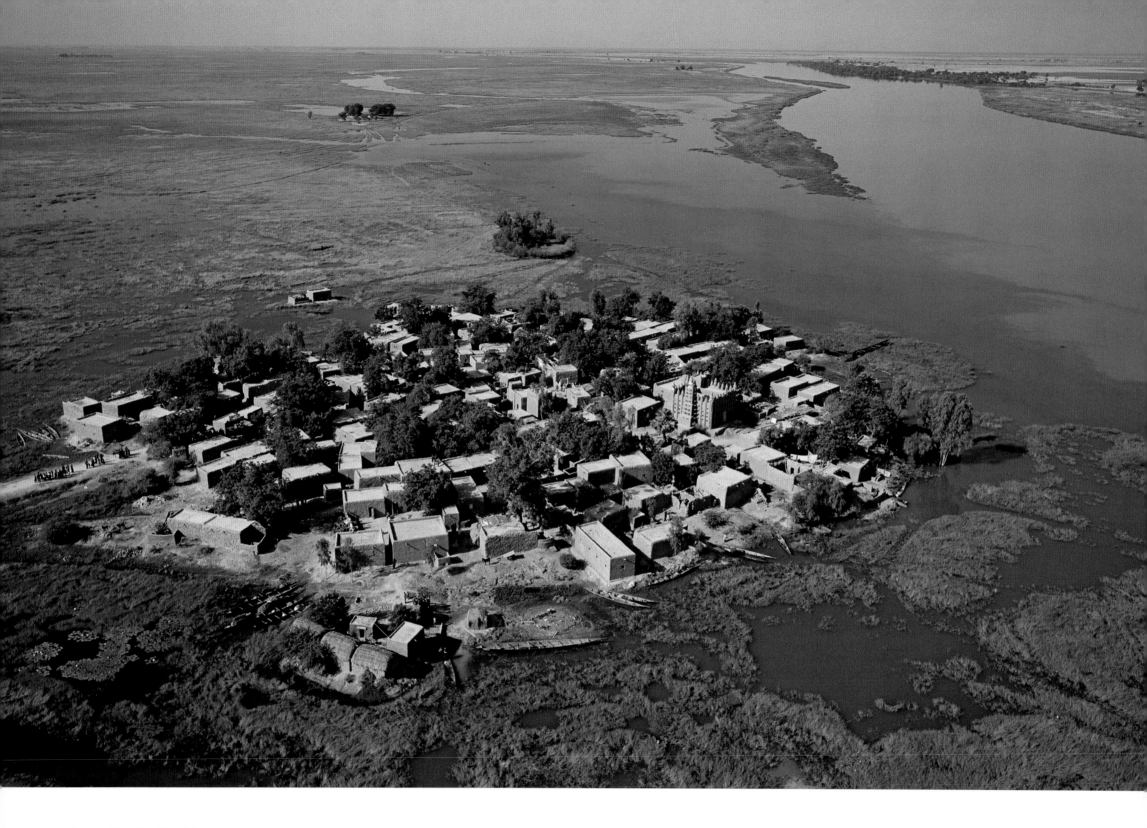

Goumina village, Niger River, Mali

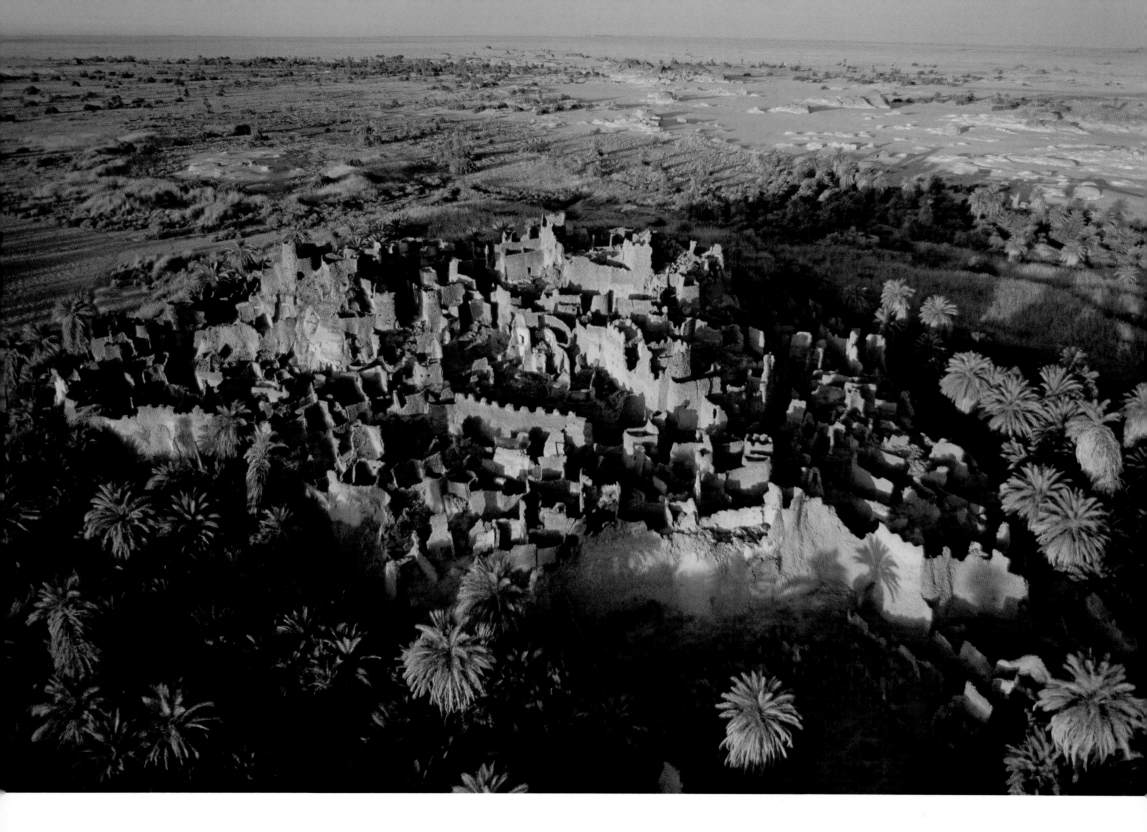

ABOVE: Ruins of Djado, Niger
OVERLEAF: Suburbs of Nouakchott, Mauritania

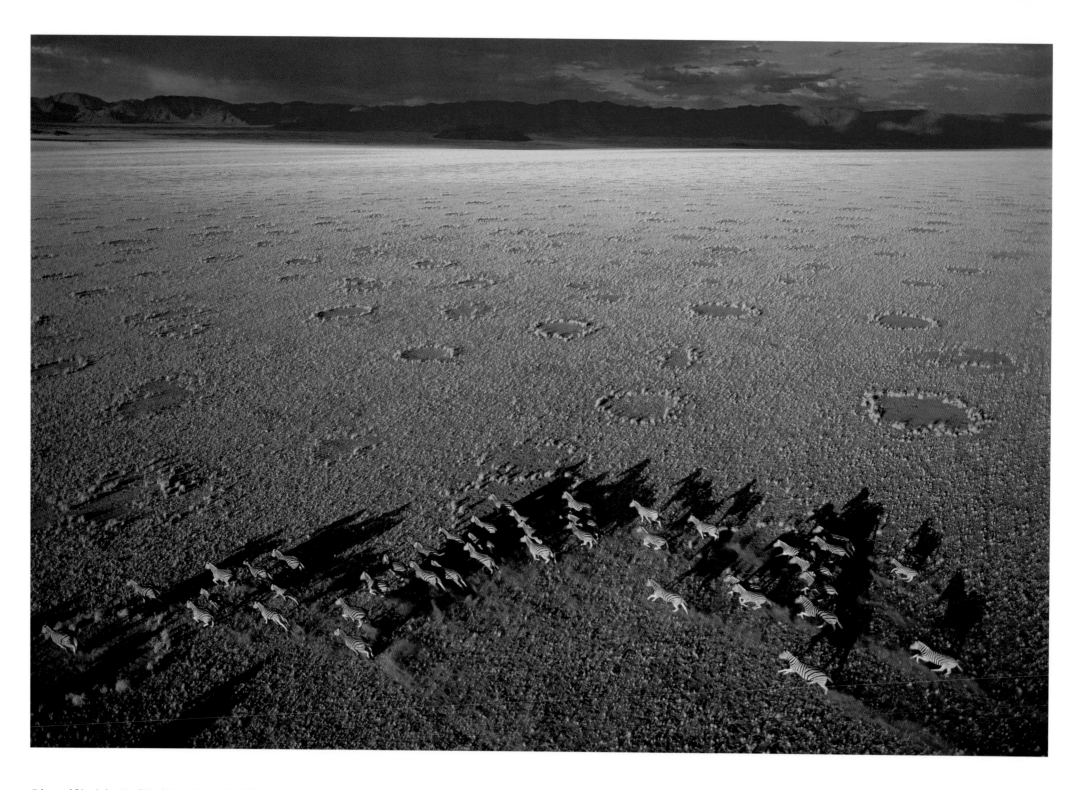

Zebras and fairy circles, NamibRand Nature Reserve, Namibia

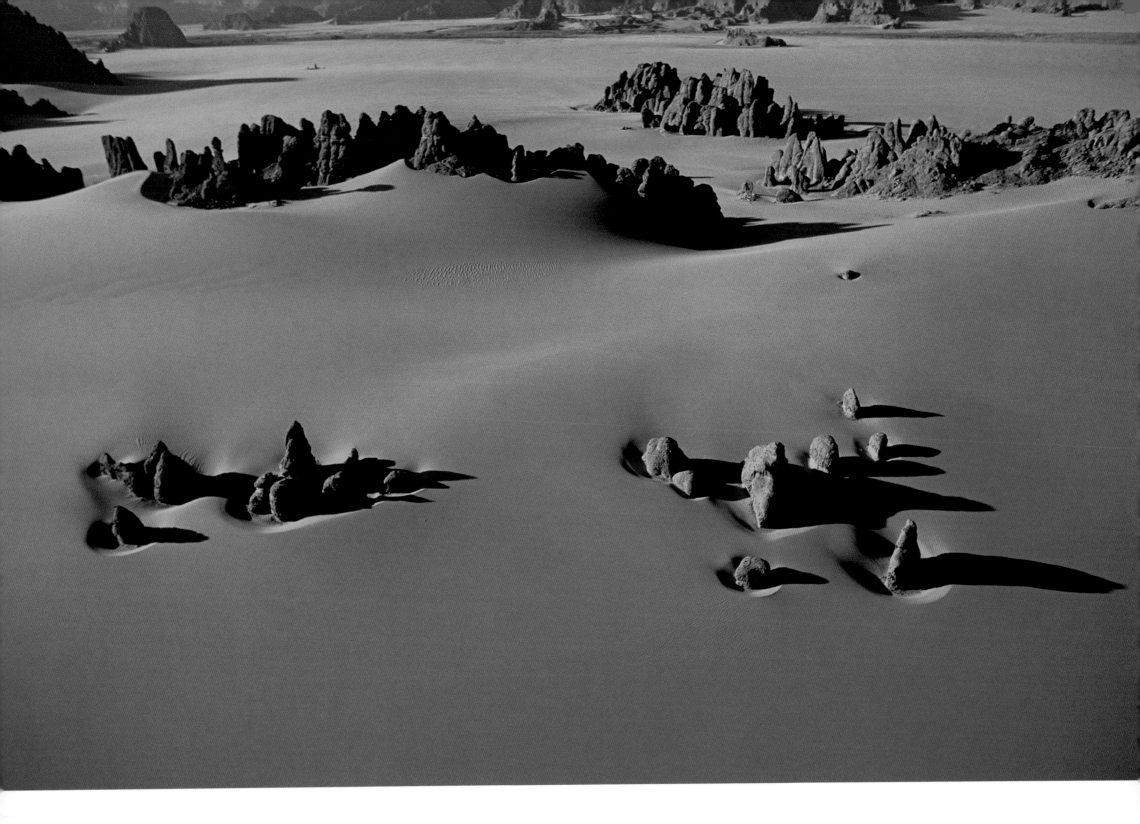

Karnasai Valley, Chad

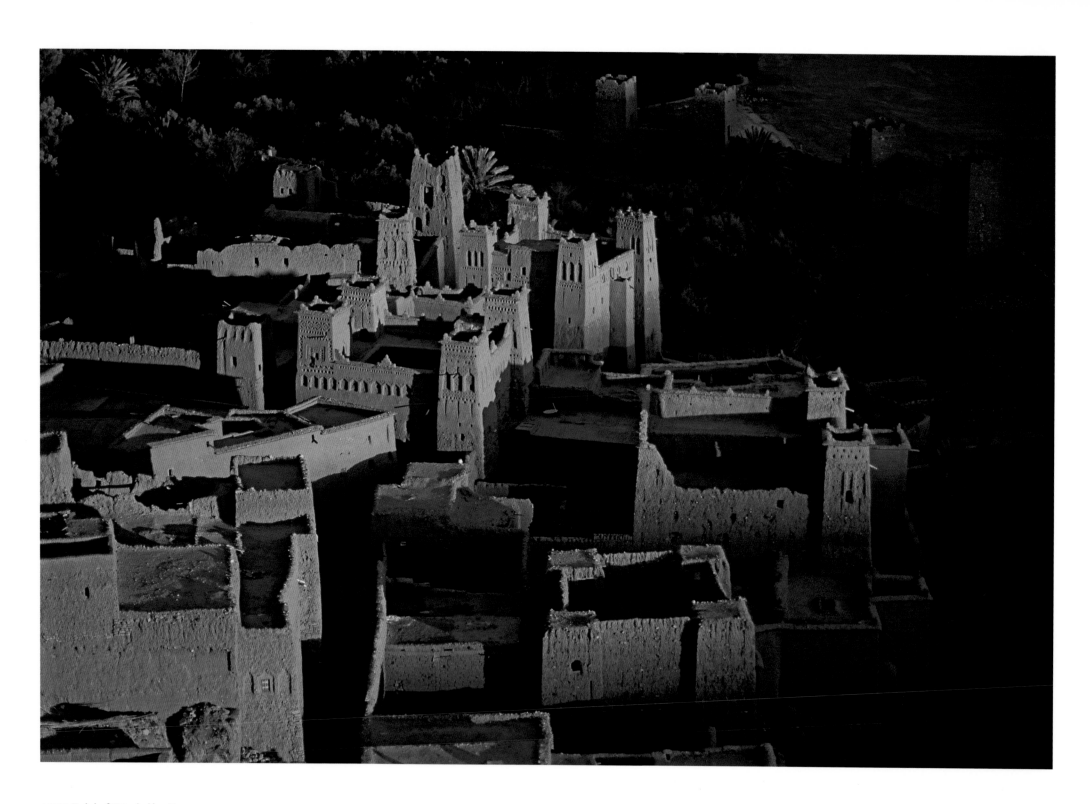

ABOVE: Kasbah of Aït Benhaddou, Morocco
OPPOSITE: Sandstone pinnacles, Karnasai Valley, Chad

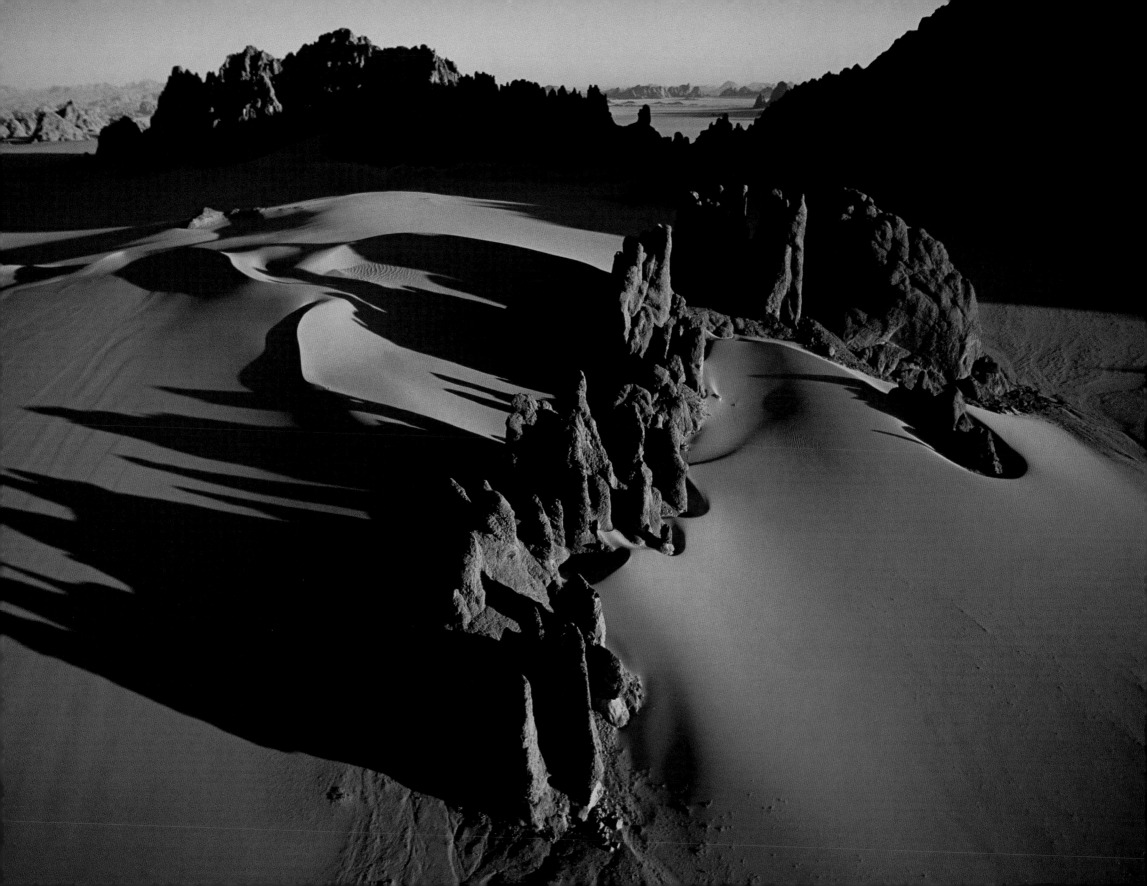

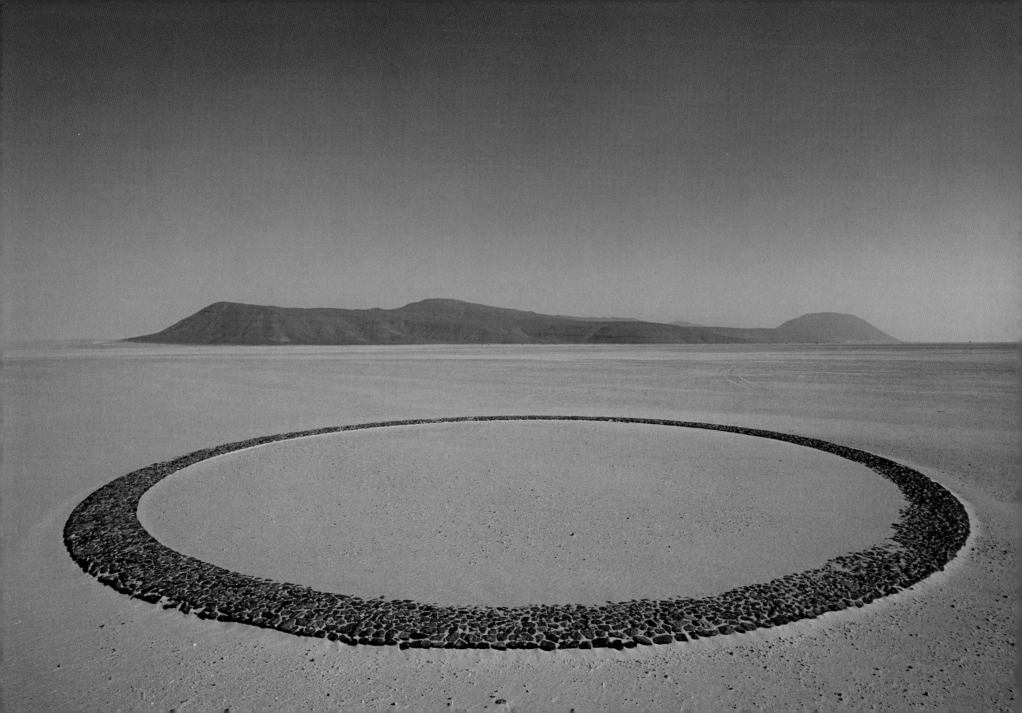

discovered an enigma in the library of Theodore Monod, where I was doing research for a *National Geographic* piece in 1997. The great naturalist had walked more of the Sahara than anyone, and even then, at the age of ninety-five, he still did field-work there and insisted on carrying his own pack. When we first met, he greeted me on the street outside his small office at the Museum of Natural History in Paris, stooped with age and quite formal in a three-piece suit. His office was absolutely stuffed with a lifetime of scholarship, and when the meeting was over he kindly allowed me

to explore his personal library of Africana. The mysterious find was an old photograph depicting a perfectly formed ring of stones set all alone in the middle of a flat expanse of desert sand. I had found it deep inside an obscure Italian journal about rock art. Monod had never seen this ring of stones, and when I tracked down the Italian explorer who had taken the photo, he suspected that it was a pre-Islamic grave but couldn't remember the location other than that it was in Niger, on the west side of the Ténéré near Adrar Madet.

A month later I was in Niger trying to track this place down so I could photograph it. I showed the photocopy to Mohamed Ixa, who is one of the best Tuareg guides in the Sahara. Mohamed never ceased to amaze me with his intimate knowledge of the desert, and he also remembered seeing the stones, some ten years earlier, near the seldom-visited rock outcrop called Adrar Madet. We headed out there and drove around for about an hour on the sand flats, using the background silhouette of Adrar Madet for orientation, until we finally caught sight of something on the flat horizon. As we neared it, we were able to make out converging lines of flat stones oriented in a "V" shape. After some more searching, we found the circle. We had assumed it to be a pre-Islamic grave, as were most of the circles formed with rocks in that part of the Sahara, but something about this one was different. It seemed too perfect to have been made by Neo-lithic peoples. When we measured it, it turned out to have a width of about three feet and a diameter of about a hundred feet. And as we explored its environs, we came across empty five-gallon containers of American motor oil and the edge of an old wooden crate of camp supplies barely poking out of the windblown sand. Inside the crate were small empty cans of food with labels from the U.S. and Nigeria that seemed to date back to the 1930s or 1940s: Rath pork sausage, baked beans, tins of fish, and empty bottles of Canadian whiskey, bottled in 1942. On the side of the

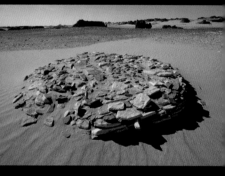

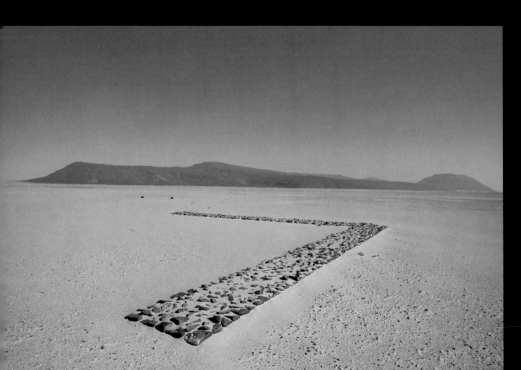

box, written by hand, was "Intendant #3, Fort Lamy," an address in the French colonial capital of what is now Chad. It was too windy to fly that afternoon, so we continued to explore the area by car, and found three other V-shaped rock piles. According to my GPS, the four of them were situated approximately a third of a mile distant and on a compass bearing exactly north, south, east, and west from the center circle.

I wrote Monod a letter about the circle but never received a reply. He died three years later. But then, some years after, I found out part of the answer in a little used bookshop in Paris, in a paperback by a Lieutenant-Colonel de Wailly of the French Army Airforce. The circle had been used as a refueling point for French military aircraft and had been established sometime in the 1930s. The French military had fuel brought out there by camel caravan once a year, two fifty-liter drums per camel, and buried them along with other supplies in the sand. Pilots would land their biplanes on the naturally firm and flat surface on the downwind side of Adrar Madet, refuel, and then overnight there before taking off in the cool calm air of the following morning. What an amazing experience it must have been to be the first to explore that pristine terrain from the air, and share bottles of Canadian whiskey under the stars of a clear desert sky. ⊠

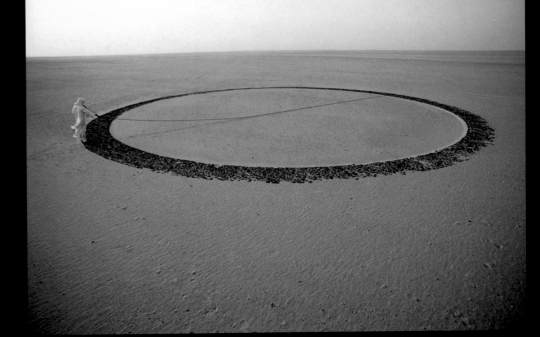

NEAR RIGHT, ABOVE AND BELOW: French military pilots at Adrar Madet in the 1930s
FAR RIGHT: Mohamed Ixa measuring the ring at Adrar Madet

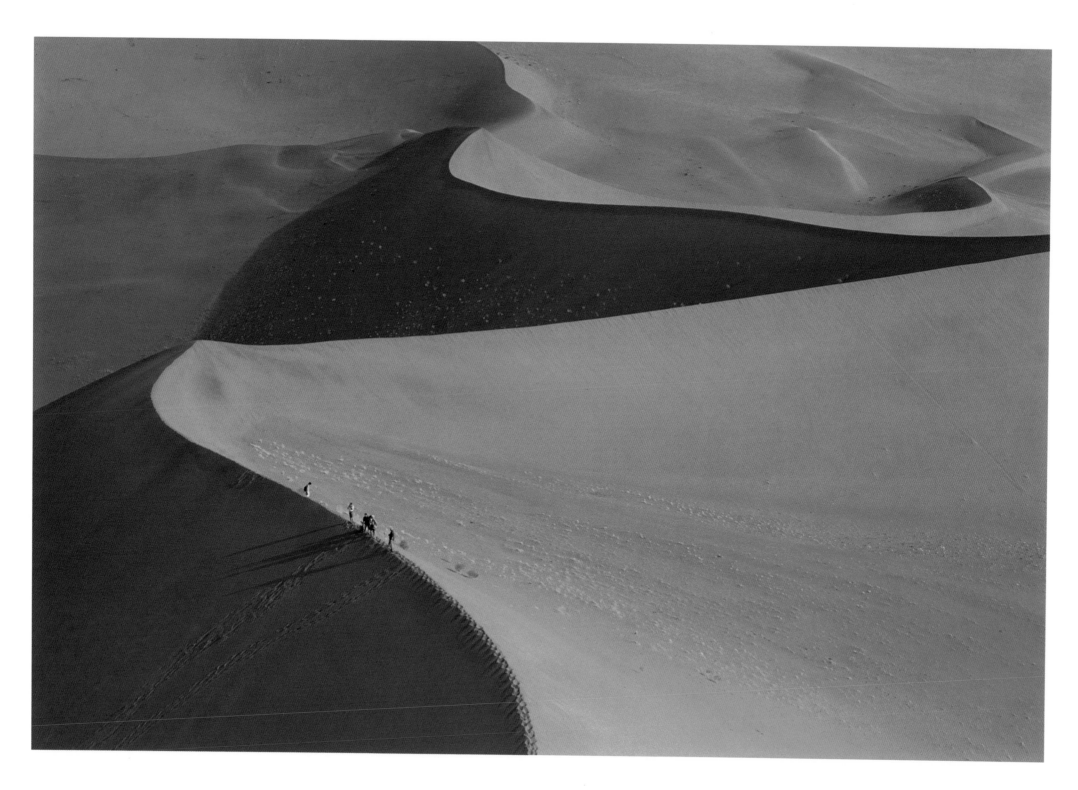

Climbing the megadunes, Sossusvlei, Namibia

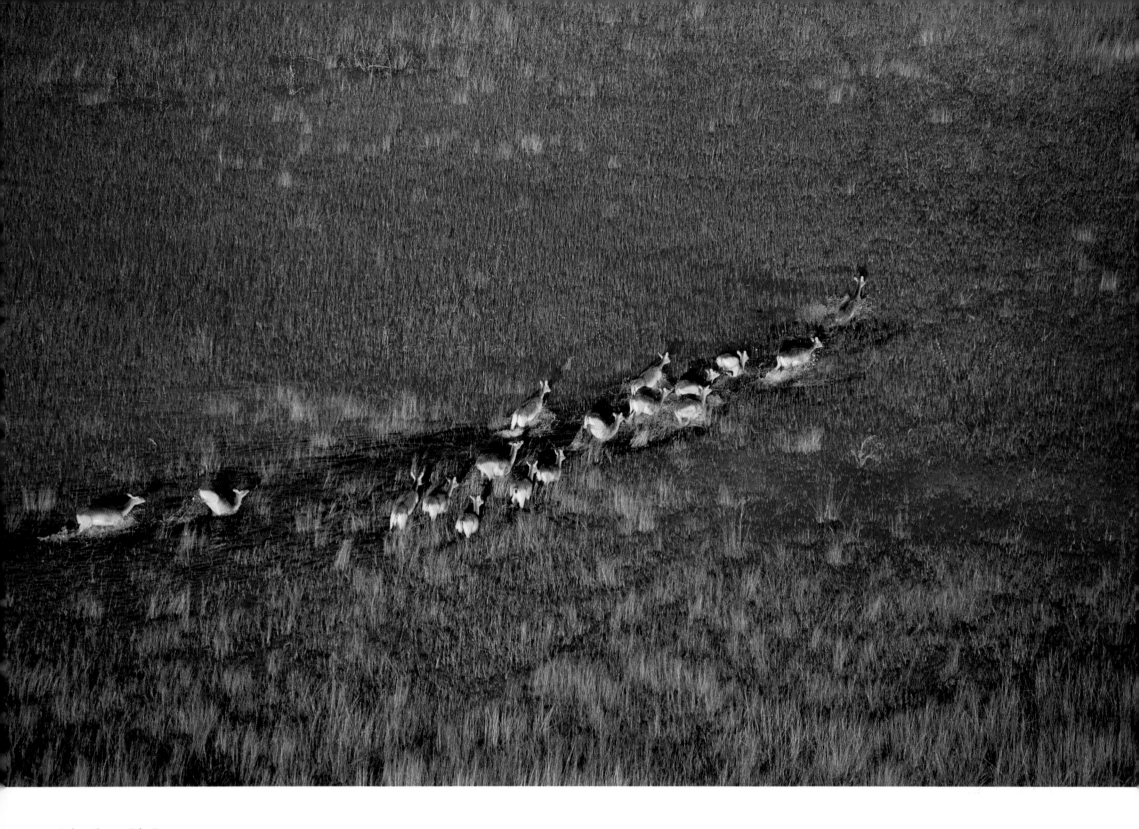

Lechwe, Okavango Delta, Botswana

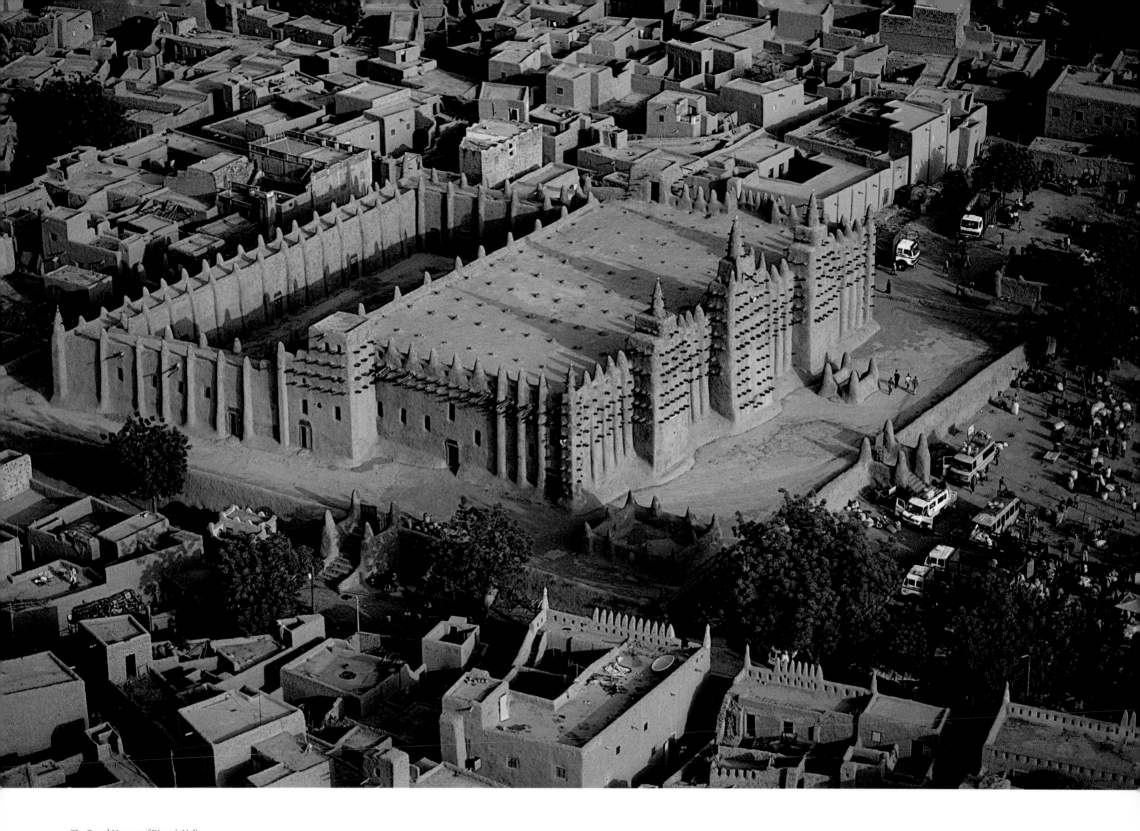

The Grand Mosque of Djenné, Mali

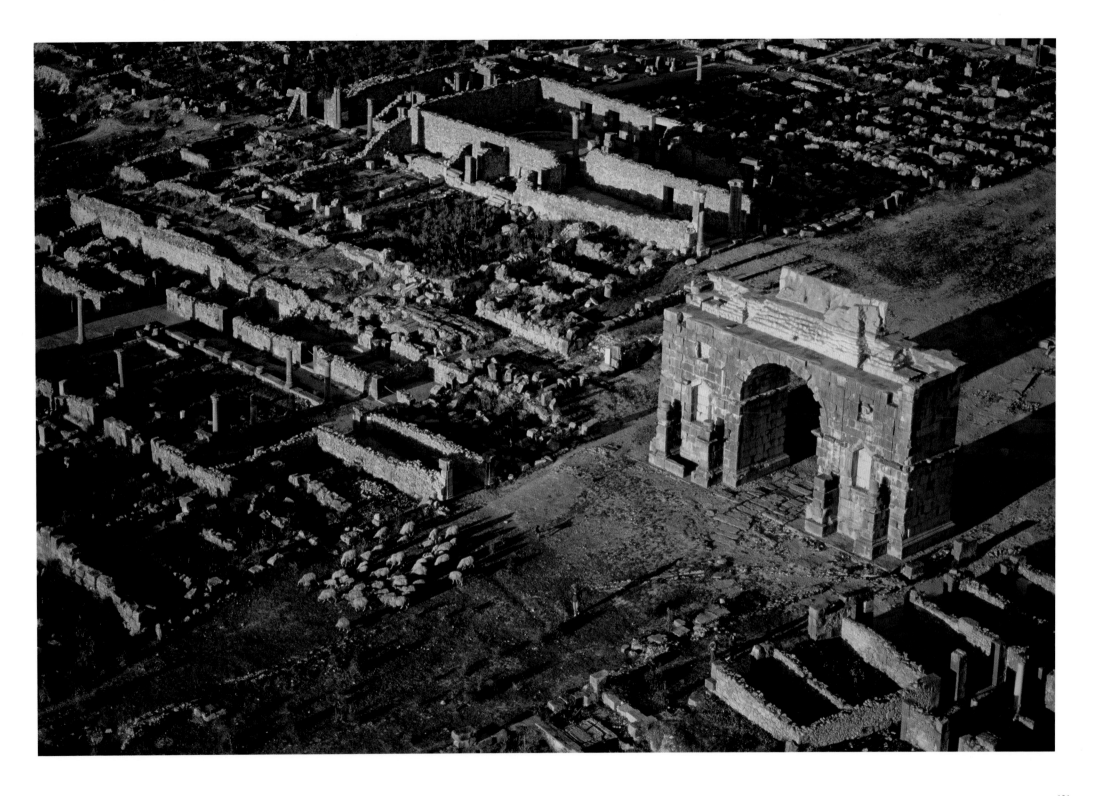

Volubilis, near Meknes, Morocco

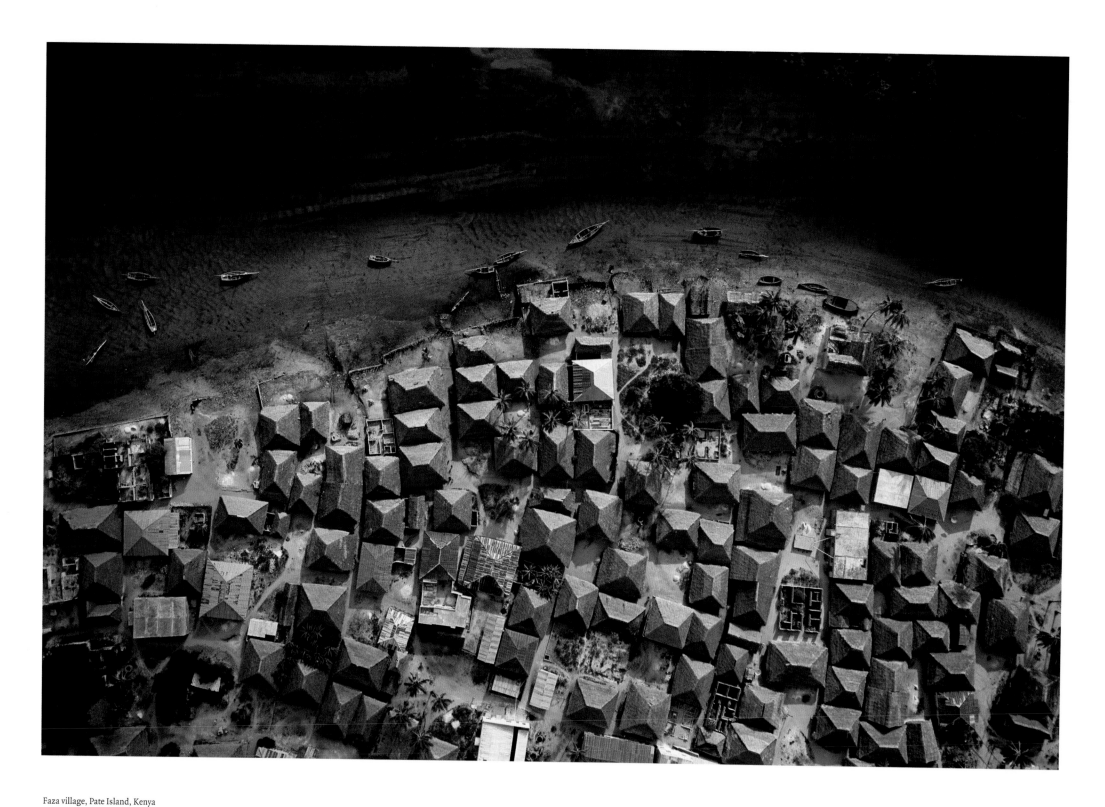

Faza village, Pate Island, Kenya

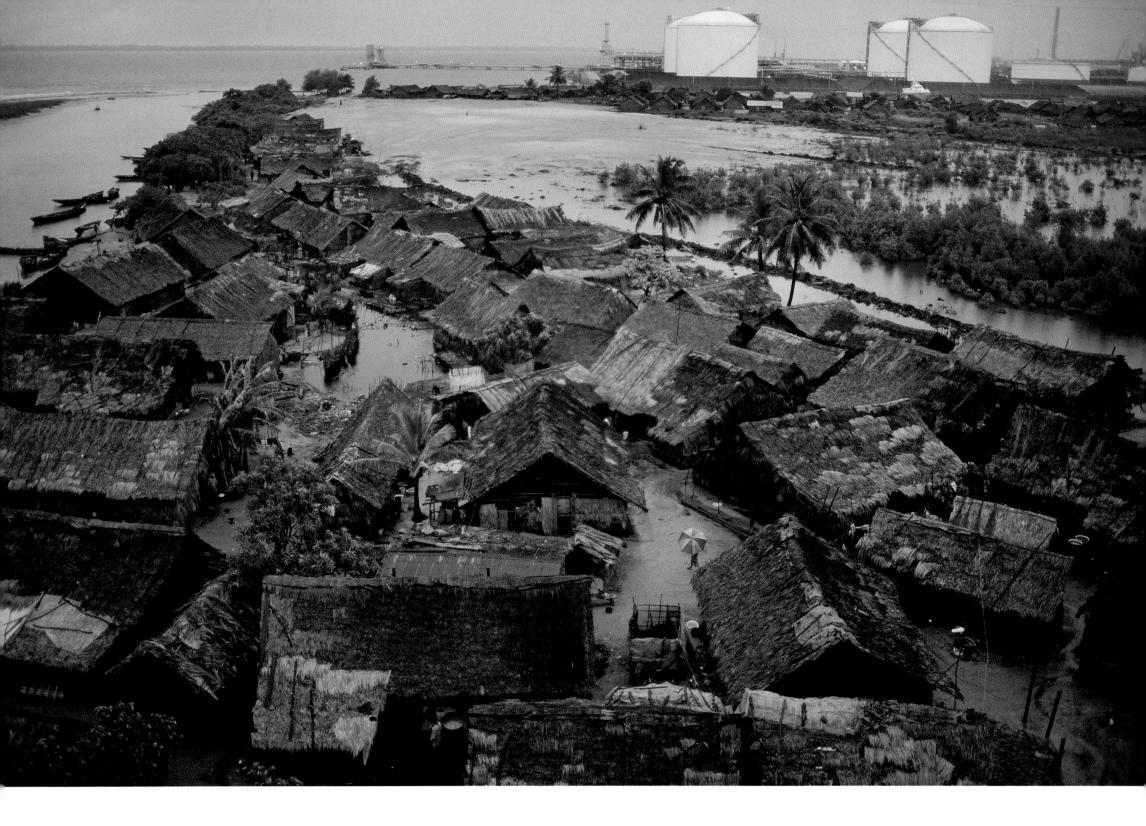

ABOVE: Finima village, Bonny, Nigeria
OVERLEAF: Swamp forest, Niger Delta, Nigeria

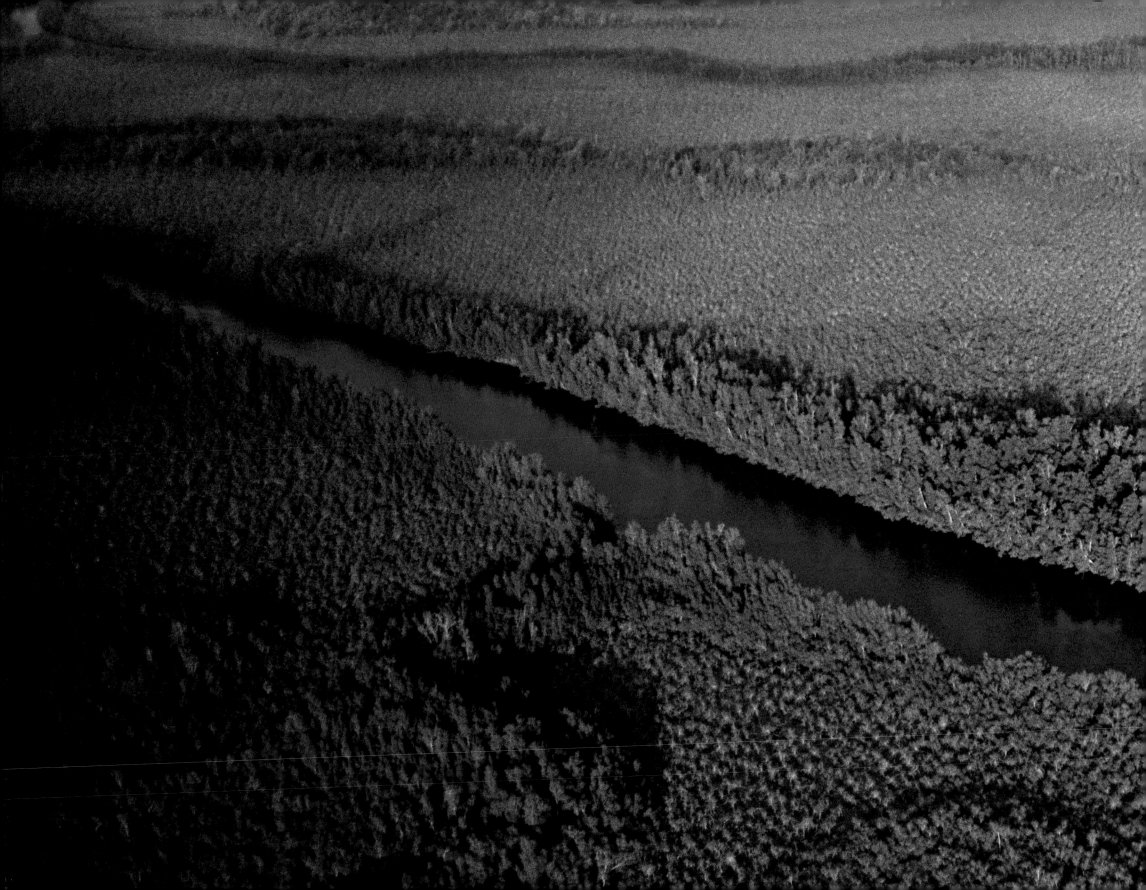

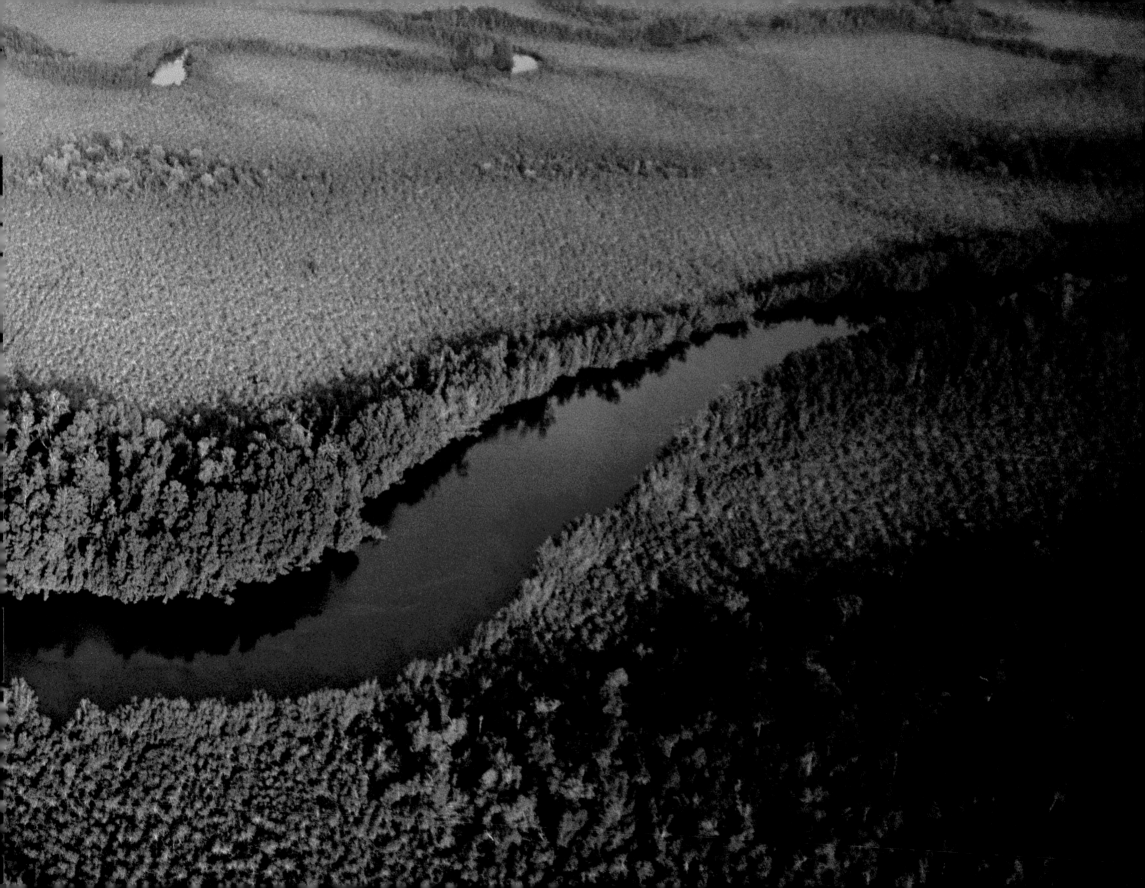

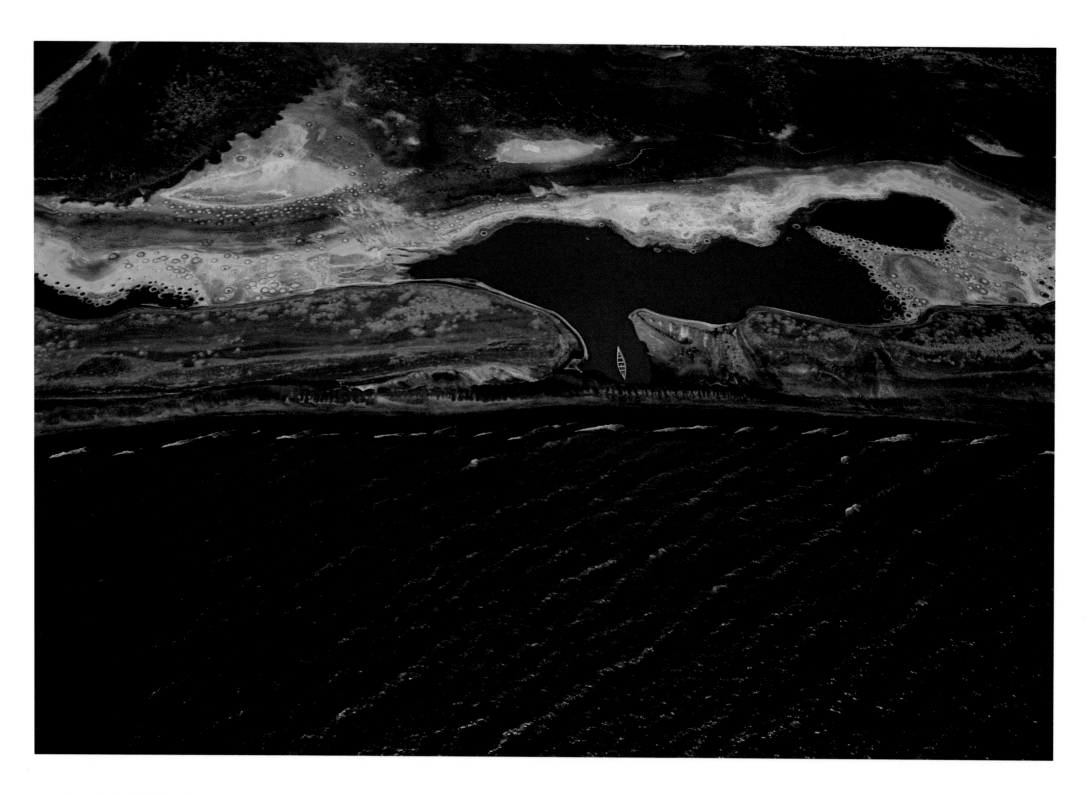

ABOVE: Airplane shadow, Lake Turkana, Kenya
OPPOSITE: Saltworks, Lac Rose, Senegal

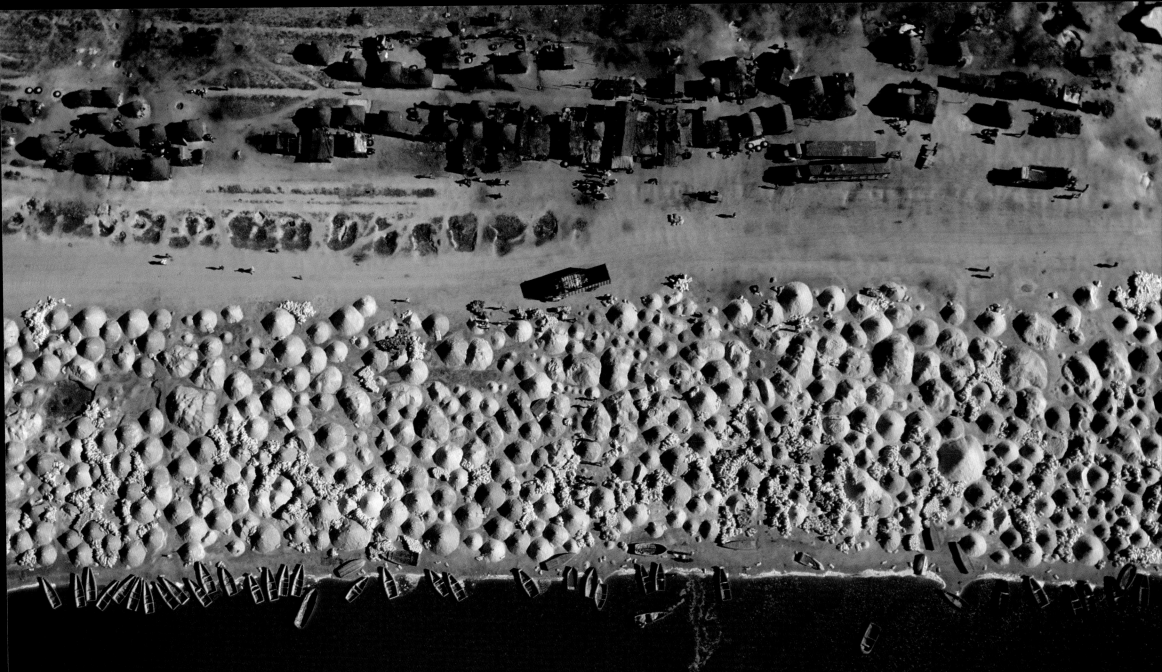

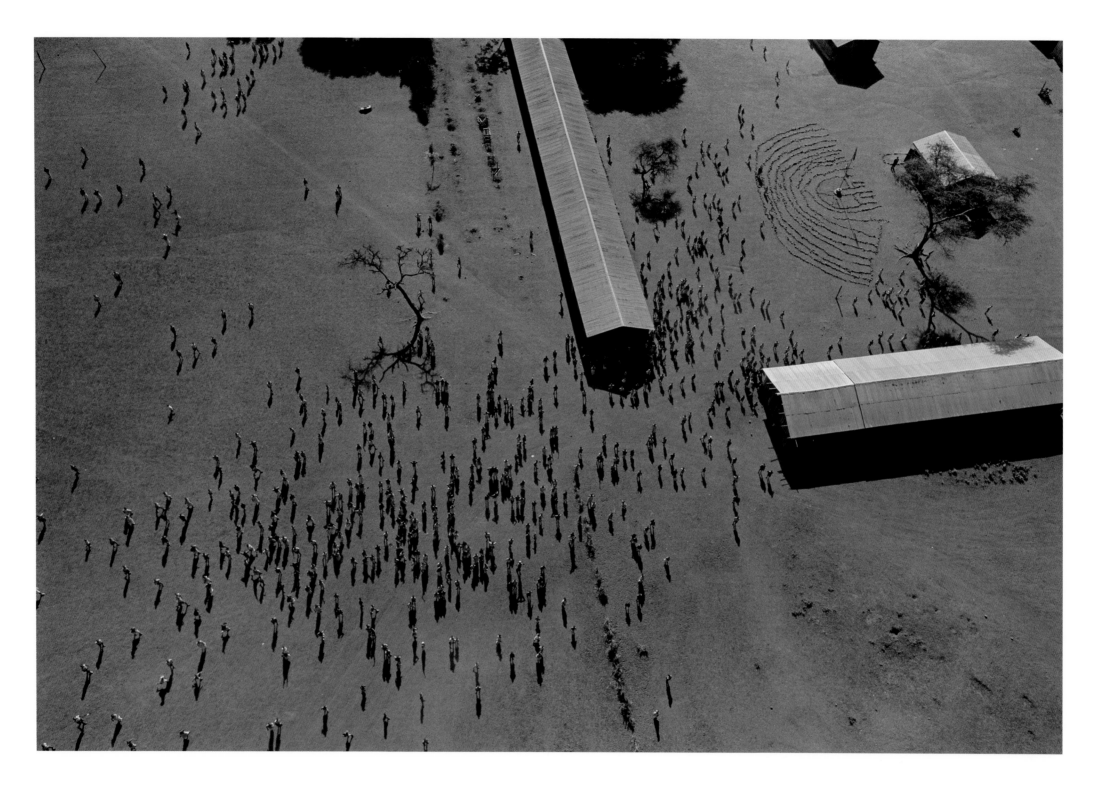

Rural school, Kimana, Kenya

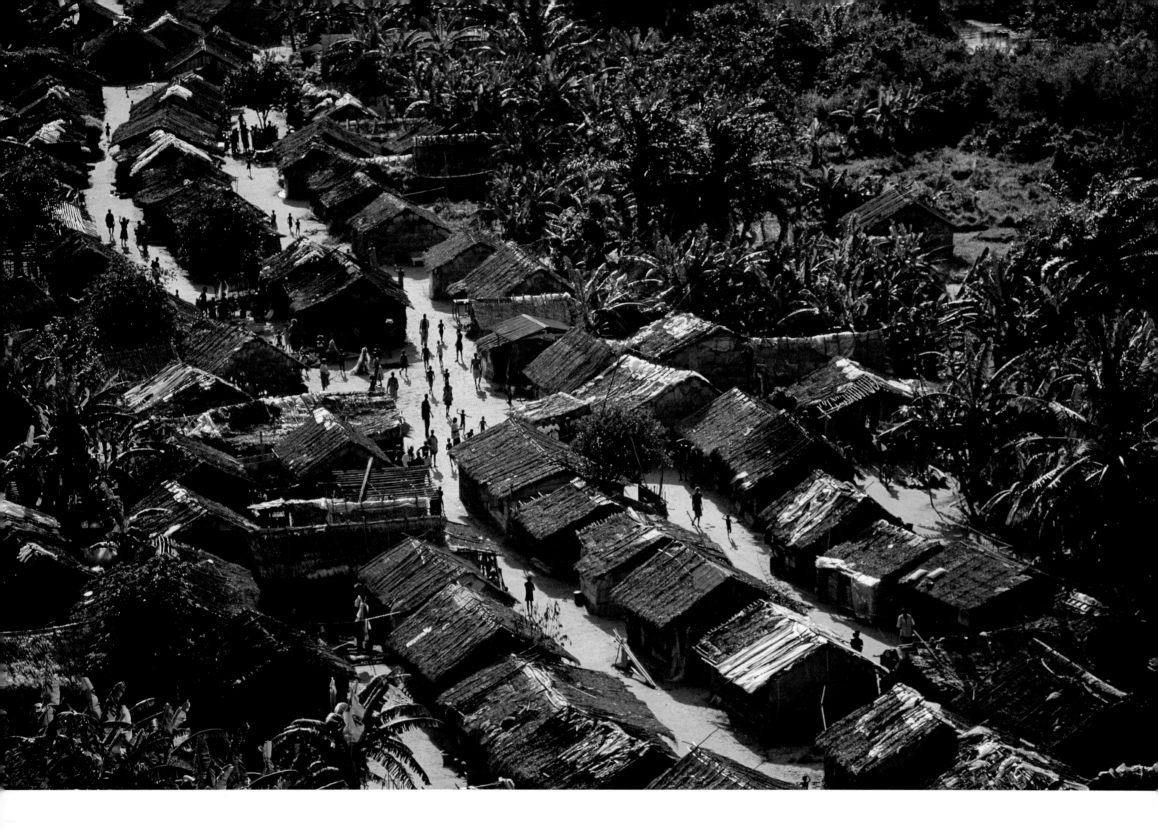

ABOVE: Village near Bonny, Niger Delta, Nigeria
OVERLEAF, LEFT: Saltworks, Teguidda-n-Tessoumt, Niger
OVERLEAF, RIGHT: Slums of Nouakchott, Mauritania

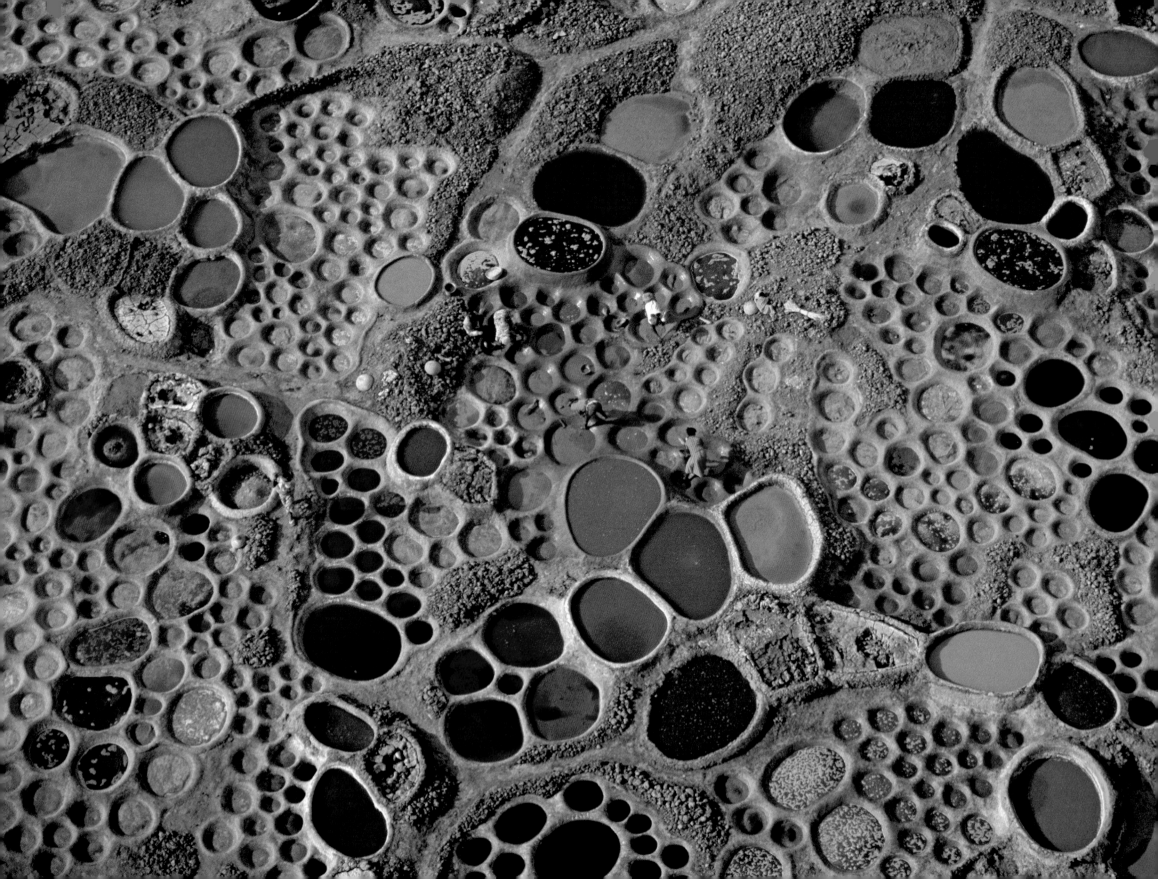

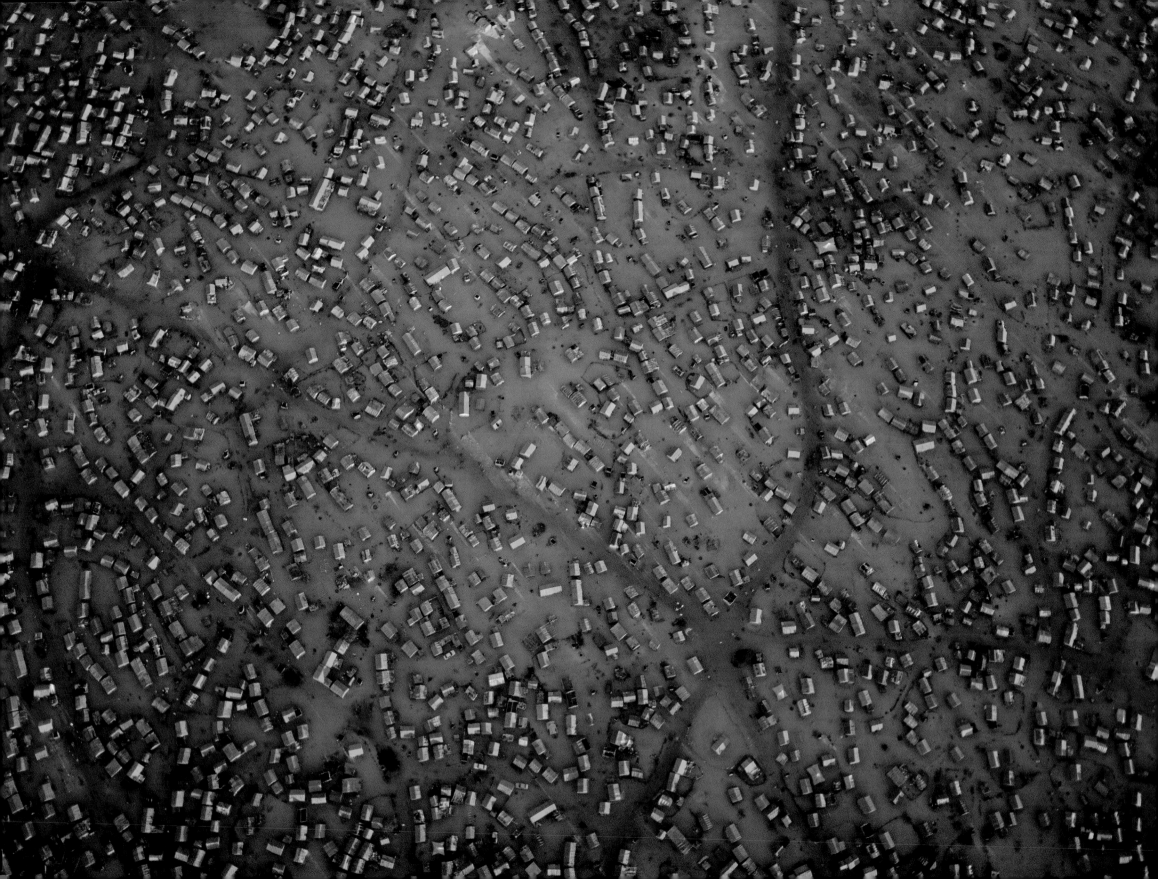

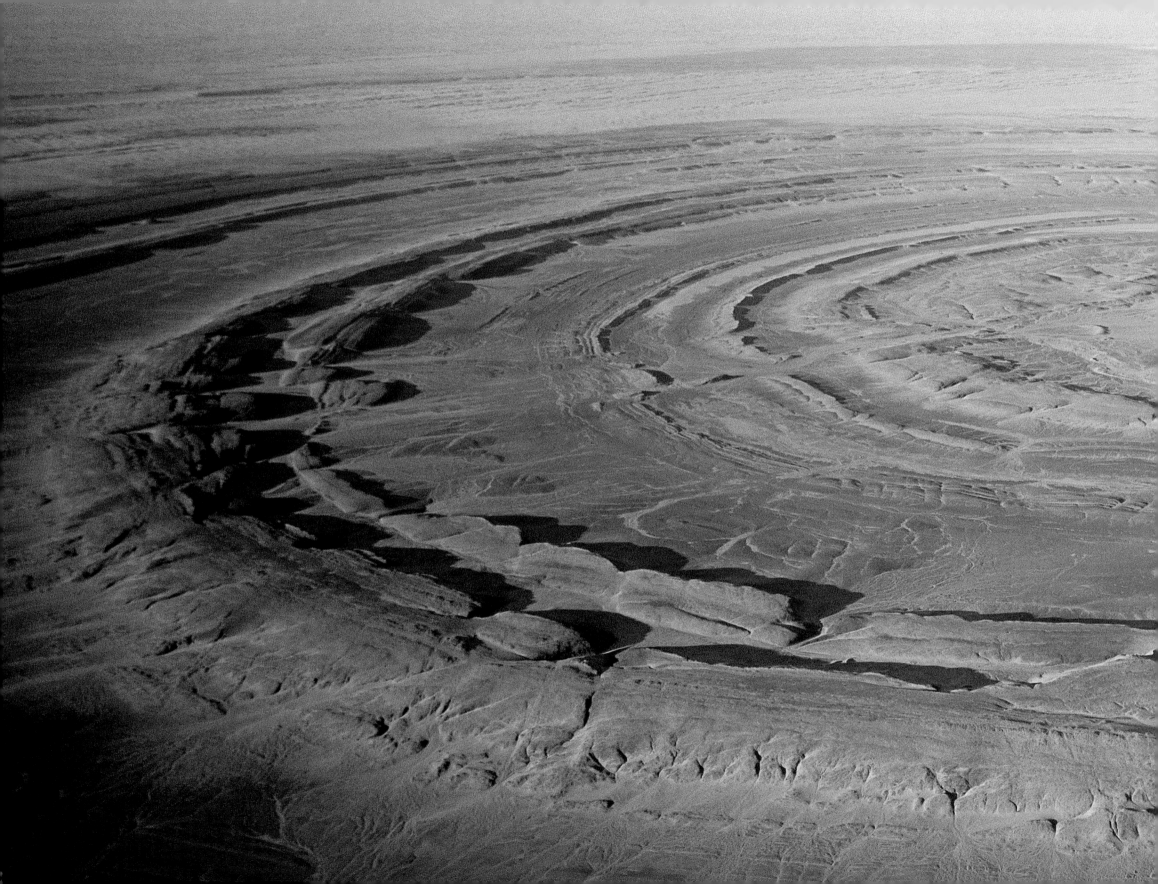

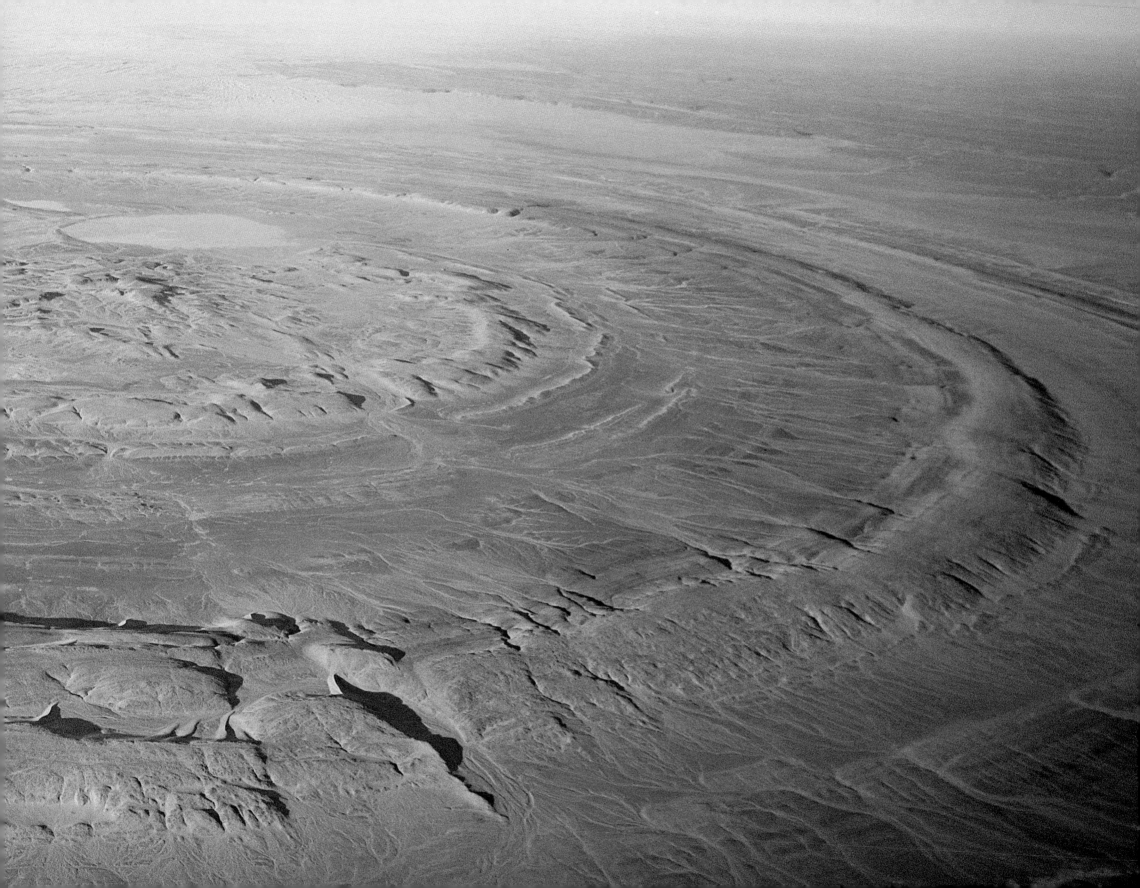

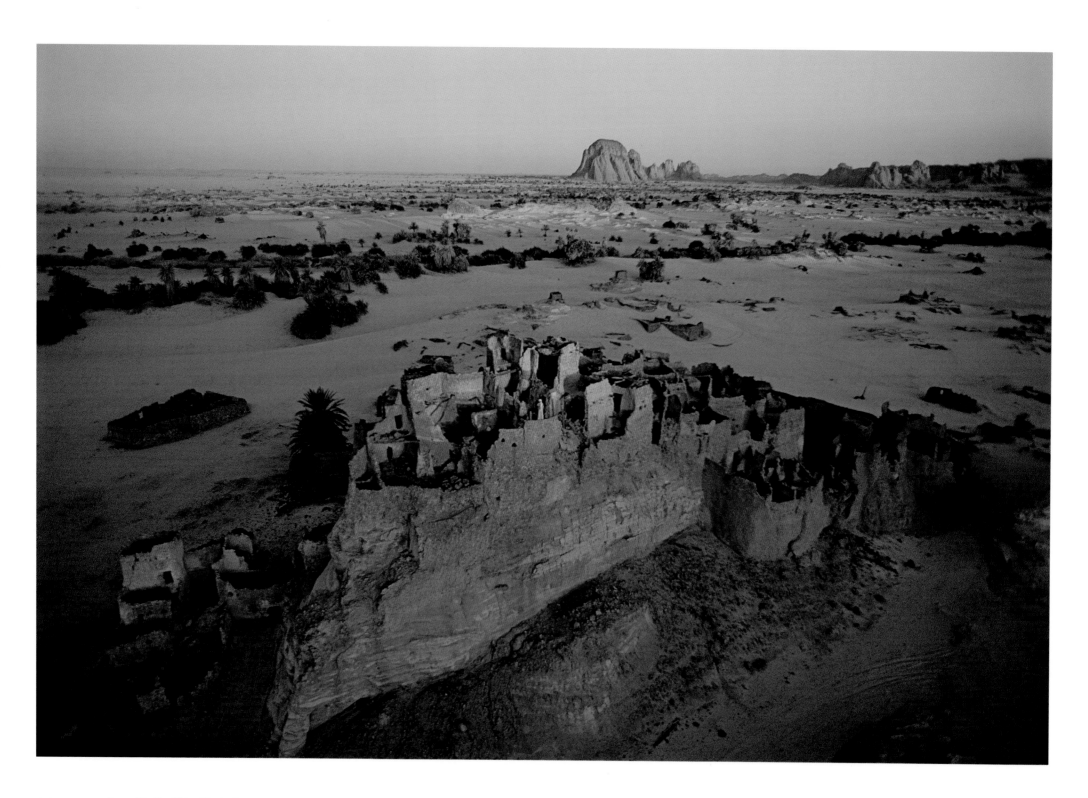

PREVIOUS PAGES: Dome of Guelb er Richat, Mauritania
ABOVE: Fortified village of Djaba, Niger
OPPOSITE: Sandstone buttes, Karnasai Valley, Chad

114

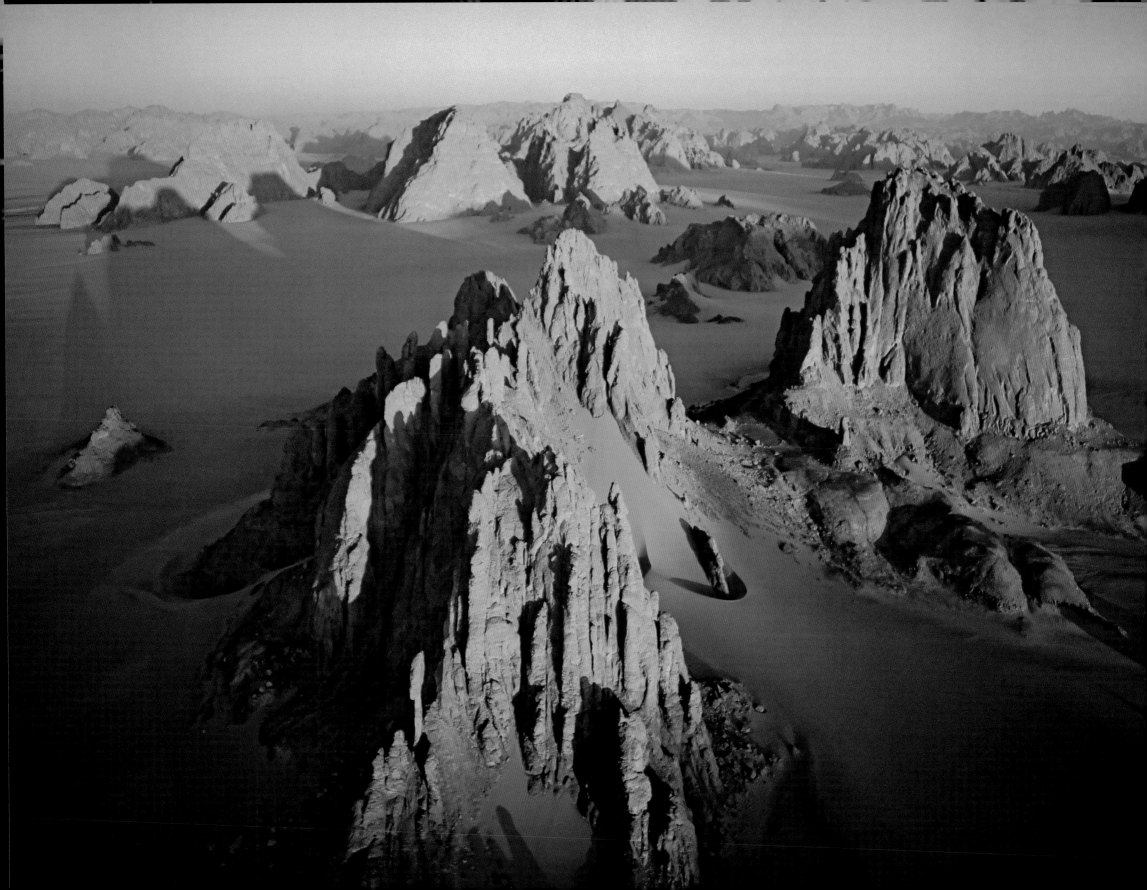

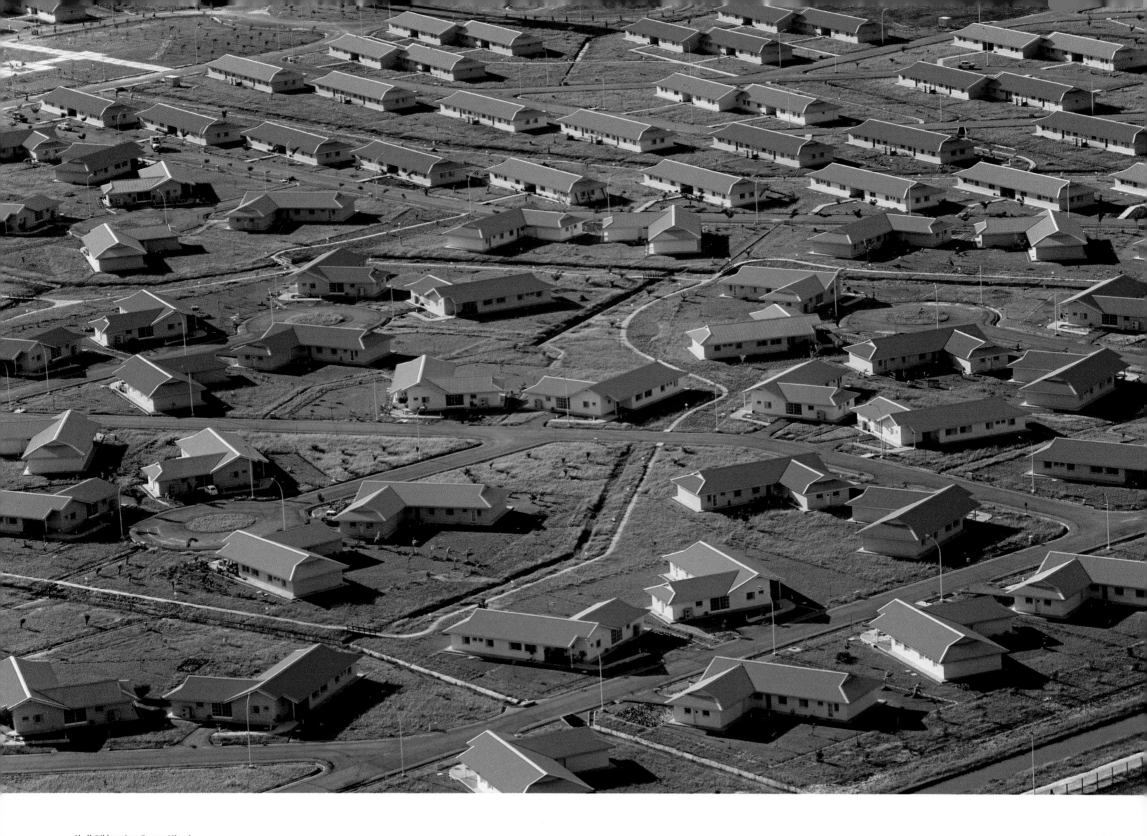

Shell Oil housing, Bonny, Nigeria

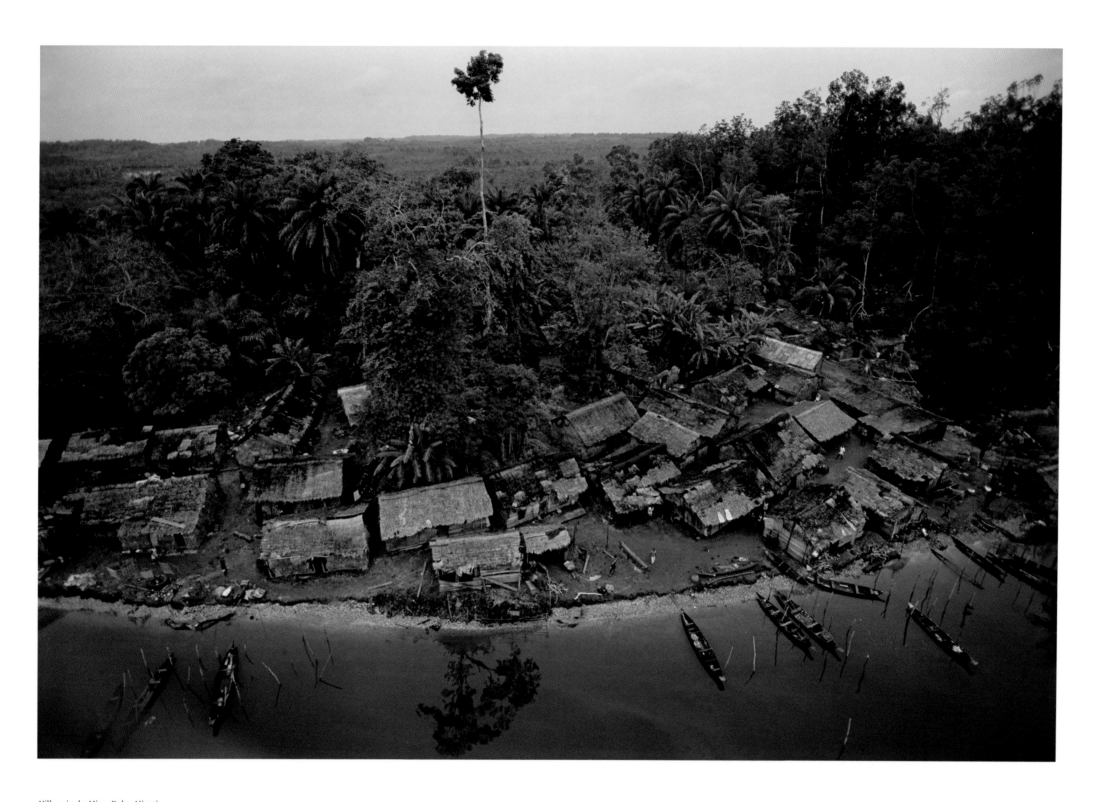

Village in the Niger Delta, Nigeria

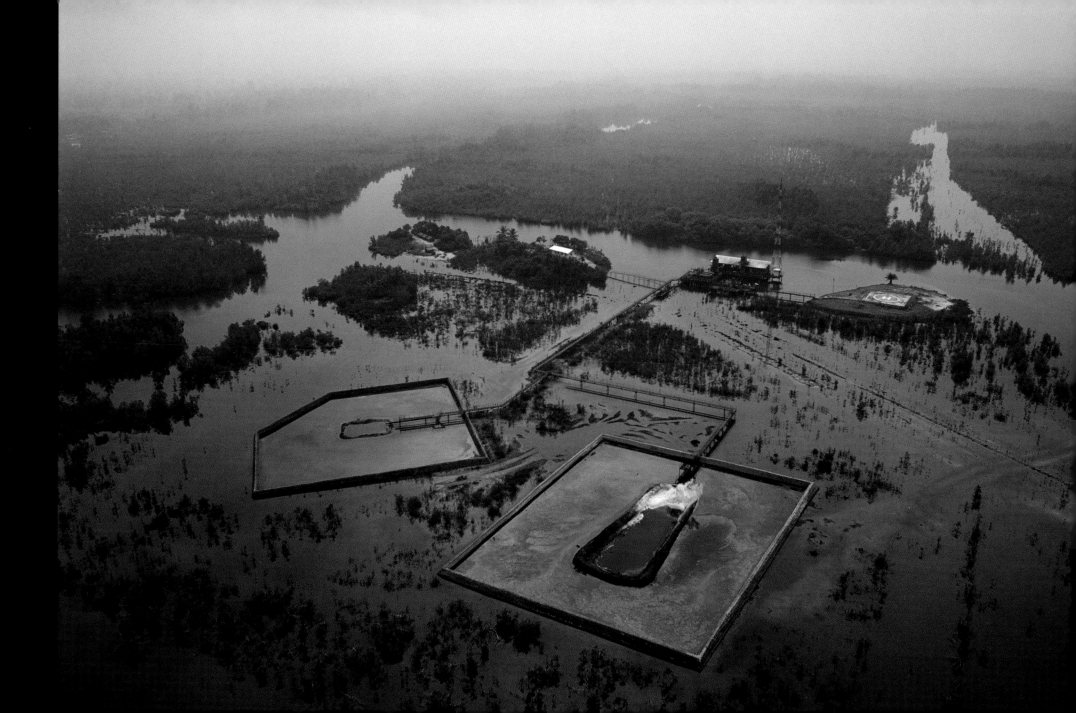

The village of Opia was a wreck. On January 4, 1999, about half of its twenty-five thatched-roofed buildings were burned to the ground. This impoverished village in the Niger Delta had been attacked by the Nigerian military with the support of boats and helicopters under contract to Chevron. Two months after the attack, I sat on the muddy riverbank of Opia with a villager named Ogbudu Francis. I was there on assignment for the German edition of *GEO* magazine. Francis told me that two young men from Opia, Kakedu Lawuru and Timi Okoro, had been killed. Chief Agbagbadi Ikinyan and Ibrahim Fabulogba, both from a neighboring Ikenyan village, had also been killed. The four bodies had been buried too far away to visit, so the villagers gave me a tour of the burned-out buildings, the only remaining evidence of their loss. Before Chevron started drilling here, Opia was just a small fishing camp, but its population had swelled with hopes of jobs, payments, and trade with the oil workers. Like most delta villages, it had no electricity, plumbing, or school, and was reachable only by boat. The most upsetting part of the tour for the villagers seemed to be the blackened foundations of the three bars with piles of burned beer bottles and melted plastic chairs. Not far away were spent aluminum teargas cylinders. When I asked Ogbudu why they had been attacked, he replied that his village was in the path of a pipeline Chevron wanted to lay from an oil rig that used to be right behind the village, in a large watery pit some fifty yards away. He told me that Chevron had given the village elders 60,000 Naira (US$680) in the fall, which he called "drinking money." Their story seemed a bit improbable to me. Why would an international, multibillion-dollar oil company attack a peaceful village of unarmed civilians? Before leaving, I took a group portrait of the Opia villagers with a protest banner that had been given to them by political activists.

Before I had left the United States, I had asked Chevron for permission to document its oil facilities in Nigeria, but I was turned down. From Nigeria, I contacted Chevron's California headquarters again, and this time I told them that I had been to Opia and wanted to get their side of the story. Two weeks later, Chevron relented: Human Rights Watch had just released a report about the killings in Opia village, which soon led to calls for a congressional investigation. The heat was on, and I suddenly found myself on a chartered airplane headed to Escravos, Chevron's fortified production facility in the delta.

The Portuguese named Escravos when it was a slave-trading port in the seventeenth century.

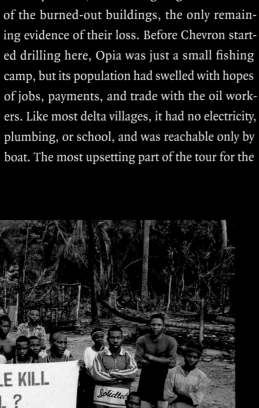

Now this strange little place exports half a million barrels of oil a day and is surrounded by a double perimeter of razor-wire and barbed wire fencing. It glows at night with generator-powered electric lights, looking somewhat like an oil tank farm inside a remote high-security penitentiary. I found Chevron's operations manager, Scott Davis, sitting in a second-story office surrounded by multiple satellite phones and monitors connected to fourteen remote video cameras. He was nervous and depressed, having gone through what he described as the worst months in his twenty years with the company. In 1998, Chevron claimed to have paid the local villagers $25,000 while drilling near Opia, but a month before the shooting, the villagers had demanded additional "thank you" money and had been turned down.

On December 31, seventeen Chevron contract employees, all Africans, were kidnapped by members of the Ijaw tribe. Eleven were eventually

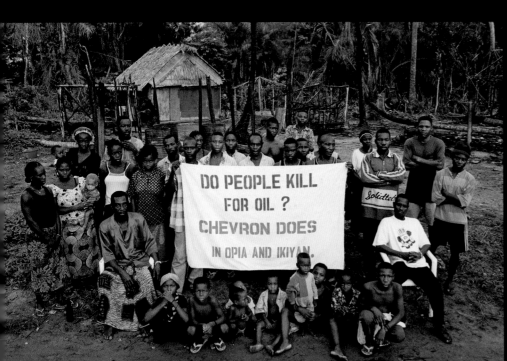

released, but six, who happened to be members of the Itsikiri tribe, were never seen again and are presumed dead.

On January 4, Davis received a radio call from the Chevron-contracted rig at Opia, reporting that they were under attack by local Ijaw villagers with automatic weapons. Davis said he could hear the weapons fire in the background during the call. After the shooting stopped, Davis gave permission for a helicopter to ferry ten Nigerian soldiers to the Opia rig while the Nigerian military was in the process of commandeering one of Chevron's crew boats. In all the commotion, one of the Nigerian officers boarded the helicopter with a loaded weapon in violation of company rules. According to a deposition made six years later by Pan African Airways helicopter pilot Allen Meier, a Vietnam veteran employed by the helicopter company, a Nigerian officer in the back of the chopper suddenly opened fire on a canoe on a river while Meier was flying reinforcements to the rig. This was a different story from the one I had

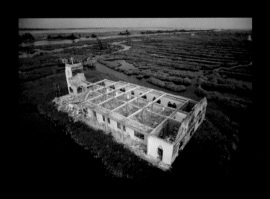

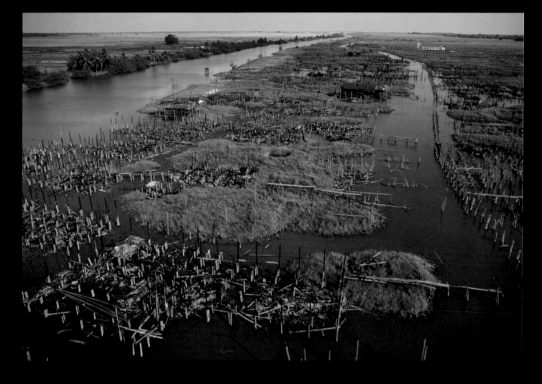

heard just two months after the incident. At this time, Roger Pell, Chevron's logistics coordinator, had debriefed the helicopter crew and heard that the shooting took place over Opia as villagers were fleeing in canoes. Chevron acknowledges that they paid soldiers involved in the Opia attack a total of $100 for their efforts on January 4, and that four villagers were killed by the Nigerian military that day.

Back in Escravos, Sam Daibo, Chevron's community relations man, suggested I take a look at a twenty-mile swath of coastline to the west of Escravos. There, he said, a string of Ilaje tribal villages had been systematically attacked and burned down by the neighboring Ijaw tribe a few months earlier. Chevron had been drilling off the coast and the Ijaw wanted to get the one hundred thousand Ilaje out of the area so that they could get Chevron payments and jobs from oil operations. The pilot was very nervous as we circled the burned-out former Ilaje village of Oroto, staying

high at first, looking for any sign of movement on the ground. Eventually he dropped down for a closer look at the deserted village where every wooden structure had been burned down to the high-water line. It was surreal to see evidence of horrors on such a calm and sunny day.

There has never been an investigation of what took place in these Ilaje villages or the events that precipitated them. And there is no record of how many people were killed in this horrific incident of tribal cleansing. Such a complete lack of justice is difficult for an outsider to comprehend, espe-

cially when no one seems to care to do anything about it. Was an act of terror against a hundred thousand people not a crime in comparison to Darfur or Rwanda? Meanwhile, eight years after the incident in Opia, Chevron is still being sued for millions of dollars because the Nigerian army killed four of its own citizens. This was not the good-natured Africa I had come to know, but a dangerous and ethically murky place. This long-exploited stretch of the African coast seemed trapped in the struggle between poverty and the lust for black gold, with no relief in sight. ▨

ABOVE: The church in the Ilaje village of Oroto, February 1999
TOP, LEFT: Chevron expatriates throw horseshoes under the satellite dishes that connect them to the outside world
TOP, RIGHT: Foundation poles of former homes in the Ilaje village of Oroto, February 1999

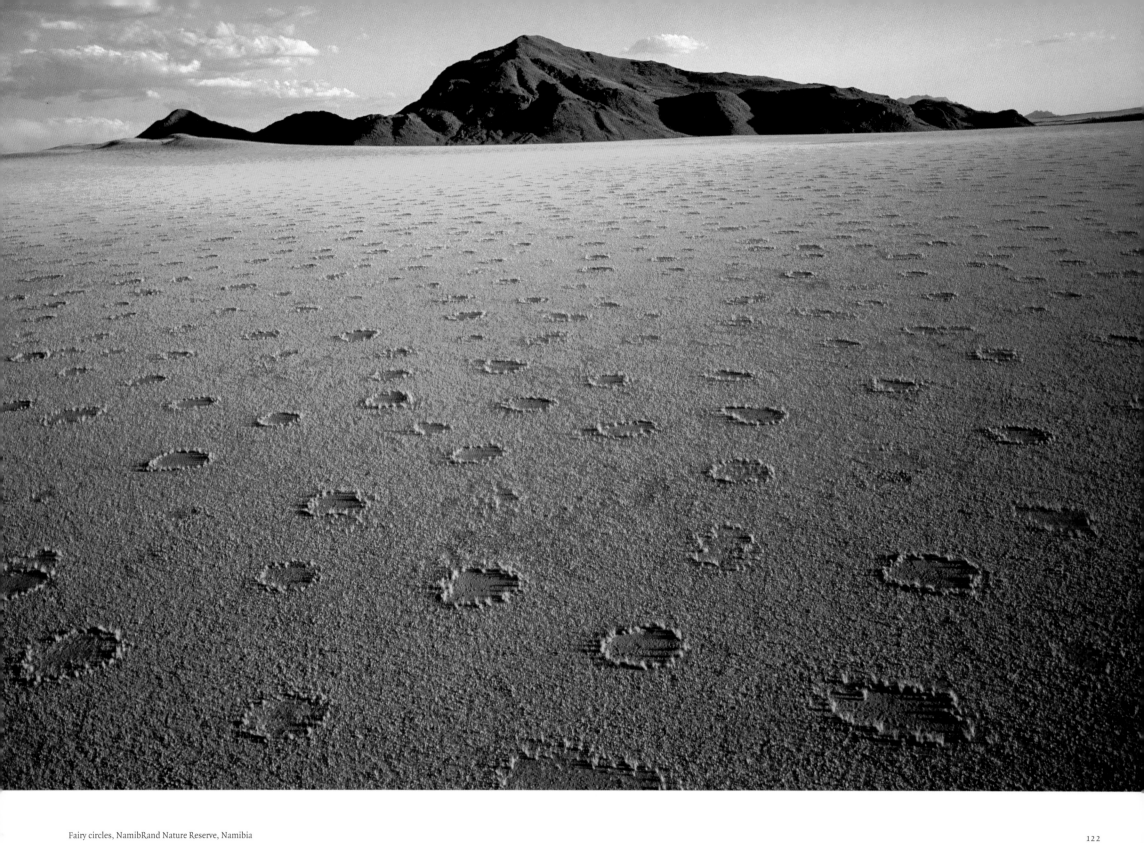

Fairy circles, NamibRand Nature Reserve, Namibia

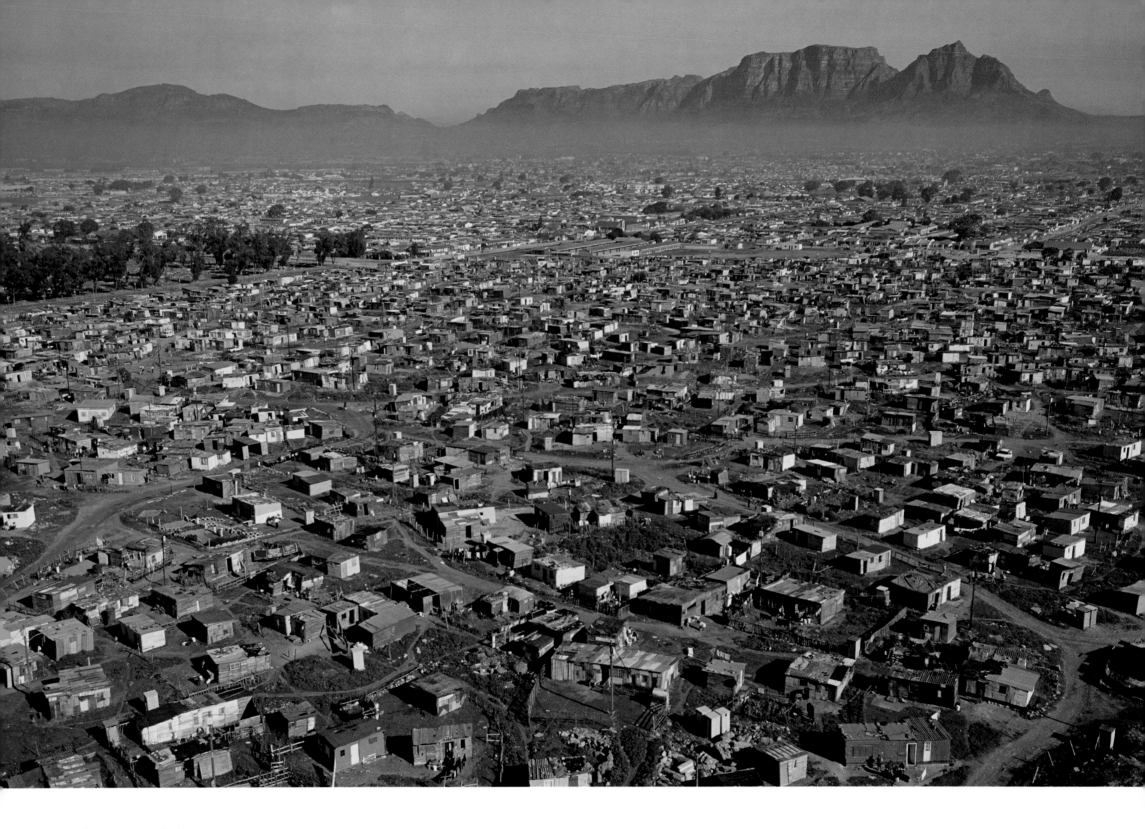

Cape Flats, Cape Town, South Africa

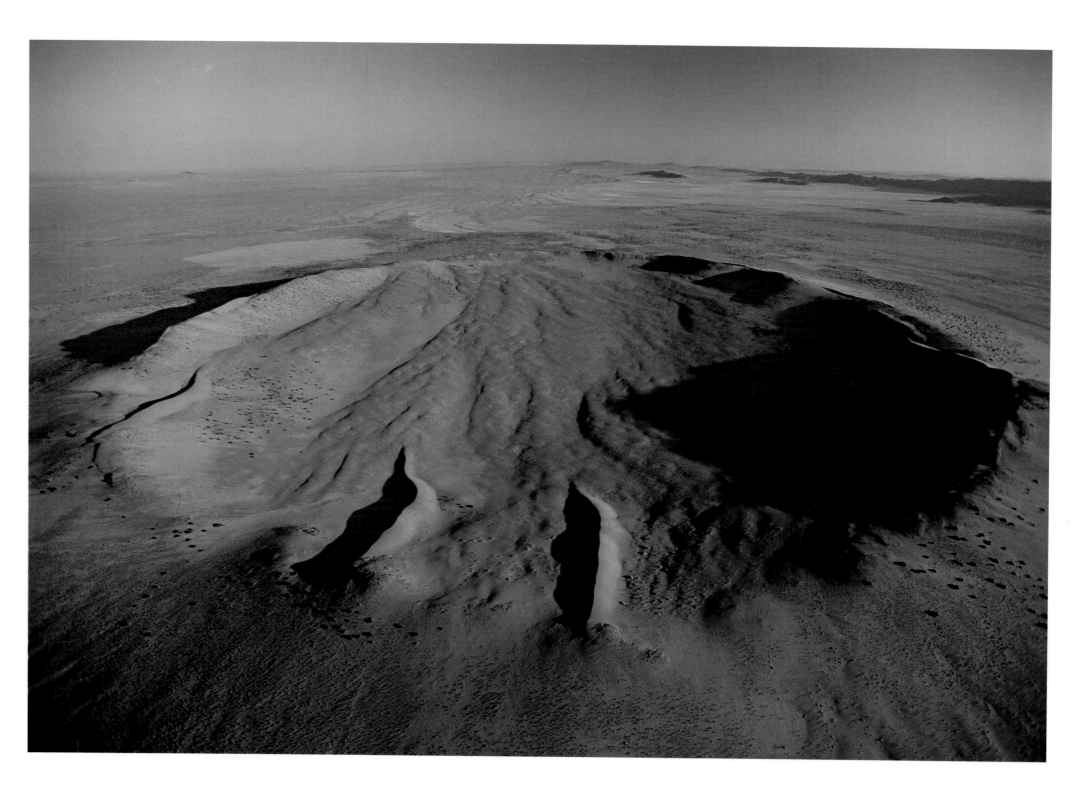

ABOVE: Meteorite crater, Sperrgebiet, Namibia
OPPOSITE: Crater lake of Mount Visoke, Rwanda/Congo

124

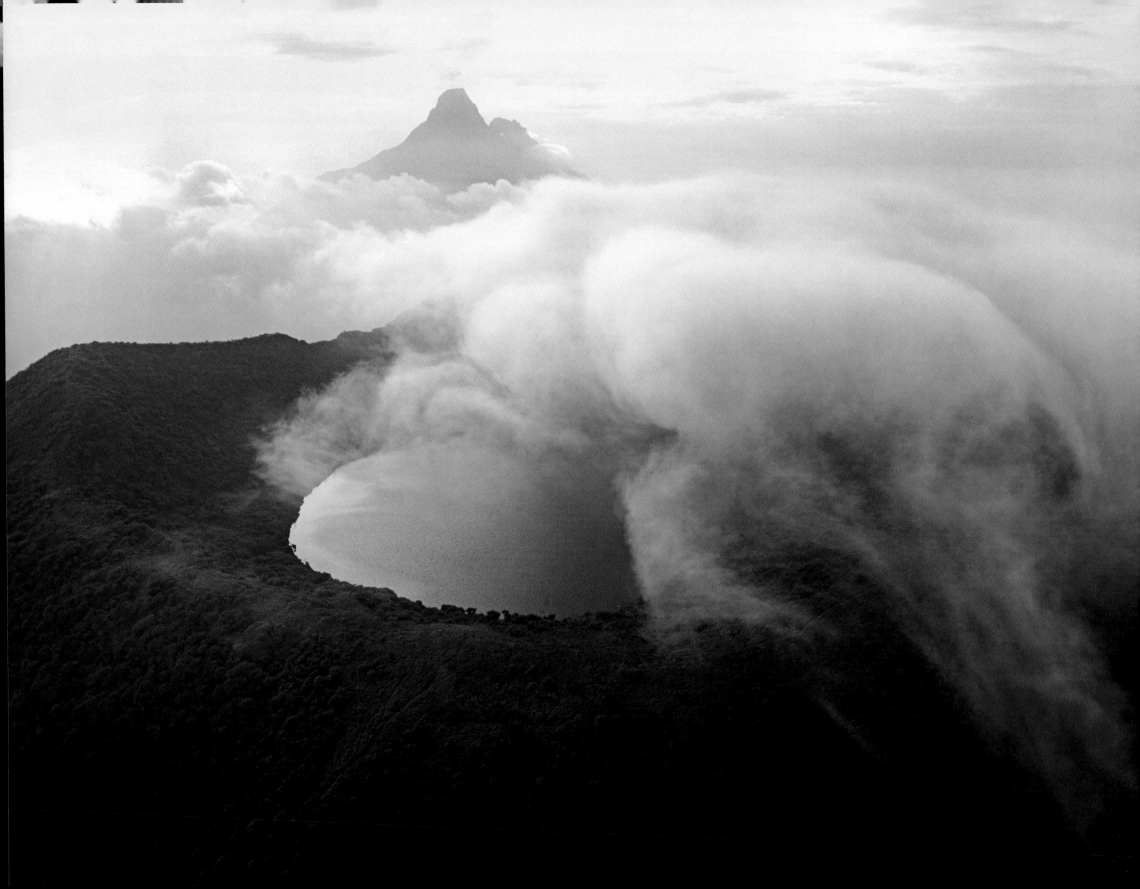

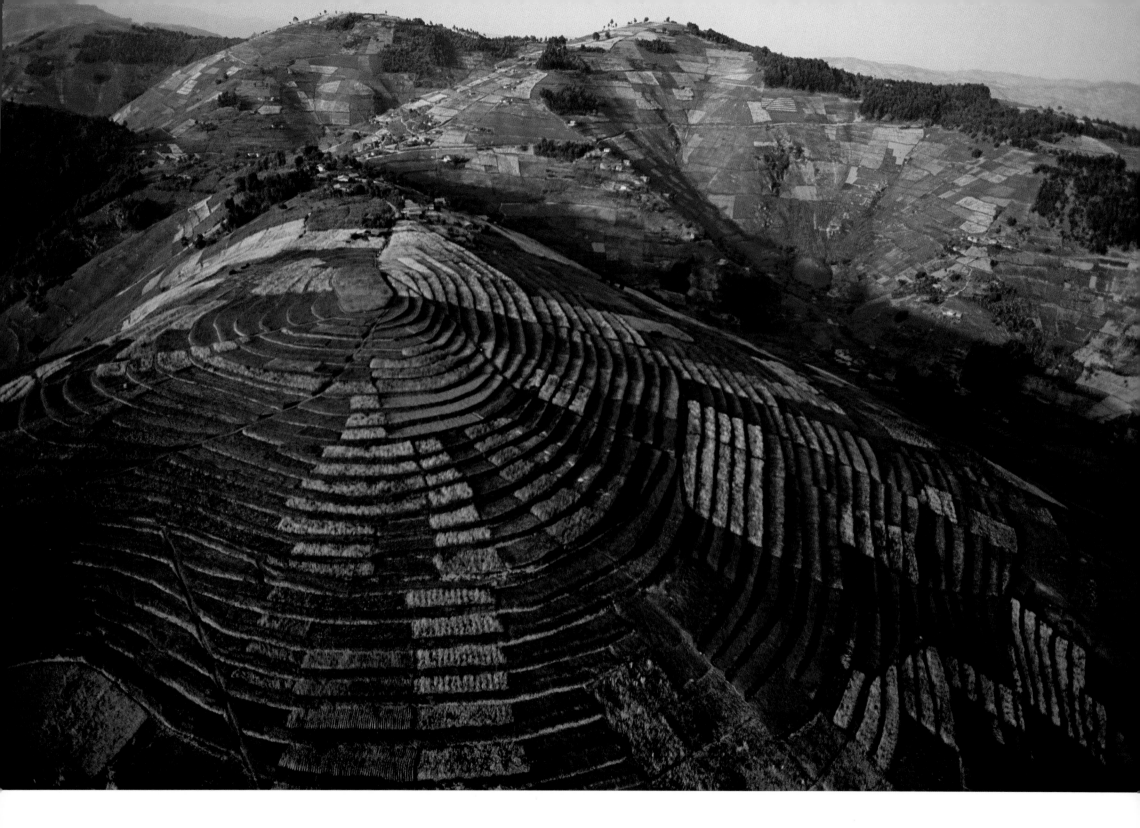

Terraced agriculture, near Kabuye, Rwanda

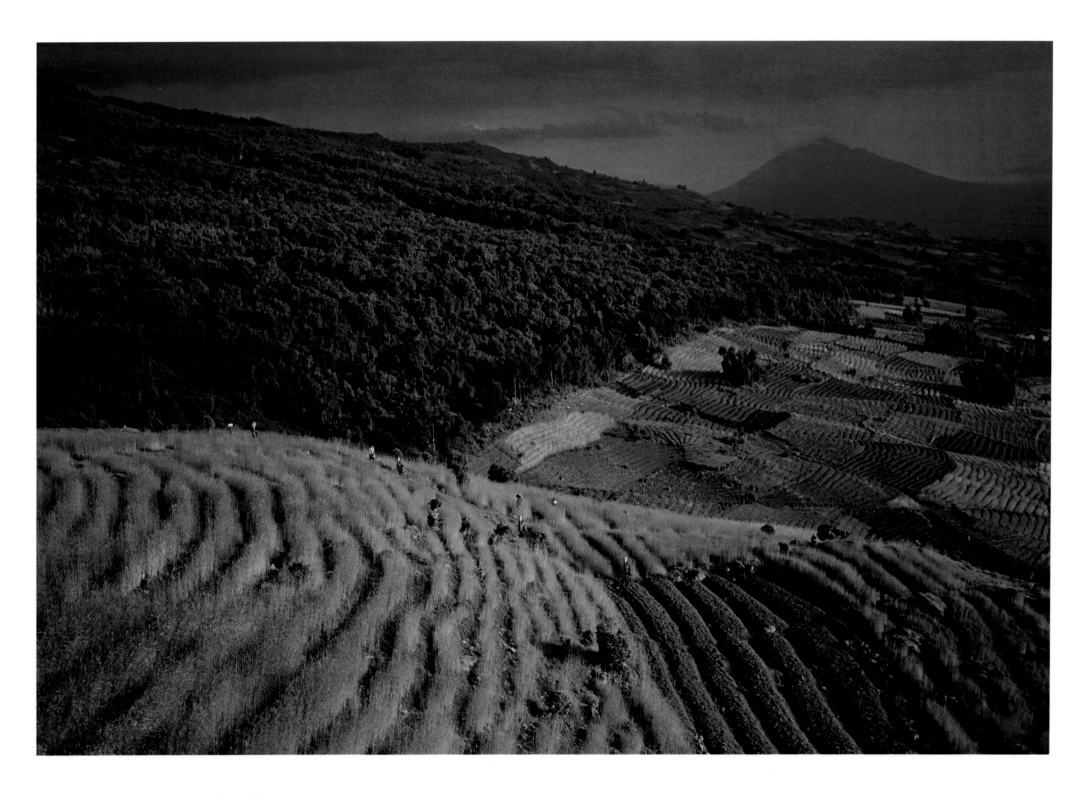

ABOVE: Edge of a gorilla reserve, Virunga Mountains, Rwanda 127
OVERLEAF: Sand fences of Tekenket, Mauritania

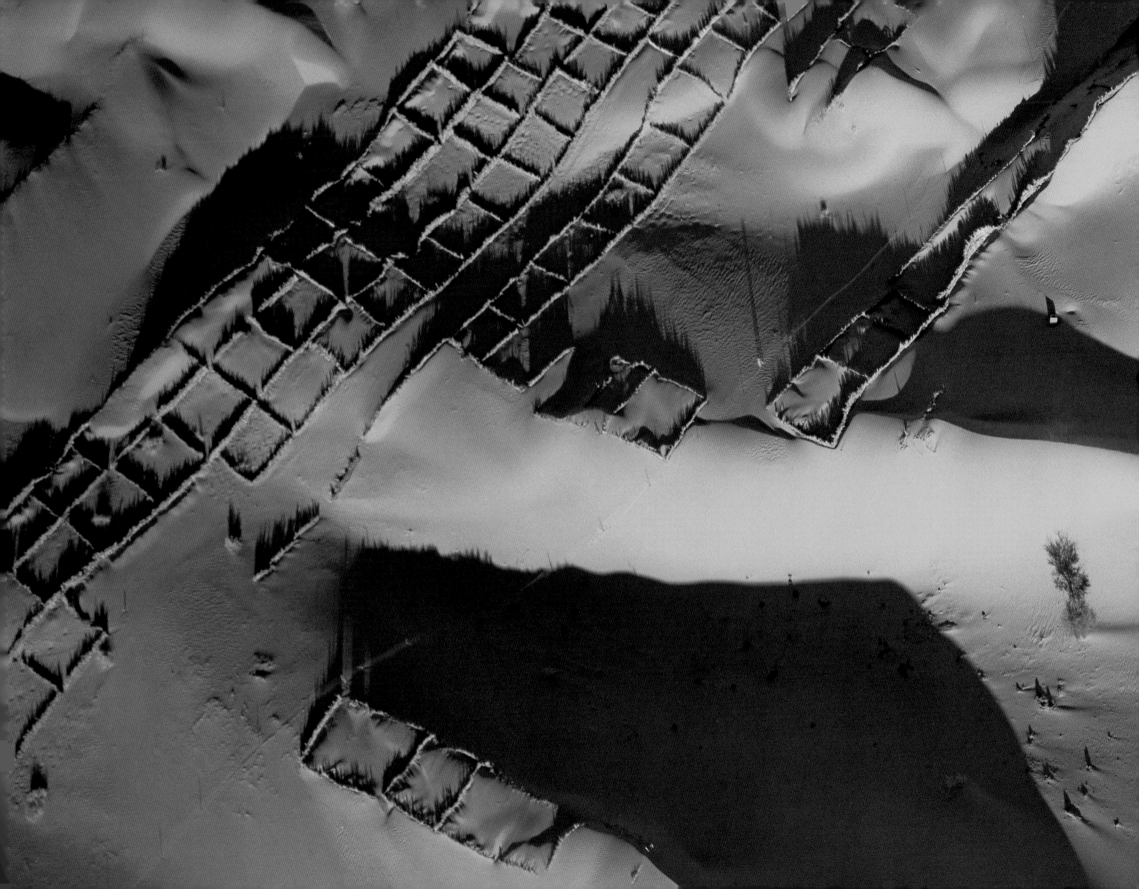

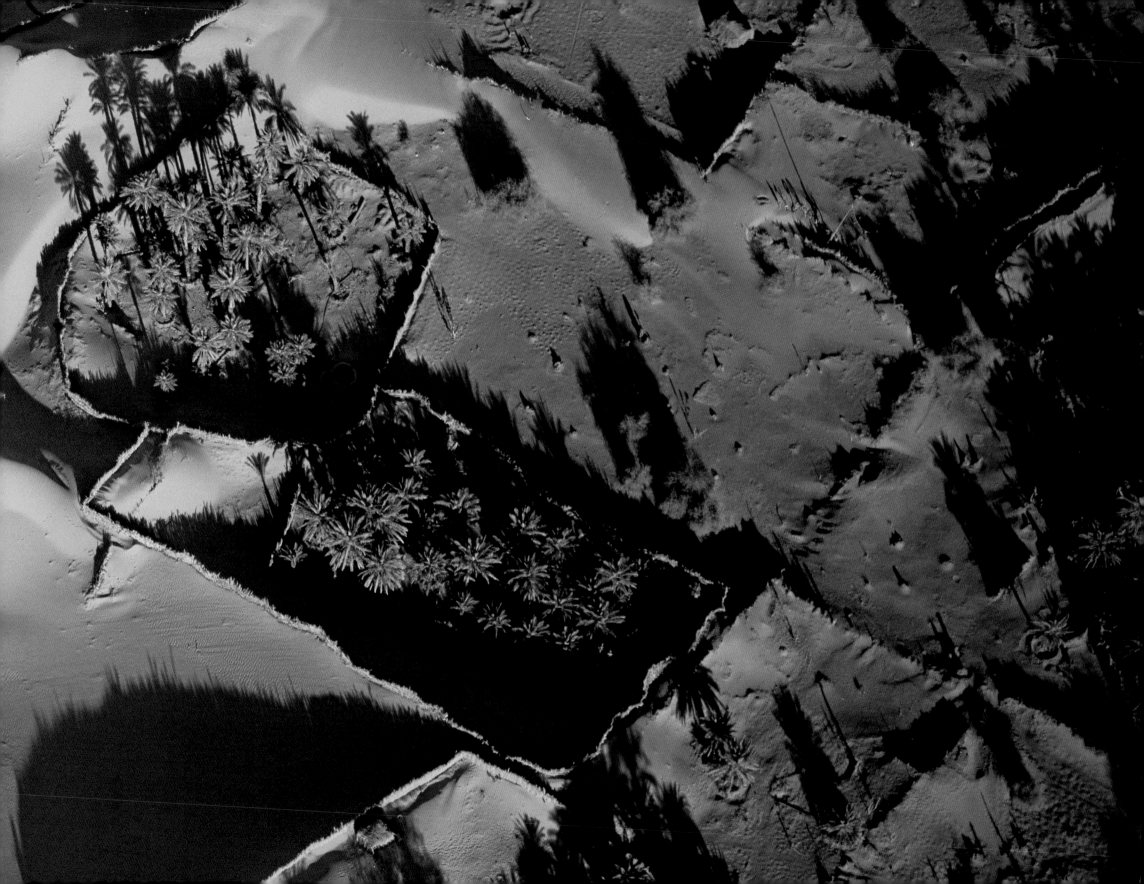

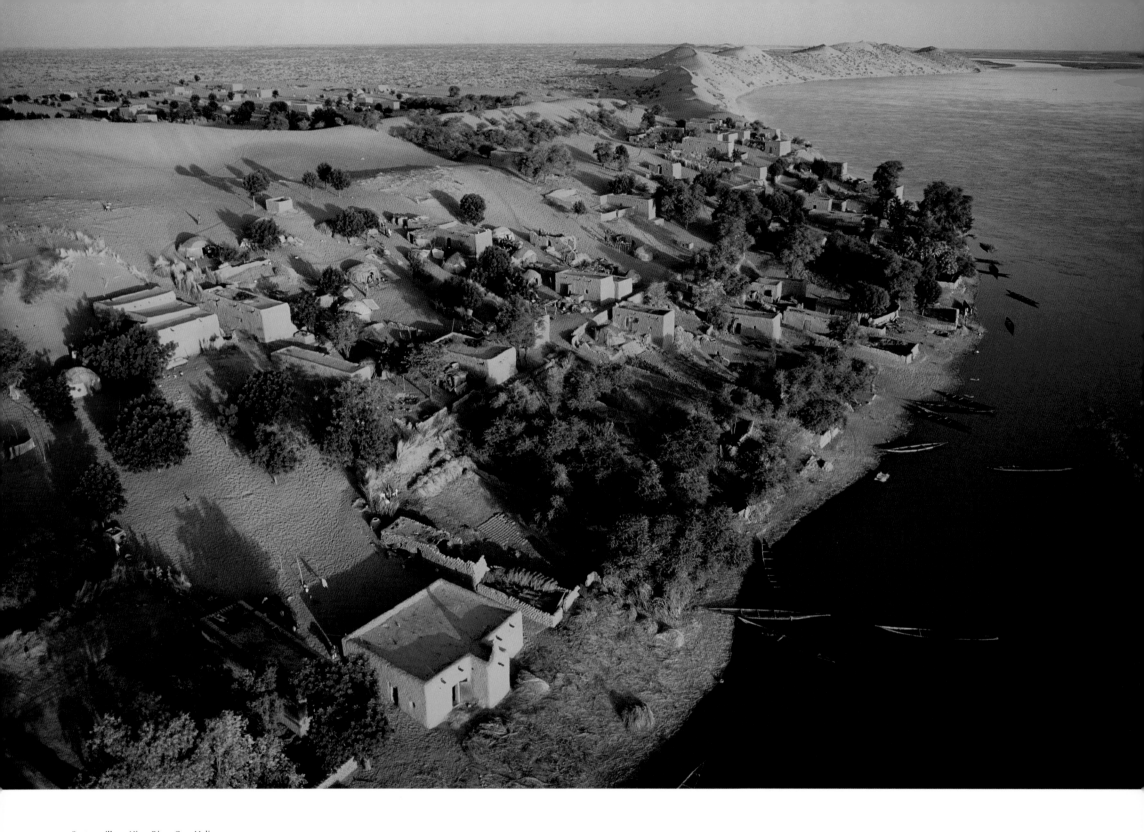

Bartaga village, Niger River, Gao, Mali

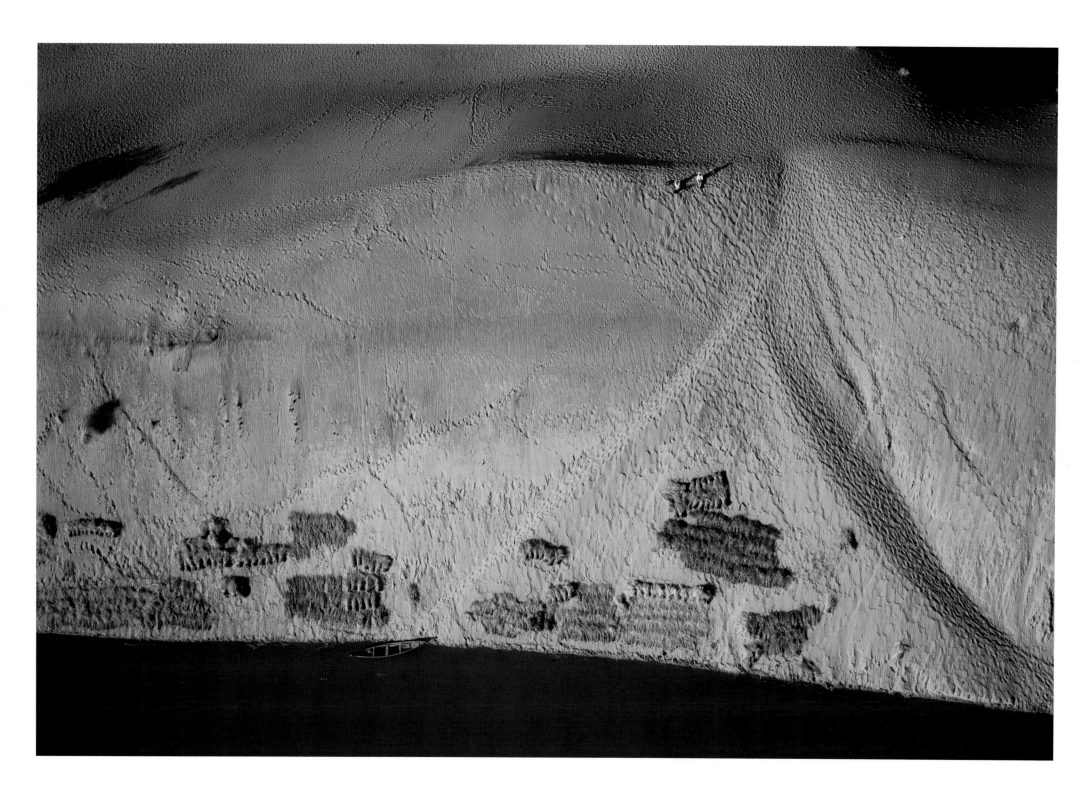

Rice drying on a bank of the Niger River, Mali

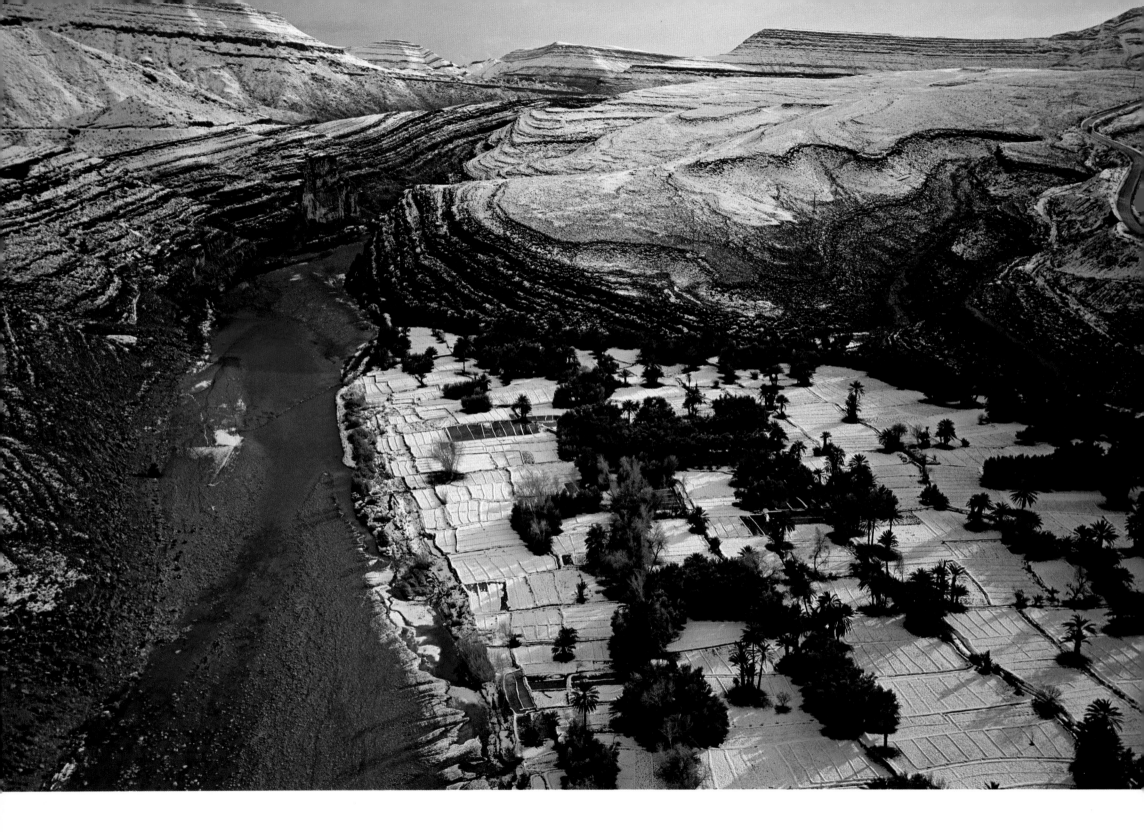

Rare snowfall in the Atlas Moutains, Gorges du Ziz, Morocco

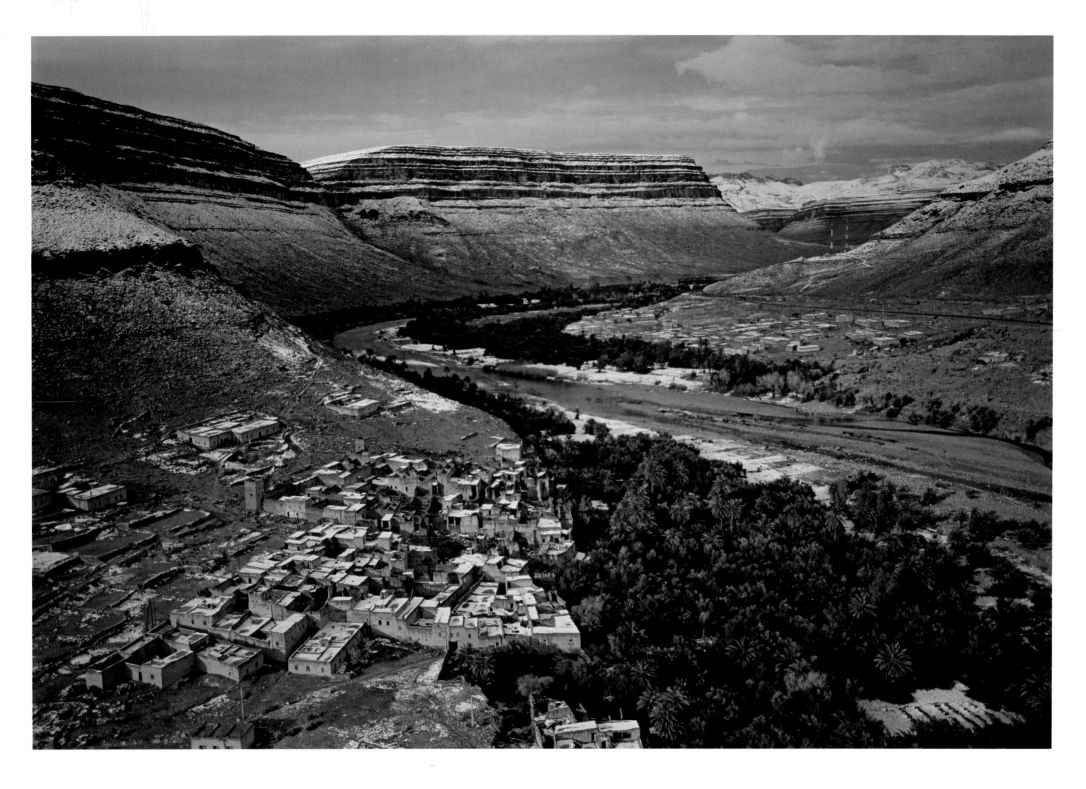

Rare snowfall in the Atlas Mountains, Gorges du Ziz, Morocco

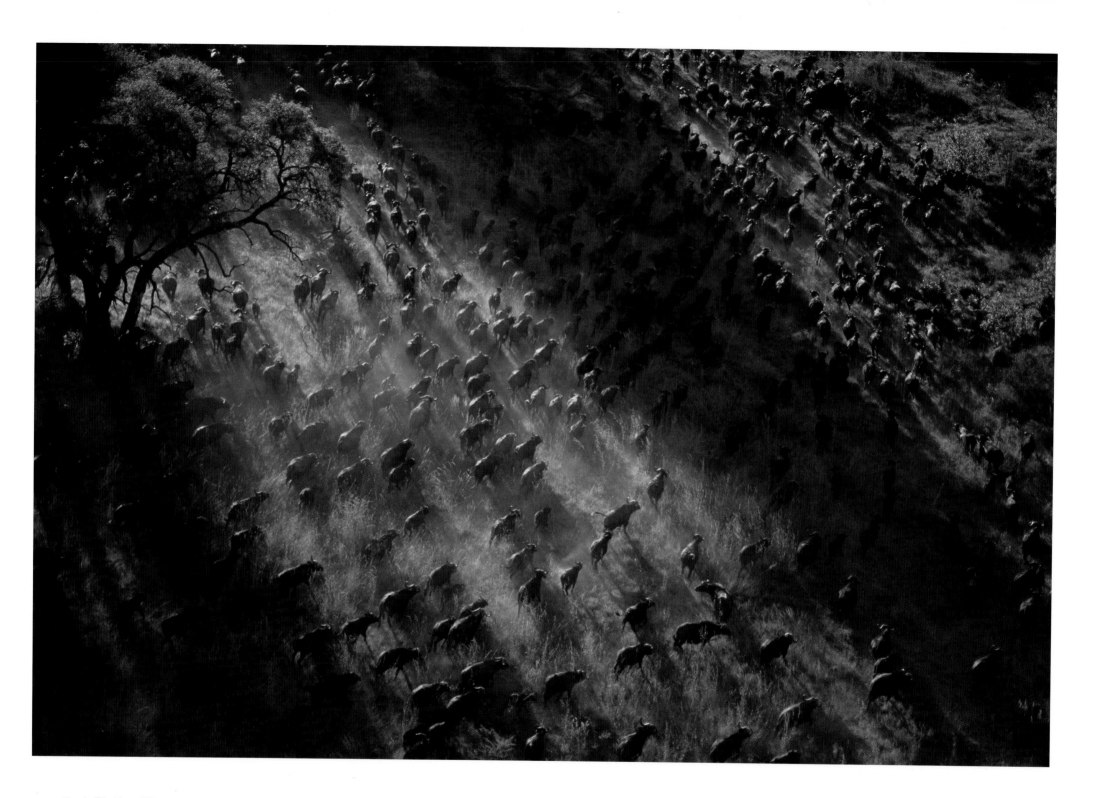

ABOVE: Cape buffalo, Linyanti River, Botswana
OPPOSITE: Saturday funerals, Soweto, South Africa
OVERLEAF: Zebra migration, Makgadikgadi Pans, Botswana

134

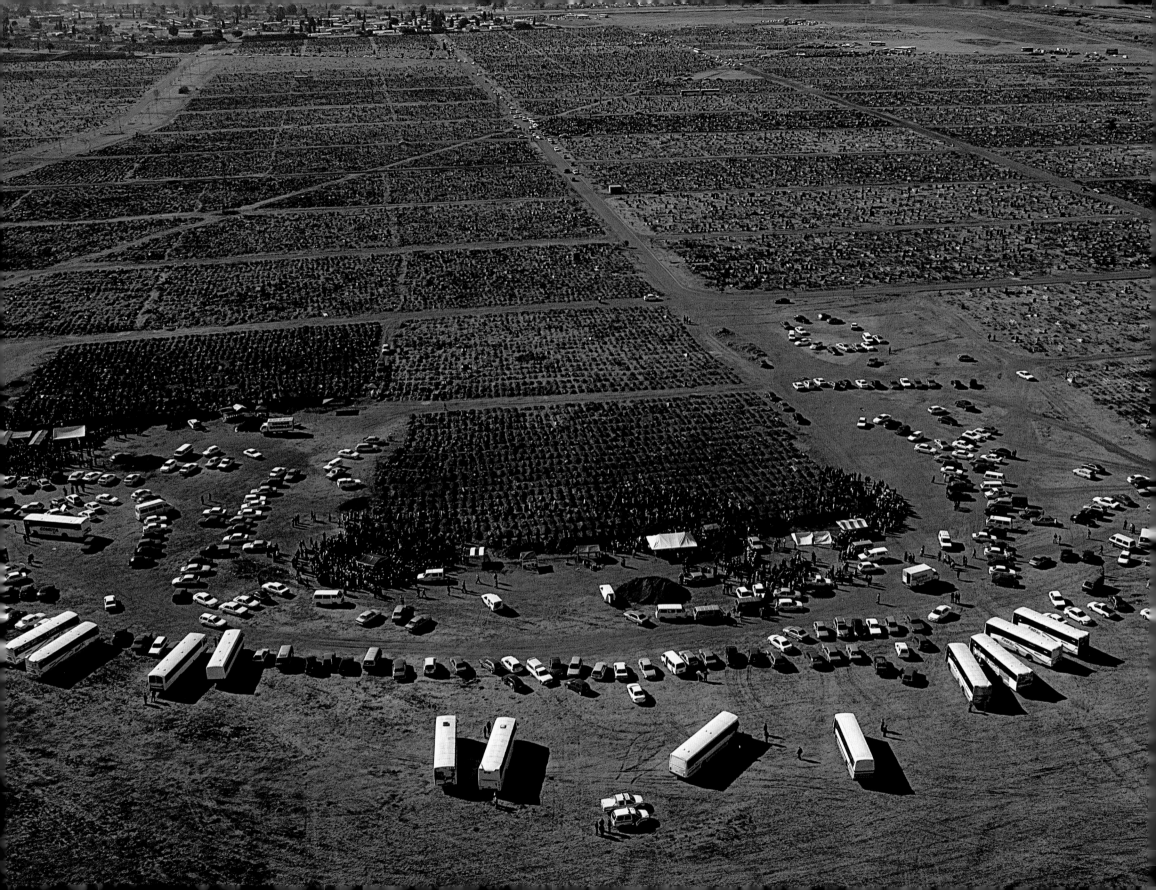

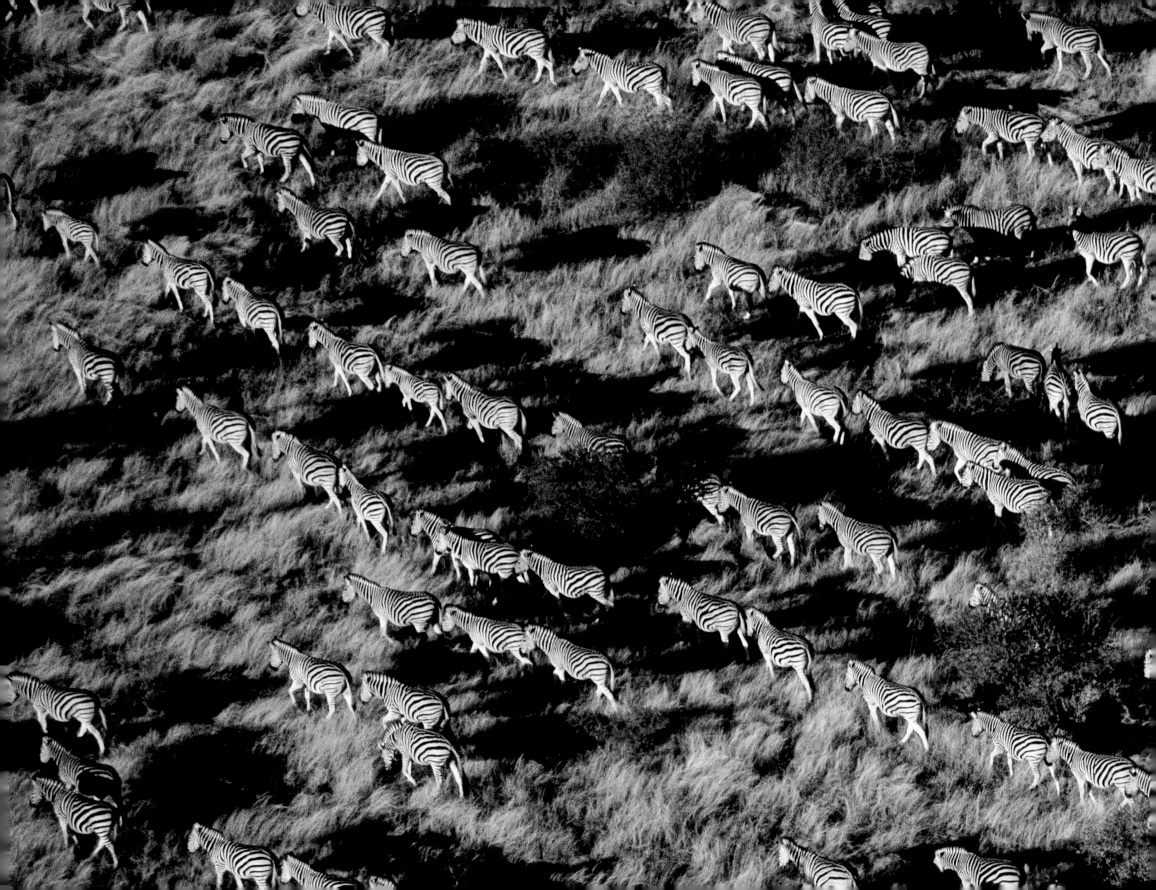

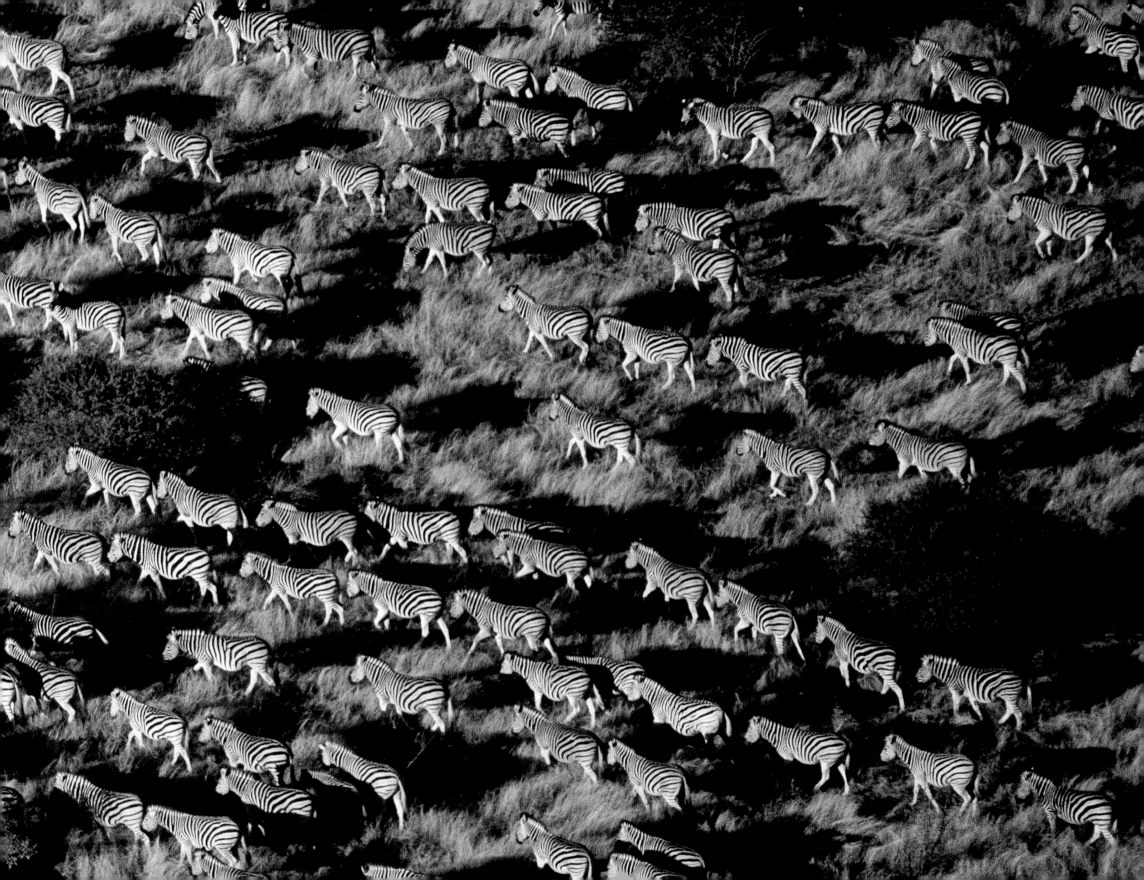

Vultures and elephant, Chobe National Park, Botswana

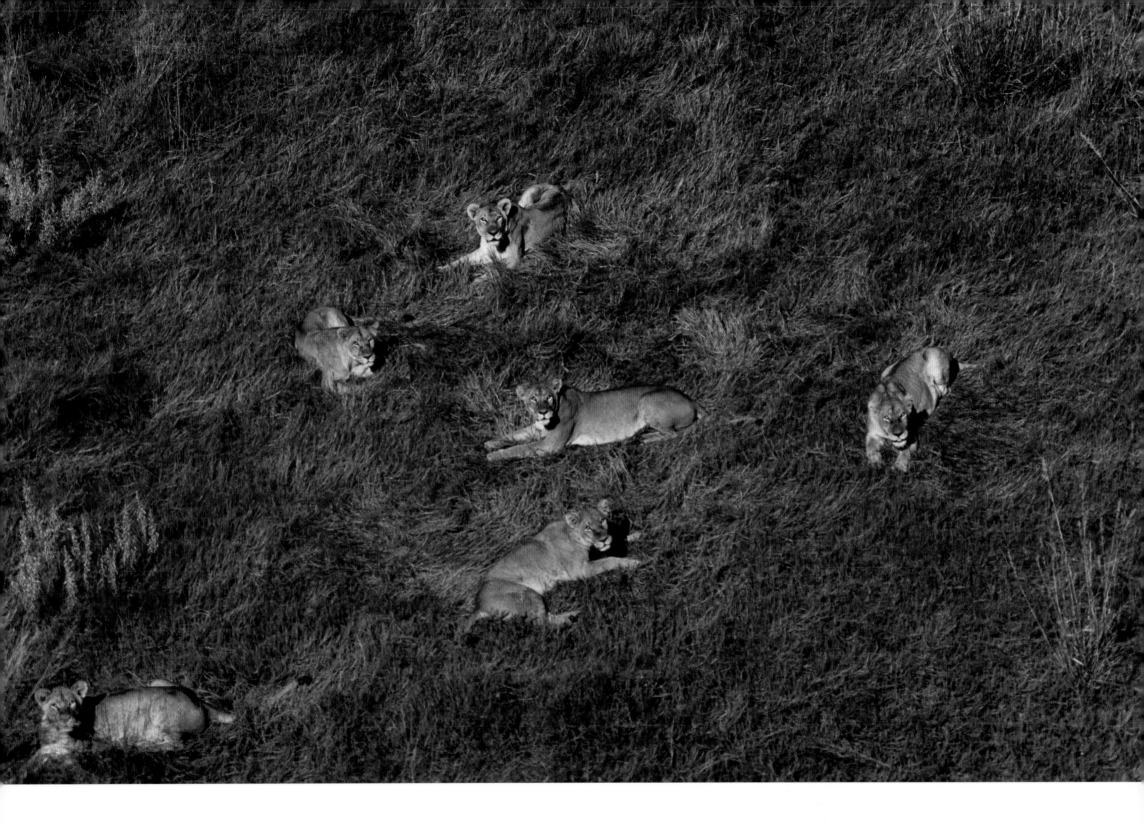

Lions, Okavango Delta, Botswana

Afternoon traffic, Cape Town, South Africa

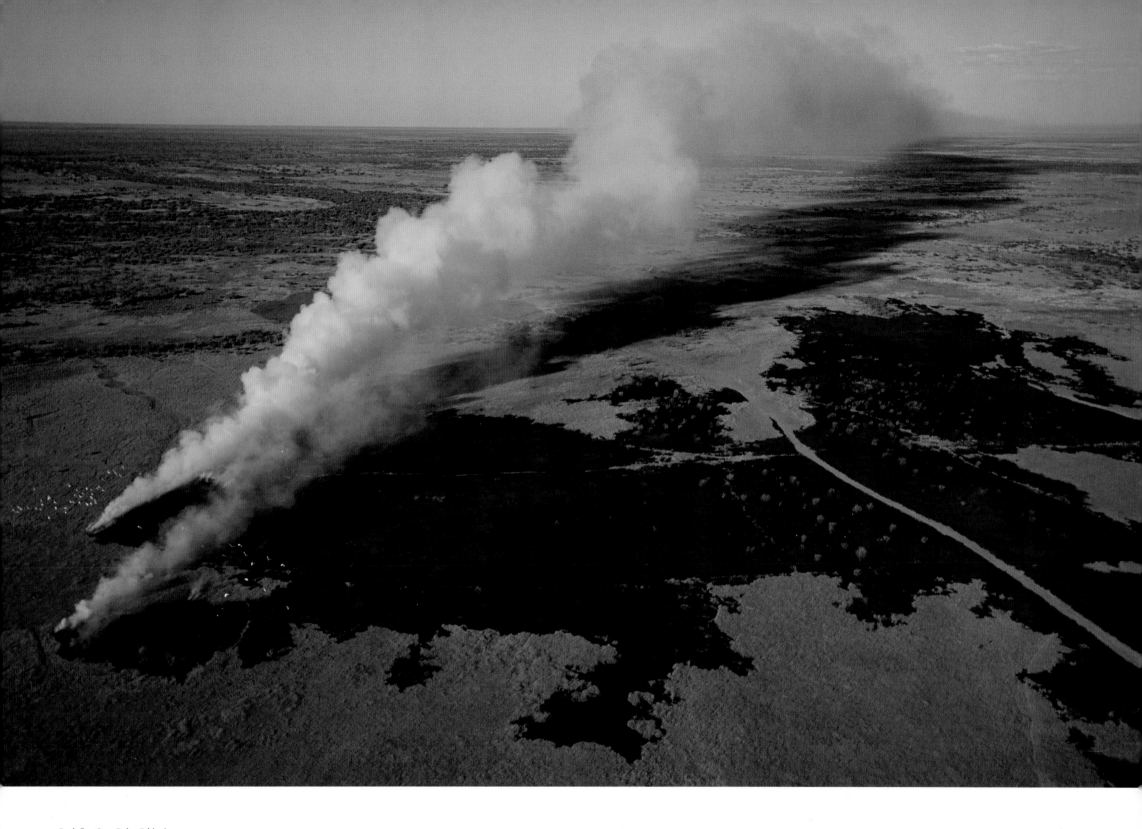

Bush fire, Omo Delta, Ethiopia

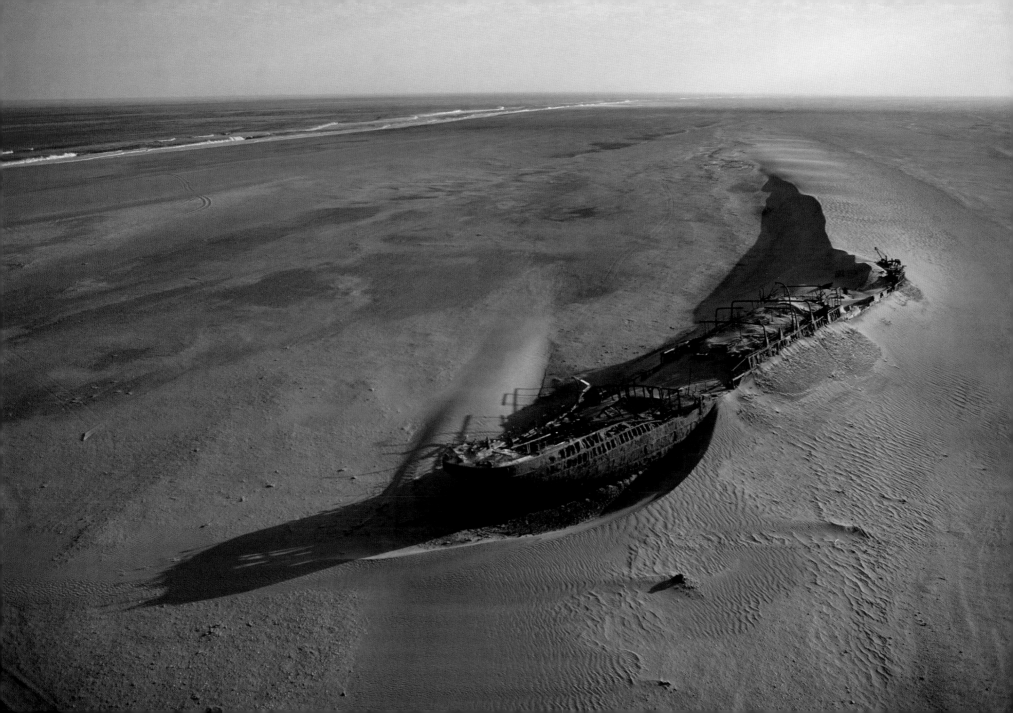

three of us peered desperately out the win-
of Hennie's aging Cessna 206, looking for
e to land. It was 8:30 in the morning, and we
unning low on fuel as we flew against the
vind of what had turned into a full-blown
torm. We had left Walvis Bay in Namibia
e sunrise, trying to catch the early morn-
ght on the *Eduard Bohlen*, an old shipwreck
as half submerged in the sand dunes some
miles to the south. This desolate stretch of
bia is known as the Skeleton Coast, for the
of whales and seals that wash up along its
, as well as for the carcasses of some thou-
commercial ships that have run aground
thick fog. But there was no place to land
ere, as the sand dunes stretch eighty miles
along 250 miles of uninhabited coastline.
nnie Rawlinson is one of the best bush
in Botswana, and Alain Arnoux and I had

been working out of his plane for weeks as we
crisscrossed southern Africa, but even Hennie
was tense that morning. The wind had been blow-
ing off the land for the past week, which was
great for us, as it left the coast clear of fog, but as
we headed back from the *Bohlen* wreck, the wind
picked up to the point where it was difficult to see
the ground, which by now resembled something
like a rapidly shifting beige carpet. As we neared
Walvis for landing, we had trouble finding the
seven-thousand-foot-long asphalt runway, even
with the aid of Hennie's handheld GPS. Finally,
we got a break in the blasts of sand, the runway
appeared, and Hennie spun the plane around to
drop us in. I've had landings with my paraglider
where the wind speed was the same as my thirty-
mile-per-hour flight speed, and I had to land
drifting straight down, with no ground speed
at all. But it's a most unsettling experience in a
fixed-wing aircraft, which lands with an airspeed
of sixty miles per hour. When the wheels finally
touched the ground, we all breathed a sigh of
relief. As we taxied in, Hennie radioed the tower,
but after a few minutes they still couldn't see us,
and we realized that we weren't moving at all—it
was just the constantly moving carpet of blowing
sand that made us think we were. Hennie had to
give it a lot of throttle to get us to the airfield's
only hangar so we could keep the plane from get-
ting damaged. It was a tricky operation, because
he couldn't turn onto the taxiway and risk having
a sideways gust flip us over. Hennie had me put

my feet on the brakes so he could pop out and get
the hangar opened up, and then it took all three
of us to push the plane inside.

It was a strange feeling, walking around the
terminal with clothes and hair matted with fine
sand among well-dressed passengers annoyed at
their delayed flights and missed connections. We
were just relieved to be back on the ground. ⊠

LEFT: Walvis Bay Airport in sandstorm
BELOW: Pushing Hennie's Cessna into the hangar at Walvis Ba

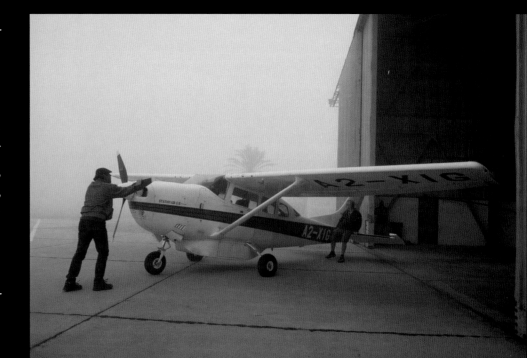

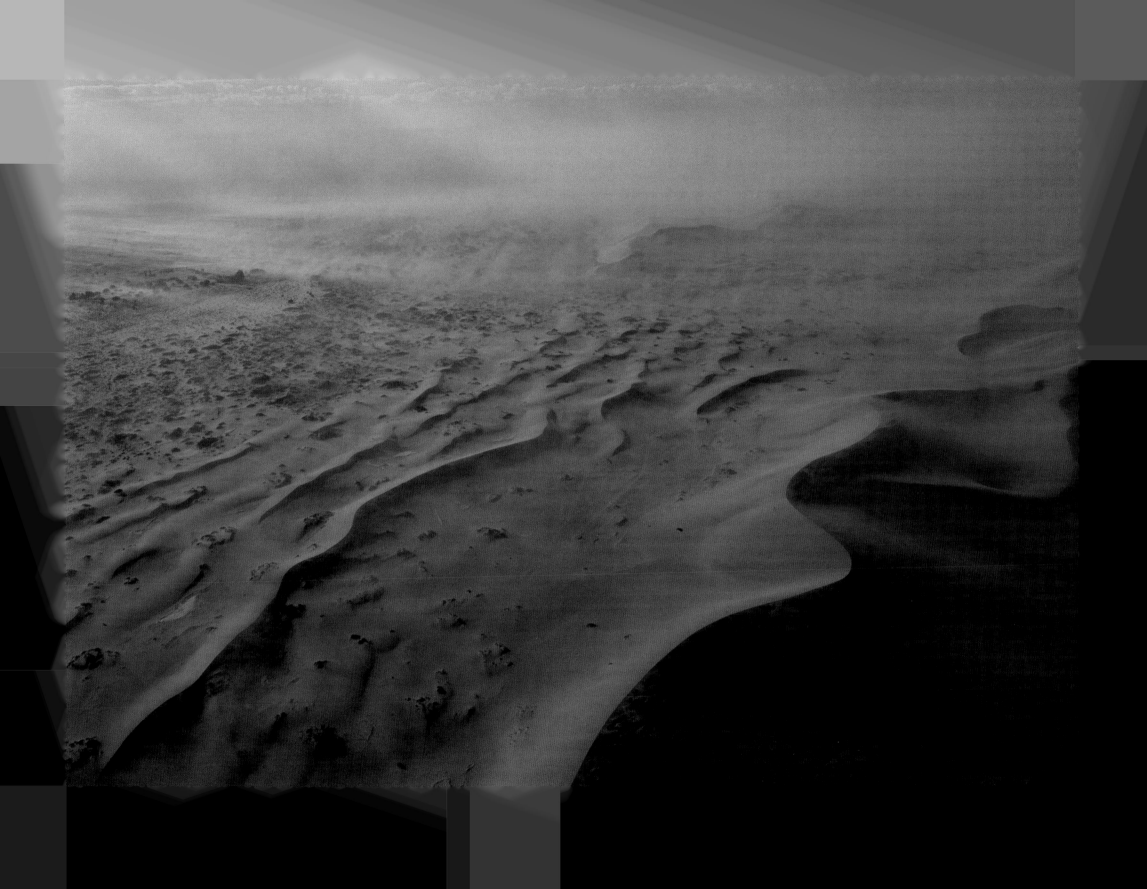

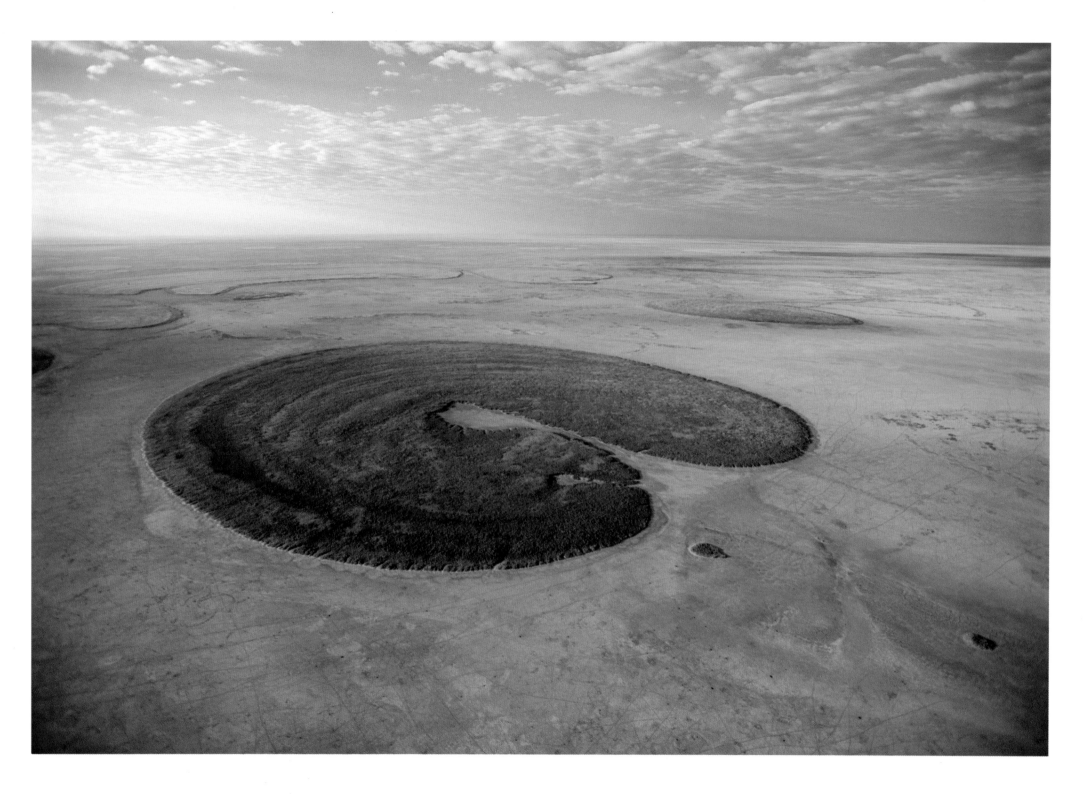

ABOVE: Grass island, Makgadikgadi Pans, Botswana
OPPOSITE: Salt ridge, Chalbi Desert, Kenya

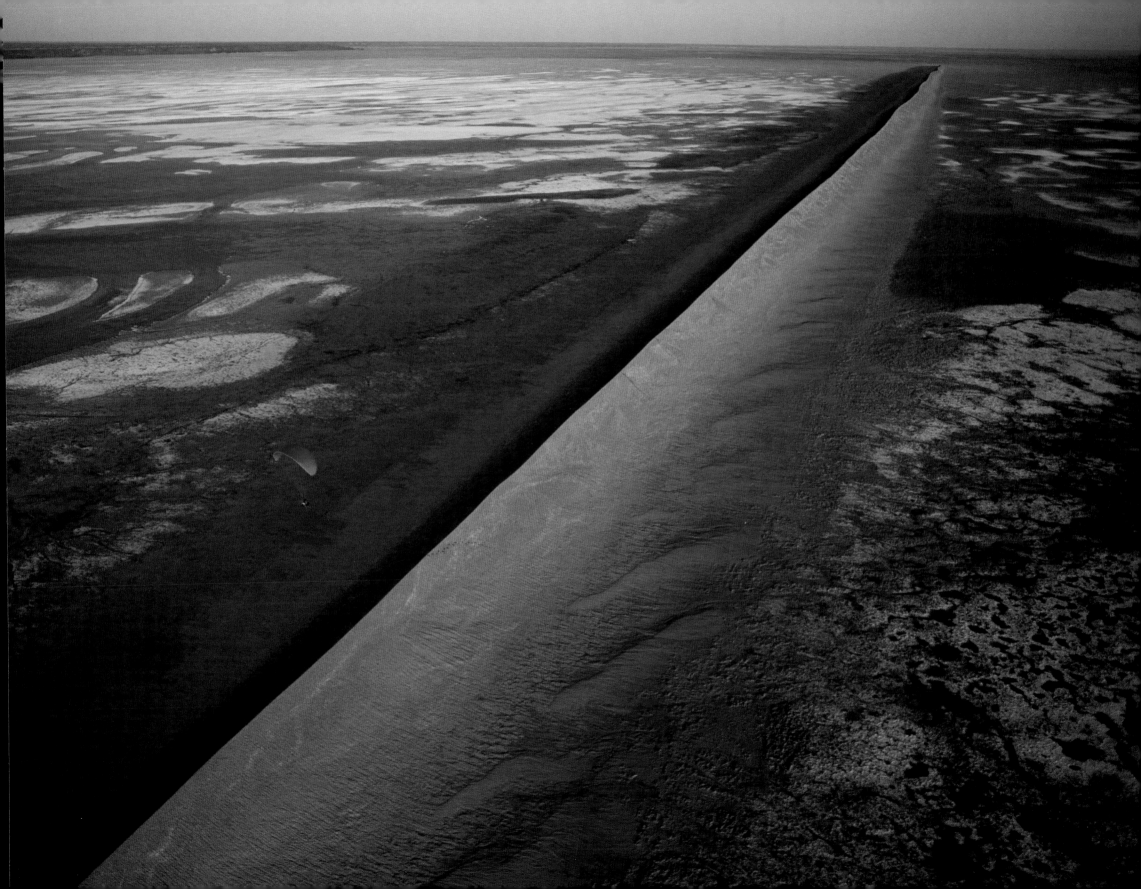

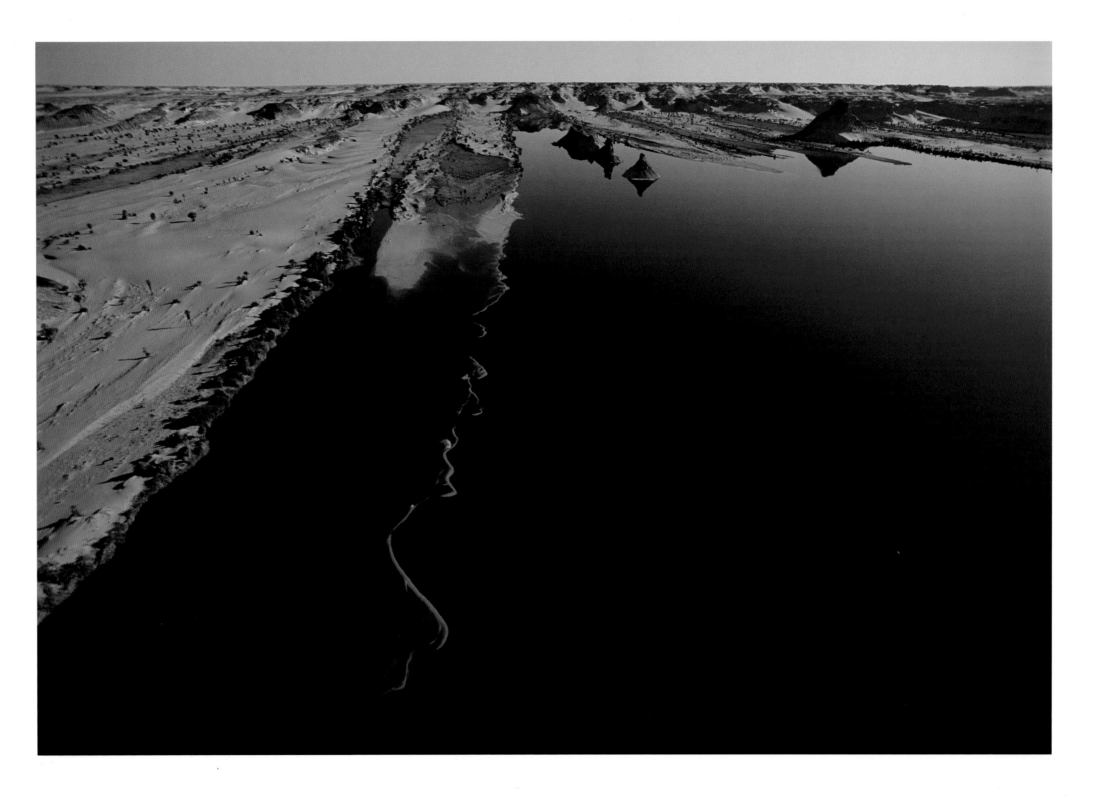

Lake Teli, Ounianga Serir, Chad

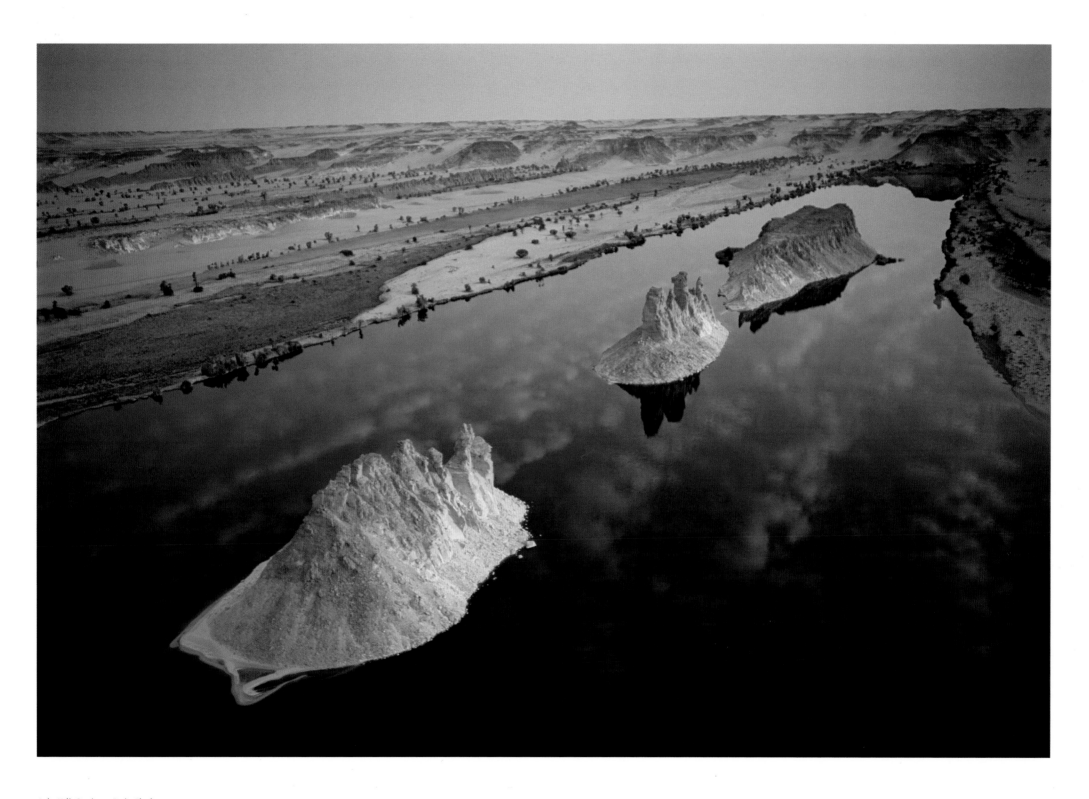

Lake Teli, Ounianga Serir, Chad

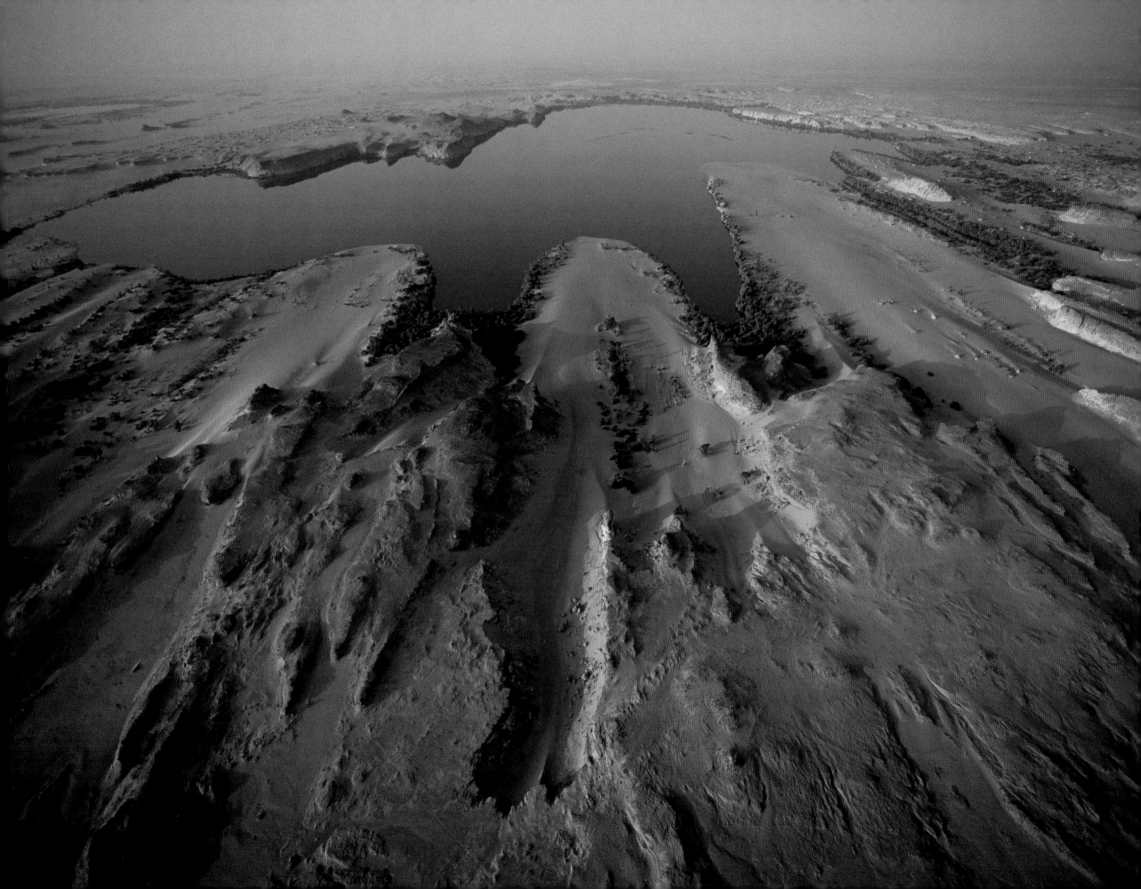

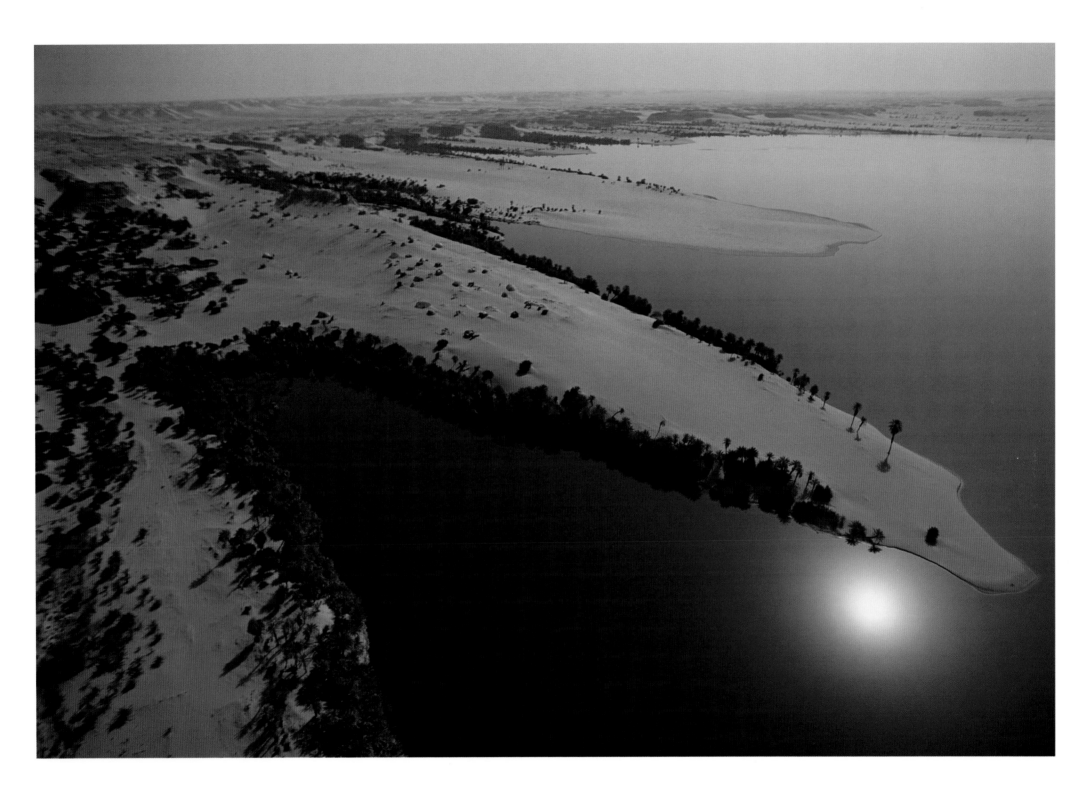

OPPOSITE: Lake Yoa, Ounianga Kebir, Chad

151

ABOVE: Lake Yoa, Ounianga Kebir, Chad

OVERLEAF: Sand dunes inundating Chinguetti, Mauritania

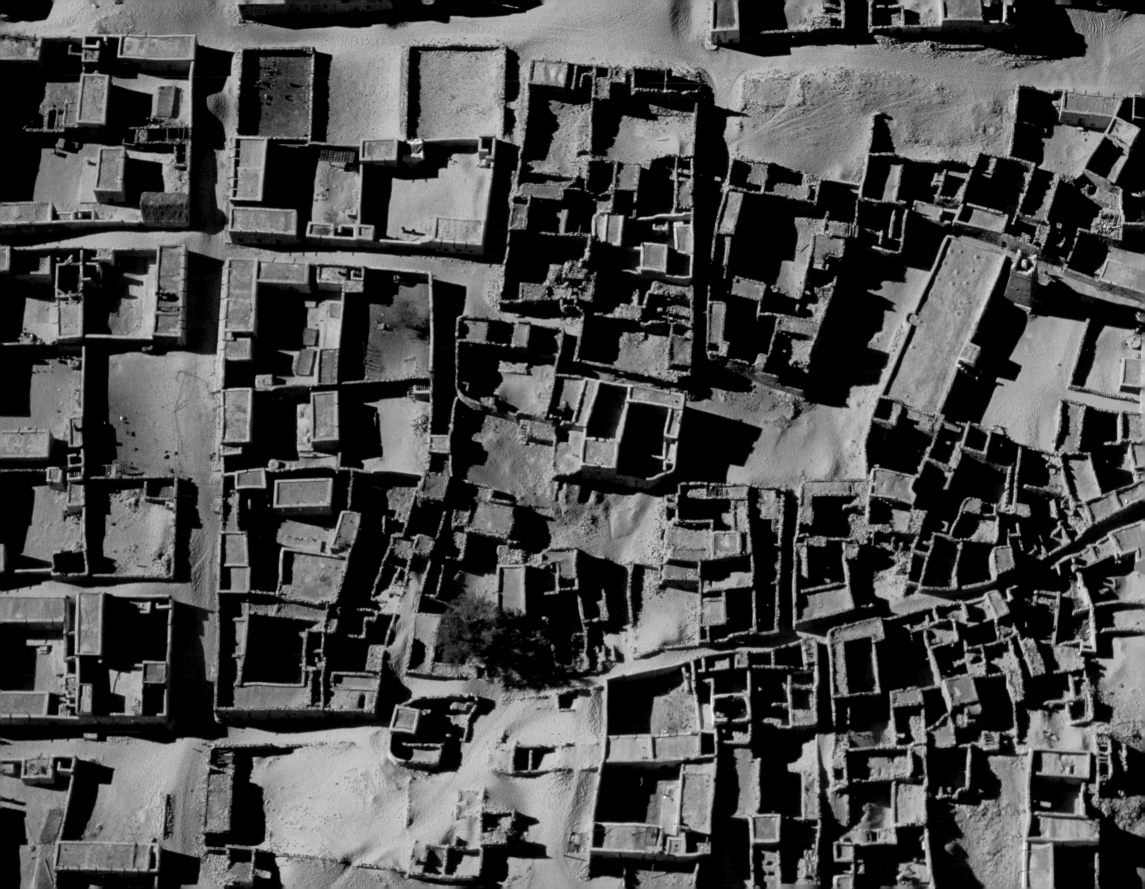

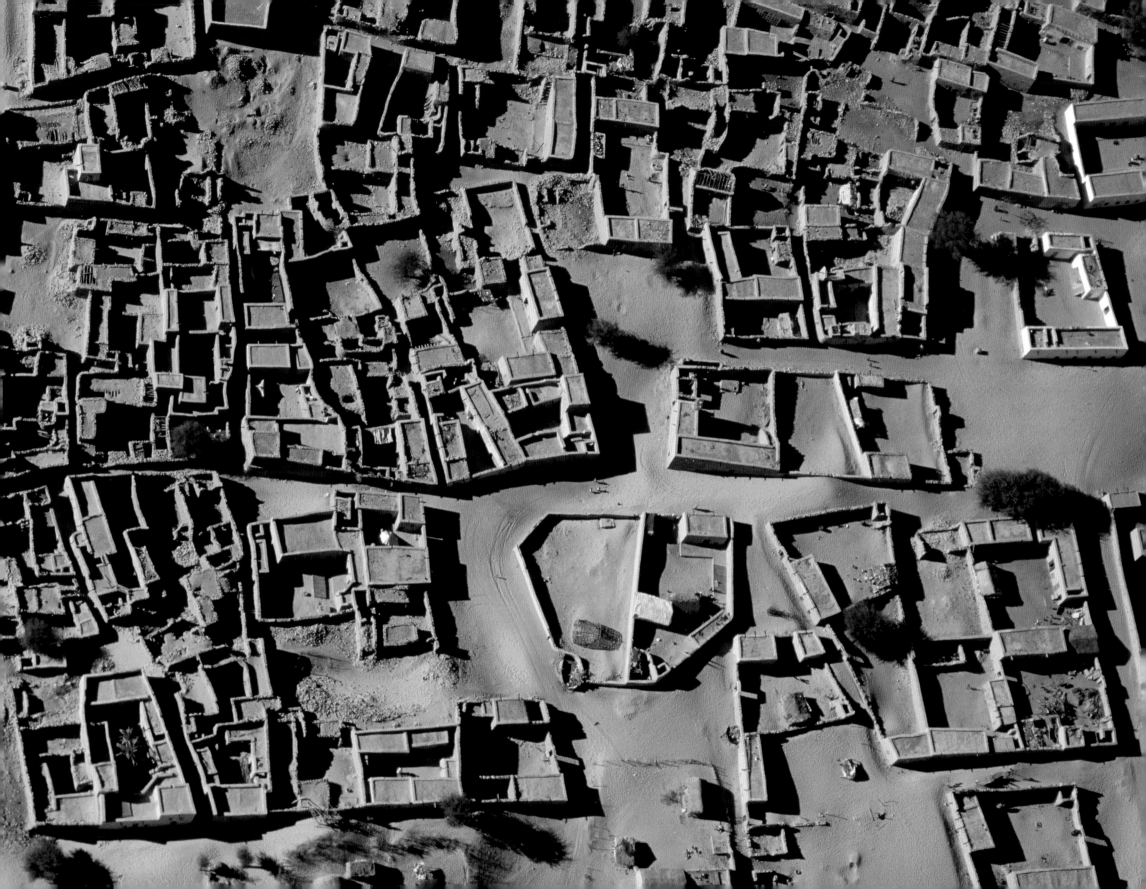

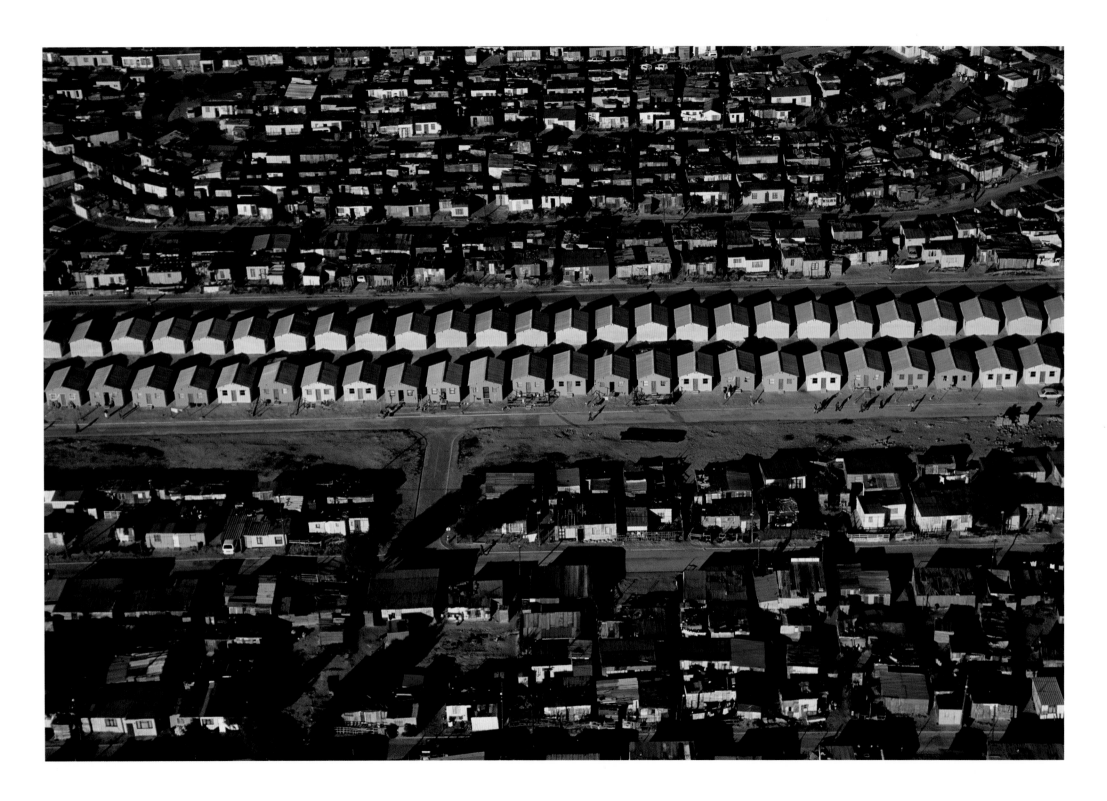

Post-apartheid housing, Cape Town, South Africa

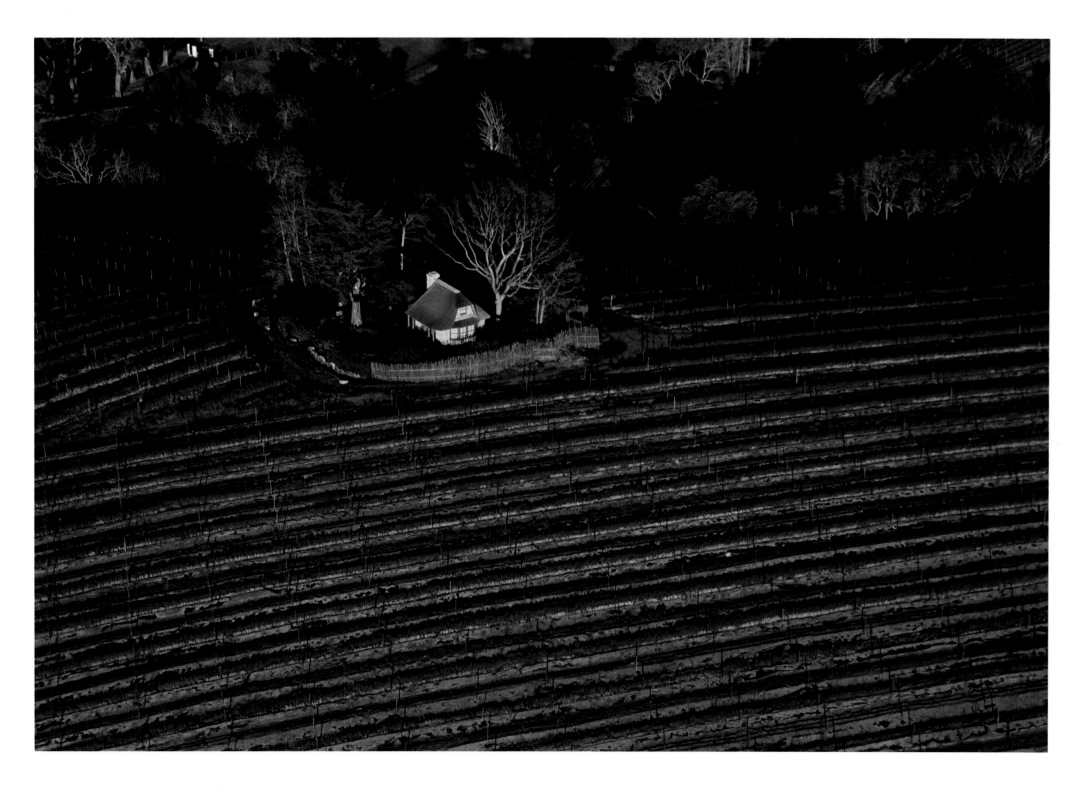

Private home, Cape Town, South Africa

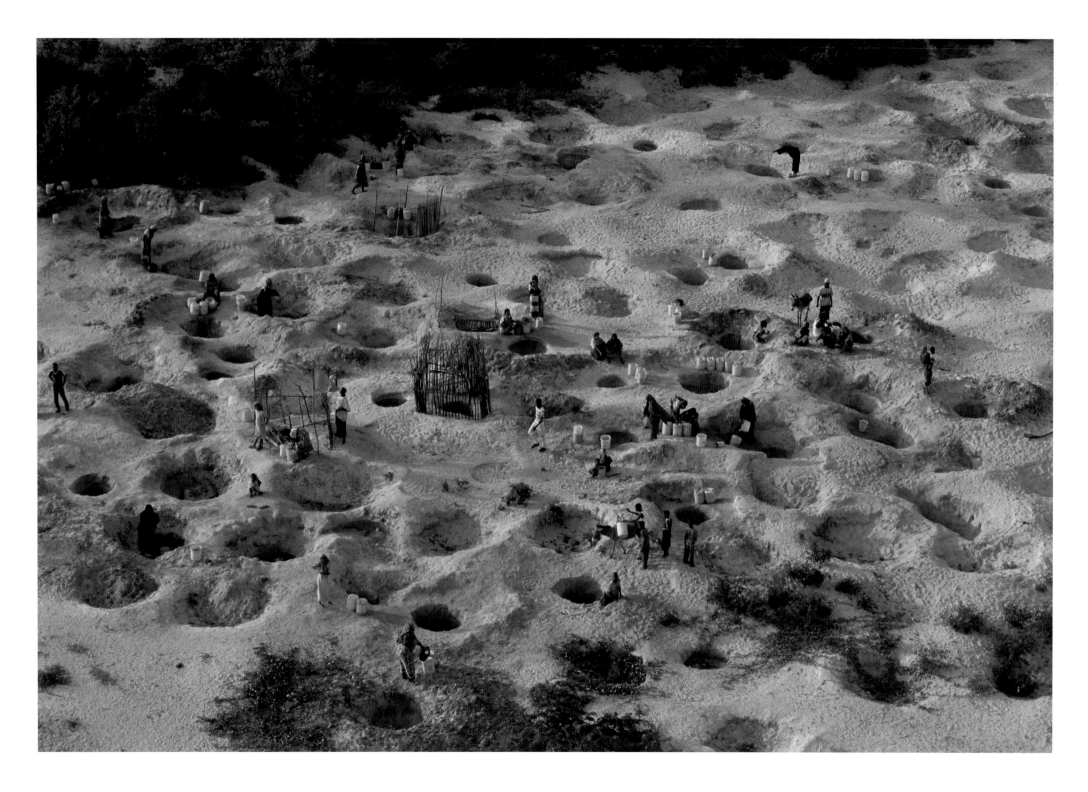

Gathering water, Pate Island, Kenya

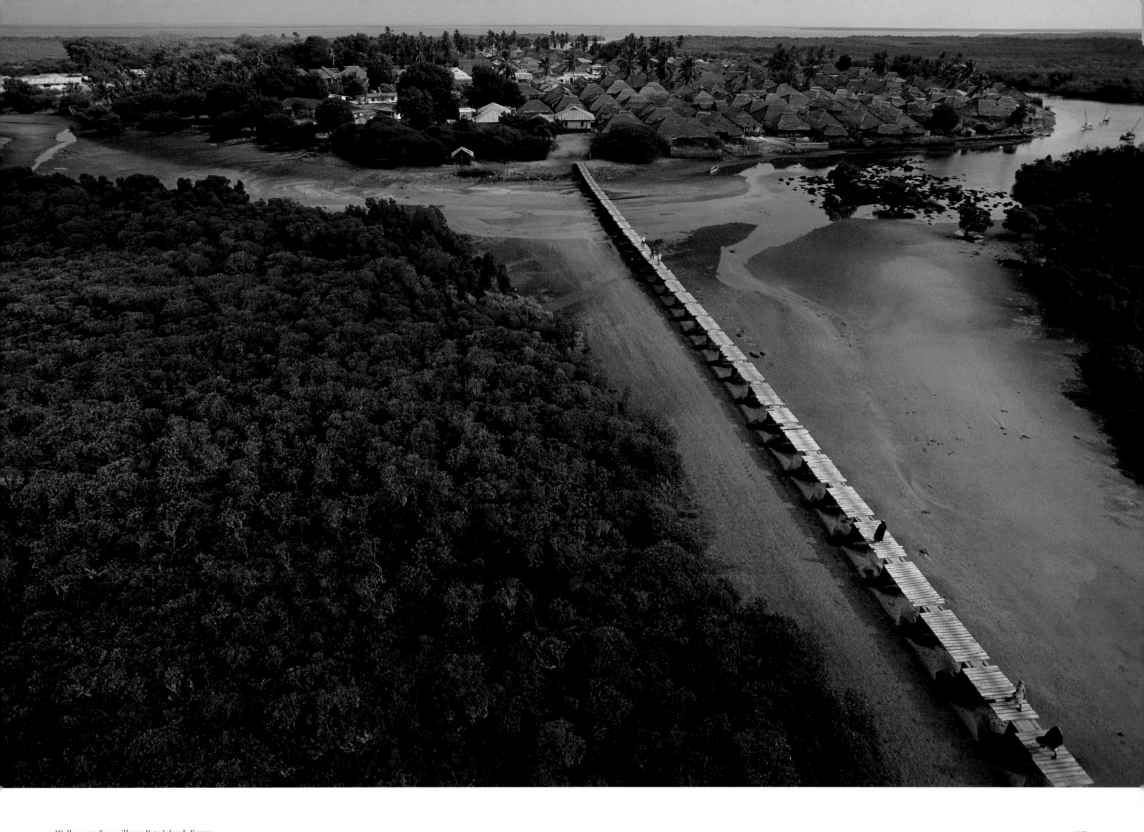

Walkway to Faza village, Pate Island, Kenya

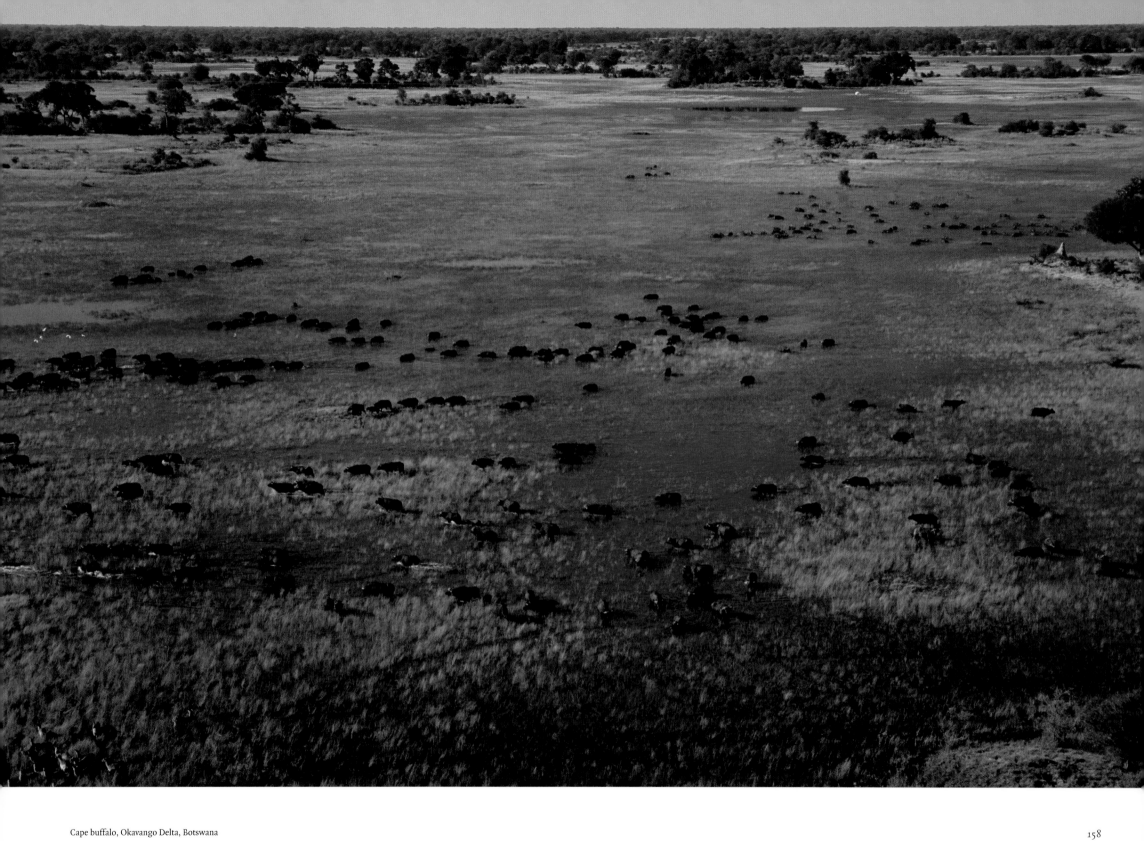

Cape buffalo, Okavango Delta, Botswana

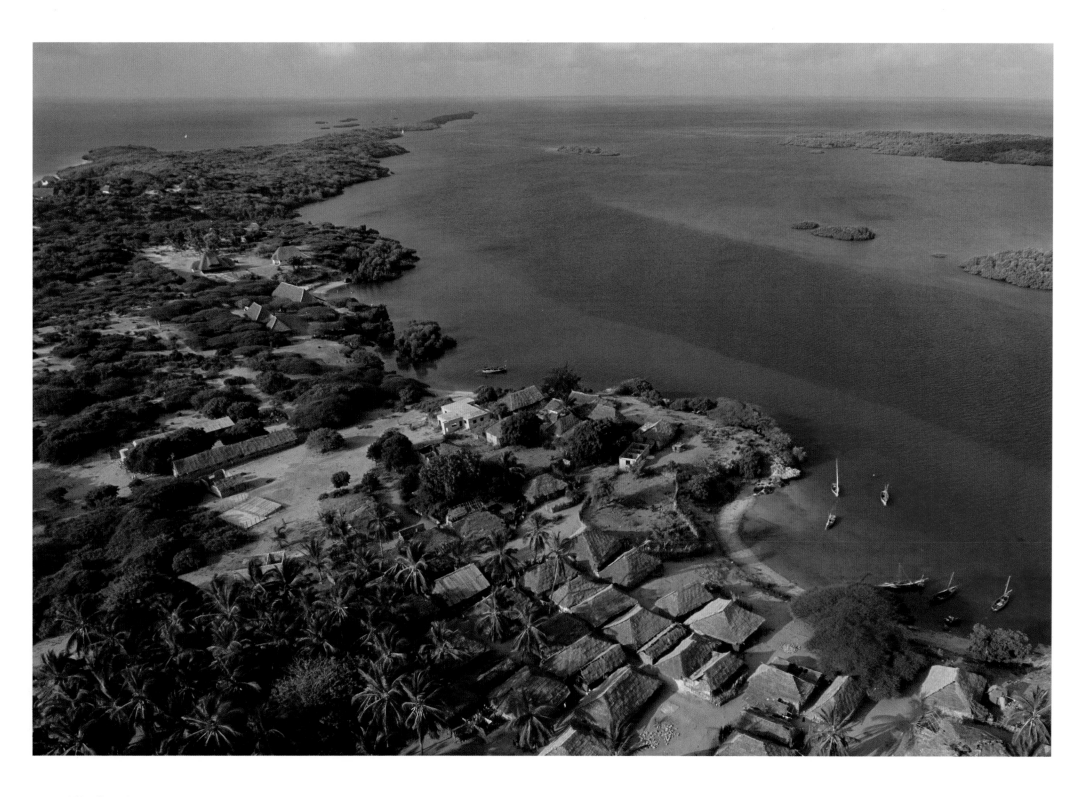

ABOVE: Fishing village, Kiwayu, Kenya
OVERLEAF: Cape Flats, Cape Town, South Africa

159

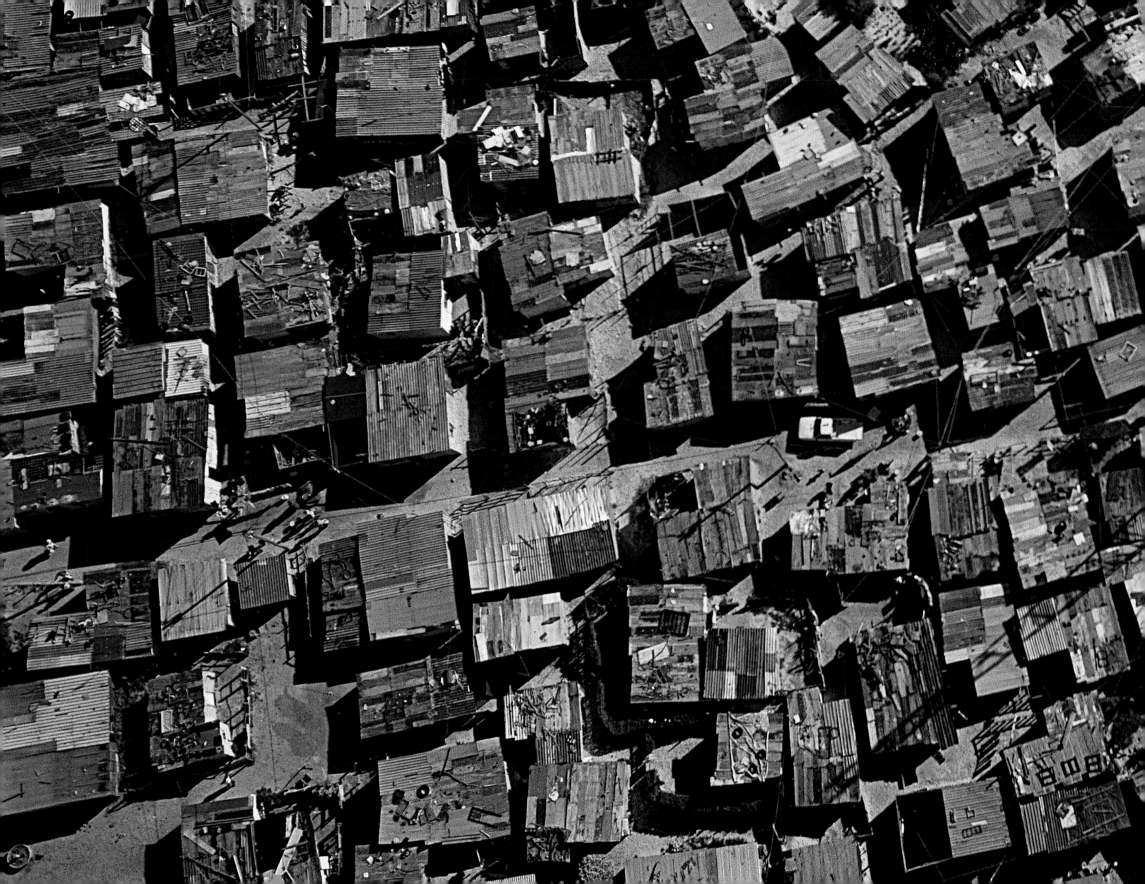

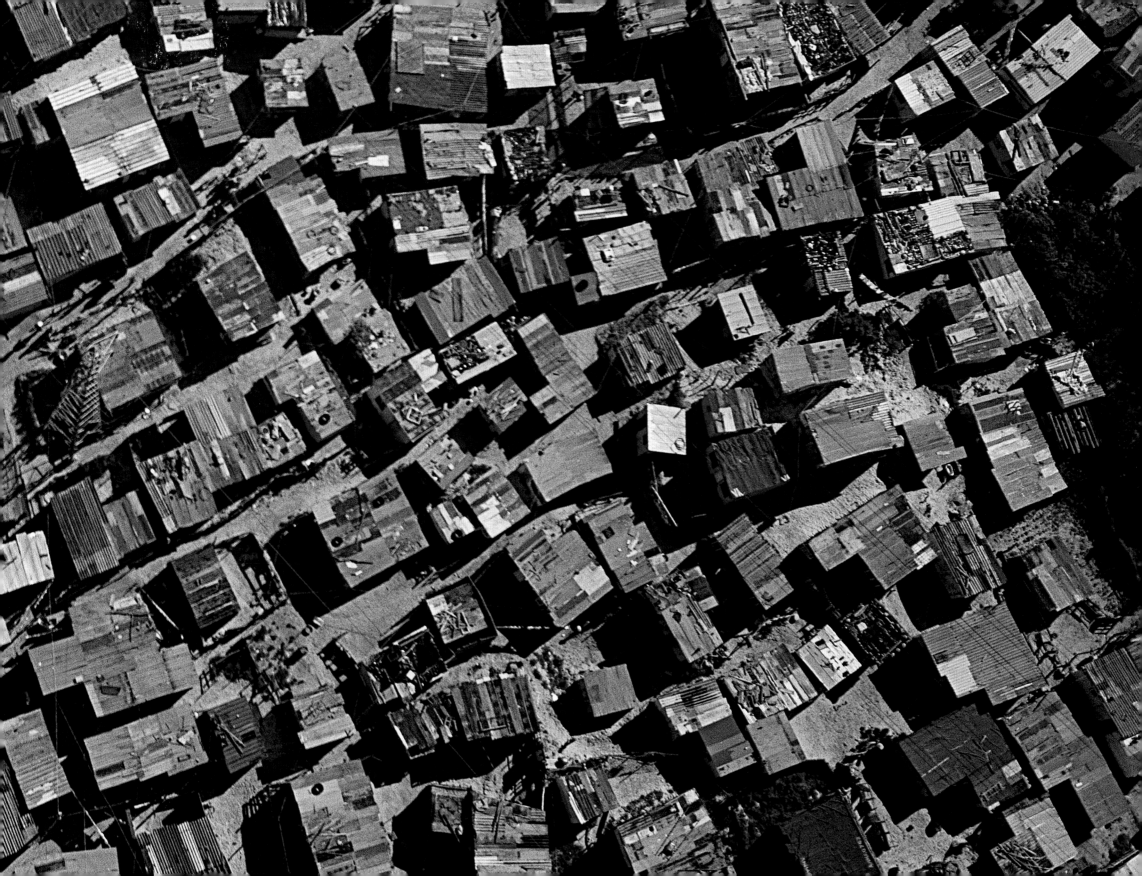

ABOVE: Flamingos, Skeleton Coast, Namibia
OPPOSITE: Goat market, Nouakchott, Mauritania

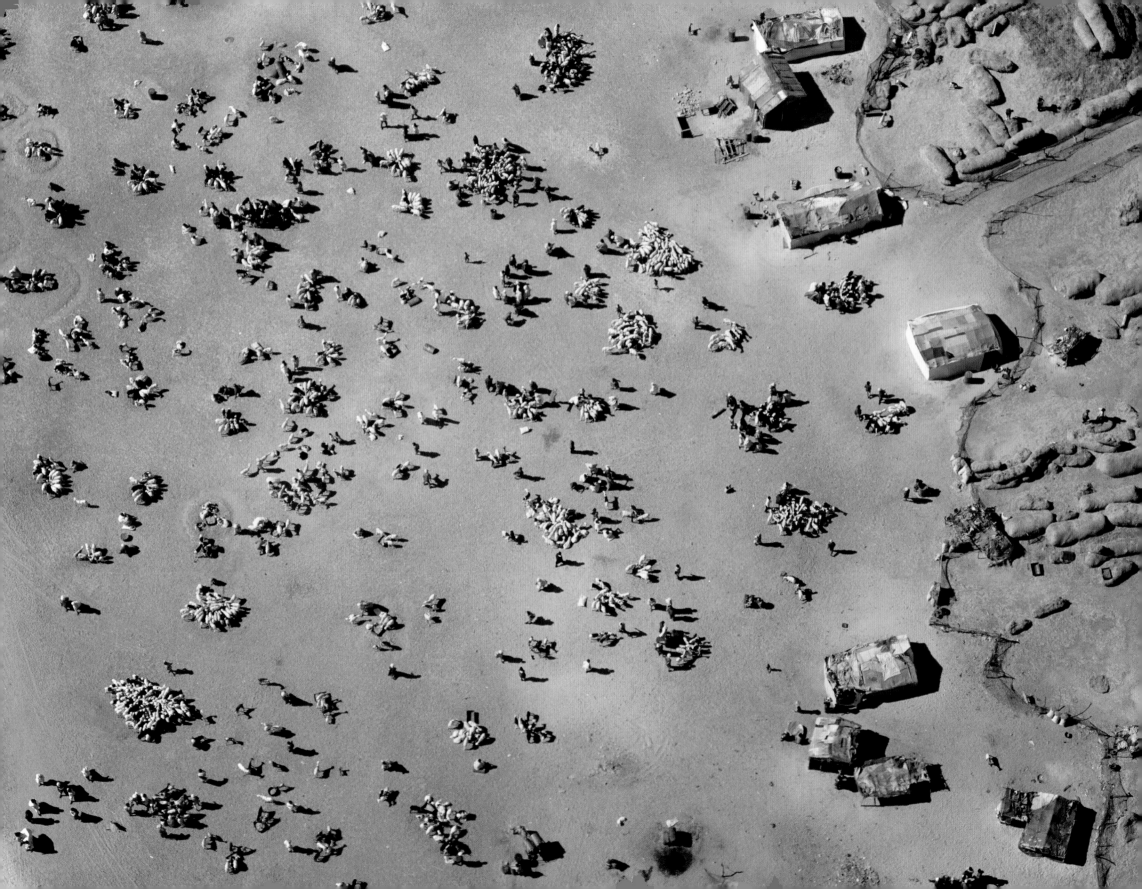

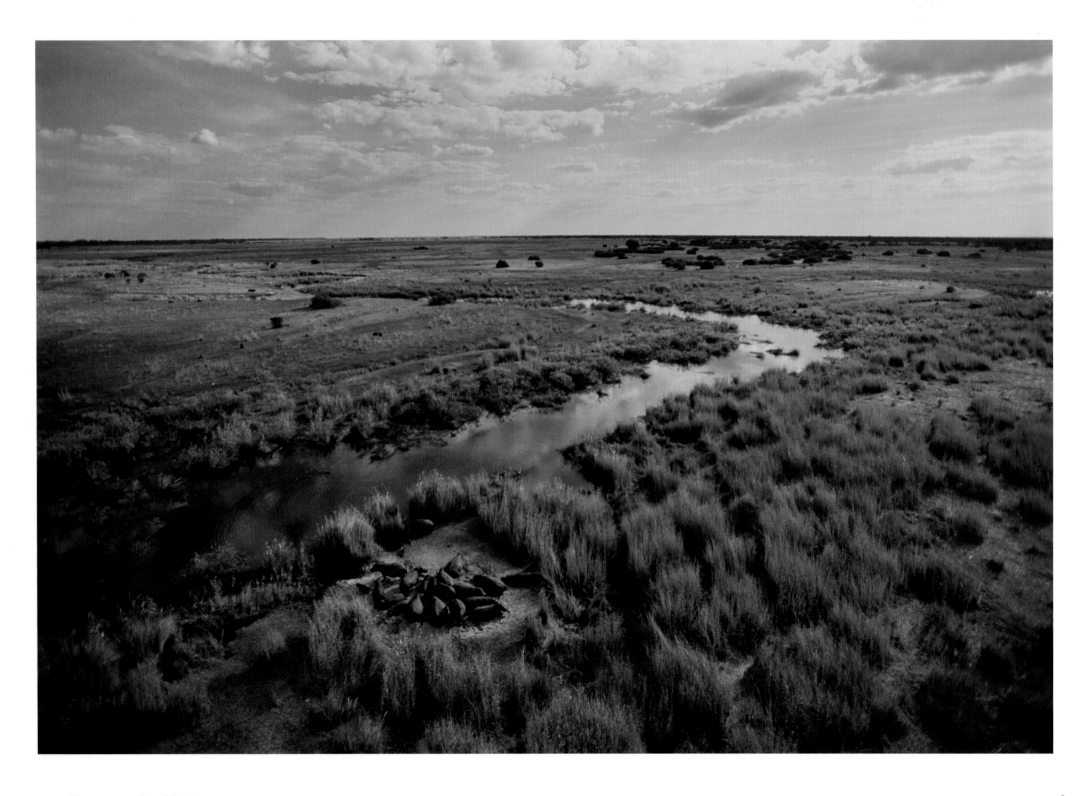

ABOVE: Hippopotamuses, Linyanti River, Botswana
OPPOSITE: Elephant family, Linyanti River, Botswana

164

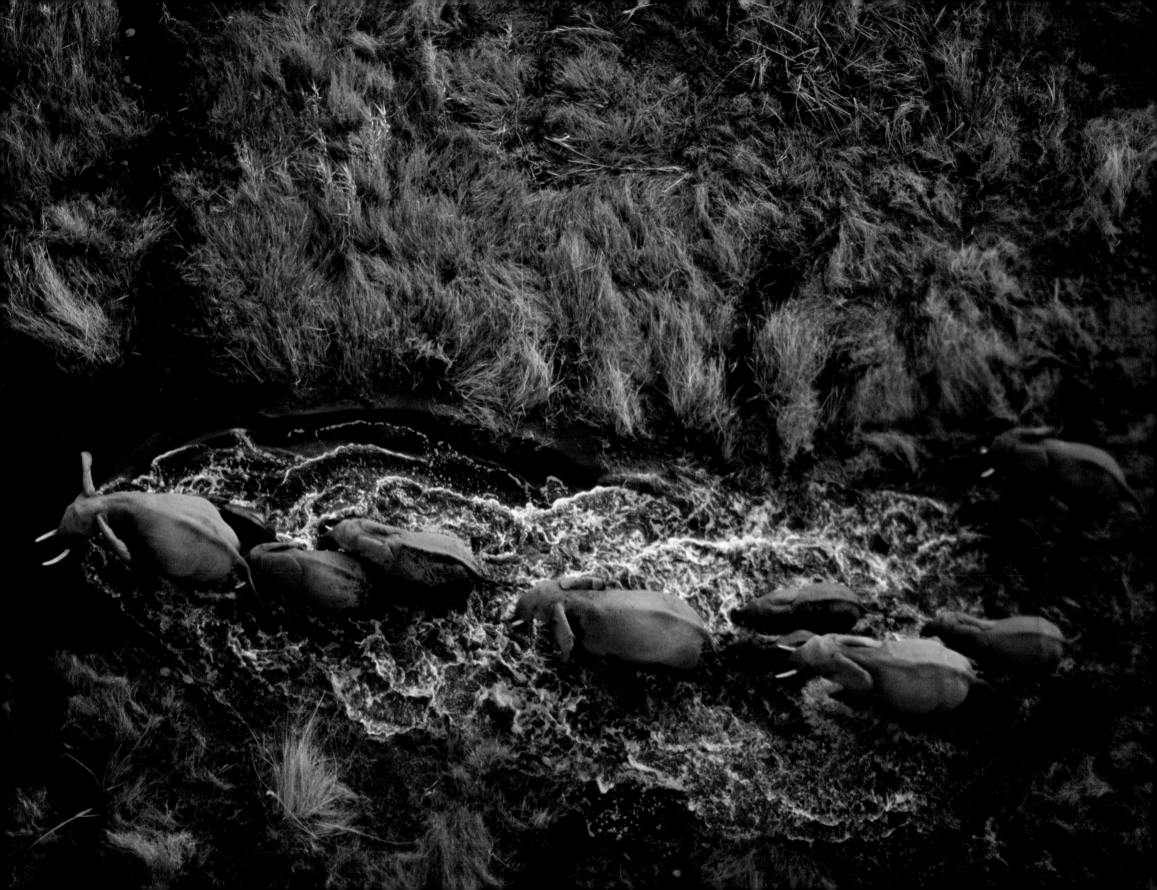

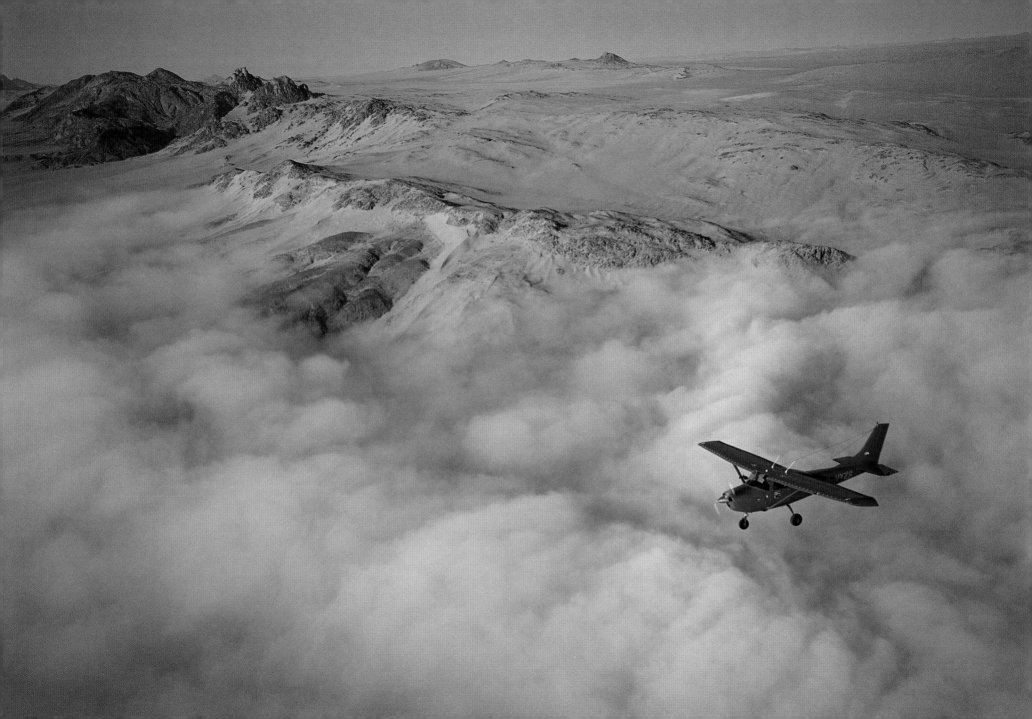

Even Africa Is a Small World

The light was dim, but the Pygmy across the campfire looked very familiar. We had driven into this research camp on a muddy logging road in a driving rain and were trying to dry out and get acquainted with our new team of game guards and trackers. I turned a log to create a bit more light, and then I realized I knew him.

It was 1989 and Mike Fay had brought me down to this southern tip of the Central African Republic (CAR) to document his study of the rain forest. Mike had come to know the area intimately, first as a Peace Corps volunteer and then as a scientist studying the ecosystem. He had even mastered Sango, the local language, and so I asked him to find out if this Pygmy guide went by the name Jean-Pierre. The man's face lit up with astonishment, and the conversation became animated as Mike translated my recol-

Équipe Forestière
Bai-hokou 11 May 89

lections of how J-P had taken my traveling companion, Marion van Offelen, and me out into the forest some ten years earlier, using little more than hand signals to communicate. Marion and I had gone out into the forest looking for elephants, and I never forgot this Pygmy named Jean-Pierre who didn't speak a word of French. He had first shown us the Pygmy's mastery of bush craft as we camped without a tent in the forest, then taken us to a clearing where he showed us our first forest elephants, proudly declaring, "Voilà!"

On our first day out exploring the rain forest, Mike showed me many of its wonders. Being with Fay here opened up levels of understanding that I never could have imagined as a young uninformed hitchhiker in the late 1970s. But now I felt as if we were peeling back the layers of an onion to reveal the intricacies of a vast hidden world. Mike showed me ants that had become infested with a brain fungus that impels them to climb trees until, finally, their heads explode, disseminating the fungal spores to the unfortunate ants below them. Later that day Mike suggested that we call in duikers (small forest antelopes) so that I could get some pictures of these extremely shy, reclusive creatures. He asked Jean-Pierre to imitate the sound of a duiker giving birth; within minutes, several duikers bounded toward us from out of the gloom to feast on the expected female's nutrient-rich afterbirth. Along the larger elephant trails, Mike opened up piles of elephant dung in search of seedpods. Elephants are the only

animals capable of eating certain large tree fruits, like those of the majestic moabi, and thus are the only animals that can transport and deposit their seeds for germination in huge piles of steaming manure. As many as one-third of lowland forest trees reproduce this way, and if forest elephants continue to be wiped out by poachers, the forest will lose much of its plant and animal diversity.

That night by the fire, Mike told me of a dream trip he hoped to make, walking on foot all the way from the CAR to the Atlantic coast in Gabon. It was six hundred miles in a straight line across what was almost entirely dense, uninhabited, roadless jungle. There was no record of any human visitation, and Mike wanted to study an ecosystem that had never been touched by humans. To me, it sounded like an interesting nightmare of leeches, infections, exhaustion, and foul-smelling clothes, and I didn't rise to the bait. But Mike did, and twelve years later he completed his "megatransect" project. It took him fifteen months to walk through two thousand miles of virgin terrain before wading into the sea with his team of Pygmy porters, who were astonished to see such a large expanse of water. With the data and images collected on that trip, Mike convinced the president of Gabon to set up a system of national parks protecting more than 615,000 acres of pristine rain forest.

I ran into Mike again in 2004 when *National Geographic* agreed to support Mike's next big project—the megaflyover. His intention was to make

LEFT: Dr. Michael Fay and George Steinmetz with forest guards near Bayanga, Central African Republic, in 1989
TOP: Mike Fay with BaAka Pygmies, Bayanga, CAR, May 1989
ABOVE: Mike Fay examining elephant dung, near Bayanga, CAR, May 1989

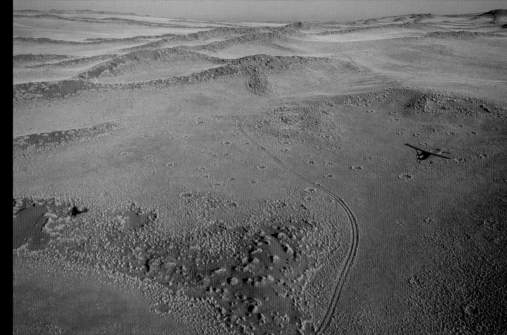

an aerial survey of every country in Africa by small plane at low altitude. Mike was hoping to find the last wild places in Africa in an effort to preserve them. The *Geographic* wanted me to document his discoveries with my motorized paraglider. It was the dream gig—to photograph the entire African continent from the air. But Mike's itinerary soon extended beyond the magazine's deadline, so we went our separate ways with a promise to meet in the course of our parallel fieldwork. Well over half the photos in this book were taken during my time on that most extraordinary project.

I caught up with Mike a few months later in Sossusvlei, a beautiful river valley that pokes into the coastal desert of Namibia. We were both fifteen years older than when we had first met in the CAR, and since then both had become smitten by the possibilities of exploring wilderness with the benefit of low-altitude aviation. As a courtesy extended to us by a luxury safari company, we were able to stay in five-star safari lodges for next to nothing. But Mike insisted on sleeping outside on the verandas of our well-appointed bungalows using his own sleeping bag. He had abandoned shaving and showering as well and seemed to be living for the sole fulfillment of his goal. I had chartered the aircraft and services of expert bush pilot Hennie Rawlinson, and we shadowed Mike and his pilot, Peter Ragg, in their refurbished red Cessna. We leap-frogged each other as we flew up the coast to meet again on the Angolan border—he was looking for data and I was chasing after

ABOVE: Michael Fay checking aerial survey data in northern Namibia
ABOVE, RIGHT: Michael Fay surveying Namib-Naukluft Park, Namibia

pictures. There we slept under the wings of our planes on a dirt airfield rather than waste time driving an hour to the lodge. Around the airfield campfire Mike pulled out his laptop and showed us the mosaic of satellite data he had flown over, overlaid with the photos taken every fifteen seconds by a digital camera mounted on the bottom of the plane. It was an impressive system and a huge undertaking, but I have to admit it gave me a headache when I imagined trying to correlate the combination of his satellite images and a hundred thousand photos with the com-

plex truth on the ground. But the headache soon faded as we sat in our safari chairs eating massive steaks washed down with whiskey under the magical canopy of a clear desert sky. The next day Mike and I parted ways once again, and I can only wonder how long it will be before we share a campfire again. ▨

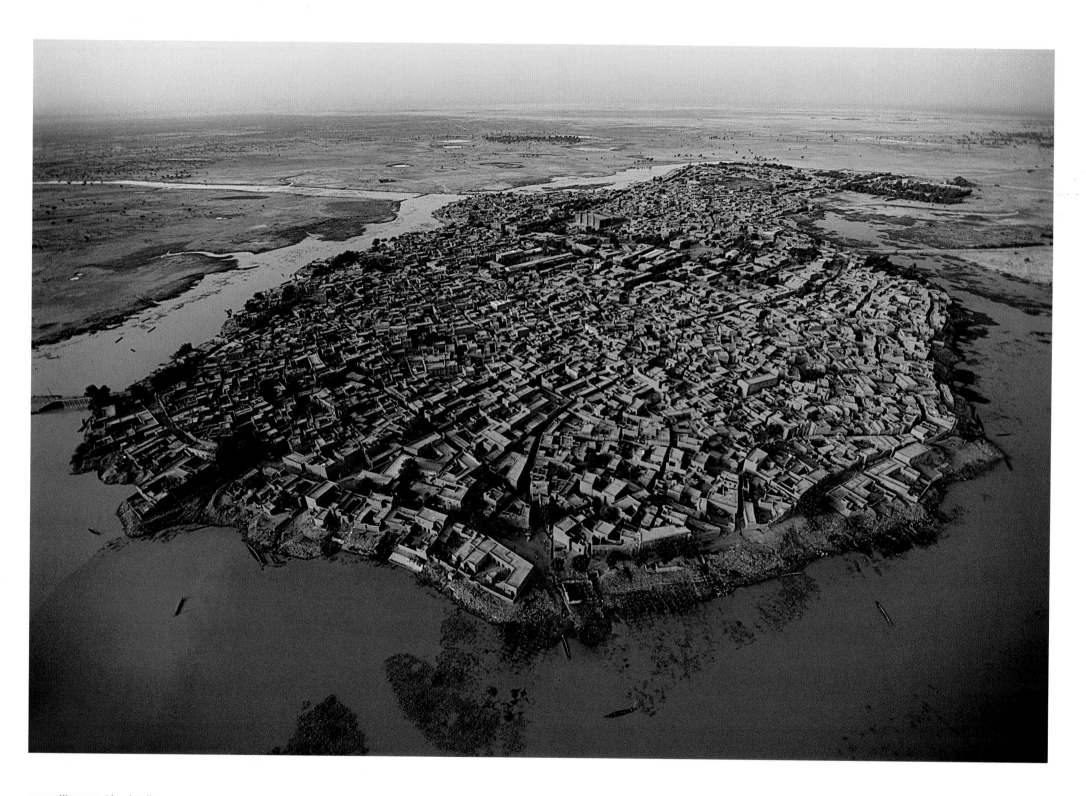

ABOVE: Wet season, Djenné, Mali
OPPOSITE: Island village near Ayorou, Niger

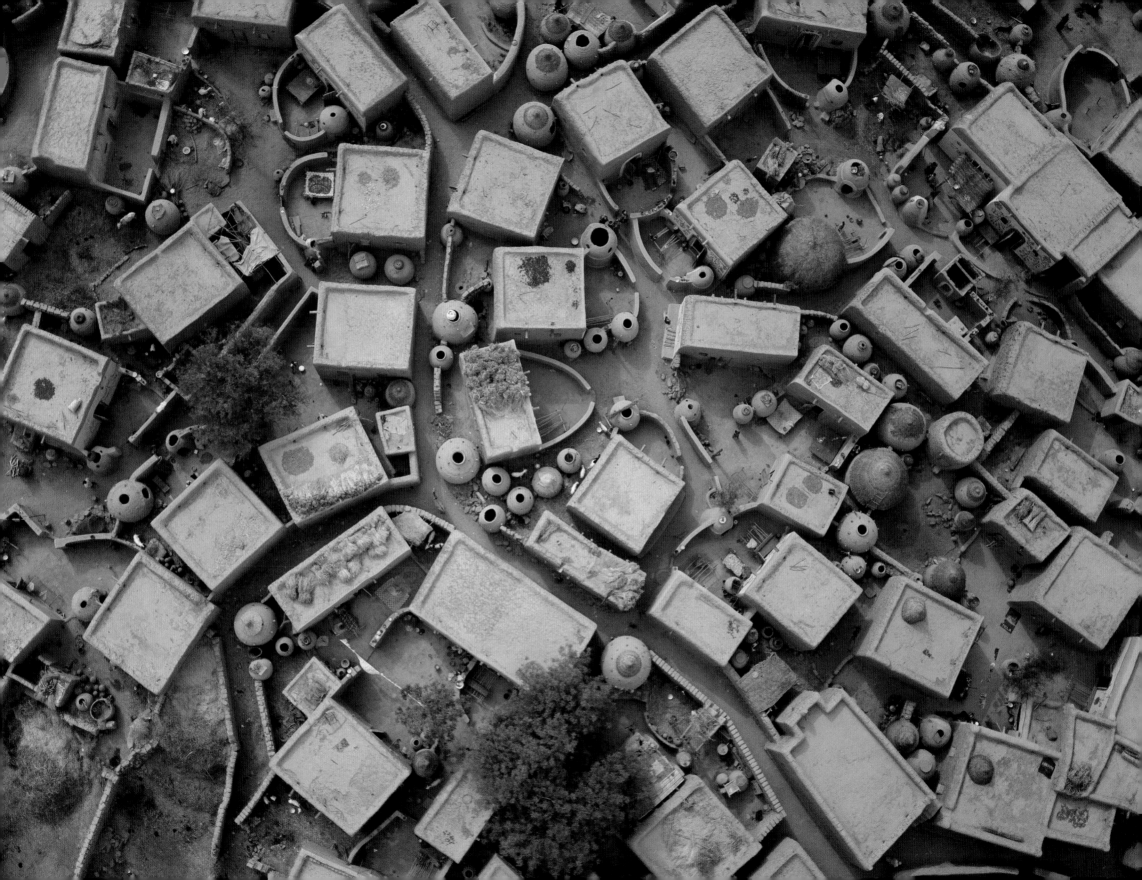

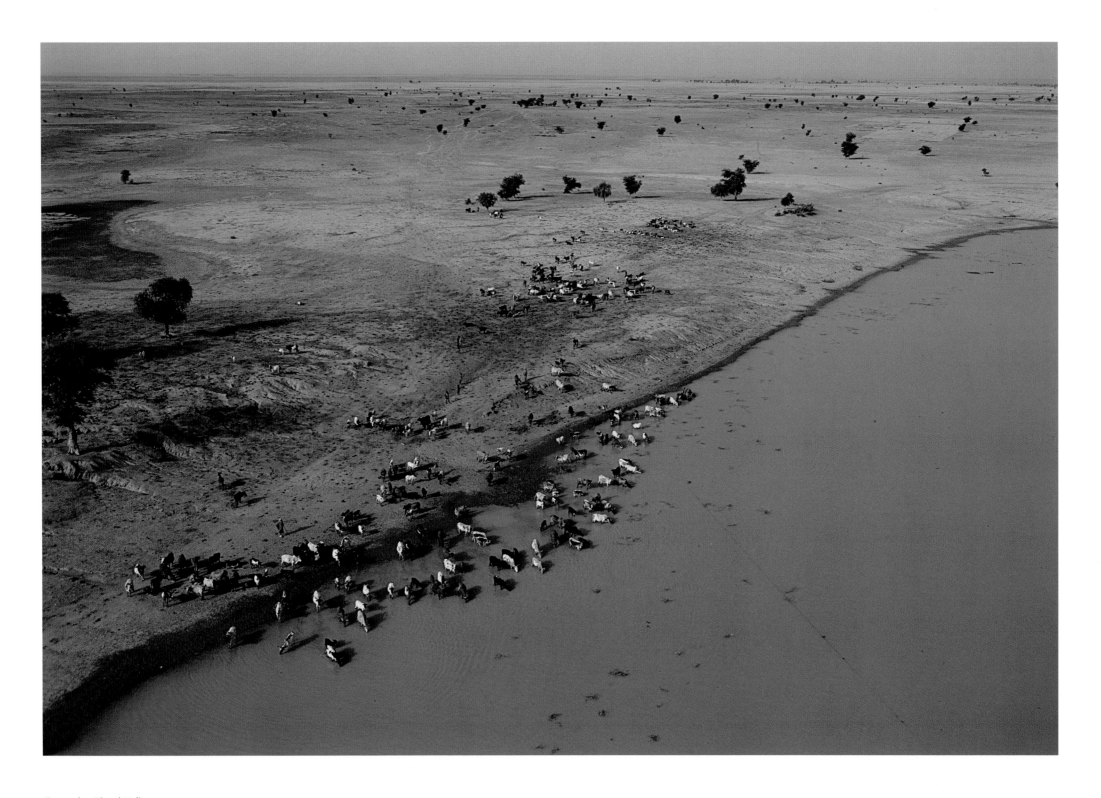

Overgrazing, Djenné, Mali

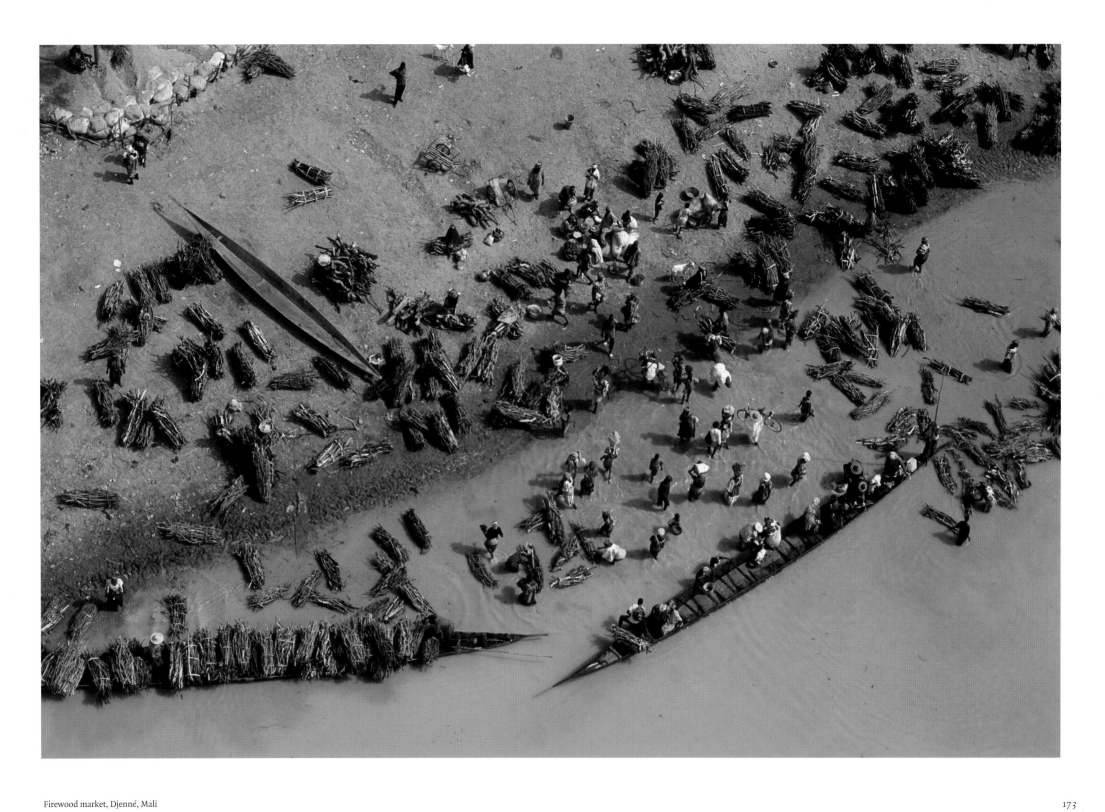

Firewood market, Djenné, Mali

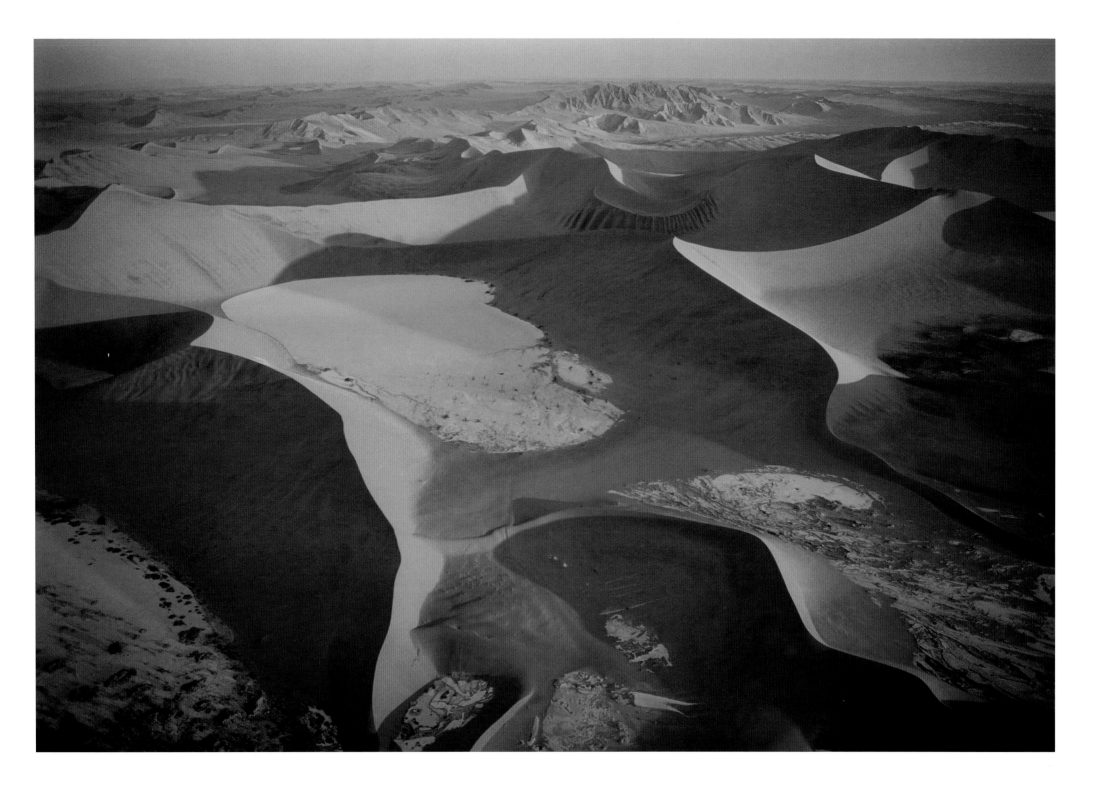

Migrating dunes, Sossusvlei, Namibia

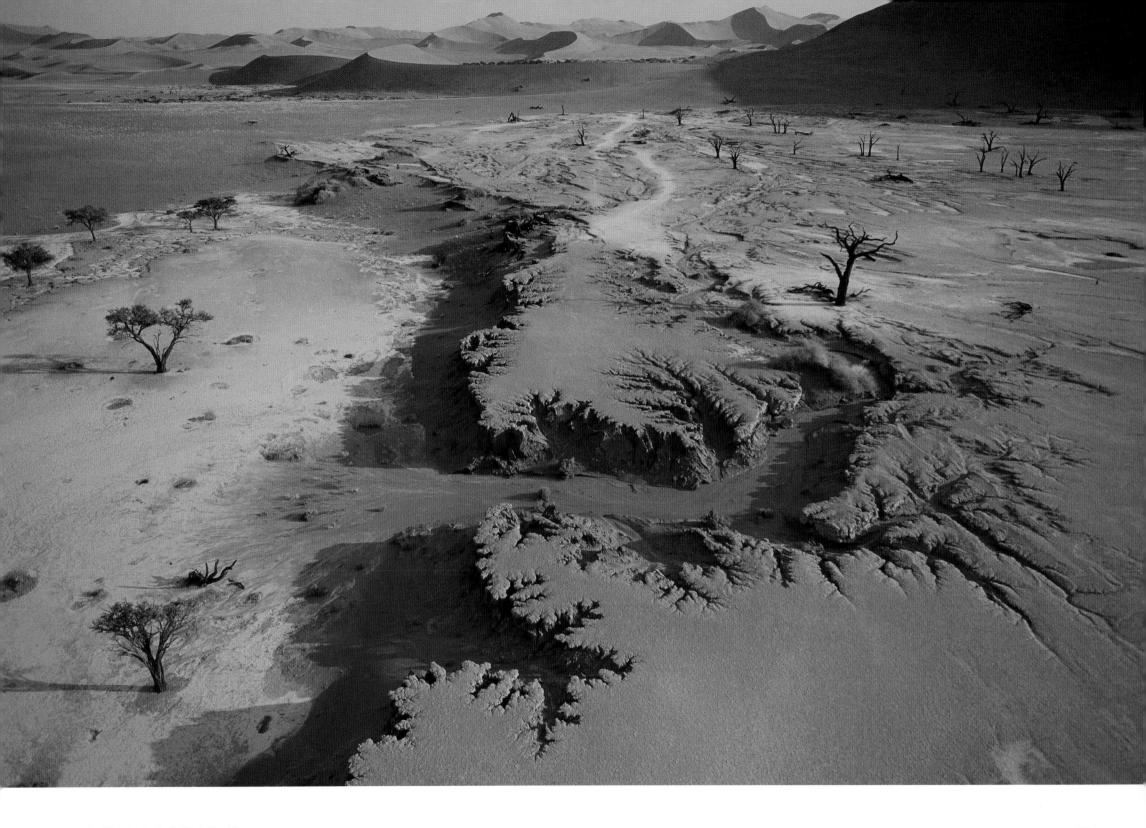

ABOVE: Dead Vlei, Namib-Naukluft Park, Namibia
OVERLEAF: Delta of Lake Natron, Kenya

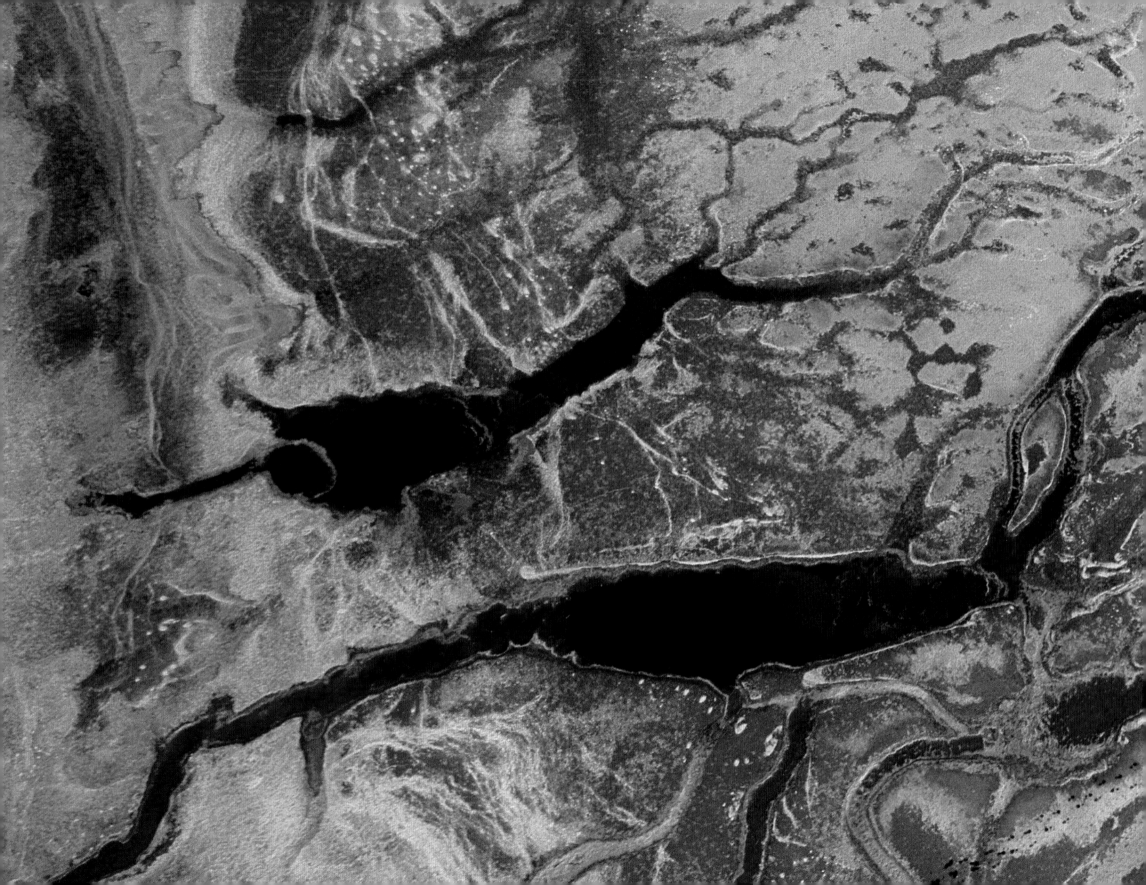

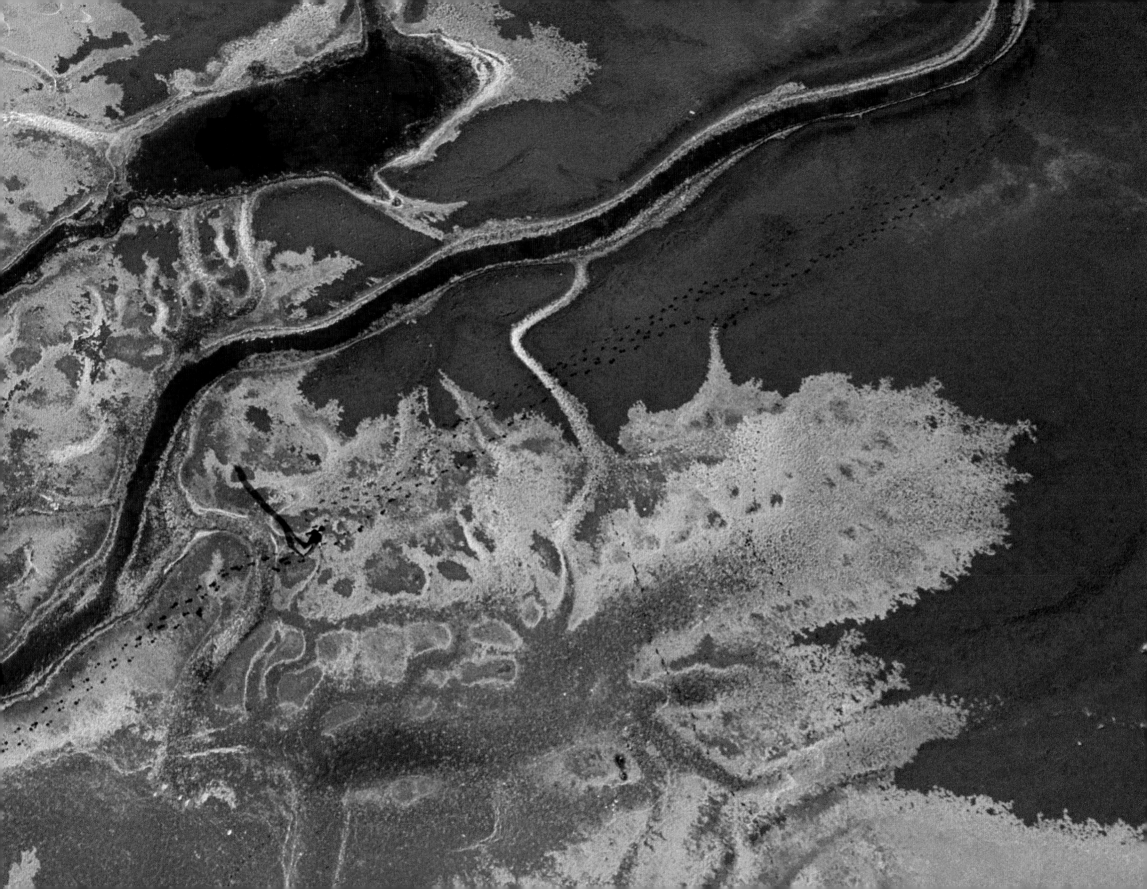

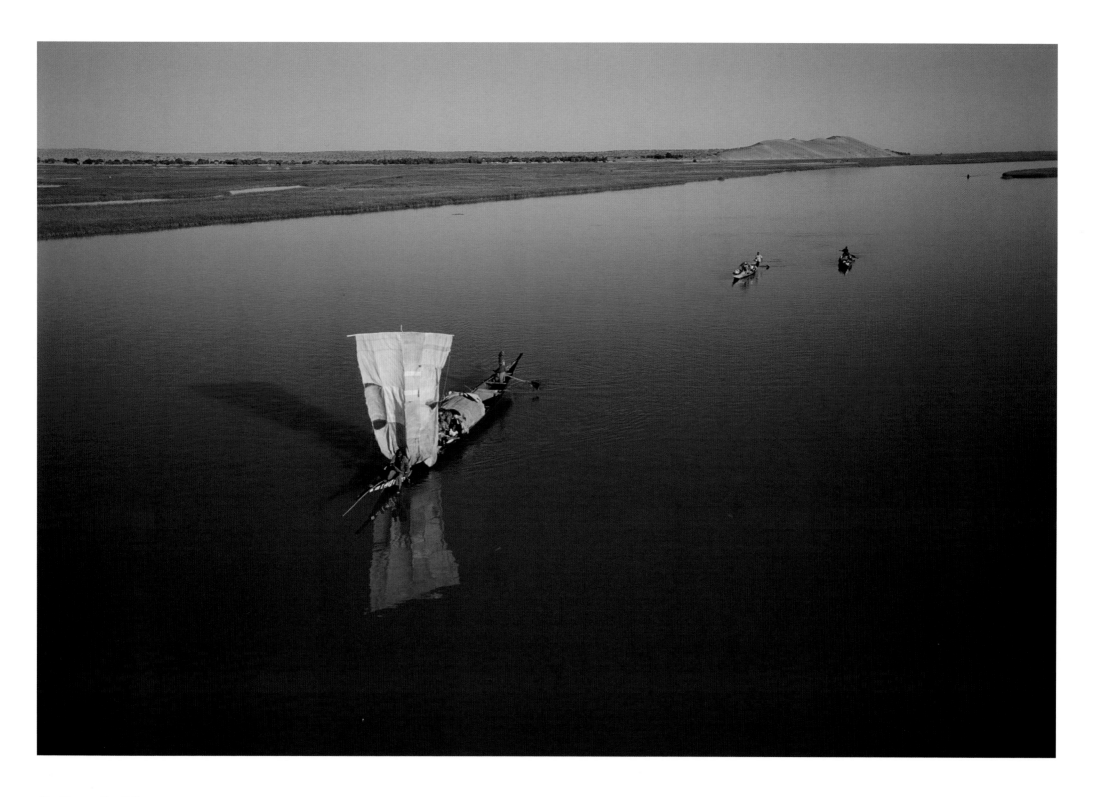

Niger River, near Gao, Mali

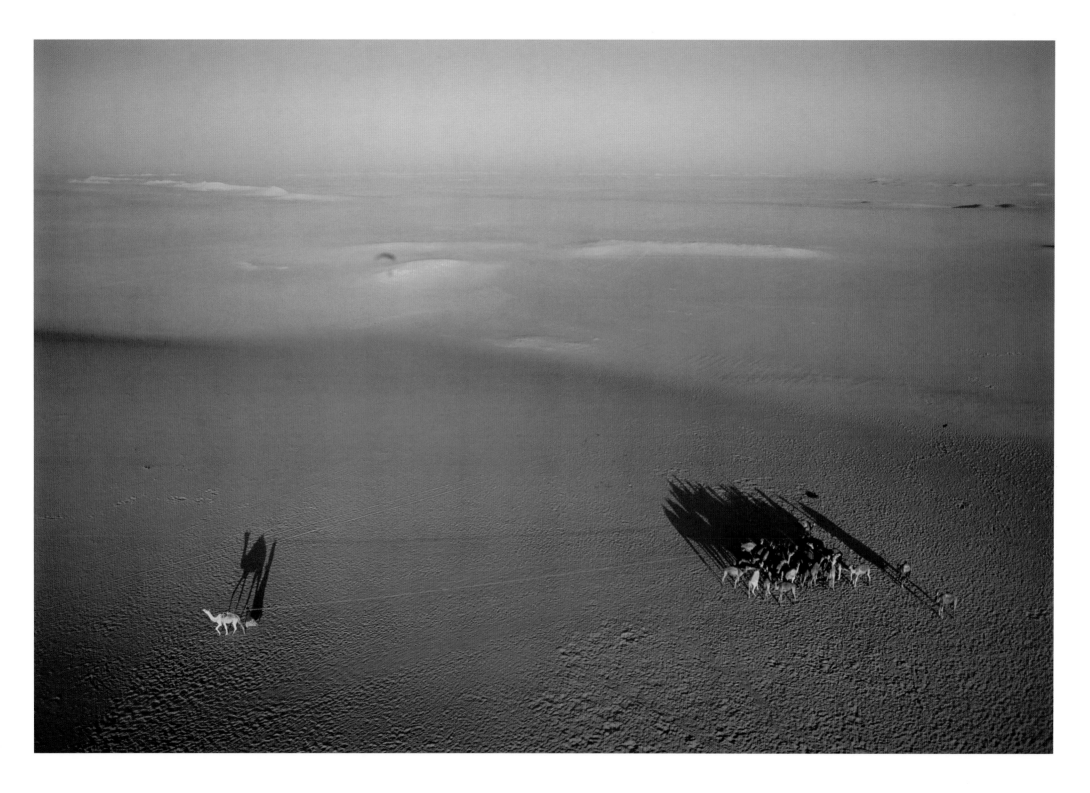

Camel drawing water near Araouane, Mali

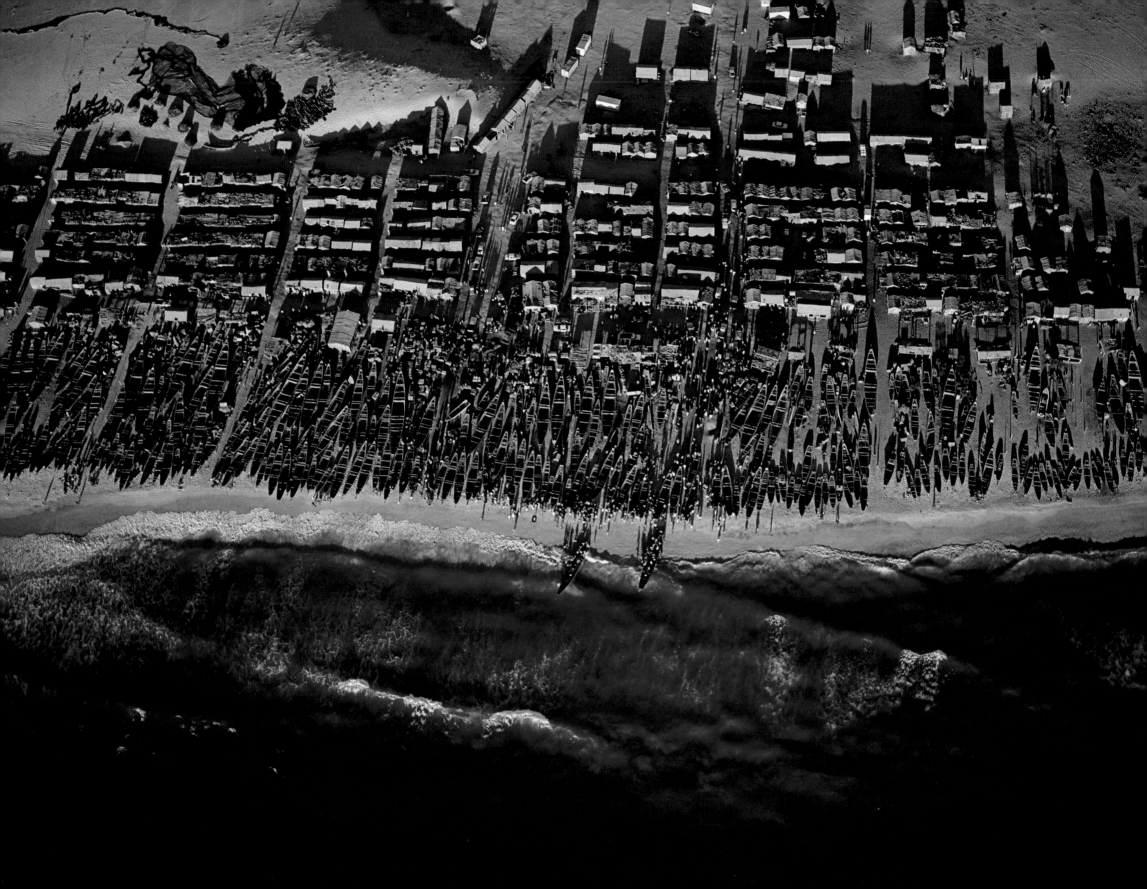

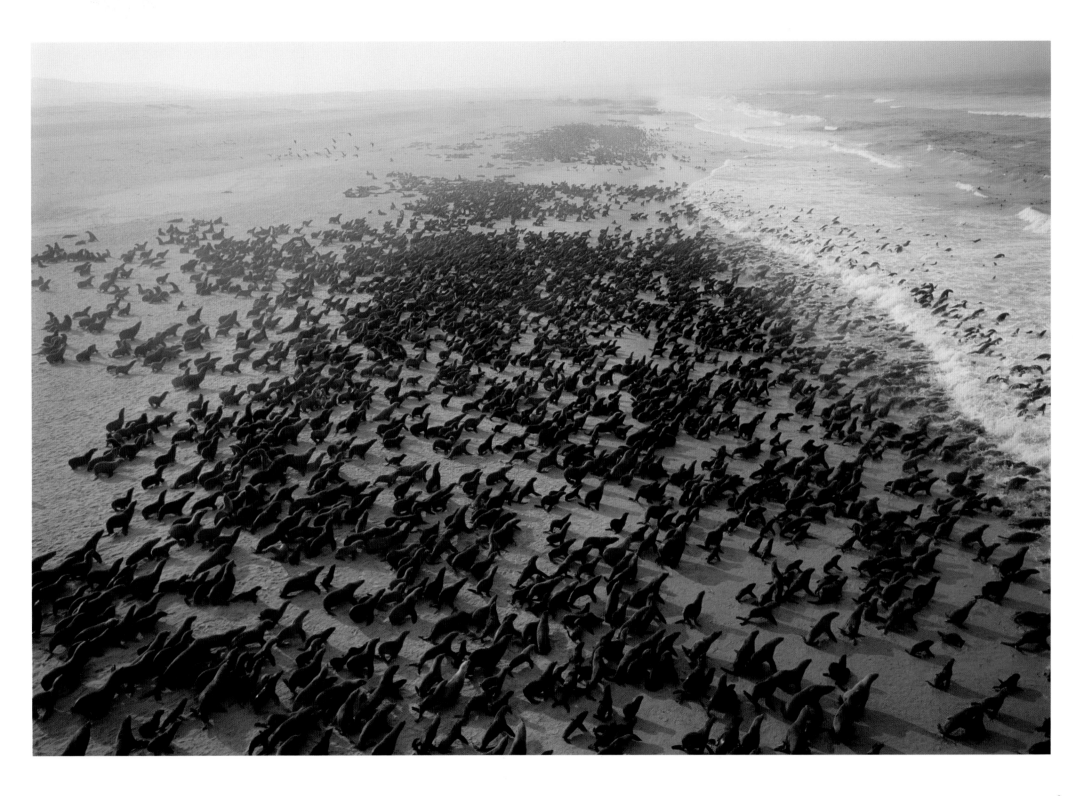

OPPOSITE: Fishing boats, Nouakchott, Mauritania

ABOVE: Seal colony, Cape Fria, Namibia

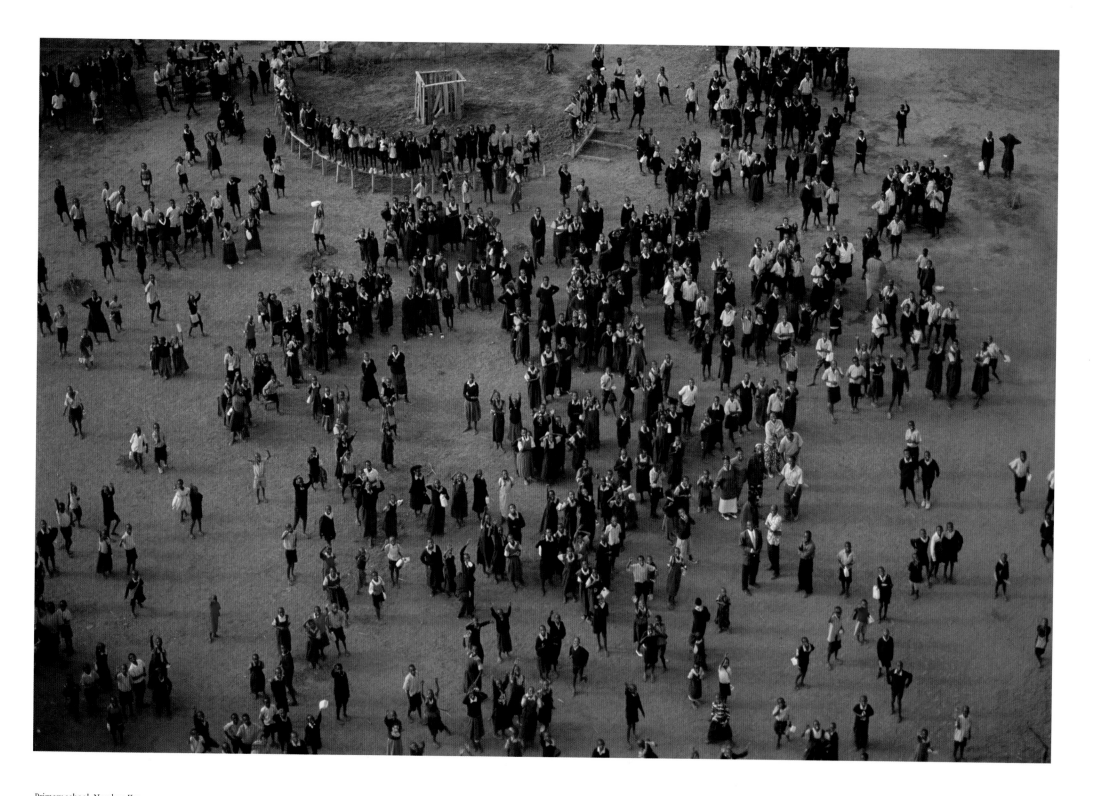

Primary school, Namlog, Kenya

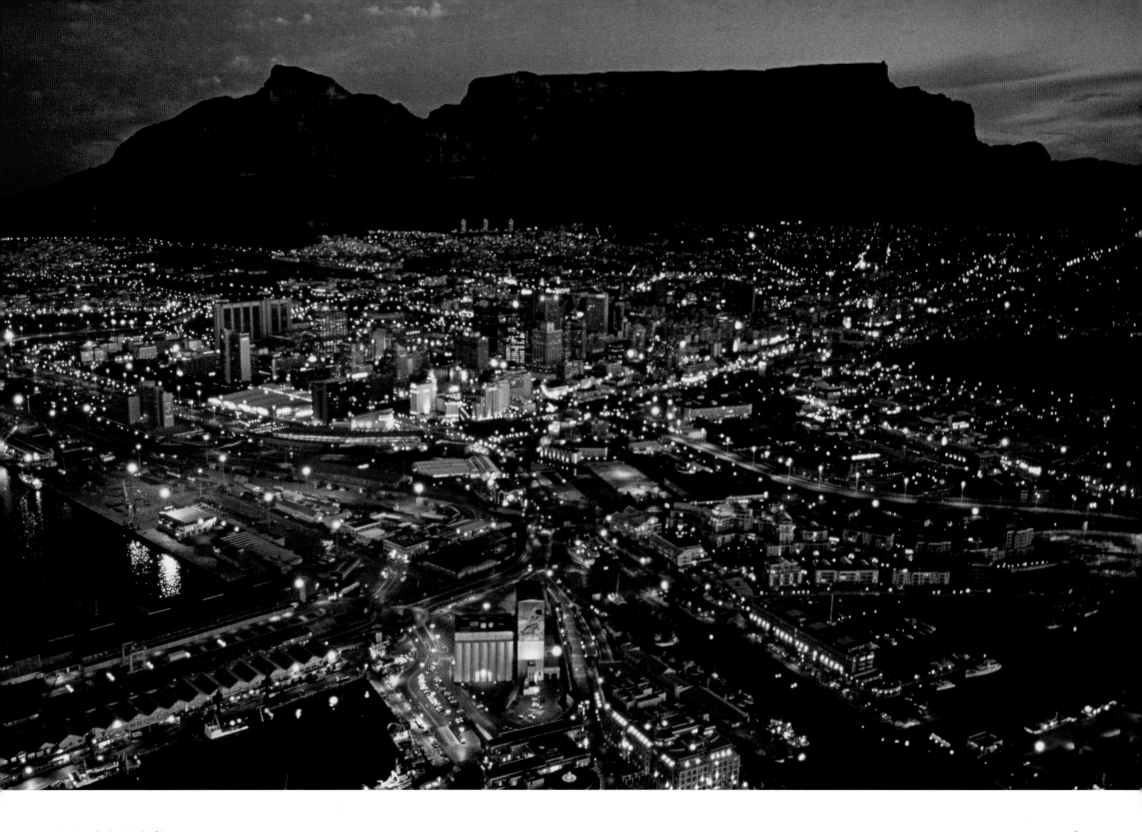

Cape Town harbor, South Africa

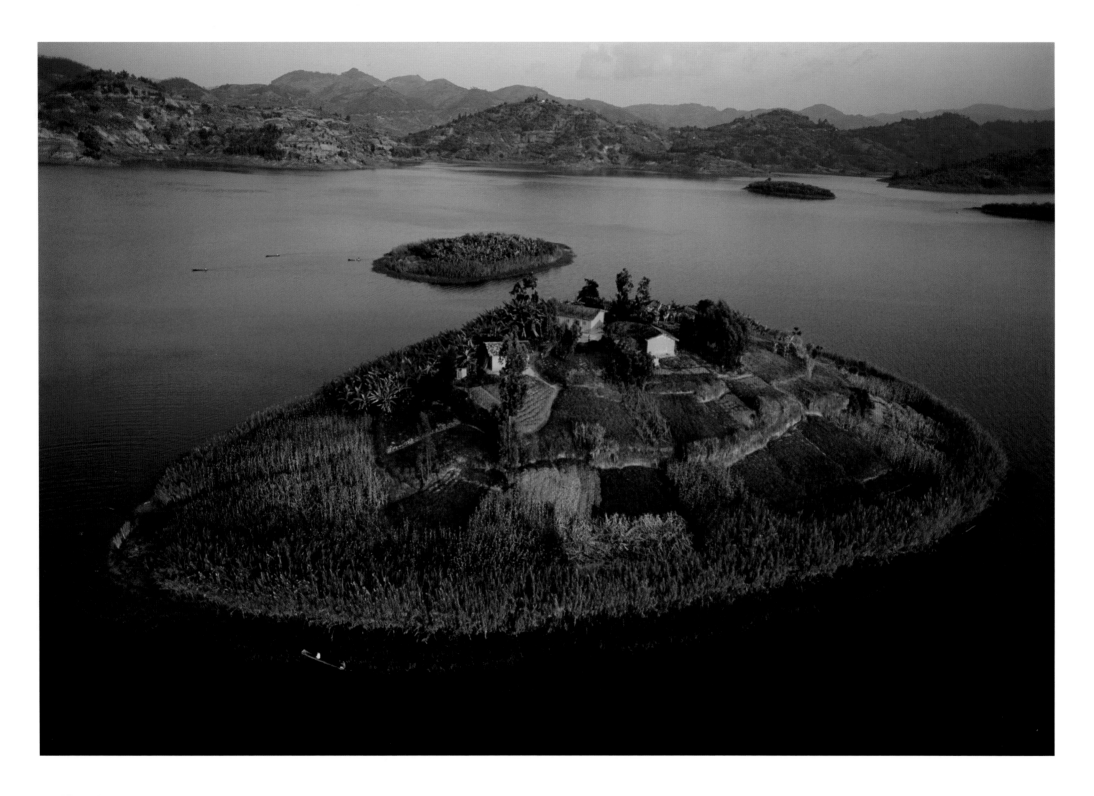

Island farm, Lake Bulera, Rwanda

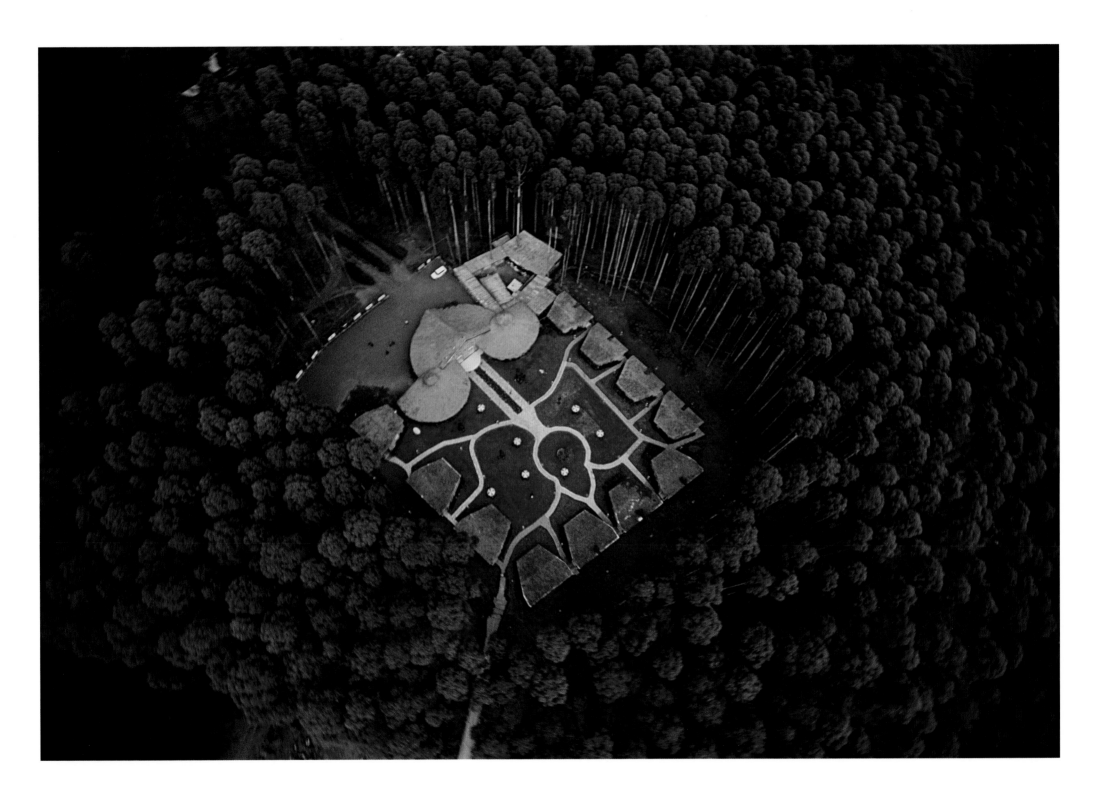

Safari lodge for gorilla watchers, Ruhengeri, Rwanda

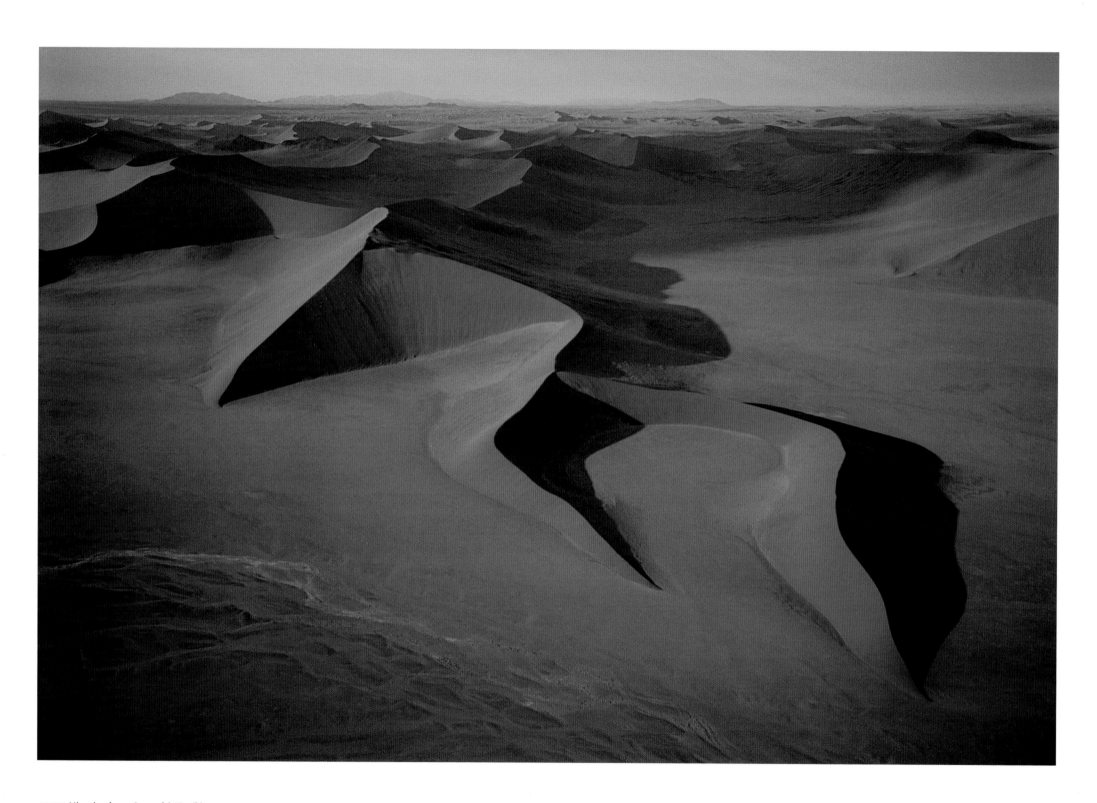

ABOVE: Migrating dunes, Sossusvlei, Namibia
OPPOSITE: Dying oasis town of Ouadane, Mauritania

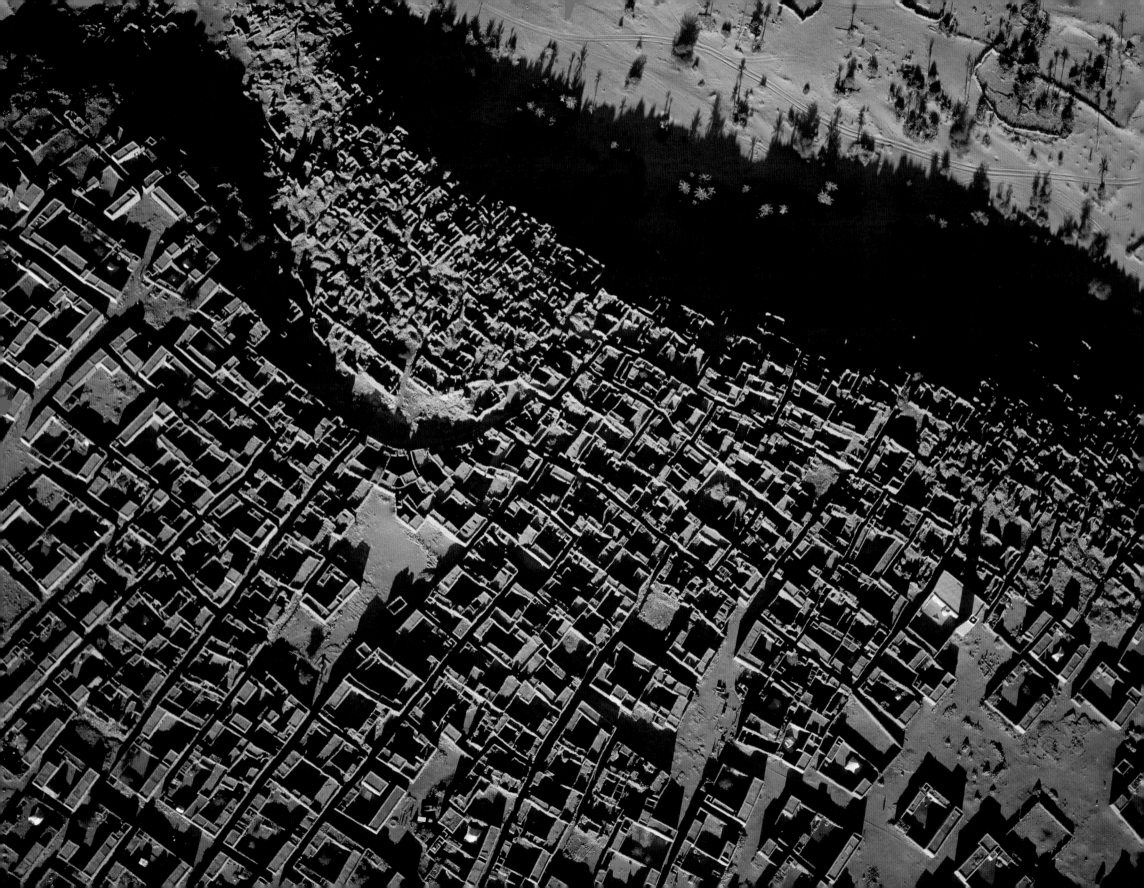

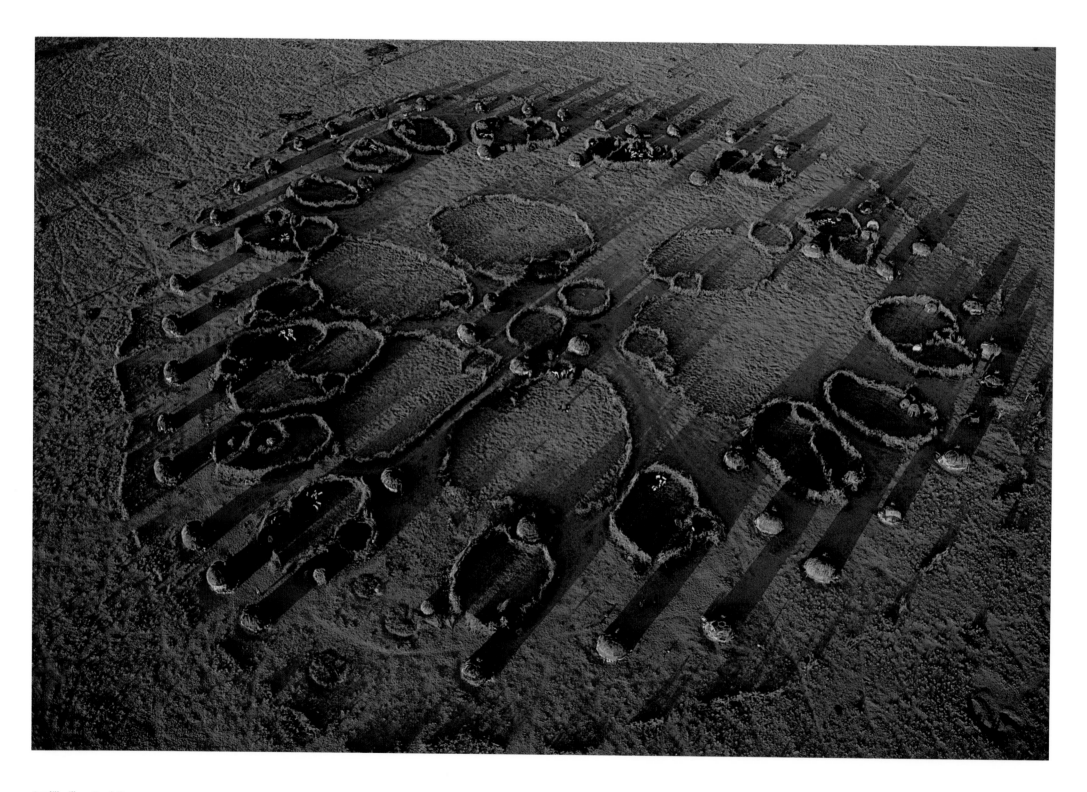

Rendille village, Kargi, Kenya

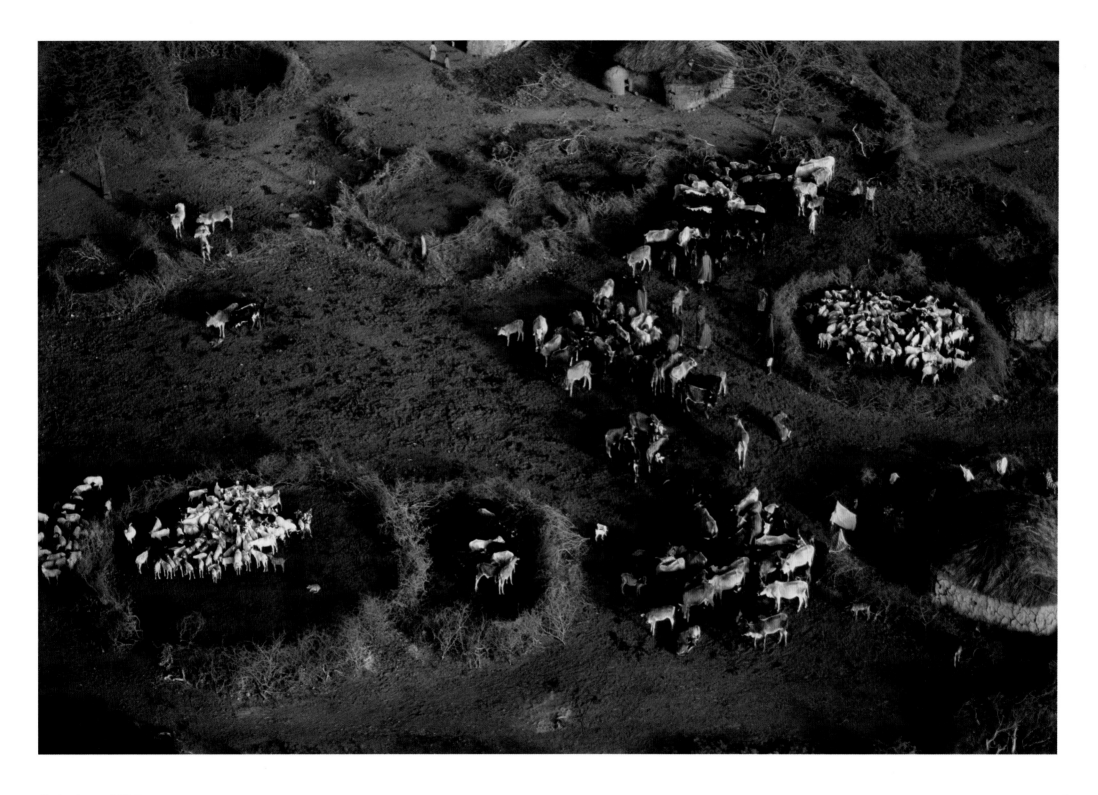

Masai cattle camp, Orbili, Kenya

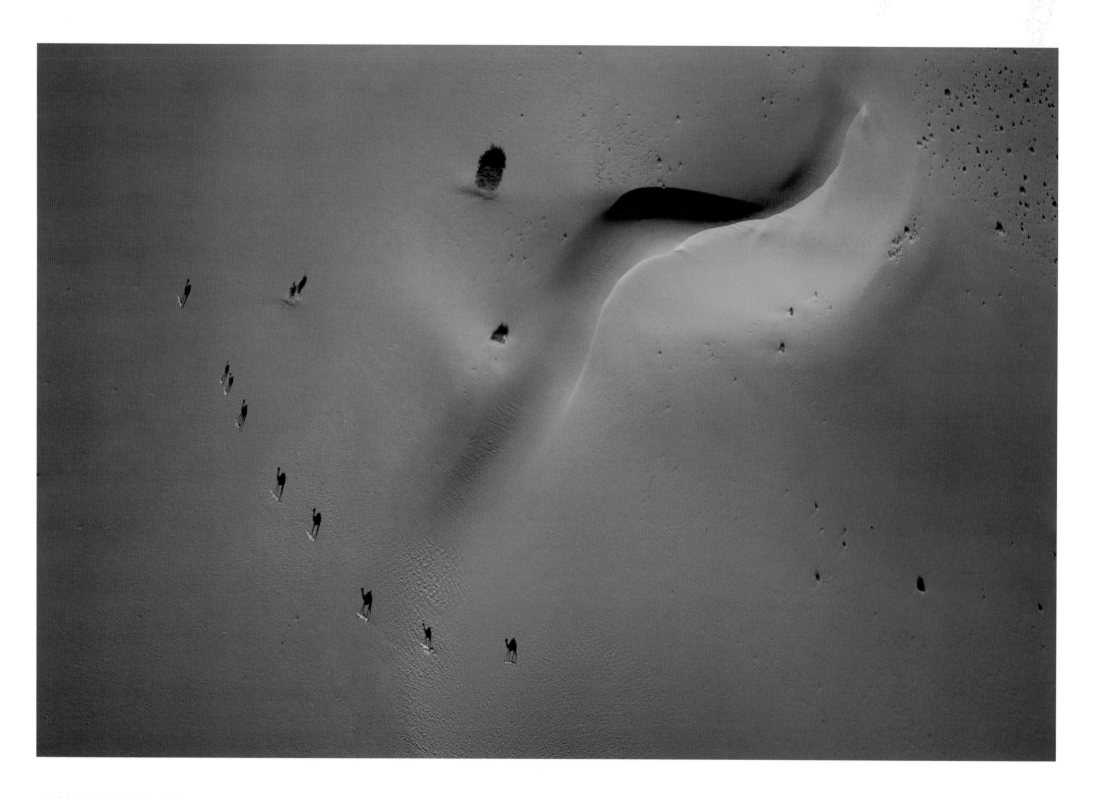

Camels leaving well of Araouane, Mali

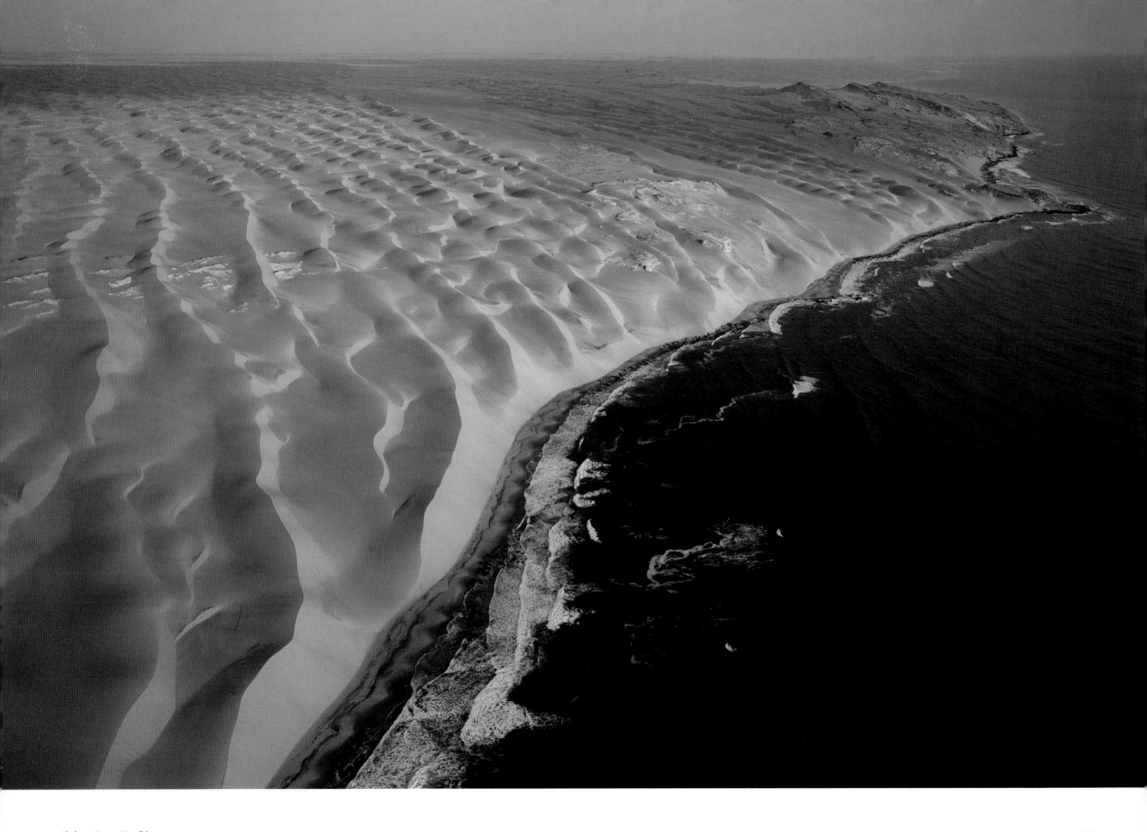

Skeleton Coast, Namibia

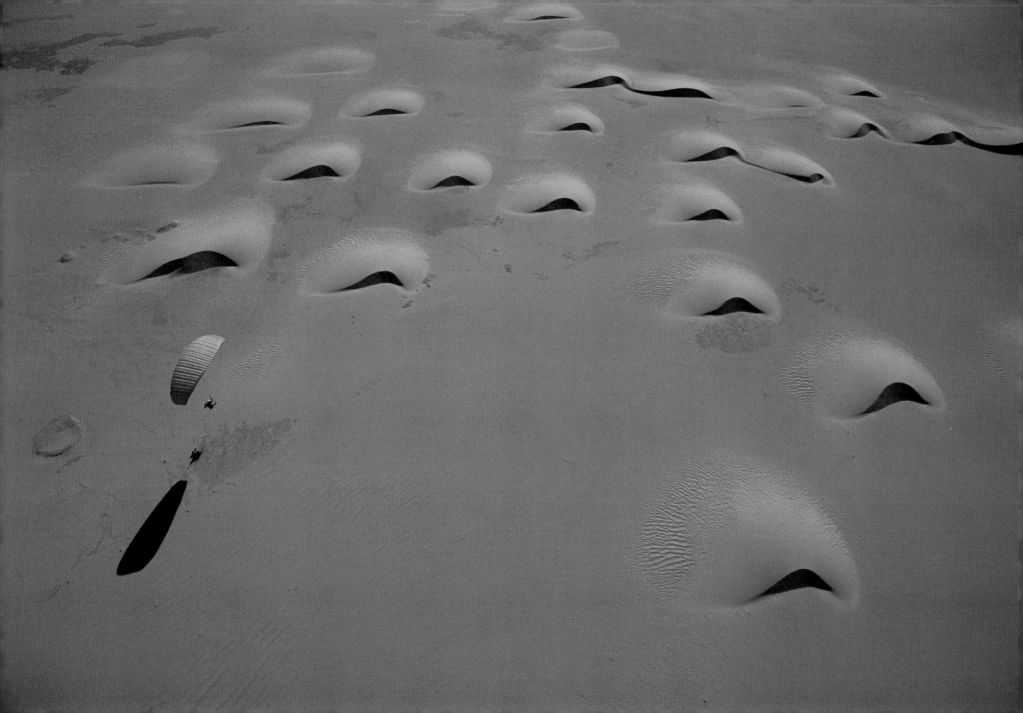

Most of the aerial photos you see in this book were taken from the seat of the lightest powered aircraft in the world, a motorized paraglider. In many ways it's the best possible platform for aerial photography, as it provides me with an unrestricted 180-degree view in both horizontal and vertical directions, like a flying lawn chair. It's also relatively quiet in flight, similar to a moped, and it lets me fly low and slow over the ground with a minimum of disturbance to the people and animals below. For takeoff, I don't need an airfield, only a small patch of open ground with enough running room and no trees or power lines in front

of me. Something slightly larger than a basketball court is usually enough space, and a downward slope or a cliff almost guarantees success. While I can gain as much as six thousand feet on a flight, I find it most effective at one hundred to five hundred feet above ground. With two and a half gallons of automobile gasoline mixed with 2 percent oil, I can fly for two to three hours.

The aircraft consists of three components: the "wing" of the paraglider (similar to an acrobatic parachute), a sixty-five-pound backpack-mounted motor, and a single-seat harness that ties the three pieces together. First I lay the glider

out on the ground perpendicular to the wind. After I've strapped myself into the harness and gotten the motor in position on my back, I face into the wind. Then, with the motor idling, I run forward, inflating the cells of the paraglider as it rises overhead. When I give it full throttle, my Fresh Breeze "monster" motor has about 175 pounds of forward thrust, which propels me forward and off the ground after some twenty to a hundred steps, depending on altitude and wind conditions. In flight all of the motor weight is off my shoulders and carried by the wing overhead. The wing flies at only one speed, approximately thirty miles per hour, and I steer with a combination of weight-shift and pulling on the kevlar lines that are attached to the paraglider's trailing edge. These lines act like wing flaps on a conventional airplane: When you pull (or lean) right on them, you turn right, and so on. As I am hanging underneath the canopy like a pendulum, my aircraft is self-stabilizing, and I can free up both of my hands for picture taking. It's a lot of trouble to get off the ground, but in flight it's a beautiful thing.

One of the disadvantages of my little aircraft is its limited speed and range. Even with significant experience it's very difficult to anticipate how areas will look from the air. For this book, I hired planes and helicopters whenever I could to scout out and shoot locations. They are great for high-altitude photos but less than ideal for low-altitude work, where their speed and noise

LEFT: Landing with a flat tire, Lake Logipi, Kenya
ABOVE: François Lagarde after landing in Timia, Niger

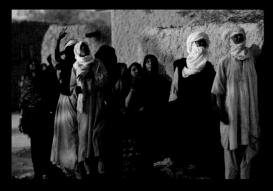

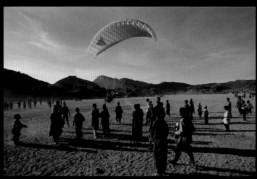

becomes a problem. And contrary to popular belief, helicopter pilots don't like to hover, and helicopters are much more stable flying at about the same forward speed (thirty mph) as my paraglider. The ideal arrangement for me in Africa is to hire a six-seat Cessna 206 with most of the rear seats removed to accommodate my motorized paragliding gear and camping equipment. I prefer to sit in the seat farthest in the back with the back door removed, which allows me to scout new locations at 150 miles per hour. If I can't get a good shot from the plane, we land at the nearest airstrip and make camp to have a go at it with my paraglider. This is only possible in a few countries with well-established tourist industries. Unfortunately, in most African countries, there are few reliable planes and pilots for hire, and what airfields there are tend to have little to no fuel and are scattered far and wide. In places like this I have to rely on cars, maps, guesswork, and I need time to get around and figure out my shooting location. The advantage of working this way is that I spend more time in one area, which allows me more freedom to choose weather and lighting conditions as well as the best time and places to fly based on conversations with the local people.

Getting There and the Jesuit Principle
My motorized paraglider packs up into three large duffle bags, each weighing less than the seventy-two pounds that is the limit for standard baggage

on most commercial aircraft. I can usually enter countries without significant problems from customs or aviation authorities, but if they do ask to see it, customs officers usually don't understand the nature of my aircraft and often want to prohibit entry, so I have a few tricks to help me get through, such as using dirty-looking bags for valuable equipment and keeping my head down to avoid eye contact. Upon arrival in a country, I spend a few hours assembling and tuning the motor, and then it gets transported in the rear of a four-by-four vehicle, or on the back of a camel, or in a speedboat, or canoe. It's a beautiful thing.

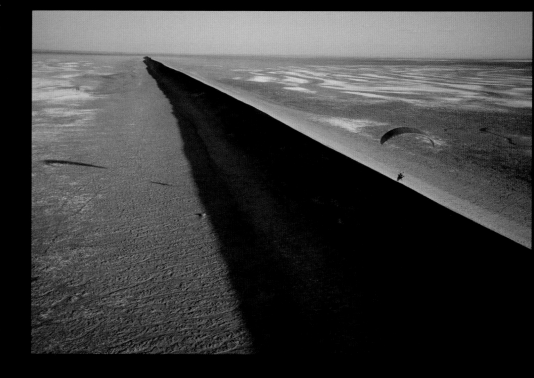

The U.S. Federal Aviation Authority considers my motorized paraglider an experimental aircraft and in the U.S., it's illegal to fly it over populated areas; outside of those areas, no license or registration is required. When I fly my paraglider overseas, I always try to get permission ahead of time but sometimes it's more practical to operate on the "Jesuit Principle," which is to say that it's a lot easier to plead for forgiveness than to obtain permission. So I try to take off in deserted places just before sunrise, when most normal people are sleeping and land in a different location near the car for a speedy pack-up and getaway. I always try

to avoid official complications, especially as this kind of aviation doesn't fit into any known category in the African bureaucracy, and I often feel as though I have to be surreptitious in my aerial picture taking.

Since 9/11, getting my aircraft motor onto a flight leaving the United States has required even more patience, as it is often perceived as hazardous cargo. Thus far I've flown my aircraft in China, Iran, Saudi Arabia, United Arab Emirates, Yemen, Botswana, Mexico, Peru, Bolivia, Oman, Chile, Namibia, Chad, Niger, Mali, Rwanda, Kenya, Ethiopia, Tanzania, Morocco, Mexico, France, Germany, and the United States. In China, I was chased by the police once (they never found me), and in Iran, I was put under house arrest three times for flying (even though I had a permit), but Africans in general are low-key, easygoing people, and I've had no serious problems there.

Camera Equipment

Digital cameras have made my life much easier. They have eliminated the need to change film, many of my Canon lenses have image stabilization built into them, and they get exceptional results with higher ASA settings than I was able

to use with film. I prefer zoom lenses in flight as they usually save me from having to change lenses. On a motorized paraglider there is nowhere to put anything except for a few zippered pouches strapped into my flight harness, so I carry just one camera around my neck while in flight. Flying this kind of aircraft is an exercise in minimalism, and anything that adds weight or complication detracts from airworthiness.

Safety

Flying the paraglider gives me the enormous advantage of being able to put myself exactly at the right place and time in the sky for a photo, but at the same time it can be a little hectic since I have to juggle taking photos and maneuvering the paraglider simultaneously. But because it's so light—the complete rig (wing, harness, and motor with fuel) weighs less than a hundred pounds—my paraglider is safer in emergency landings than almost any other aircraft.

The other advantage is that I land on my feet, so there's no wheel to get stuck in the sand or bounce on irregular terrain. I've had my share of mishaps, like landing in the ocean while photographing whales in Mexico, or getting dragged across a dry lake in a sandstorm in Iran, but generally speaking, if I had used any other kind of aircraft for what I've been doing, I probably wouldn't be alive today. The most common problem is a stumble on landing followed by an inelegant headfirst sprawl onto the ground.

LEFT: François Lagarde has just landed near pre-Islamic graves, Djado Plateau, Niger
ABOVE: François Lagarde examining a pre-Islamic grave, Djado Plateau, Niger

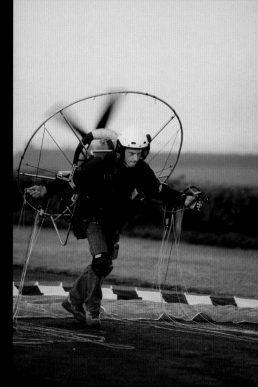

This is a stripped-down aircraft with no back-up systems, so if the motor quits for any reason, you simply glide to the ground with a 7:1 glide ratio—seven units forward for every unit down. Thus, if I'm a hundred feet above ground I have a circle with a seven hundred–foot radius below me in which I am able to land. I have a firm rule never to fly over terrain that I can't make an emergency landing on, such as large forests, big cities, volcanic rocks, or large expanses of water without a safety boat.

The glider is quite stable in calm conditions, thus I try to limit my flying to early morning and late afternoon hours, which also provides the best light for pictures. Turbulence can cause the wing to collapse, but after more than ten years and thousands of hours of flying, this has never happened. But I always have someone along to watch out for me. Usually this is another pilot who can help with moving the lines of the paraglider during the hectic moments when the wind unexpectedly changes direction for sunrise takeoffs. They can then follow me in a car or boat with binoculars and radio in case I can't make it back to the takeoff location.

I do this kind of flying because it gives me the opportunity to photograph remote areas in a way they have never been seen before. Yes, it is exciting to fly, but I don't go out on weekends and fly for fun. I'm a photographer who flies, not a pilot who takes pictures, and I always have to balance my desire for getting a unique image against the realities and unknowns of each situation.

No Wrecks?

This kind of flying is a hazardous endeavor without a rule book, so I always try to plan ahead. In the swamps of the Niger River in Mali, I made sure I had on a life vest and that my friend Alain Arnoux was following me in a boat with a radio at all times. I burned up three motors in flight on that trip, each time over the river, and each time I managed an emergency landing on dry land. The decision about whether a location or the weather is safe for flying is a tricky one. Sometimes the takeoff area is OK, but the area I want to photograph has no safe place to land for a great distance around it. Sometimes we have to wait a day for the weather to improve. The temptation, of course, is to give it a shot, but I always try to have a fellow pilot with me whom I trust to help make that final decision. As the saying goes, takeoffs are optional, but landings are mandatory. And for me, with a wife and three little kids on the other side of the world, I have to be sure I'll arrive back home intact. ⊠

RIGHT: George Steinmetz taking off near Kericho, Kenya

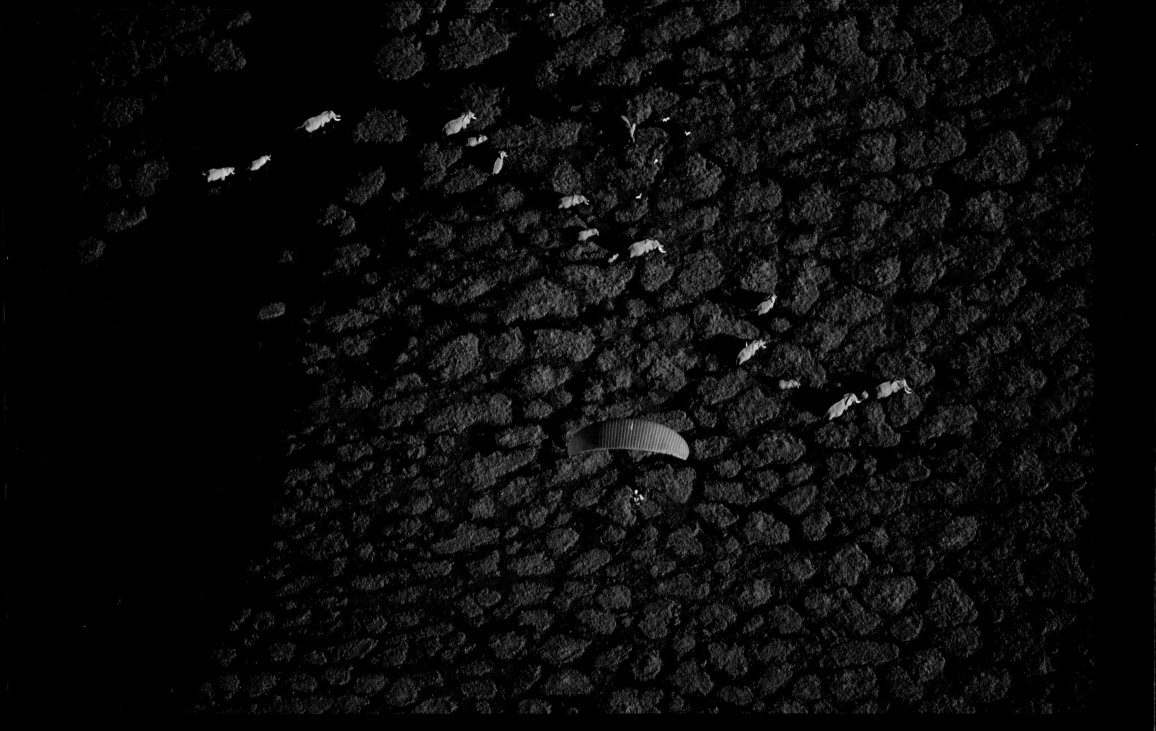

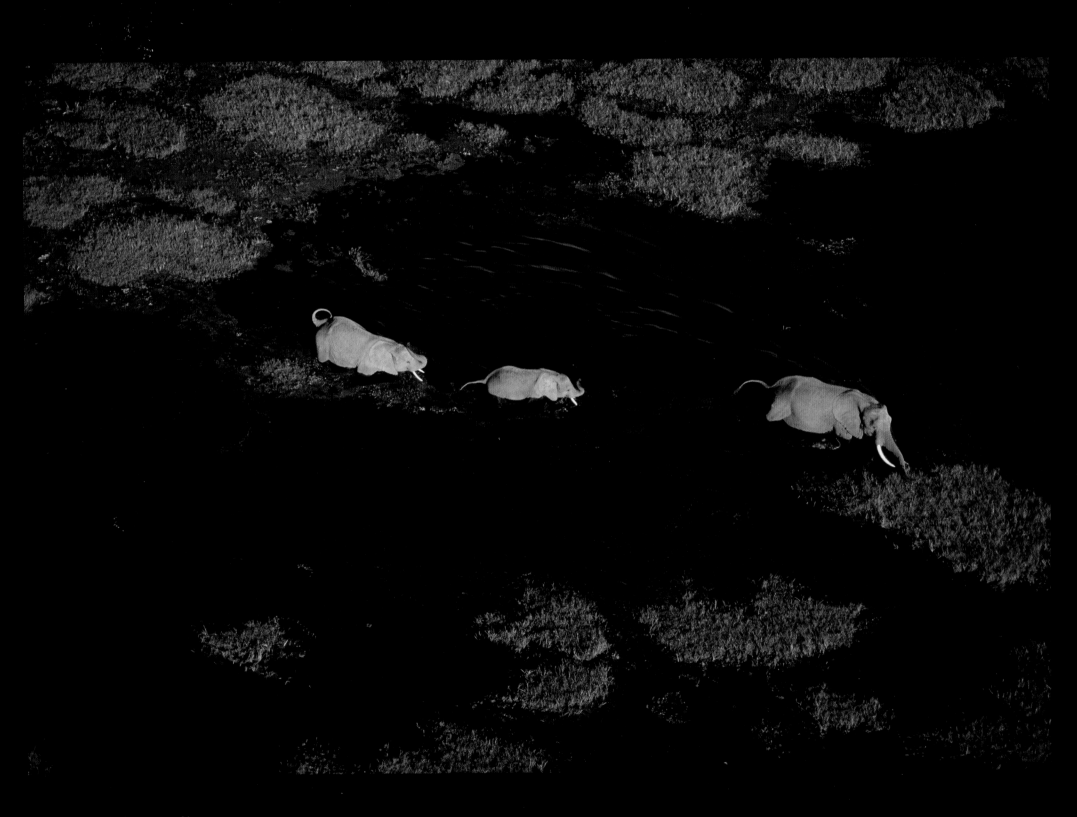

George Steinmetz's simultaneous view of the same
elephants over Lake Amboseli, Kenya

African Air **Captions**

[25] *Paragliding over Arakaou, Niger*
I don't like to fly this high (some 5,600 feet above-ground) in my paraglider, but it was the only way to get a view of the extinct volcano of Arakaou. Much of the Ténéré was once part of Lake Chad, but increasing aridity has turned it into a sea of sand.

[26] *Salt caravans, Fachi, Niger*
A caravan of camels, each carrying more than four hundred pounds of salt, leaves Fachi, and passes another caravan heading to the Sahara. This ancient trade continues to this day, as poverty leaves little opportunity for local Tuareg to earn money for their families. Their cargo will end up in local markets as far south as Nigeria.

[27] *Pinnacles of sandstone, Karnasai, Chad*
The pink light of dawn illuminates the Karnasai Valley. The orange color of the sand indicates that it is many thousands of years old.

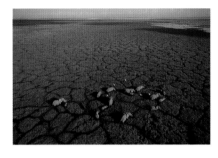

[28] *Elephants, Lake Amboseli, Kenya*
A network of elephant trails bisects the green grasses of Lake Amboseli at the center of Amboseli National Park in Kenya. The elephants migrate almost daily from the surrounding plains to drink and graze during the dry season. A worldwide ban on the ivory trade has allowed Kenya's elephant population to slowly rebound.

[29] *Airplane shadow, Lake Natron, Tanzania*
Salt-loving algae color the hypersaline waters of Lake Natron red. The lake's unusual mineral content is leached from the surrounding volcanoes. The temperatures in the salty mud can reach 120 degrees Fahrenheit, and depending on rainfall, the alkalinity can reach that of pure ammonia.

[30] *Camel caravan near Chinguetti, Mauritania*
A small group of adventurous European tourists retrace the ancient caravan route between the dying Mauritanian oasis towns of Chinguetti and Tidgikdja. The region is a mobile sea of complex barchan dunes known as El Djouf, which take on the appearance of human silhouettes when viewed from above.

[31] *Three cars crossing the Ténéré, Niger*
Desert guide Mohamed Ixa leads three expedition cars across the Erg du Capot Rey, a featureless sand flat more than 250 miles wide in the Ténéré section of the Sahara. In Neolithic times the Ténéré was the northwestern extension of what is now Lake Chad and seasonal hunter-gathers roamed its ebbing marshes. Today their stone mortars and pestles for grinding grain can be found half buried in the sand.

[32–3] *Sanga village, Bandiagara Escarpment, Mali*
Millet and other crops are set out to dry on the rooftops of the Dogon village of Sanga atop the Bandiagara Escarpment. The Dogon have developed a sophisticated irrigation system to nurture small yet highly fertile gardens. In the center of the village is the *toguna*, where the men gather to socialize and conduct village business.

[34] *Apartheid-era housing, Cape Town, South Africa*
The long houses in this part of Cape Town were built during the apartheid era to house "colored" people, but the population of Cape Flats has surged, and now squatters have built their own improvised housing in between the original structures.

[35] *Wetland farming, Nyabarongo River, Rwanda*
A patchwork of water and raised beds of bananas emerges from the swampy floodplain of the Nyabarongo River near Kigali. High rural population density has forced Rwandans to cultivate even the most marginal pieces of fertile land in an effort to support their growing families.

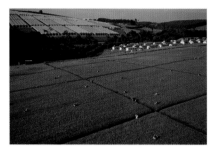

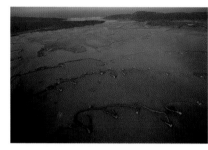

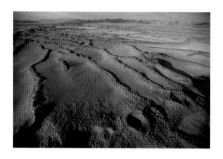

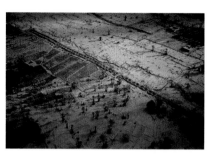

[36] *Vegetable garden, Timbuktu, Mali*
Vegetable gardens in Timbuktu are irrigated by women carrying water drawn from a hand-pumped well. The young crops are covered in fabric to protect them from the intense sunlight, and carefully fertilized patches of green are separated by windscreens of rushes to protect them from the winds that blow in from the Sahara.

[37] *Tea and flower plantations, Kericho, Kenya*
Kenya is the world's third-largest exporter of tea, with three hundred tons shipped per year. This fertile region near Kericho is ideal for tea, since it receives six feet of annual rainfall at an elevation of 6,500 feet; there is also a large number of laborers ready to pick it by hand. In the background lies housing for workers, as well as greenhouses for growing flowers that are exported to Europe.

[38] *Fish traps, Kosi Bay, South Africa*
These traditional fish traps in Kosi Bay have been passed down through many generations of Zulu fishermen. The traps were designed to catch fish on the rising and falling tides just a few miles south of the Mozambique border. This is the best-preserved large estuary on South Africa's Indian Ocean coastline and is an important sanctuary for a wide variety of plant, bird, and marine life.

[39] *Vegetated dunes, Namib-Naukluft Park, Namibia*
Native grasses trap moisture from coastal fog and colonize the migrating sand dunes of Namib-Naukluft Park in Namibia. The sand's red color indicates that it is thousands of years old, as that is the length of time required for the iron-rich minerals in the sand to oxidize in the dry climate.

[40–1] *Subterranean aqueducts, Skoura, Morocco*
The oasis town of Skoura, on the edge of the Sahara, is now largely abandoned, along with its system of subterranean aqueducts. The aqueducts, known locally as *khettara*, are used to transport mountain water for miles into the desert. They are easily identified from the air by the chain of holes used to clean them out; they look as if the earth had been attacked by a giant sewing machine.

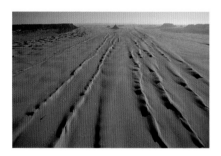

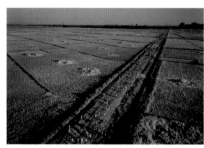

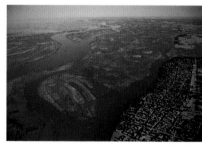

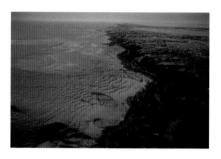

[42] *Seif dunes, Demi, Chad*
World-champion paramotorist Alain Arnoux rides the Harmattan winds that have created a river of mobile seif dunes near the oasis of Demi in Northern Chad. The dune field stretches for hundreds of miles across the Sahara; beginning in Libya, it channels through the rugged buttes of Erdi to Northern Chad and on into the Ténéré in Niger.

[43] *Rice plantation, Mwea, Kenya*
The British began this 33,000-acre rice scheme in Kenya decades ago by forcing anticolonial fighters to dig canals and work the fields. Today, almost three thousand families harvest their private plots, here seen with their rice stalks piled up waiting to be burned. The lack of crop rotation and organic fertilizers has led to a recent drop in production and an increasing incidence of malaria.

[44] *Bozo fishing village, Bani River, Mali*
A village of Bozo fishing families has built their homes right up to the high-water line of the Bani River. The Bozo are famous for their mastery of the river and its arts, particularly canoe building and mud architecture. The largest building on this islet is the village mosque.

[45] *Niger River, Gao, Mali*
Gao has been a major trading center along the Niger River for thousands of years, and is the end of one of the major caravan routes across the Sahara Desert. The roads along the river get very little use, as the majority of trade and travel in northern Mali is by motorized canoes. Here the river is seen in flood when the islands are lush with rice.

[50] *Kuiseb River, Namib-Naukluft Park, Namibia*
The Kuiseb River canyon forms the northern limit of the Namib Sand Sea. Winds from the south move the sand into the canyon where it is flushed to the Atlantic Ocean by seasonal flooding. The canyon is a crucial water supply for wildlife in the Namib-Naukluft Park, a pristine coastal wilderness.

[51] **Mine dumps of Johannesburg, South Africa**
The Soweto suburb of Johannesburg has grown up around the waste rock dumps of the gold deposits that were discovered here in 1886. A cold winter morning leaves a shroud of pollution over the most industrialized city in Africa. These mine dumps are in the process of being removed and reprocessed for residual gold.

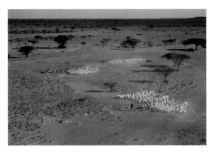

[52] **Rendille goat herds, Kargi, Kenya**
The seminomadic people of the Rendille tribe are forced to travel great distances to find grazing for their flocks of goats and camels. There had been no rain for almost a year, forcing most of the able-bodied men to travel tens of miles away with their livestock.

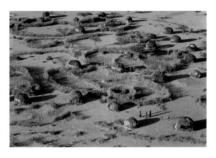

[53] **Rendille village, Kargi, Kenya**
Seminomadic people of the Rendille tribe in northern Kenya are slowly being drawn into permanent settlements like this one near Kargi. A combination of drought and pressure to join the cash economy have led approximately half of the estimated thirty thousand Rendille to live in settlements where they have access to education and water, but lack grazing for their livestock.

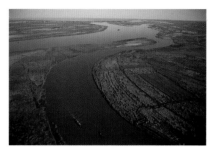

[54] **Rice and market boats, Niger River, Mali**
Traffic along the Niger River near Gao in northern Mali is mostly by small canoes and market boats. The river floods annually, nurturing a naturally irrigated rice crop that marks the edge of the Sahara.

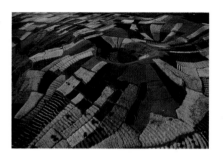

[55] **Terraced volcano, Virunga Mountains, Rwanda**
Terraced fields of wheat climb the slopes of a small volcano (nine thousand feet) in the Virunga Mountains of Rwanda, the most densely populated country in Africa. Volcanic soil and a cool, high-altitude climate combine with ample tropical rain and sunshine to make this some of the most productive agricultural land on the continent.

[56–7] **Suburban sands of Nouakchott, Mauritania**
A small strip of tarmac separates the newly rich from the newly poor in Nouakchott, the capital of Mauritania. Before independence in 1960, this small oasis supported fifteen families in mud houses, and now more than seven hundred thousand people have flocked here to seek wealth and refuge from the desertification of their traditional grazing lands. Perhaps one-third of these refugees live in this *bidonville*, or shantytown, without running water or sewage facilities.

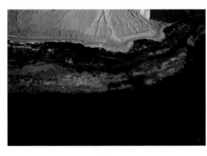

[58] **Flamingos, Lake Logipi, Kenya**
Flamingos wade in the shallow salty waters of Lake Logipi in the Great Rift Valley. These skittish birds feed on bacteria and plankton that thrive in this highly basic aqueous soup. The lake is surrounded by active volcanoes and is cut off from roads to the outside world.

[59] **Seal colony, Cape Fria, Namibia**
A colony of more than one hundred thousand Cape fur seals frolics on the beach near Cape Fria, Namibia. This northernmost colony of Cape fur seals congregates here to feed on the abundant fish caused by the upwelling of the Benguela current in the Atlantic Ocean. This is one of the most remote sections of the Skeleton Coast, and access is tightly controlled to protect its fragile environment.

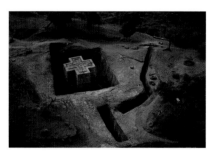

[60] **Monolithic church, Lalibela, Ethiopia**
Bet Giyorgis church in Lalibela, Ethiopia, is perhaps the most beautiful of the monolithic churches, which were all carved out of volcanic bedrock some eight hundred years ago. Starting with the surface of the roof at ground level, King Lalibela's workers carved down the outside of the walls, then tunneled in the windows, up to the roof, and down to the doors. Trenchlike stairs and tunnels access the church.

[61] **Grand Mosque, Agadez, Niger**
The minaret of Agadez's Grand Mosque is a masterpiece of Sudanese-style mud architecture. At eighty-nine feet, it is the tallest structure in this ancient caravan town. Rebuilt in 1844, it has a permanent scaffold of decorative poles that protects the minaret, making it easier to maintain and repair after a strong rain.

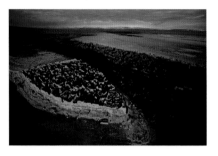

[62] Ruins of a fortified city, Meski, Morocco
The walled city of Meski was built some five hundred years ago on a bend in the Ziz River, which meanders from the Atlas Mountains to the Sahara. The town has since been abandoned, but the river valley is an extended oasis that is still farmed for dates and vegetables.

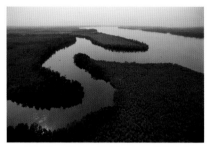

[63] Swamp forest, Niger Delta, Nigeria
This section of the Niger Delta, with its meandering streams and mangrove forest, is considered ecologically healthy. As the tidal fluctuation brings increased nutrients, the river's edge can support much higher mangroves and other tree species.

[64–5] Two people on a dune, Chinguetti, Mauritania
Two people venture out for an afternoon walk on the dunes near Chinguetti, Mauritania. The orange color of the sand is due to the oxidation of iron minerals from lakes that have since evaporated. Chinguetti was once an important stop for the salt caravans crossing the Sahara, but it is now slowly being buried by migrating sand dunes.

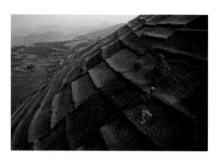

[66] Terraced agriculture, Virunga Mountains, Rwanda
Terraced fields climb the slopes of a dormant volcano in the Virunga Mountains of Rwanda. Rich volcanic soil, four feet of annual rainfall, and a cool nine-thousand-foot climate have created an ideal agricultural environment. Here, small ridges act as barriers to reduce the runoff of fertile volcanic topsoil.

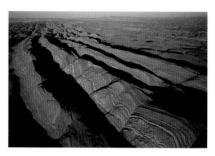

[67] Vertically oriented bedrock, Ugab River, Namibia
These severely eroded north-south ridges of mica schist were formed millions of years ago near what is now the Ugab River in northern Namibia. The subterranean waters underlying this ephemeral river are shallow enough in places to fill hollows and sustain a wildlife population that includes the rare desert elephant.

[68] Rice plantation, Mwea, Kenya
Piles of harvested rice stalks dot the fields of a government-organized scheme of tenant-farmed rice fields near Mwea. Each family has a ten-acre plot that is supplied with water from a government-run canal. Most of the privately run plots (four hectares per family) have recently been harvested, and the rice stalks are piled up, waiting to be burned.

[69] Firing water jars, near Mopti, Mali
Villagers prepare for the communal firing of water jars a few miles downriver from Mopti. During the rice harvest, the community burns rice chaff to harden their jars, which are used for storing and cooling water throughout the floodplains of the Niger River.

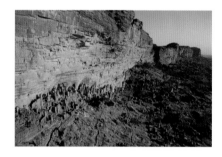

[74] Abandoned cliff dwellings, Bandiagara Escarpment, Mali
Thousand-year-old dwellings cling to the base of the Bandiagara Escarpment. The Telem people once inhabited this ancient village, but they abandoned the region three hundred years ago. Now, the Telem homes and granaries are used for burial of the Dogon who live in a village at the bottom of the cliff.

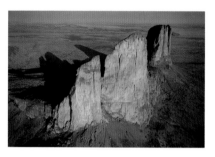

[75] Hand of Fatima, Hombori, Mali
The Hand of Fatima is a dramatic group of sandstone spires that rises two thousand feet above the arid plains near Hombori. In recent years it has become a coveted ascent for international rock climbers.

[76] Irrigated gardens, Bilma, Niger
In the gardens of traditional agriculturalists near Bilma, potable water comes from an artesian well that is channeled to fields for flood irrigation. The gardens are used to cultivate date palms, grain, onions, and leeks. Rain is exceptionally rare in this part of the Sahara, and many children grow up without ever experiencing it.

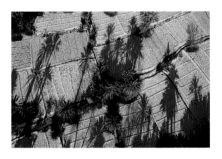

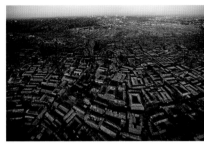

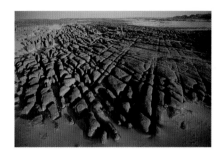

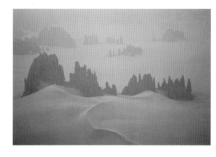

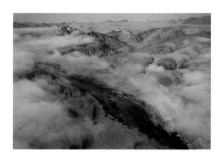

[77] *Date palms after a snowfall, Gorges du Ziz, Morocco*
The first snowfall in thirty-two years lasts only a day in the garden plots of the Gorges du Ziz. It was extremely rare to see snow fall on date palms, but this is the highest elevation (four thousand feet) at which the desert trees are found. The snow was the result of an unusual winter storm coming out of the Sahara.

[78] *Kibera slum, Nairobi, Kenya*
The Kibera slum, the largest in all of Africa, pours out over the outskirts of Nairobi. Its population has exploded to more than eight hundred thousand as young people flock to the Kenyan capital from the countryside in search of work. The unemployment rate for Kenyan youth is more than 25 percent, and many of them end up in this squatter camp along the railroad tracks.

[79] *Wind streets in the Ennedi Plateau, Chad*
Stress cracks turn into corridors for wind and sand, further eroding the bedrock of northern Chad. This ancient sandstone massif forms a boundary between the Sahara and the Sahel, and is home to seminomadic Toubou clans who depend on small oases hidden in such labyrinths to get their herds of camels and goats through the long, dry season.

[80–1] *Sandstorm, Karnasai Valley, Chad*
The murky light of a sandstorm shrouds these sandstone pinnacles a few miles from Chad's border with Libya. This is one of the most remote regions of the Sahara. Except for one or two families of goat herders who come here once a year, it is uninhabited and otherworldly.

[82] *Coastal fog, Kunene River, Angola/Namibia*
The Kunene River, which separates Namibia from Angola, is blanketed in fog as the cold Benguela current brings moist air (but no rain) over the warm sands of the Skeleton Coast. The current and the wind come from the south, and the wind drives sand into the river where it is flushed out to the sea.

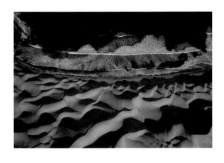

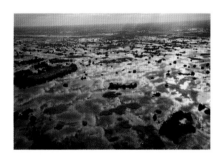

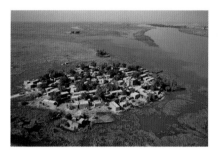

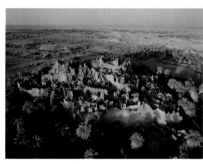

[83] *Skeleton Coast, Namibia*
Cold waters lap at desert dunes in this remote section of the Skeleton Coast, halfway between Walvis Bay and Luderitz. The area got its name from the large number of shipwrecks, which added to the whale and seal skeletons that litter its beaches.

[84] *Zebras, Makgadikgadi Pans, Botswana*
Herds of zebras congregate in the Makgadikgadi Pans. This photo was taken a week before the last surface water disappeared, which forced a migration of thousands of zebras away from the abundant grasses here for a distant water source.

[85] *Freshwater flood, Okavango Delta, Botswana*
The Okavango Delta is the world's largest inland delta, covering six thousand square miles of the Kalahari Desert during full flood, as seen here. This is one of the richest wildlife areas in Africa, and is always in flux as the region floods and dries each year.

[86] *Goumina village, Niger River, Mali*
During the wet season, the village of Goumina becomes a small island in the Niger River floodplains. Here, people rely on the river to rise every summer to irrigate their rice crops and to supply them with a way to reach nearby Mopti and other trading centers along the river.

[87] *Ruins of Djado, Niger*
The ancient and mysterious city of Djado, once a fortified citadel on the slave traders' route to Libya, is now a haunting jumble of decaying mud structures. The city died not long after the abolition of the slave trade, and its palm groves are now only seasonally visited by Toubou people, who come to harvest dates, which are said to be the best in Niger.

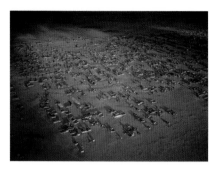

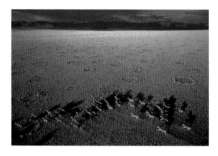

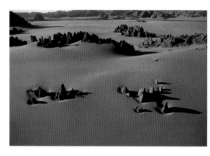

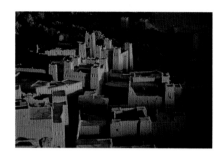

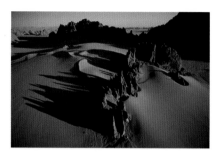

[88–9] *Suburbs of Nouakchott, Mauritania*
At the edge of Nouakchott, Mauritania, the population is rapidly expanding out into the Sahara Desert. Nouakchott means "the place of winds" in Berber, and here it is illuminated through a hole in a dense morning fog bank that has blown in from the Atlantic.

[90] *Zebras and fairy circles, NamibRand Nature Reserve, Namibia*
Burchell's zebras run wild across the plains of NamibRand Nature Rreserve. The thin grasses here have a rare speckled pattern known as "fairy circles," a phenomenon of stunted growth that is poorly understood. NamibRand, covering 665 square miles, is said to be the largest private nature reserve in southern Africa.

[91] *Karnasai Valley, Chad*
The orange sand of these dunes is formed by the erosion of Nubian sandstone, which itself was formed from ancient sand dunes millions of years ago. Since this photo was taken, rebels have laid land mines in the shifting sands, further isolating this valley from the outside world.

[92] *Kasbah of Aït Benhaddou, Morocco*
Aït Benhaddou is both a living city and a UNESCO World Heritage site that has been restored for use in Hollywood movies (*Lawrence of Arabia* and *Gladiator* were filmed here). The entry gate and its two towers were built for *Lawrence of Arabia*, but the rest is said to be authentic restoration.

[93] *Sandstone pinnacles, Karnasai Valley, Chad*
Pinnacles of sandstone rise through the dunes of the Karnasai Valley, a deserted pocket of the Sahara on the north side of the Tibesti Massif. Strong Harmattan winds sandblast the base of the sandstone pinnacles, hollowing out wind pits around their bases.

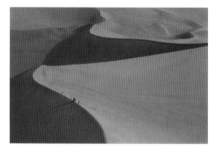

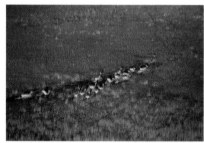

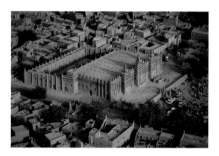

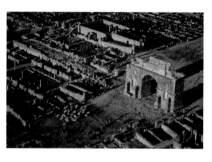

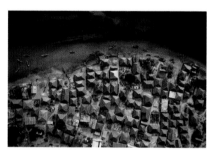

[98] *Climbing the megadunes, Sossusvlei, Namibia*
Climbing the megadunes of Sossusvlei is a popular morning activity for visitors. They are not the highest dunes in the world, but their color and form make them among the most spectacular. The dunes begin as white beach sand, but by the time visitors reach seventy-five miles inland, the dunes turn brick-orange due to the oxidation of iron minerals from coastal fog.

[99] *Lechwe, Okavango Delta, Botswana*
Lechwe bound through marsh grasses with ease, since they have elongated hooves and a high-rumped build that give them speed in soggy terrain. They feed primarily on grass around flooded areas that protect them from terrestrial predators. Their populations have been decimated over the past hundred years, and they are now found primarily in national parks.

[100] *The Grand Mosque of Djenné, Mali*
The Grand Mosque dominates the large market square of Djenné, one of the oldest cities in sub-Saharan Africa. The current mosque was completed in 1907, and is the largest mud structure in the world. Its mud surface is refurbished after each rainy season during an extraordinary festival involving the entire community.

[101] *Volubilis, near Meknes, Morocco*
A local shepherd allows his flock to graze near the triumphal arch of Volubilis, the best-preserved Roman ruins in Morocco. During the second and third century, it was considered the wealthiest city in northwest Africa. At its peak it had a population of twenty thousand, but an earthquake destroyed it in the late fourth century.

[102] *Faza village, Pate Island, Kenya*
Thatched roofs made of coconut palms mix with those of metal to provide shelter in the fishing village of Faza. At high tide Faza is surrounded by water and a mangrove swamp, with only a small elevated boardwalk to connect it to the rest of the island. Transportation consists of traditional dhow sailboats and the occasional interisland market boat.

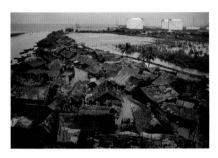

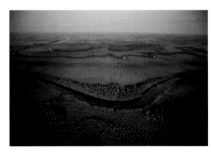

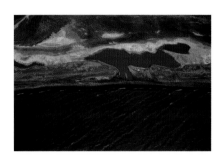

[103] *Finima village, Bonny, Nigeria*
Finima village sits across a narrow channel from a liquefied natural gas facility in Bonny, Nigeria. Despite living in the shadow of one of the country's newest export terminals, Finima has no electricity, piped water, or sanitation facility. Heavy rains on the morning this picture was taken led to flooding from inadequate drainage. Drinking water comes from hand-drawn wells, and food arrives by market boat, as there is no passable road.

[104–5] *Swamp forest, Niger Delta, Nigeria*
The Niger Delta ecosystem is undergoing rapid change due to a combination of decreased fresh water inflow; pollution related to oil production; and the hunting, fishing, and logging activities of its residents, who have few economic opportunities.

[106] *Airplane shadow, Lake Turkana, Kenya*
The eastern shore of Lake Turkana is deserted except for a fishing canoe and the shadow of a small plane. The salty Lake Turkana is slowly drying up, putting pressure on the fish, wildlife, and people who depend on the water for survival in the arid north of Kenya. The small, salty lagoon seen here is stained red with algae.

[107] *Saltworks, Lac Rose, Senegal*
Small boats bring in loads of salt gathered from the bottom of the algae-stained waters of Lac Rose near the coast of Senegal. The salt is put into conical piles to dry on the shore before being loaded into trucks for transport to market near Dakar. The lake is also the end point for the annual Paris-Dakar road race.

[108] *Rural school, Kimana, Kenya*
Children and teachers have rushed out of a rural school near Amboseli National Park in Kenya try to catch a glimpse of my motorized paraglider in flight. The curved lines of stones in the upper right are used to organize children during the morning flag-raising ceremony.

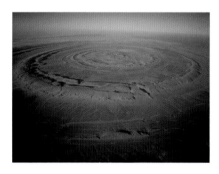

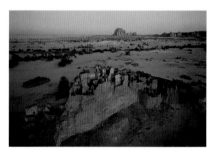

[109] *Village near Bonny, Niger Delta, Nigeria*
A poor village teems with onlookers as a helicopter for Shell Oil flies overhead. In spite of the oil wealth that is being exported from the nearby tank farms in Bonny, this is one of the poorest and least developed regions of Nigeria, the biggest oil producer in sub-Saharan Africa.

[110] *Saltworks, Teguidda-n-Tessoumt, Niger*
Like a mosaic assembled on a hard desert floor, pools of evaporating saltwater are worked by the villagers of Teguidda-n-Tessoumt. Briny water is drawn from shallow wells and mixed with salty soil to produce slurries of different colors. The blue pools have a thin layer of salt on their surface that reflects the color of the sky.

[111] *Slums of Nouakchott, Mauritania*
Dirty paths of sand form the roads in this shantytown that is taking over an evergrowing area of Nouakchott. Due to severe drought and rapid urbanization, the vast majority of Mauritanians now live in the capital; its population has doubled in the past eight years.

[112–13] *Dome of Guelb er Richat, Mauritania*
This natural dome formation is a landmark seen by astronauts, who call it "the Eye of Africa," as they pass over the Sahara in space. With a perfectly symmetrical bull's-eye shape, twenty-five miles in diameter, it was originally thought to be a massive meteorite impact, but it is now known to be a natural volcanic bulge that was leveled by erosion. The French naturalist Théodore Monod first investigated this formation on foot in the 1940s.

[114] *Fortified village of Djaba, Niger*
Desert guide Mohamed Ixa watches the sunrise from the top of the abandoned village of Djaba, once a citadel on the slave-trading route to Libya. Sun and windblown sand are taking their toll, and Djaba is slowly crumbling from its perch atop a pinnacle of sandstone.

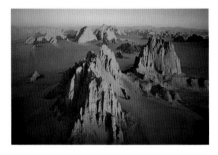

[115] *Sandstone buttes, Karnasai Valley, Chad*
Heavily eroded sandstone buttes rise above a sea of sand. The Karnasai Valley is part of the Aouzou Strip, which was occupied by Libya from 1973 to 1987. For the past decade, the area has been closed to outsiders due to land mines and rebel activity.

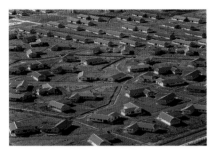

[116] *Shell Oil housing, Bonny, Nigeria*
New housing was built for workers at Shell Oil's liquefied natural gas facility near Bonny, Nigeria. This enclave of Western prosperity is an anomaly in the poorest region of Nigeria, where most people live in thatch houses without electricity or running water.

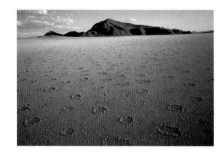

[117] *Village in the Niger Delta, Nigeria*
Although Nigeria is the biggest oil producer in Africa, corruption and a large population prevent significant benefits from reaching its people. In this riverside village near Buguma Creek in the Niger Delta, most residents live without electricity, running water, or access to basic medical facilities.

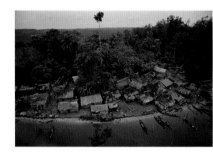

[122] *Fairy circles, NamibRand Nature Reserve, Namibia*
The thin grasses in this region of NamibRand Nature Reserve have taken on a rare speckled pattern known as "fairy circles," a strange phenomenon whereby grass refuses to grow in small, regularly spaced circular areas that dot the landscape. Scientists speculate that it may be the result of some kind of growth-inhibiting substance left in the ground by either insect colonies or root systems of plants that are no longer found in the area.

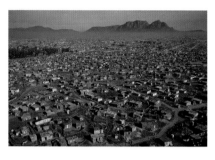

[123] *Cape Flats, Cape Town, South Africa*
A rapidly growing population of black and mixed-race people struggling to find work in post-apartheid South Africa occupies the Cape Flats section of Cape Town. The wealthy and better-known part of Cape Town is on the opposite side of Table Mountain, visible in the background.

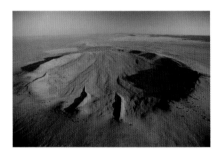

[124] *Meteorite crater, Sperrgebiet, Namibia*
Roter Kamm, a 3.7-million-year-old meteorite crater is raked by wind and sand in the remote diamond-mining area of southwestern Namibia. It is strictly forbidden for anyone to enter the diamond-mining district, leaving this deep impact crater (one and a half miles wide and 130 yards deep) in pristine condition.

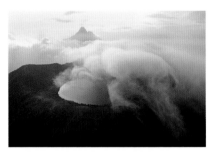

[125] *Crater lake of Mount Visoke, Rwanda/Congo*
Mount Visoke (12,175 feet), situated on the border between Rwanda and Congo, is at the heart of the mountain gorilla preserve in Parc National des Volcans. This small crater lake is found at the summit of Visoke. In the background is Mount Mikeno in Congo.

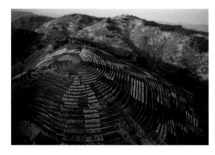

[126] *Terraced agriculture, near Kabuye, Rwanda*
Terraced crops climb the slopes of virtually every mountain in northern Rwanda. Any speck of arable land is taken, so people push into increasingly fragile landscapes—and one another in a desperate effort to feed their growing families. The population of Rwanda has quadrupled in the past fifty years, and land scarcity contributed to Rwanda's genocide in 1994.

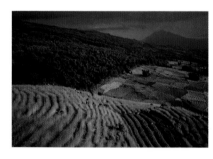

[127] *Edge of a gorilla reserve, Virunga Mountains, Rwanda*
At the edge of the Parc National des Volcans in Rwanda, villagers walk through terraced fields of wheat on their way to fetch water. The park is a closely protected sanctuary for mountain gorillas, which bring in large sums of money from foreign tourists. Rwanda has Africa's highest rural population density, and intense competition for farmland has pushed people to cultivate right up to the park boundary at 9,500 feet.

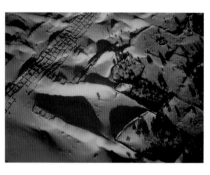

[128–29] *Sand fences of Tekenket, Mauritania*
A grid of sand fencing is an attempt to slow the advance of migrating dunes into the ancient Saharan oasis of Tekenket in Mauritania. This technique was originally developed in China's Gobi desert, and can slow the advance of dunes onto croplands, but it rarely stops their movement.

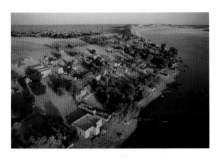

[130] *Bartaga village, Niger River, Gao, Mali*
The Bartaga village mosque (foreground) faces sunrise just upstream from Gao, where the Niger River forms the southern boundary of the Sahara Desert. Villagers bring their cattle down to the river to drink each morning, and graze them inland to stay clear of mosquitoes.

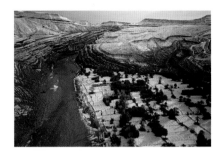

[131] *Rice drying on a bank of the Niger River, Mali*
Two men enjoy the morning view from atop a dune while their rice dries on a bank of the Niger River, just upstream from Gao, Mali. This dune is said to be the tallest along the northern section of the river. Rice is the main wetland crop in Mali and is planted when the river is high after summer rains.

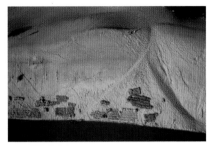

[132] *Rare snowfall in the Atlas Mountains, Gorges du Ziz, Morocco*
A rare snowfall blankets the fields of Ifri on the Ziz River, which channels water from the high Atlas Mountains out into the Sahara Desert. The village of Ifri is sited on high infertile ground to preserve the limited amount of agricultural land for dates and other crops.

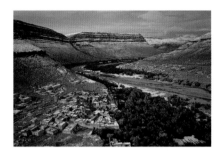

[133] *Rare snowfall in the Atlas Mountains, Gorges du Ziz, Morocco*
The first snowfall in thirty-two years lasts only a day in the *ksar* (fortified village) of Ifri in the Gorges du Ziz. The old ksar was built from stones and sun-baked mud bricks, with watchtowers at its corners to warn against raids from marauding tribes that once roamed the Sahara.

[134] *Cape buffalo, Linyanti River, Botswana*
A herd of cape buffalo stirs up dust as they move through woodlands in the Linyanti area of northern Botswana. Buffalo congregate in woodlands for cover, but prefer wetlands for fresh grazing, which mostly takes place at night. They have poor eyesight and hearing and herd in large numbers to protect themselves from predators.

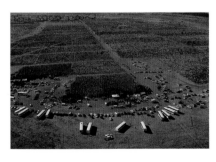

[135] *Saturday funerals, Soweto, South Africa*
It is estimated that half to a third of all funerals at this Soweto cemetery are for people who have died from HIV. Funerals usually occur on Saturday morning and families invite huge numbers of guests for elaborate ceremonies, food, and drink.

[136–37] *Zebra migration, Makgadikgadi Pans, Botswana*
A herd of thousands of zebras congregate near the last remaining waterhole in Botswana's Makgadikgadi Pans as they prepare to migrate west to the Boteti River. This is the largest animal migration in southern Africa. However, it recently has been complicated by the construction of a fence along the river, which was built to separate cattle from wildlife.

[138] *Vultures and elephant, Chobe National Park, Botswana*
This elephant died from disease in the floodplain of the Zambezi River in Chobe National Park, Botswana. By the end of the dry season the area has some of the largest herds of elephants in Africa. The elephant herds in Botswana have continued to grow, causing conflict with increasing human population.

[139] *Lions, Okavango Delta, Botswana*
A pride of lions takes an afternoon rest in the Okavango Delta, and show no fear of a low-flying aircraft. This photo was taken from an airplane, as an emergency landing of my motorized paraglider here could have ended badly.

[140] *Afternoon traffic, Cape Town, South Africa*
This afternoon traffic jam at an intersection near the Cape Flats section is a common occurrence. South Africa is the most industrialized country in Africa, with more vehicles per capita than any other sub-Saharan nation.

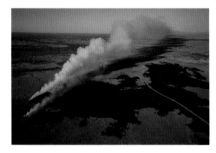

[141] *Bush fire, Omo Delta, Ethiopia*
Plumes of smoke rise from a bush fire set by local
Murile cattle herders near the mouth of the Omo River
in southern Ethiopia. Bush fires are set to stimulate
the growth of new grass for grazing livestock and to
clear the land for planting crops.

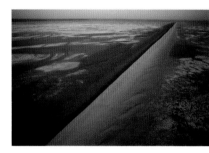

[146] *Grass island, Makgadikgadi Pans, Botswana*
In the salt flats of the Makgadikgadi Pans, Botswana,
an island of grass forms an isolated patch of grazing
for zebras and other migratory wildlife. The shape of
the island indicates that it was once a crescent-shaped
barchan dune facing into the dominant east wind.

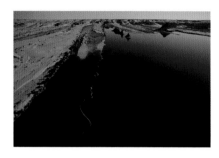

[147] *Salt ridge, Chalbi Desert, Kenya*
The salt flats surrounding this unusual ridge in
northern Kenya were too soft to be accessed by car,
so world-champion pilot Alain Arnoux explored it
with a motorized paraglider. The stiff winds allowed
Alain to skip along the brick-hard ridge with his feet
while still flying, and in the process he discovered that
what appears to be a long sand dune is actually a ridge
of salty mud that traps blowing sand.

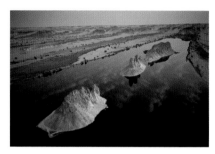

[148] *Lake Teli, Ounianga Serir, Chad*
Ounianga Serir, the largest lake complex in the Sahara,
is being cut into pieces by fingers of sand, which
blows through breaks in the surrounding cliffs. The
lakes here have slightly different elevations, and the
higher ones are less salty. Maps from aerial surveys
done in 1954 show the lakes much larger and more
connected, indicating that the water level has dropped
significantly since then.

[149] *Lake Teli, Ounianga Serir, Chad*
Three shiplike islands of Nubian sandstone dominate
Lake Teli. Recent discoveries of foundations and
fireplaces atop the largest island indicate that it was
occupied, perhaps as a refuge in times of war, as
recently as a hundred years ago. Today, the local
people live on a combination of livestock and dates,
which are harvested in groves along the lakeshore.

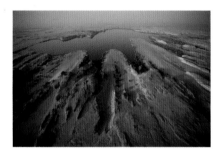

[150] *Lake Yoa, Ounianga Kebir, Chad*
Harmattan winds blow sand through breaks in a
cliff of Nubian sandstone above Lake Yoa, slowly
dividing and filling the lake with sand. The lake is fed
freshwater from springs that yield groundwater more
than five thousand years old. This fossil water once
fell as rain when the Sahara was a much wetter place.
Here, the view looks downwind toward the south.

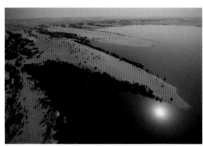

[151] *Lake Yoa, Ounianga Kebir, Chad*
Naturally irrigated date palms line the shore of
this hypersaline lake in the Central Sahara. Intense
sunlight and winds have created a paradox: You can
drink freshwater out of your footsteps in the beach
sand, but the lake water a few feet away is virtually
lifeless and saltier than seawater.

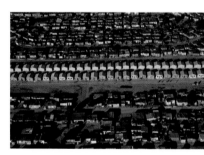

[152–53] *Sand dunes inundating Chinguetti, Mauritania*
The medieval city of Chinguetti, Mauritania, was
founded in the eighth century and was once a rich
center in the salt trade before the arrival of European
sailing ships to the African coast. The city is famous
for its Moorish architecture and libraries of Koranic
and scientific texts. It has been designated a World
Heritage Site by UNESCO.

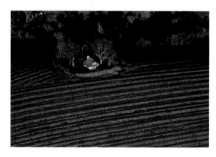

[154] *Post-apartheid housing, Cape Town, South Africa*
A rapidly growing population of black and mixed-race
South Africans occupies the Cape Flats section of
Cape Town. The two rows of houses in the middle of
the photograph are called "Mandela Homes" and are
a new style of house, complete with plumbing and
electricity, being built by the government to improve
the lives of the poor.

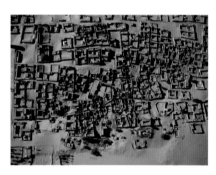

[155] *Private home, Cape Town, South Africa*
Located in the wealthy Constantia Valley section
of Cape Town, this isolated house is surrounded by
vineyards of sauvignon blanc. South Africa has one of
the most unequal distributions of wealth and income
in the world.

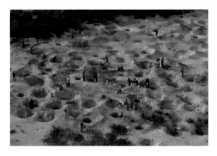

[156] *Gathering water, Pate Island, Kenya*
Villagers on Pate Island dig small holes in the beach sand to gather brackish drinking water less than three hundred feet from the ocean. Freshwater is a limited resource for the growing population on this low-lying island, which has no plumbing or electricity.

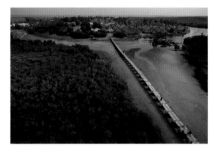

[157] *Walkway to Faza village, Pate Island, Kenya*
Faza, a village of fishermen on Pate Island in northern Kenya, is surrounded by water and mangrove swamps at high tide. There are no cars here, only traditional dhow sailboats and the occasional motorized water taxi. The village is attached to the shore by a long elevated causeway for foot traffic and handcarts.

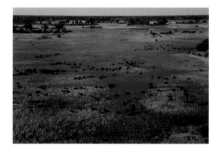

[158] *Cape buffalo, Okavango Delta, Botswana*
A herd of cape buffalo moves across a flooded section of the Okavango Delta in Botswana. Cape buffalo thrive in the mixed habitat of the Okavango, where they find wetland grasses for food and dense bush for shade and cover.

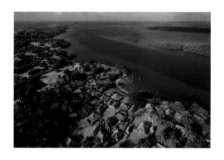

[159] *Fishing village, Kiwayu, Kenya*
This fishing village on Kiwayu Island is part of Kiunga Marine National Reserve where local villagers are allowed to fish for subsistence and trade. The reserve protects nine mangrove species and seagrass beds that sustain sea turtles, dugongs, fish, and bird life.

[160–61] *Cape Flats, Cape Town, South Africa*
The Cape Flats section of Cape Town was known as the dumping ground of apartheid— where non-whites were relocated under the Group Areas Act. It is now home to the same population that still is struggling to find work in the new South Africa.

[162] *Flamingos, Skeleton Coast, Namibia*
Flamingos take flight over a wind-whipped lake just north of Luderitz, Namibia. They feed in shallow saline lagoons near the Atlantic Coast, and use their specially adapted beaks to filter the algae. Due to their instinctive fear of predatory raptors, the flamingos quickly take flight at the sight of my overflying aircraft.

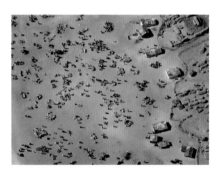

[163] *Goat market, Nouakchott, Mauritania*
The drought that struck the Sahel in the mid-1980s wiped out most of the goats, cattle, and camels that were the livelihood for the vast majority of Mauritania's population. Today, 90 percent of the country's people live in Nouakchott, the coastal capital, where a hunger for fresh meat leads one to the town's goat market. The men's taste for blue robes is evident even in an aerial photograph.

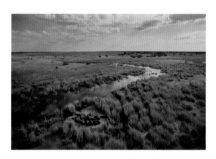

[164] *Hippopotamuses, Linyanti River, Botswana*
A herd of hippopotamuses rest in the afternoon heat, in the Linyanti area of northern Botswana. Hippos are most active at night when they leave the water to forage for fresh vegetation and have been known to travel sixty miles or more in a single night.

[165] *Elephant family, Linyanti River, Botswana*
After a day of feeding on grass in the Linyanti River in northern Botswana, a family of elephants starts their return to dry brushland in the late afternoon. Botswana has strictly managed its elephant herds for many decades, but elephant population growth has put them in conflict with local farmers and increased their impact on a limited wildlife habitat.

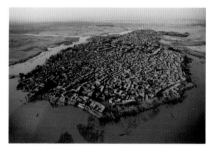

[170] *Wet season, Djenné, Mali*
Djenné, one of the oldest cities in sub-Saharan Africa, is situated on an island in the Bani River. It flourished as a meeting place for traders from the deserts of Sudan and the tropical forests of Guinea. In addition to its commercial importance, Djenné is also known as a center of Islamic learning, and its Great Mosque is considered a masterpiece of mud architecture.

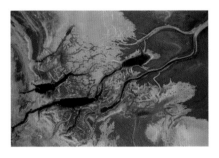

[171] *Island village near Ayorou, Niger*
In the village of Ayorou, located on an island in the Niger River, traditional African life continues as it has for centuries. Crops are laid out to dry on the flat mud roofs, fishing and trading boats ply the river, and cattle swim from bank to bank in search of fresh grass. The facades of the houses are patterned with white clay.

[172] *Overgrazing, Djenné, Mali*
Cattle come from miles around to drink from the Bani River near Djenné, Mali. The land has been stripped of almost all trees and shrubbery due to the intensive grazing and the gathering of firewood for the town, making the soil far more susceptible to rain and wind erosion.

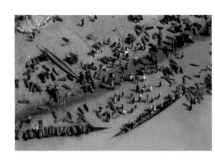

[173] *Firewood market, Djenné, Mali*
On the island city of Djenné the streets are so narrow that there is no place to park the donkey carts that bring heavy goods to the weekly market. Here traders from the surrounding villages offload firewood from boats used to cross the Bani River.

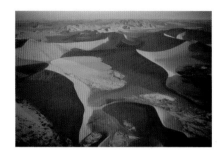

[174] *Migrating dunes, Sossusvlei, Namibia*
A migrating complex of orange barchan dunes in Sossusvlei began as white beach sand on the Atlantic coast and were slowly driven northeast by the trade winds. After millions of years, they reached the base of the Naukluft Mountains, and the oxidation of their iron minerals by coastal humidity has turned them brick-orange in color. Here, they have migrated across the white clay plain of the Tsauchab River that has washed down from the mountains.

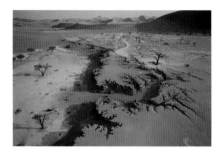

[175] *Dead Vlei, Namib-Naukluft Park, Namibia*
When Namibia's Tsauchab River floods all the way down to the desert dunes, it turns its terminus, Dead Vlei, into a temporary lake. One of the massive dunes that borders Dead Vlei has moved, causing the lake bed to expand to a lower level, dropping the water table and killing the trees that give Dead Vlei its name.

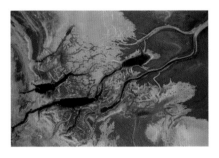

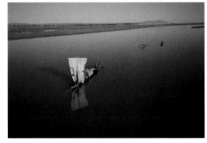

[176–77] *Delta of Lake Natron, Kenya*
A freshwater tributary on the north edge of Lake Natron is stained red by salt-loving algae that permeate the mud flats. The lake lies at the bottom of the Great Rift Valley that is slowly splitting East Africa off from the rest of the continent. The long shadow on the right is cast by Alain Arnoux, who abandoned an attempt to wade into the lake's caustic waters.

[178] *Niger River, near Gao, Mali*
A boat along the Niger River in northern Mali tries to let the wind speed the trip downstream to Gao. The river is the main transportation artery in this remote region as the roads are in poor condition and largely unused.

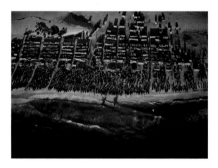

[179] *Camel drawing water near Araouane, Mali*
A lone camel draws water from a remote well at Dayet en Nahrat, between Araouane and Timbuktu in northern Mali. The areas around water wells in Mali are barren, as livestock using the water have overgrazed most of the vegetation. This well is a common resting place for camel caravans on their way to and from the salt mines of Taoudenni.

[180] *Fishing boats, Nouakchott, Mauritania*
The population of Mauritania was more than 90 percent pastoral nomads at the time of independence, but after a severe drought in the 1980s, most of Mauritania's population moved to the coast. Now desert nomads have turned to the sea to survive, but overfishing by huge foreign factory ships is rapidly depleting one of the world's richest fisheries.

[181] *Seal colony, Cape Fria, Namibia*
A colony of a hundred thousand Cape fur seals begins a stampede for the Atlantic as I make a low pass over the Skeleton Coast in my motorized paraglider. The seals had been sunning on the beach in the late afternoon, and taking a break from fishing in the cold waters of the Benguela current. Flying only fifty feet above them I could smell their fishy breath and hear their doglike bark as they headed for the safety of the sea.

[182] *Primary school, Namlog, Kenya*
Children and teachers empty out of a primary school to watch my motorized paraglider in flight near Amboseli National Park. Kenya has one of the highest literacy rates in Africa, with some 80 percent of those over age fifteen being able to read and write.

[183] *Cape Town harbor, South Africa*
The port of Cape Town glitters at sunset. With a population of 2.9 million, it is the third largest city in South Africa. With its stunning geographic position between the Atlantic and Indian oceans, it is considered the most beautiful big city in Africa.

[184] *Island farm, Lake Bulera, Rwanda*
Rwanda's intense competition for farmland drives farmers to cultivate even the most unlikely plots of fertile land, such as this tiny islet in Lake Bulera. The country's growing population has led to intensive farming of staples like beans, maize, bananas, and potatoes, which in turn have decreased the fertility of the soil and led to accelerated erosion.

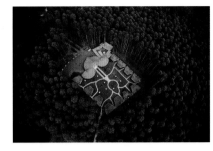

[185] *Safari lodge for gorilla watchers, Ruhengeri, Rwanda*
Kinigi Guest House was built for tourists visiting the mountain gorilla reserve of Parc National des Volcans in Rwanda. This protected sanctuary for mountain gorillas brings in a tightly controlled number of foreign tourists who pay $500 for a one-hour gorilla encounter, which is twice the annual income of an average Rwandan. The lodge is surrounded by a tree farm.

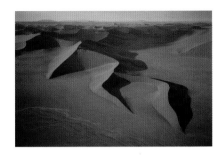

[186] *Migrating dunes, Sossusvlei, Namibia*
The compound barchan dunes of the Namib desert migrate northward like a multi-pronged fork across Sossusvlei in Namib-Naukluft National Park. Barchan dunes have been described as the largest life form in the world's desert; they move, adapt, grow, and reproduce, and thus fit the conventional definition of a life form.

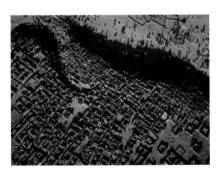

[187] *Dying oasis town of Ouadane, Mauritania*
The ancient city of Ouadane, Mauritania, was founded in the twelfth century as a center for the salt trade as well as a gathering point for seminomadic Berber tribes. It is one of the most remote outposts in central Mauritania, and inhabitants still pitch their tents inside their compounds as a refuge from the harsh Saharan climate.

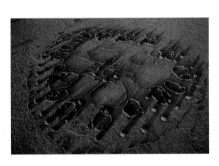

[188] *Rendille village, Kargi, Kenya*
The seminomadic people of the Rendille tribe live in circular villages composed of small family huts and thorn-scrub pens for their goats and camels. This village is near the small missionary post at Kargi in northern Kenya, where mission services (dispensaries, schools, water wells) have concentrated more of the Rendille in the area than can be supported on local grazing.

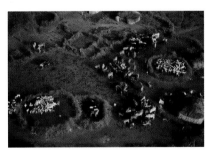

[189] *Masai cattle camp, Orbili, Kenya*
Masai cattle and goats are let out of their *kraal*, or circular enclosure, near Orbili, which is adjacent to Amboseli National Park in Kenya. Masai kraals are made of acacia thorn that protect their communal herds from nocturnal predators, such as lions. Masai homes, made of sticks, mud, and animal dung, are located inside the kraals. Cow blood and milk account for a large portion of the Masai diet.

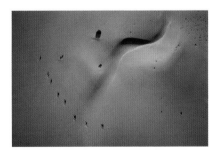

[190] *Camels leaving well of Araouane, Mali*
Camels leave the well at Araouane, a welcome stopover for salt caravans traveling from Taodenni to Timbuktu. The ancient salt trade continues to supply edible salt to the markets of much of northern Mali. Salt was once such a valuable commodity that it was traded as far south as Ghana for its weight in gold.

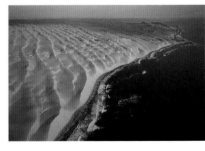

[191] *Skeleton Coast, Namibia*
The cold waters of the Benguela current allow little moisture other than fog to reach Namibia's Skeleton Coast. In this remote area halfway between Walvis Bay and Luderitz in Namib Naukluft Park, there are no roads and very few visitors. This unique coastal wilderness has recently been turned into an integrated nature preserve stretching from South Africa all the way to Angola.

Alain Arnoux

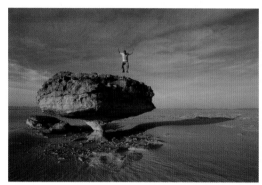

François Lagarde

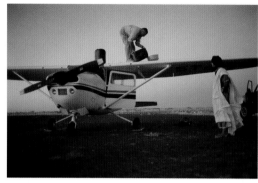

Gilbert Mairey

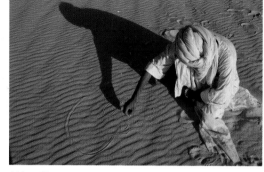

Mohamed Ixa

This book would not have been possible without the help of a lot of people who believed in my crazy idea. First and foremost I am indebted to my great friends François Lagarde and Alain Arnoux. Both are world-class pilots who have patiently traveled with me on many expeditions. On more occasions than I care to remember, I simply could not have taken off or landed safely without them.

In Africa I had with me the best of local aircraft pilots and guides: Marc Alberca and Mohamed Ixa in Niger; Pier-Paolo Rossi and Piero Ravà in Chad; Belete Gebre and Tom Mattanovich in Ethiopia; Petit Moussa Guindo in Mali; Hennie Rawlinson, Peter Perlstein, Wihan Wilders, and Tico McNutt in Botswana; David Allen, Alexis Peltier, and Thomas Samoes in Kenya; Maurizio Pegoraro in Morocco; Chris Bakkes and Chris Liebenberg in Nambia; Gilbert Mairey and Bruno Lamarche in Mauritania; Yalex Aigbe in Nigeria; Gerhard Kleynhans, Helene and David Hamman, Cornelius of Lanseria Flight School; Chris Sheasby and Greg Johnson in South Africa; and Martin Lustyk in Rwanda.

I would like to thank:
Markus Muller and Meikel Werner at Fresh Breeze, for making the marvelous motors that have helped me defy gravity, and for shipping me the parts when I succeeded in breaking the unbreakable.
Ken Baier, for so kindly teaching me how to paraglide safely as well as how to improvise when it was required.
Marion van Offelen, for giving me a helping hand when I was young and hungry.
Brook LeVan, who was my companion on many early safaris and adventures.
Brian Aubry and Suzanne Reier, for giving me couches to sleep on over many decades and continents.
Caroline Herter, for her long-standing encouragement and creative support for this work.
Curt Holzinger, for getting me to Africa and lending me the camera that led to a lifetime preoccupation.
Writer Donovan Webster, for his patience and friendship in the field.

Photography is largely a solitary profession, but I am deeply indebted to the generosity of my fellow photographers: Gerd Ludwig was the first to understand the uniqueness of what I could do with my little aircraft and the first to encourage my work with it. Nick Nichols has always been a tremendous friend and source of inspiration. And my dear friend Ed Kashi, who helped me get started in photography and continues to show me the way forward with innovation and commitment.

I would like to thank Eric Himmel at Abrams in New York, who was the first to see that my thirty years of travels in Africa would make an interesting book; Hervé de La Martinière, who instantly grasped the personal nature of this work, committed to making it into a book, and put together the first-class team that made it a reality; my endlessly patient text editor at Abrams, Andrea Danese, for enduring innumerable changes; and Nathalie Bec at Éditions de La Martinière, for collecting the visual elements into one volume with grace and elegance. I would also like to thank Marie-Laure Garello for making my pictures glow on the printed page. Marine Gille was instrumental in creating an elegant design—she made superb choices while at the same time allowing me to have a voice throughout the process.

Most of the fieldwork that created these photos was generously funded by *National Geographic*. Bill Allen, Susan Welchman, Susan Smith, Bill Douthitt, John Echave, Kent Kobersteen, and David Griffin were all early supporters. Chris Johns had the vision to set me loose in Africa with a very long leash; he sent me out to take aerial photos of an entire continent with only one instruction: Show me what I have never seen before. How great is that? And Kathy Moran was the guardian angel who helped me edit the pictures for this book.

Additional aid came from my dear friends Ruth Eichhorn and Peter-Matthias Gaede at the German edition of *GEO* magazine, who sent me to Nigeria with writer Christoph Reuter. Christoph did an incredible job of getting us into (and out of) places where few outsiders dared to go.

Donovan Webster

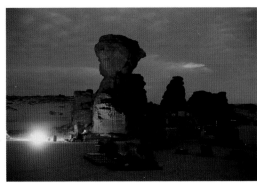

Camp in Ténéré, Niger

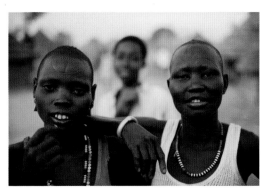

Rumbek, Sudan, 1979

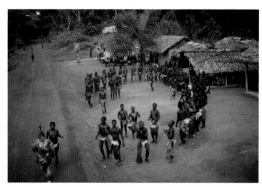

Mbuti Pygmy village, Zaire, 1979

I would like to thank David Cohen, who sent François Lagarde and me to Namibia for the book *A Day in the Life of Africa*. Dave van Smeerdijk, Colin Bell, and Suzanne Rodrigues at Wilderness Safaris gave me extraordinary advice, hospitality, and logistical support while I was in Namibia.

At my home office in New Jersey, I am indebted to the organizational skills of my former office managers Lisa Addario, Lorena Barros, Lynn Wilkins, Jen Petreshock, and Catherine Converse. I would especially like to thank Catherine for doggedly converting my pictures into digital files for this book, and my current office manager, Jessica Licciardello, for being the humble hands of my mind.

But most of all, I would like to thank the two anchors in my life: my mother, Verna Steinmetz, and my wife, Lisa Bannon. Verna has always been my greatest fan, in spite of the fact that she forbade me to go to Africa in the first place and tried to get me to pursue a more reasonable career.

And my wife, Lisa Bannon, the love of my life, who puts up with my travels and obsessive behavior, takes care of our three kids while I'm in the field for long periods of time, and still has time for her own career as a journalist at the *Wall Street Journal*. Her wisdom and editing skills deftly shaped the text for this book. And to my three children— Nell, John, and Nicholas—you and Lisa are the joys of my life.

Travelers and journalists are dependent on the kindness of strangers, which was especially true in my case. This book simply would not exist without the generosity of thousands of gracious African villagers, countless truck drivers, bureaucrats, missionaries, witch doctors, mercenaries, and expatriates. They may have forgotten the stranger who passed through their lives, but I will always remember their kindness.

For more information go to www.GeorgeSteinmetz.com

Book design: Marine Gille

For the English-language edition:
Andrea Danese, Editor
Shawn Dahl, Designer
Neil Egan, Jacket design
Jules Thomson, Production Manager

© IGN, Paris, 2008, for the excerpt of the topographic map on p. 48
of Takolokouzet NE-32-XVI, authorization no. 80-8024
© D.R. for the images on p. 97, left, excerpted from L'Escadrille du
désert, Sahara, 1935–1937 by Michel de Wailly (Athanor, 1988)
© Alexis Peltier for the photograph on p. 198

Library of Congress Cataloging-in-Publication Data

Steinmetz, George, 1957-
 African air / by George Steinmetz.
 p. cm.
 ISBN 978-0-8109-8403-5
 1. Aerial photography—Africa. 2. Africa—Aerial photographs.
3. Steinmetz, George, 1957– I. Title.

TR810.S76 2008
778.3'5096—dc22

 2008017511

Abrams books are available at special discounts when purchased
in quantity for premiums and promotions as well as fundraising or
educational use. Special editions can also be created to specification.
For details, contact specialmarkets@hnabooks.com or the
address below.

HNA
harry n. abrams, inc.
a subsidiary of La Martinière Groupe

115 West 18th Street
New York, NY 10011
www.hnabooks.com